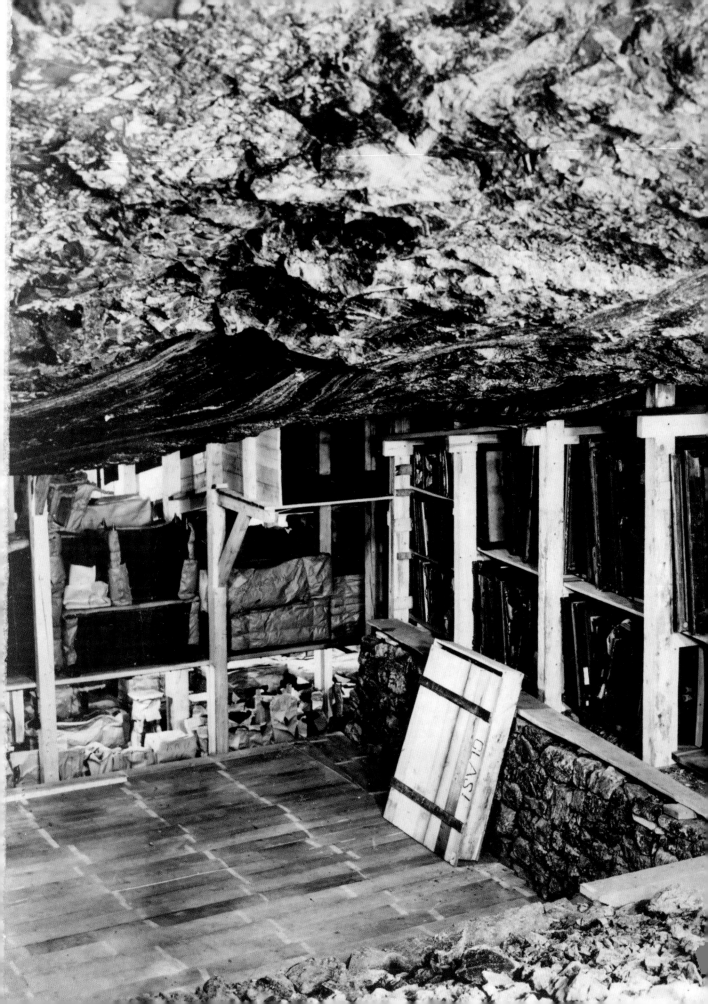

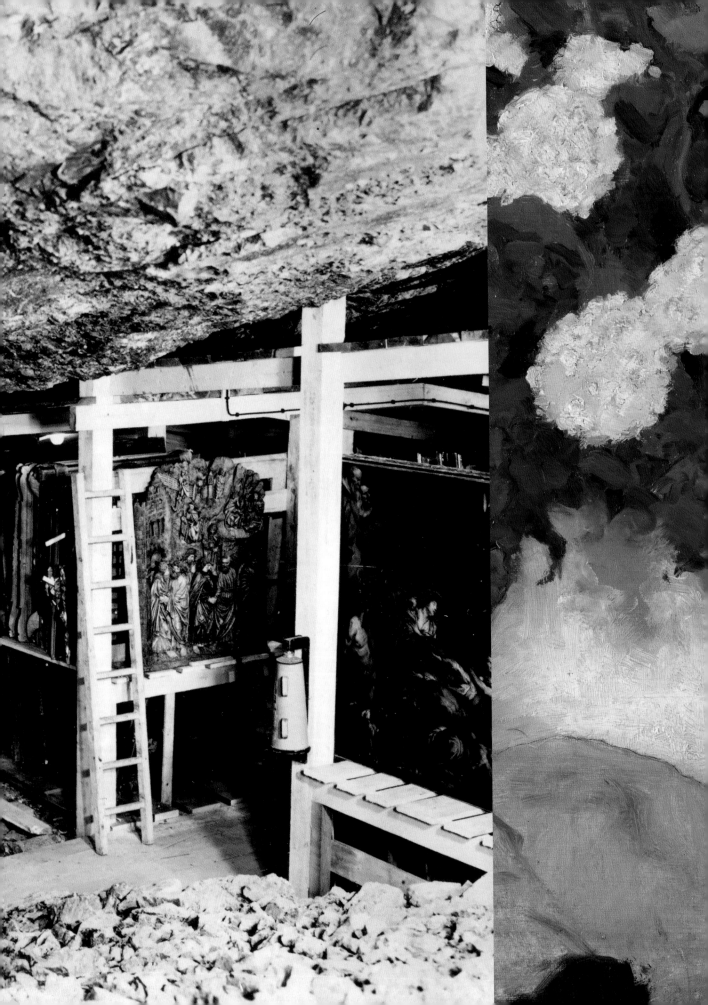

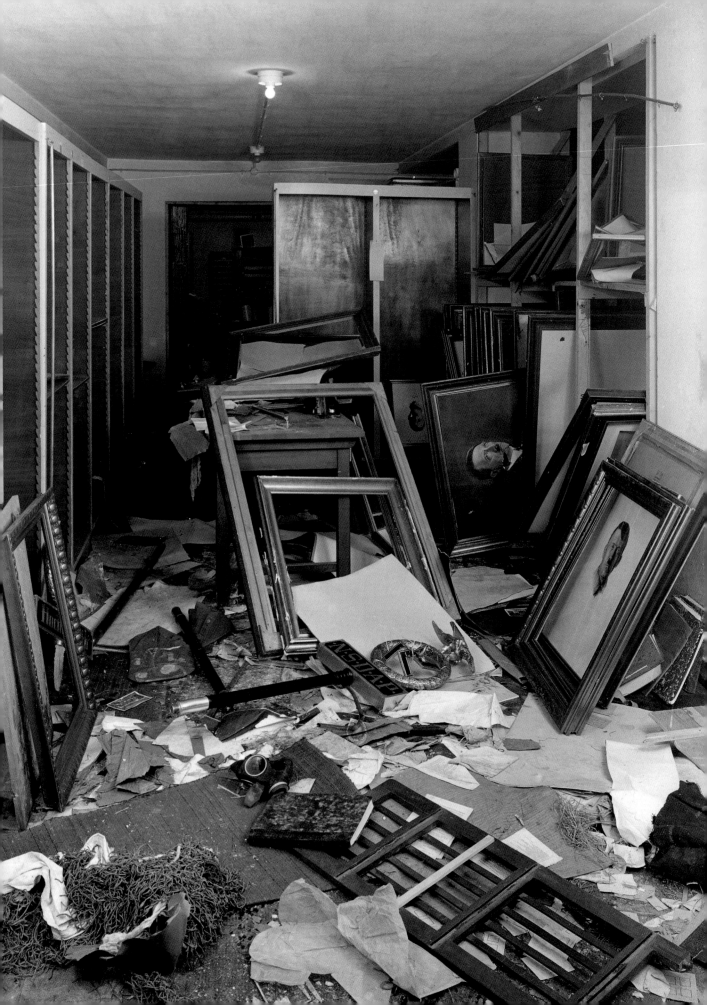

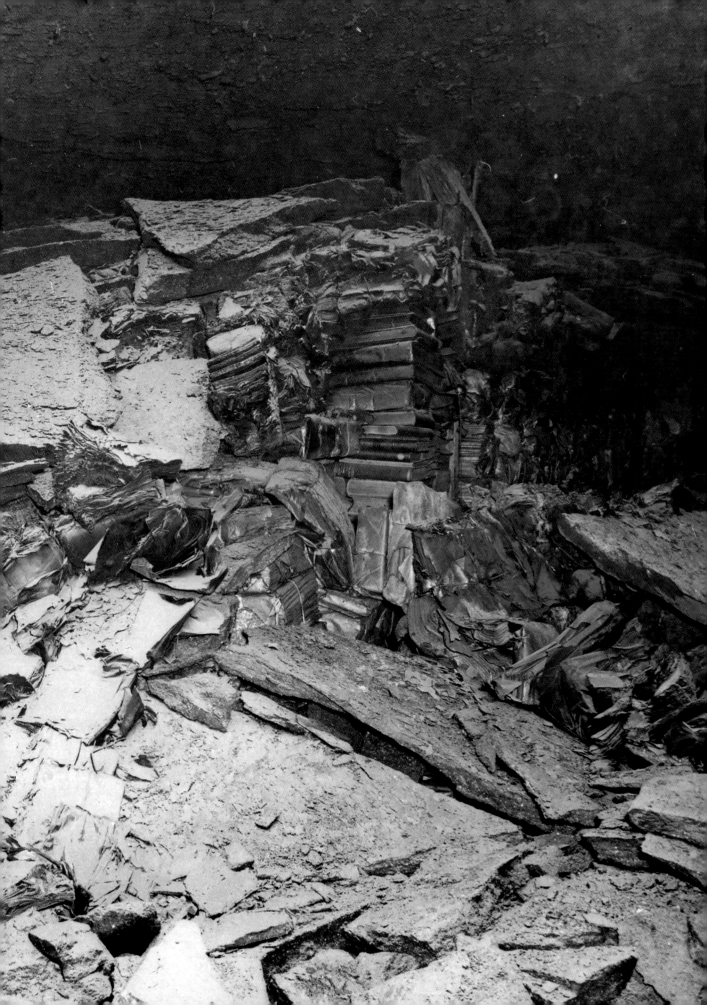

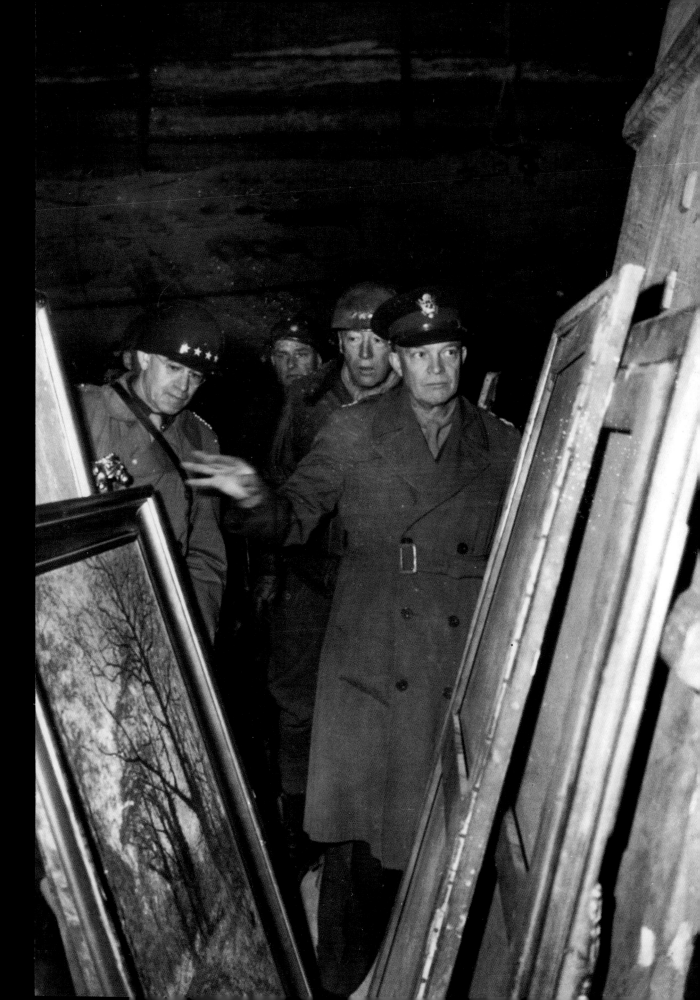

AFTERLIVES

Recovering the Lost Stories of Looted Art

**Darsie Alexander
and Sam Sackeroff**

**Essays by
Julia Voss and
Mark Wasiuta**

Jewish Museum, New York
Under the auspices of the Jewish Theological Seminary of America

Yale University Press
New Haven and London

den 31st Januar 1817.

Contents

15 **Foreword**
Claudia Gould
Helen Goldsmith Menschel Director
Jewish Museum

17 **Donors and Lenders to the Exhibition**

18 **Acknowledgments**

20 **The Room of the Martyrs, Jeu de Paume, Paris**

49 AFTERLIVES
THE SEIZURE, MOVEMENT, AND RECOVERY OF LOOTED ART
Darsie Alexander

79 RECONSTRUCTING CULTURE
Sam Sackeroff

107 THE ARCHITECTURE OF DISPOSSESSION
Mark Wasiuta

125 THE HISTORY OF GERMAN ART POLITICS
FROM 1933 TO 2019, TOLD IN TEN EXHIBITIONS
Julia Voss

144 **Collection and Redistribution:**
The Allied Collecting Points in Germany
145 The Offenbach Archival Depot
154 The Munich Central Collecting Point
160 The Wiesbaden Central Collecting Point

171 **Recovered Works and Their Histories**

223 **Artists' Portfolios**
224 Maria Eichhorn
232 Hadar Gad
240 Dor Guez
248 Lisa Oppenheim

257 **Selected Bibliography**
Olivia Casa

264 **Index**
268 Jewish Museum Board of Trustees, 2021
269 Image Credits and Copyrights

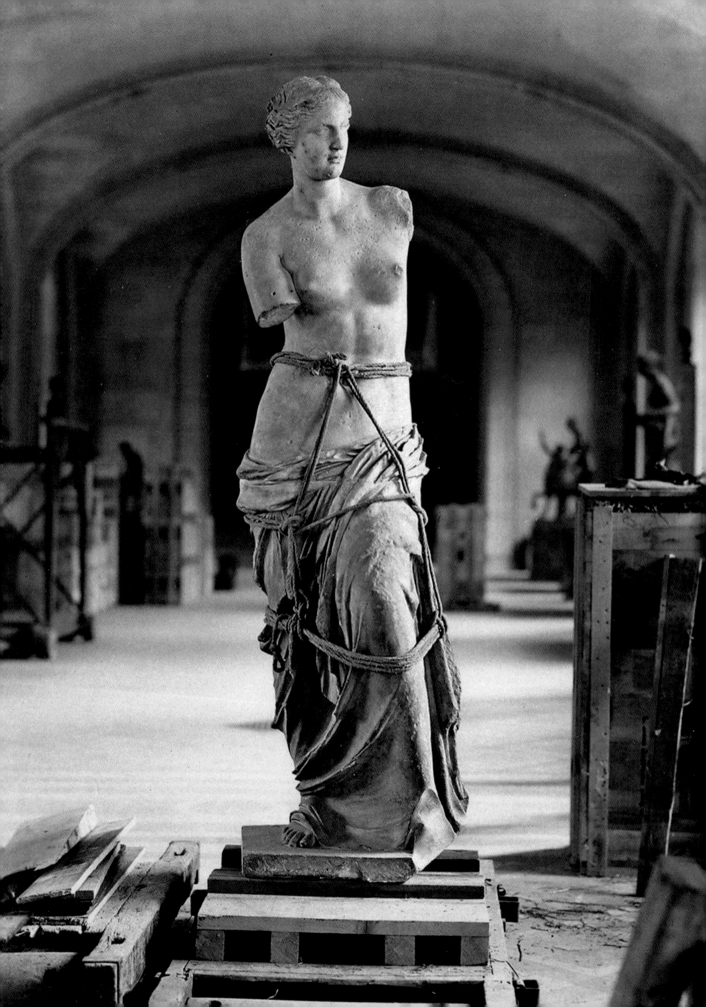

Foreword

In a year that has seen the world and the United States grappling with both the overwhelming COVID-19 pandemic and rising threats to democracy, I find myself thinking afresh about the idea of "afterlives": the notion that art can express both trauma and survival in ways that extend far beyond our own experience. Never has this idea seemed more crucial than now. In this difficult moment we do well to reflect on the Holocaust, the crisis of the last century, and strive to understand the ways art functioned and continues to function in troubled times.

All works of art tell stories, but sometimes they are also actors in a larger and broader narrative. This publication and its accompanying exhibition explore the intertwining of these two levels of meaning: the content of the artwork and the journey of the physical object from its creation to the present day. *Afterlives* is a powerful testament to the enduring influence of art and the central role it plays in both the preservation and the revitalization of culture. At the same time, it reminds us that the inherent meaning of a work of art can evolve as its history accrues and the context for viewers shifts. These are issues of enormous importance for all museums, and particularly for a culturally specific institution such as the Jewish Museum.

Culture is often caught in the crosshairs of history. Since World War II, wartime conflict has eroded or destroyed precious historical sites in Cambodia, Syria, Iraq, and Afghanistan; others have been degraded by mass tourism, flood, fire, and economic disaster. Against such odds, the existence of artworks from bygone eras is an astounding gift. Yet it comes at a price: objects that once had a private life within a home or synagogue, lovingly used and handled, may need to be safeguarded in the cooler and more public space of the museum, their everyday poetry transformed into formal terms as the subjects of study and memory.

I am grateful to the talented staff of the Jewish Museum, who have made this publication and exhibition possible in circumstances more difficult than we could have imagined when the project was first conceived. Darsie Alexander, the Susan and Elihu Rose Chief Curator, originated the idea and invited four remarkable contemporary artists, Maria Eichhorn, Hadar Gad, Dor Guez, and Lisa Oppenheim, to weave the art of our own time into the argument. She and Sam Sackeroff, Lerman-Neubauer Assistant Curator, whose tireless research is present on every page of this book, together delved deeply into the museum's records and collections, bringing forth fresh perspectives on our own history and core values. Ruth Beesch, Senior Deputy Director, Programs and Strategic Initiatives, provided essential assistance. Thanks to Jonah Nigh, Sarah Supcoff, and their colleagues on the development, marketing, and communications teams. Eve Sinaiko, Director of Publications, coordinated this beautiful publication; Adam Michaels and Siiri Tännler of IN-FO.CO produced the stellar design. Dan Kershaw, working with Elizabeth Abbarno, Michael Stafford, and the Exhibition Services staff, expertly designed and prepared the exhibition. My great thanks for the tireless work of our curatorial assistant on this project, Olivia Casa, and interns Bradford Case and Marie-Eve Lafontaine.

Many private collectors and institutions have lent us precious artworks, and we offer them our heartfelt gratitude. Our generous donors have upheld us at a critical time. As always, the Jewish Museum is sustained and encouraged by its staunch Trustees, under the visionary leadership of Board Chairman Robert A. Pruzan and President Stephen M. Scherr.

Claudia Gould
Helen Goldsmith Menschel Director
Jewish Museum

As World War II approached in 1939, French authorities evacuated the *Venus de Milo* from the Louvre in Paris to safe storage in the country.

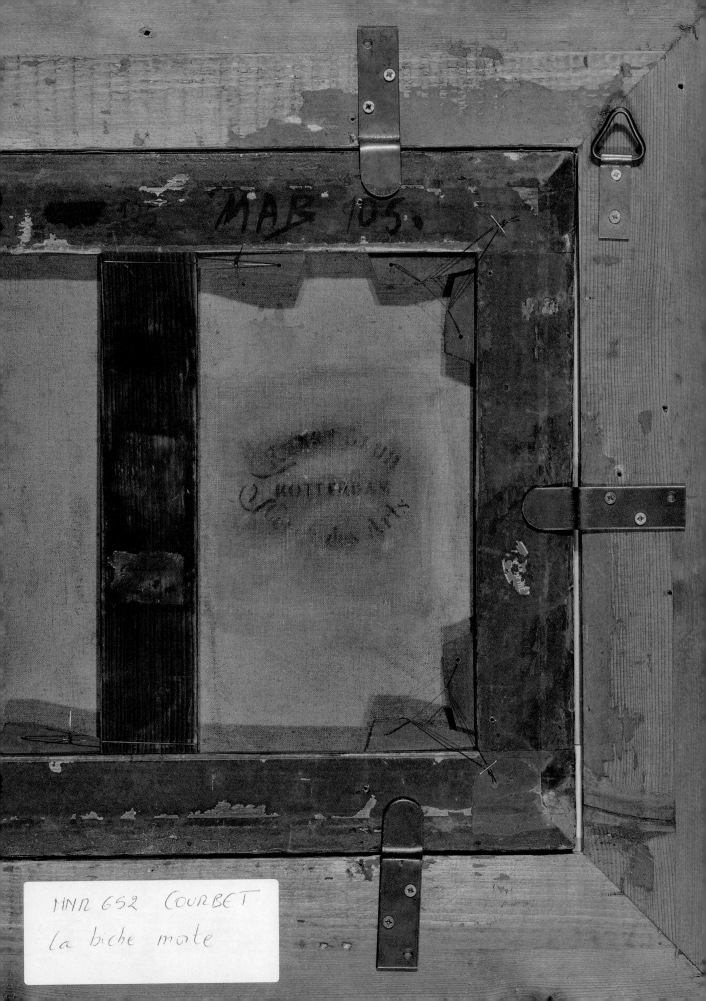

Donors to the Exhibition

Afterlives: Recovering the Lost Stories of Looted Art is made possible by The Marilyn and Barry Rubenstein Family Foundation, The Wilf Family Foundations, the David Berg Foundation, the Conference on Jewish Material Claims Against Germany, The Joan Toepfer Charitable Trust, Ulrika and Joel Citron, Linda and Ilan Kaufthal, Liz Lange and David Shapiro, Vivian and Daniel Bernstein, Blavatnik Family Foundation, Nancy and Larry Pantirer Family Foundation, Betty Pantirer Schwartz, The Samuel H. Kress Foundation, Artis Contemporary Israeli Art Fund, and The Lupin Foundation.

Additional support is provided by the Centennial Fund, The Skirball Fund for American Jewish Life Exhibitions, Barbara S. Horowitz Contemporary Art Fund, and other generous donors.

The publication is made possible, in part, by the Dorot Foundation.

ועידת התביעות
Claims Conference
Conference on Jewish Material Claims
Against Germany

Lenders to the Exhibition

Art Institute of Chicago
Chrysler Museum of Art, Norfolk, Virginia
Getty Research Institute, Los Angeles
Estate of Hugo Simon
Jewish Theological Seminary, New York
Leo Baeck Institute, New York
Musée National d'Art Moderne, Centre Pompidou, Paris
Musée du Petit Palais, Geneva
Museum of Modern Art, New York
National Archives and Records Administration, College Park, Maryland
National Gallery of Art, Washington, DC
Nelson-Atkins Museum of Art, Kansas City, Missouri
New York Public Library
Philadelphia Museum of Art
Private collections
Ringling Museum of Art, Sarasota, Florida
Tate, London
United States Holocaust Memorial Museum, Washington, DC
University of Michigan Art Museum, Ann Arbor
Virginia Museum of Fine Arts, Richmond
Wadsworth Atheneum Museum of Art, Hartford, Connecticut
Walker Art Center, Minneapolis
Whitney Museum of American Art, New York
Yad Vashem, the World Holocaust Remembrance Center, Jerusalem
Yale University Art Gallery, New Haven, Connecticut
Yeshiva University, New York
YIVO Institute for Jewish Research, New York

The back of Gustave Courbet's *Dead Doe* (see page 195) is still inscribed at upper right with the Nazi inventory number "MAB 105" (Möbel-Aktion Bilder), a reference to the looting of the painting by the Möbel-Aktion operation in 1942.

Acknowledgments

This project, as the title suggests, tracks the evolution and passage of art through time, and books are likewise often prolonged efforts marked by many stages, both predictable and unprecedented. The emergence of the novel coronavirus halfway through the project of this publication added a new twist to our work and placed heavy demands on all participants devoted to keeping this ambitious production on track. Claudia Gould, Helen Goldsmith Menschel Director of the Jewish Museum, championed the exhibition from the outset and ensured broad institutional support for our work together during this unique time. The senior staff likewise stepped forward to corral their teams toward our common goals. A heartfelt thanks goes to Ruth Beesch for her trusted insight and deep historical knowledge of the museum and its mission; Jonah Nigh for his ability to connect so meaningfully with our supporters and stakeholders; Sarah Supcoff for bringing our work to the attention of New York City and beyond; Nelly Silagy Benedek for creating an array of cross-generational programs to align with this publication; Cindy Caplan for her stewardship of the many contracts and agreements that surround this endeavor; and David Rubenstein for his understanding of how this projects fits into the big picture of Jewish Museum operations and priorities.

A very special acknowledgment is due to Eve Sinaiko, Director of Publications, whose intricate knowledge of every facet of the book-production process was matched only by her deep investment in our research. We thank our colleagues at Yale University Press, Patricia Fidler, Amy Canonico, Sarah Henry, and Heidi Downey, for their superb work.

Other key members of the Jewish Museum staff served as the backbone of this effort. Elizabeth Abbarno pored over every contract and budget line of the exhibition with fastidious care; Bradford Case spent an entire summer locating hard-to-find works from the Room of the Martyrs at the Jeu de Paume and provided extensive provenance histories for each; Marie-Eve Lafontaine ably assisted; Taylor Catalana methodically obtained rights to countless images for this volume; Allison Curran and Collin Garrett brought both patience and poise to the solicitation process, and kept us all on track for a succession of intense grant deadlines. Katherine Danalakis watched over the care and movement of all objects needed for the exhibition and brought her tremendous institutional knowledge to our research; Amelia Kutschbach supported our efforts to ensure the accuracy of information published here and proofed countless rounds of text and footnotes; Julie Maguire seamlessly managed an enormously dynamic loan process complicated by a COVID-19 era of evolving deadlines; Jenna Weiss amplified the exhibition in attendant lectures and events during its run. Special recognition is due to the museum's curators for their invaluable insights. Claudia J. Nahson and Abigail Rapoport brought their passion for the ceremonial objects into our discussions early on; Kelly Taxter vigorously championed the inclusion of living artists in our effort; Olivia Casa compiled an early and extensive bibliography, helping to guide our subsequent research; Julija Lazutkaite played an instrumental role in the loan process and provided a level of constant support that was critical in bringing this project to life. Deep gratitude is extended to our wonderful colleagues Shira Backer, Susan Braunstein, Stephen Brown, Mason Klein, Marisa Kurtz, Kristina Parsons, Rebecca Shaykin, Aviva Weintraub, and Nora Rodriguez for their thoughtfulness and generosity. The incredible support of the families involved in this

project extends to those most closely connected to its curators: David Little and daughters Sophie and Nina provided a backdrop of thoughtfulness, warmth, and humor as this publication grew in scope and depth, giving welcome feedback and a dose of levity as the lead essay advanced over time. Flora Birnbaum was a source of insight and wisdom throughout.

The artists and creative team involved in this project deserve special recognition. Maria Eichhorn, Dor Guez, Hadar Gad, and Lisa Oppenheim all produced new work for this exhibition that ties into its historical themes. In the course of doing so, they often unearthed valuable discoveries that have inflected our thesis with deeper insight and perspective. We appreciate the work of their collaborators and gallerists along the way: Nora Alter, Aura Rosenberg, and John Miller; and Shifra Shalit, Dvir Intrator, and Eloi Boucher at Dvir Gallery, Brussels and Tel Aviv. We are also enormously grateful for the contributions of the essayists featured in this volume, Mark Wasiuta and Julia Voss. Adam Michaels and Siiri Tännler at IN-FO.CO produced the elegant design for this volume, integrating and pacing its distinct sections into a cohesive and sumptuous whole. The installation design was overseen by the ever-patient and professional Dan Kershaw. Internal graphics were commandeered by Yeliz Secerli, and digital assets produced by Director of Digital JiaJia Fei.

Research for the publication involved connecting with colleagues from across the globe. A trip to Israel curated by Rivka Saker and Hillit Zwick at Artis occurred at a formative stage in the content development, with lasting implications for the exhibition and publication. We are grateful to Jane Wilf, who helped us access the vast resources of Yad Vashem in Israel. David Zivie of the French Ministry of Culture, Paris, gave us invaluable aid. Thanks are likewise due to Marjorie Klein-Dugerdil, Petit Palais; Angela Lampe, Centre Pompidou; Elodie Landais, Artcurial; Dr. Eckart Marchand, Warburg Institute Archive; Paul Salmona and Pascale Samuel, Musée d'Art et d'Histoire du Judaïsme; Shlomit Steinberg, Israel Museum; Margaret Fox and Michelle Chesner, Columbia University; and Edward Wouk, University of Manchester. Restitution expertise was required throughout this process, particularly from Dr. Petra Winter of the Zentralarchiv, Staatsmuseum, Berlin.

We also wish to recognize the efforts of Anne-Marie Belinfante, Dorot Jewish Division, and Hope Cullinan, New York Public Library; Shulamith Berger, Yeshiva University Library; Vivian Uria, Yad Vashem; David C. Kraemer and Naomi Steinberger, Jewish Theological Seminary; Xavier Dominique, Ader Auction House; Stephanie Halpern, YIVO Archives, YIVO Institute for Jewish Research; Barbara Kirshenblatt-Gimblett, New York University; Ambre Nerinck-Seltzer; Johann Schiller; Anne Rothfeld and Jim Zeender, United States National Archives and Records Administration; Anne Umland, Museum of Modern Art, New York.

It is an understatement to say that without the efforts of these exceptional colleagues, who persevered to do their jobs from home or virtually during an unprecedented time, the *Afterlives* project could not have been realized. All of us extend a heartfelt thanks to all of you for your dedication and tenacity.

Darsie Alexander
Susan and Elihu Rose Chief Curator

Sam Sackeroff
Lerman-Neubauer Assistant Curator

The Room of the Martyrs, Jeu de Paume, Paris

During the German Occupation of France, the gallery and exhibition building in Paris known as the Jeu de Paume was occupied by the Einsatzstab Reichsleiter Rosenberg (ERR), a Nazi task force charged with looting art. The ERR used the space as a temporary storage and transit depot: between 1940 and 1944 some twenty-two thousand works of art passed through it, stolen from private and public collections, including thousands of Jewish homes. Private

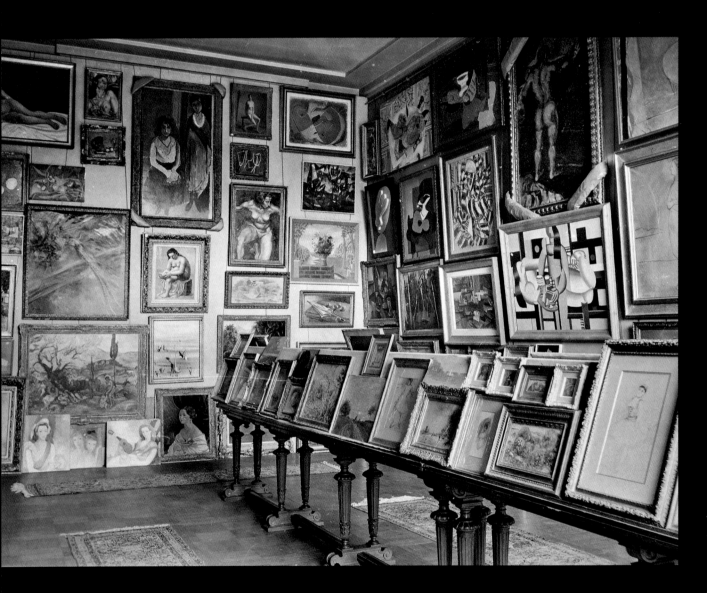

viewings were held for Nazi officials who visited to select great works of art for themselves, for the personal collections of Hitler and Goering, and for the planned Führermuseum (see page 130).

One room was set aside for artworks deemed "degenerate," whose destiny was very different: they were to be sold off or destroyed. It is estimated that more than five hundred works were burned in the gallery's courtyard; many others were sent

to auction. The name "Room of the Martyrs" was probably coined by Rose Valland, a curator and member of the French Resistance who worked at the Jeu de Paume during the war, secretly taking meticulous notes about shipments of artworks in and out, which later proved invaluable in tracing many after the war. Some were recovered, others are known, or presumed, not to have survived.

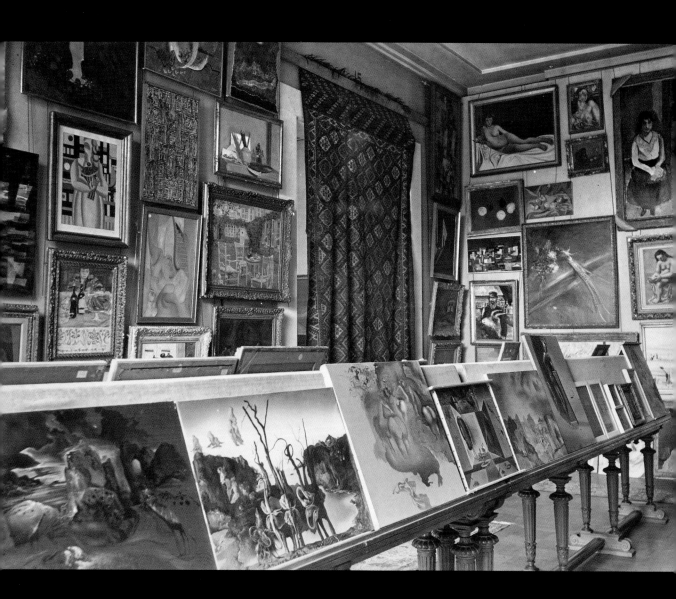

The Room of the Martyrs, photographed from two overlapping angles on a day probably in 1942. After the war the French Ministry of Culture established the Musées Nationaux Récupération to inventory spoliated works

held in French museums, conduct provenance research, and return them to owners where possible. Most of the works pictured have been identified. Works that are known to have survived are reproduced on the following pages;

those whose present location is unknown, or that are confirmed to have been destroyed, are listed on pages 46–47, together with whatever information can be established regarding their ownership at the time of looting

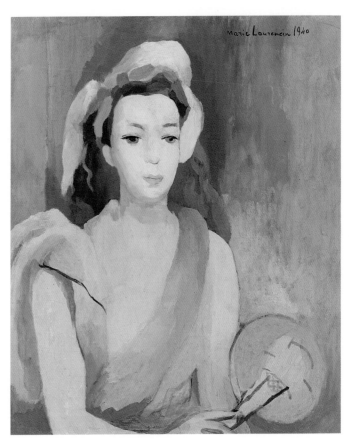

Marie Laurencin, *Young Breton Woman*, 1940
Looted from the collection of Paul Rosenberg,
restituted, later sold
Oil on canvas, 25¾ × 21½ in. (65.3 × 54.6 cm)
Private collection

Marie Laurencin, *Two Female Heads*, 1928
Looted from the collection of Paul Rosenberg, restituted
Oil on canvas, 18⅞ × 15 in. (48 × 38 cm)
Musée Marie Laurencin, Tokyo

THE ROOM OF THE MARTYRS

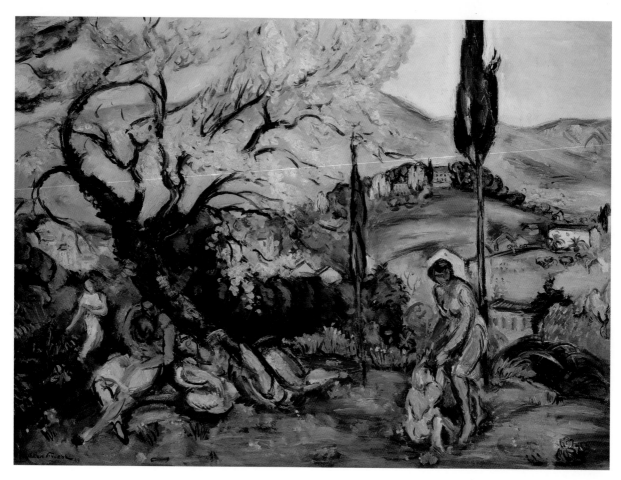

Achille-Emile Othon Friesz, *Spring*, or *Almond Tree in Bloom*, 1929
Looted from the Rothschild collection, restituted
Oil on canvas, 38¼ × 51½ in. (97 × 130 cm)
Private collection

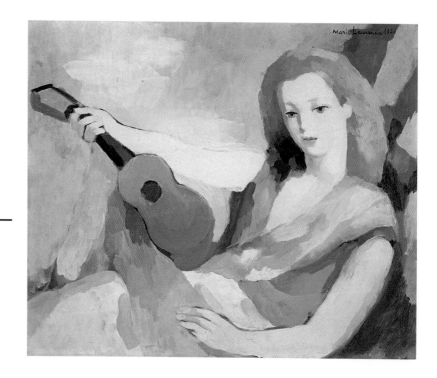

Marie Laurencin, *Trophy*, 1940
Looted from the collection
of Paul Rosenberg, restituted,
later sold
Oil on canvas, 21¼ × 25⅝ in.
(54 × 65 cm)
Private collection

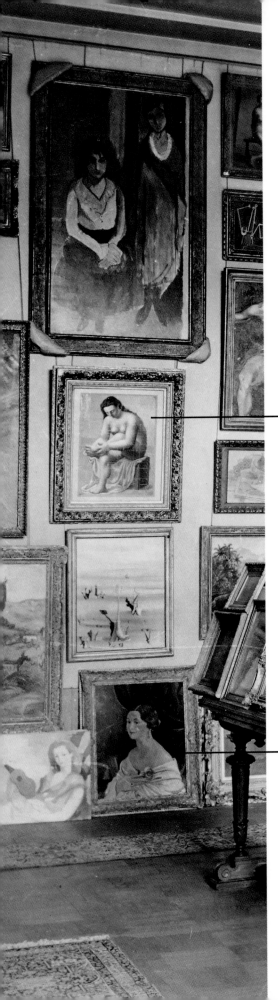

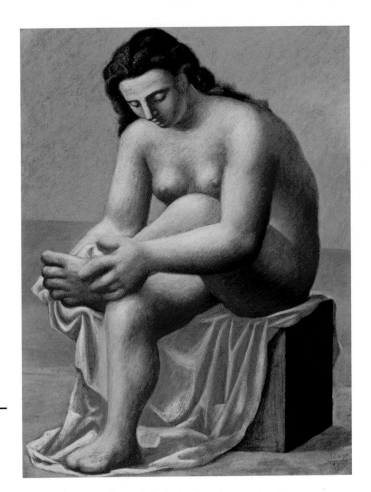

Pablo Picasso, *Seated Nude Drying Her Foot*, 1921
Looted from the collection of Paul Rosenberg,
restituted March 1947
Pastel on paper, 26 × 20 in. (66 × 50.8 cm)
Museum Berggruen, Nationalgalerie, Staatliche
Museen, Berlin

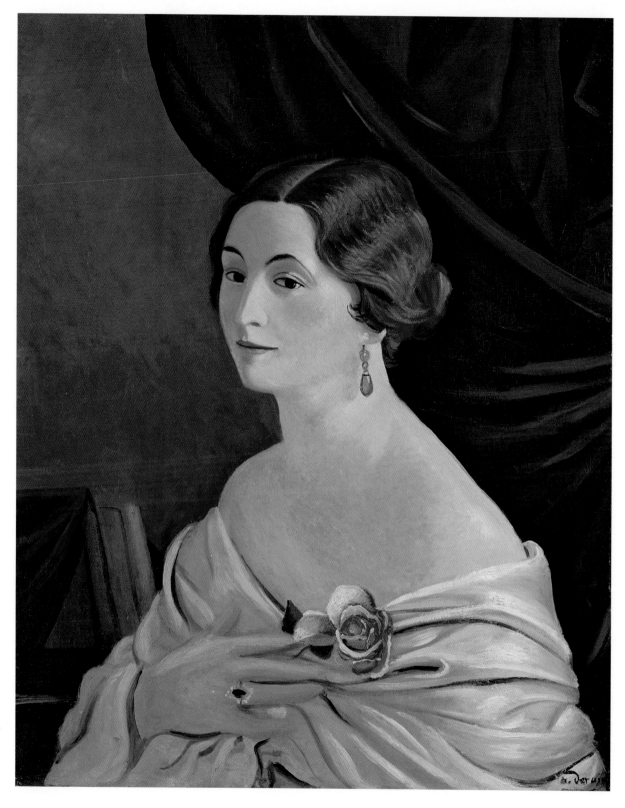

André Derain, *Portrait of Mme Osusky*, 1928
Looted from the collection of Stefan Osusky, Minister Plenipotentiary
of the Czechoslovak Republic, but seized from a member of the
Rothschild family to whom the work had been entrusted; restituted
June 15, 1945, later sold
Oil on canvas, 29 × 23⅝ in. (73.5 × 60 cm)
Private collection

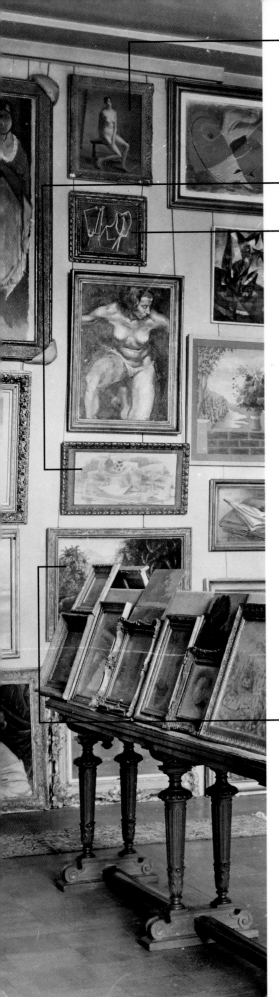

André Derain, *Seated Female Nude*, c. 1929
Looted from the Rothschild collection, restituted,
later sold
Oil on canvas, 21⅝ × 18⅛ in. (55 × 46 cm)
Private collection

Pablo Picasso, *Group of Characters*, 1929
Looted from the collection of Alphonse Kann,
restituted July 11, 1947, later sold
Oil on canvas, 13 × 16⅛ in. (33 × 41 cm)
Association des Amis du Petit Palais, Geneva

THE ROOM OF THE MARTYRS

Georges Braque, *Bowl of Fruit and Partition*, 1920–21
Looted from the collection of Alphonse Kann,
restituted July 11, 1947, later sold
Oil on panel, 13⅞ × 28¾ in. (35.2 × 73 cm)
Private collection

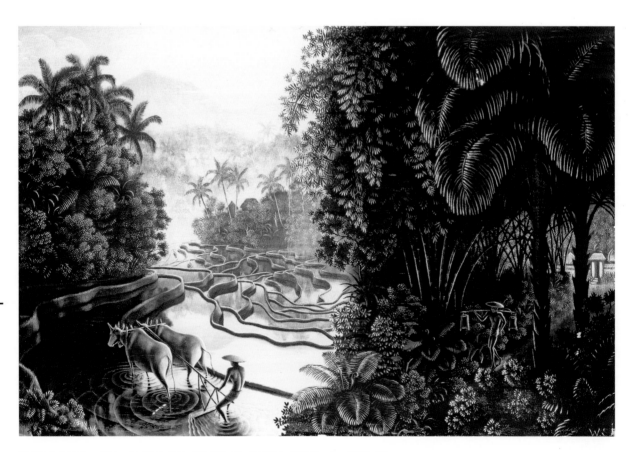

Walter Spies, *View across the Sawahs to Gunung Agung*, c. 1937–39
Looted from the collection of Peter Watson, restituted
Oil on board, 24⅜ × 35⅞ in. (62 × 91 cm)
Private collection

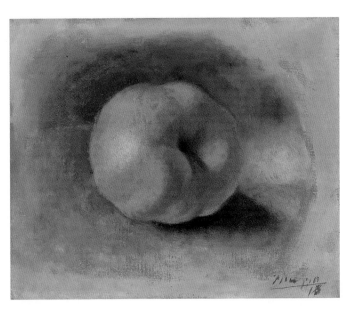

Pablo Picasso, *Apple*, 1918
Looted from the collection of Paul Rosenberg,
restituted March 1947, later sold
Oil on canvas, 8½ × 10½ in. (21.5 × 26.6 cm)
Private collection

THE ROOM OF THE MARTYRS

Fédor Löwenstein,
Composition, 1939
Looted from the artist,
December 1940; marked in Nazi
records for destruction, but
not destroyed; documented
in storage at the Musée du
Louvre, Paris, 1973; entered
the inventory of the Musées
Nationaux Récupération,
2011; heirs identified, 2021;
restitution in process
Oil on canvas, 25½ × 31¾ in.
(64 × 80.5 cm)
Musées Nationaux Récupér-
ation, on deposit at the
Musée National d'Art Moderne,
Centre Pompidou, Paris

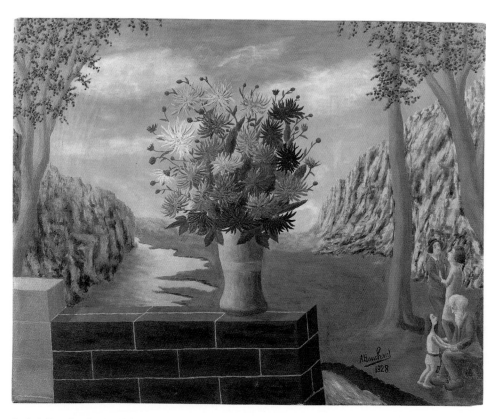

André Bauchant, *Dahlias in a Pink Vase*, 1928
Looted from the collection of Alphonse Kann,
restituted July 11, 1947, later sold
Oil on canvas, 29⅜ × 37¼ in. (74.5 × 94.5 cm)
Private collection

Pablo Picasso, *Still Life with Blue Guitar*, 1924
Looted from the collection of Alphonse Kann,
restituted July 11, 1947, later sold
Oil on canvas, 39⅜ × 31⅞ in. (100 × 81 cm)
Museum Berggruen, Nationalgalerie,
Staatliche Museen, Berlin

Johan Barthold Jongkind, *Ice Skaters on the Canal*, 1881
Looted from the collection of Levy de Benzion,
restitution status unknown, later sold
Oil on canvas, 9⅞ × 13¾ in. (25 × 35 cm)
Private collection

THE ROOM OF THE MARTYRS

Georges Braque, *The Mauve Tablecloth*, 1936
Looted from the collection of Paul Rosenberg,
restituted September 12, 1947, later sold
Oil on canvas, 38¼ × 51⅛ in. (97 × 129.8 cm)
Private collection

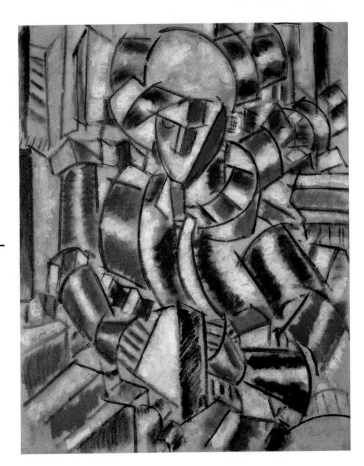

Fernand Léger, *Woman in Red and Green*, 1914
Looted from the collection of Paul Rosenberg,
October 17, 1941; traded by the ERR with other
"degenerate" artworks to Gustav Rochlitz in
exchange for an old-master painting acquired for
the Hermann Goering collection, February 9, 1942;
restituted September 16, 2003, later sold
Oil on canvas, 39½ × 31¾ in. (100.8 × 80.4 cm)
Private collection

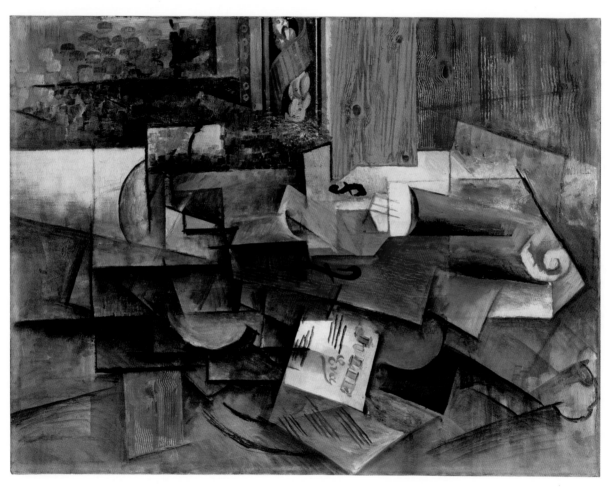

Pablo Picasso, *Violin (Jolie Eva)*, 1912
Looted from the collection of Alphonse Kann,
restituted July 11, 1947, later sold
Oil on canvas, 23⅝ × 31⅞ in. (60 × 81 cm)
Staatsgalerie, Stuttgart

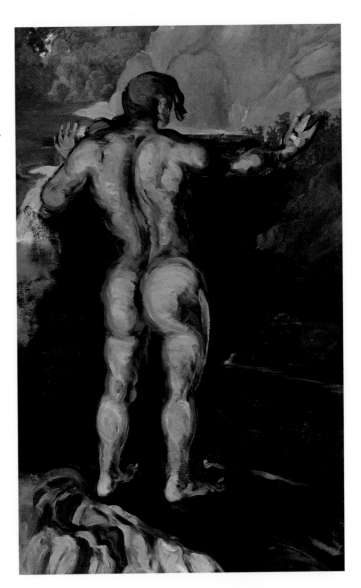

Paul Cézanne, *Bather and Rocks,* c. 1860-66
Looted from the collection of Alphonse Kann,
restituted July 11 or August 11, 1947, later sold
Oil on canvas, transferred from plaster, 66 × 41½ in.
(167.6 × 105.4 cm)
Chrysler Museum of Art, Norfolk, Virginia,
gift of Walter P. Chrysler Jr.

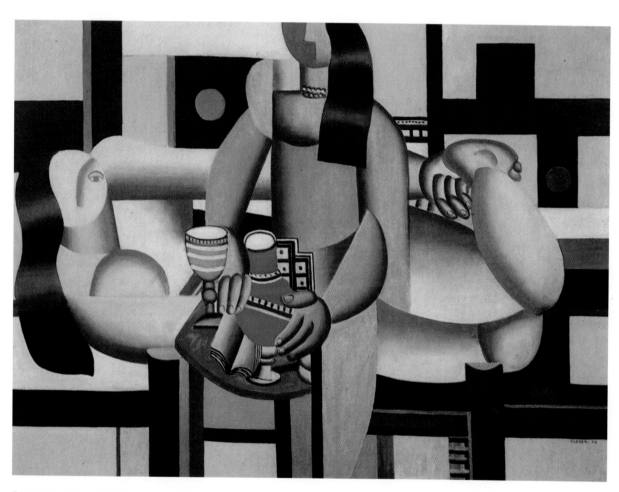

Fernand Léger, *Odalisques*, 1920
Looted from the collection of Alphonse Kann,
restituted July 11, 1947, later sold
Oil on canvas, 38 × 51 in. (96.5 × 129.5 cm)
Private collection

THE ROOM OF THE MARTYRS

Henri Matisse, *Composition*, c. 1915
Looted from the collection of Alphonse Kann, traded by the ERR with other
"degenerate" artworks to Gustav Rochlitz in exchange for an old-master painting
acquired for the Hermann Goering collection, February 9, 1942; restituted to
Alphonse Kann, c. 1946, with the help of Henri Matisse, later sold
Oil on canvas, 57½ × 38⅛ in. (146 × 97 cm)
Museum of Modern Art, New York, gift of Jo Carole and Ronald S. Lauder, Nelson
Rockefeller Bequest, gift of Mr. and Mrs. William H. Weintraub, and Mary Sisler
Bequest (all by exchange)

Henri Matisse, *The Rose
Marble Table,* 1917
Looted from the collection
of Alphonse Kann in October
1940; traded by the ERR
with other "degenerate" art-
works to Gustav Rochlitz in
exchange for an old-master
painting acquired for the
Hermann Goering collection,
February 9, 1942; restituted
to Alphonse Kann, July 1947,
later sold
Oil on canvas, 57½ × 38¼ in.
(146 × 97 cm)
Museum of Modern Art,
New York, Mrs. Simon
Guggenheim Fund

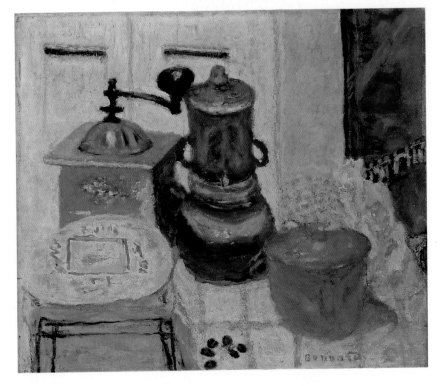

Pierre Bonnard,
Coffee Grinder, 1930
Looted from the collection
of Alphonse Kann, restitution
status undetermined
Oil on canvas, 18⅞ × 22½ in.
(48 × 57 cm)
Kunst Museum Winterthur,
Switzerland, donated by
Dr. Herbert and Charlotte
Wolfer-de Armas, 1973

THE ROOM OF THE MARTYRS

Fernand Léger, *Girl with a Bouquet*, 1921
Looted from the collection of Alphonse Kann,
restituted July 11, 1947, later sold
Oil on canvas, 25⅝ × 19⅝ in. (65.1 × 49.8 cm)
Private collection

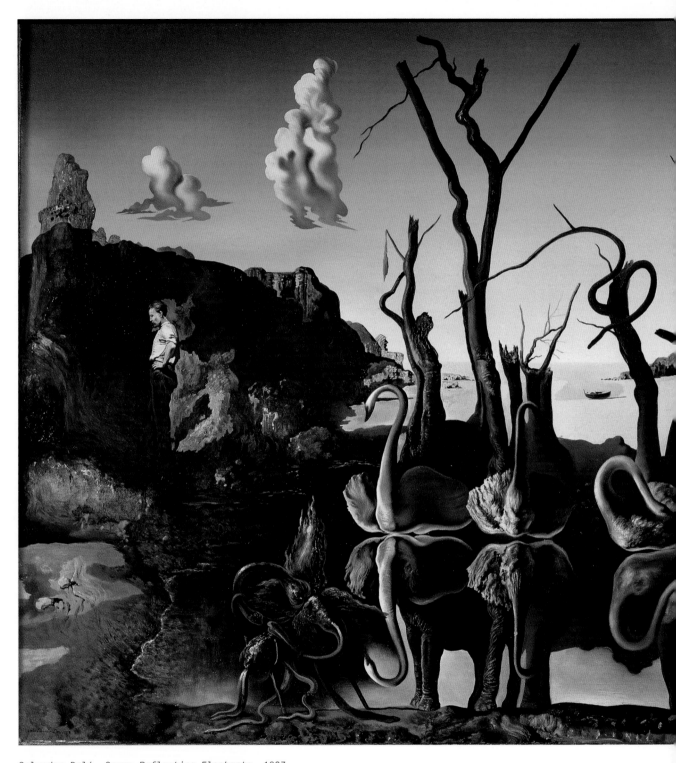

Salvador Dalí, *Swans Reflecting Elephants*, 1937
Looted from the collection of Edward James, restituted, later sold
Oil on canvas, 20⅛ × 30⅜ in. (51 × 77 cm)
Private collection

Jean-Louis Forain, *Visit to the Dancers*, or
Dancers and Subscriber, 1905
Looted from the collection of Levy de Benzion,
restituted to the heirs of Levy de Benzion
Oil on canvas, 23⅝ × 28¾ in. (60 × 73 cm)
Private collection

Giorgio De Chirico, *The Day of Celebration*, 1914
Looted from the collection of Alphonse Kann,
restituted July 11, 1947, later sold
Oil on canvas, 30½ × 23¾ in. (77.5 × 60.3 cm)
Private collection

THE ROOM OF THE MARTYRS

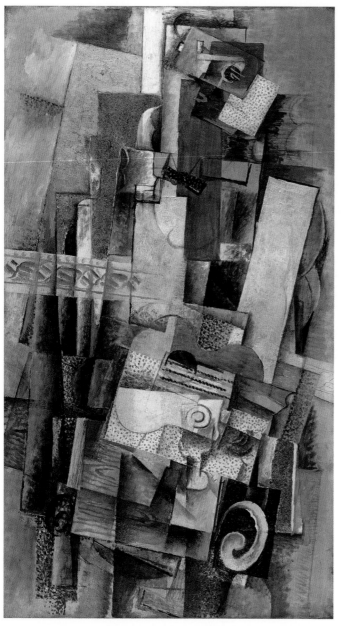

Georges Braque, *Man with a Guitar*, 1914
Looted from the collection of Alphonse Kann in November
1940, traded by the ERR with other "degenerate"
artworks to Gustav Rochlitz in exchange for an old-master
painting acquired for the Hermann Goering collection,
February 9, 1942; entered the Musée National d'Art
Moderne, Centre Pompidou, Paris, in 1981; accession
formalized in 2005 with the heirs of Alphonse Kann
Oil and sawdust on canvas, 51⅛ × 28½ in. (130 × 72.5 cm)
Musée National d'Art Moderne, Centre Pompidou, Paris

Maurice Utrillo, *Church in the Countryside*, c. 1915
Looted from the collection of the Cercle des Nations,
Paris, restituted, later sold
Oil on cardboard, 19¾ × 26¾ in. (50 × 68 cm)
Private collection

Félix Vallotton, *Reclining Female Nude*, 1905
Looted from the collection of Alphonse Kann in October 1940,
restituted July 11, 1947, later sold
Oil on canvas, 35 × 45⅝ in. (89 × 116 cm)
Döpfner Collection, Potsdam, Germany

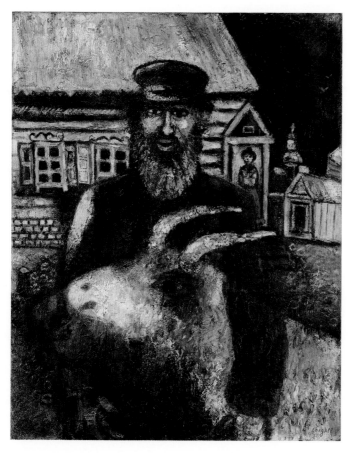

Marc Chagall, *Man with a Goat*, c. 1924–25
Looted from the Rothschild collection,
restituted, later sold
Oil on canvas, 28⅜ × 22½ in. (72 × 57.1 cm)
Toyama Prefectural Museum of Art and Design, Japan

Lost and Untraced Works from the Room of the Martyrs

The photographs of the Room of the Martyrs on pages 20–21 include many artworks known to have been destroyed during the war, or whose present status is unconfirmed. Those that can be identified are listed here. Works that cannot be identified are omitted, as are those that survived, which appear on previous pages. Provenance and restoration information is in some cases based on best available research at time of publication.

LEFT PHOTOGRAPH

ON THE BACK WALL, LEFT TO RIGHT, TOP TO BOTTOM

André Favory, *Bust of a Woman,* or *The Wife of the Artist,* date unknown
Looted from the collection of Mme Robert Braun, restituted December 10, 1946
Medium unknown, c. 21⅝ × 15¾ in. (55 × 40 cm)
Status unknown

André Derain, *Still Life,* or *Still Life with Pot,* date unknown
Looted from the collection of Robert de Rothschild or possibly from the collection of Stefan Osusky, Minister Plenipotentiary of the Czechoslovak Republic, seized from a member of the Rothschild family to whom the work had been entrusted; restituted March 12, 1946
Oil on canvas, 13 × 15¾ in. (33 × 40 cm)
Status unknown

Giovanni Boldini, *Pheasant,* date unknown
Looted from the collection of Robert or Maurice de Rothschild
Oil on canvas, 48⅞ × 49¼ in. (124 × 125 cm)
Status unknown

Henri Matisse, *Two Sisters,* date unknown
Looted from the collection of Alphonse Kann
Oil on canvas, 65 × 36⅝ in. (165 × 93 cm)
Status unknown

Yves Tanguy, *Composition,* or *The Surveyor,* 1938
Looted from the collection of Peter Watson

Oil on canvas, 28⅜ × 23¼ in. (72 × 59 cm)
Destroyed in July 1943

Pierre-Eugène Clairin, *Female Nude,* date unknown
Looted from the collection of Levy Hermanos, restituted
Oil on canvas, 36⅝ × 26 in. (93 × 66 cm)
Status unknown

André Masson, *Wounded Animal,* 1929
Looted from the collection of Alphonse Kann, marked in Nazi records for destruction
Oil on unknown support, 25⅝ × 36¼ in. (65 × 92 cm)
Status unknown

Maurice Savreux, *Umbrella and Apples,* date unknown
Looted from the collection of Robert de Rothschild, restituted
Oil on canvas, 15⅝ × 30¾ in. (37 × 78 cm)
Status unknown

ON THE RIGHT WALL

Georges Braque, *Glass and Compote,* 1922
Looted from the collection of Alphonse Kann, restituted
Oil on unknown support, 7⅞ × 25⅝ in. (20 × 65 cm)
Status unknown

Jean Arp, *Composition,* or *Head and Leaf,* 1929
Looted from the collection of Alphonse Kann, marked in Nazi records for destruction
Painted wood relief, 34⅝ × 26¾ in. (88 × 68 cm)
Status unknown

Maurice de Vlaminck, *Still Life with a Bowl of Fruit,* date unknown
Looted from the Rothschild collection, probably restituted
Oil on canvas, 29⅛ × 36¼ in. (74 × 92 cm)
Status unknown

Maurice de Vlaminck, *Forest,* date unknown
Looted from the Rothschild collection, probably restituted
Oil on canvas, 29⅛ × 35⅞ in. (74 × 91 cm)
Status unknown

Pablo Picasso, *Still Life with Compote, Mandolin, Wall, and Bottle,* 1923
Looted from the collection of Alphonse Kann, restituted 1998
Oil on canvas, 51⅜ × 38⅝ in. (130 × 98 cm)
Status unknown

Pablo Picasso, *Nude Woman by the Seaside,* date unknown
Looted from the collection of Paul Rosenberg
Ink and pastel on paper, 42⅛ × 27½ in. (107 × 70 cm)
Status unknown

ON THE STANDING SHELF, LEFT TO RIGHT

Paul Guigou, *View of Chailly,* or *Chailly Plain, Stormy Sky,* date unknown
Looted from the collection of Salomon Flavian
Medium unknown, 9⅞ × 16½ in. (25 × 42 cm)
Status unknown

Jean-François Raffaëlli, *Church Square,* or *Leaving Mass,* date unknown
Looted from the collection of Levy de Benzion, probably restituted
Oil on cardboard, 11⅞ × 15¾ in. (30 × 40 cm)
Status unknown

Camille Corot, *Evening in the Valley,* 1852
Looted from the collection of Salomon Flavian, restituted March 30, 1950
Medium unknown, 9 × 13¾ in. (23 × 35 cm)
Status unknown

Paul Cézanne, *Bathers at Rest,* date unknown
Looted from the collection of Alphonse Kann, restituted June 2, 2005
Lithograph and watercolor, 16⅞ × 20½ in. (43 × 52 cm)
Status unknown

Eugène Delacroix, *Interior of a Mosque,* date unknown
Looted from the collection of Paul Rosenberg
Watercolor, 5⅞ × 5⅞ in. (15 × 15 cm)
Status unknown

Camille Pissarro, *Road through Fields*, 1872
Looted from an unknown collection
Oil on canvas, 16⅞ × 21¼ in.
(43 × 54 cm)
Status unknown

Edgar Degas, *Dancer*,
date unknown
Looted from the collection of
Paul Rosenberg, restituted
Chalk drawing, 12¼ × 8⅝ in.
(31 × 22 cm)
Status unknown

Claude Monet, *Sailboat at Sea, Offshore near a Cliff*, or *Sailboats at Sea*, date unknown
Looted from the collection of
Alfred Lindenbaum
Medium unknown, 7⅛ × 15 in.
(18 × 38 cm)
Status unknown

Auguste Renoir, *Head of a Woman*,
date unknown
Looted from the collection of
Alfred Lindenbaum
Medium unknown, 3⅛ × 3½ in.
(8 × 9 cm)
Status unknown

Auguste Renoir, *Head of a Man*,
date unknown
Looted from the collection of
Alfred Lindenbaum
Medium unknown, 3½ × 4 in.
(9 × 10 cm)
Status unknown

Auguste Renoir, *Young Nude Girl*,
date unknown
Looted from the collection of
Paul Rosenberg
Medium unknown, 8⅝ × 4⅛ in.
(22 × 10.5 cm)
Status unknown

Auguste Renoir, *Rose*,
date unknown
Looted from the collection of
Paul Rosenberg
Oil on canvas, 2½ × 4⅞ in.
(6.5 × 12.5 cm)
Status unknown

Auguste Renoir, *Head of a Woman*,
date unknown
Looted from the collection of
Alfred Lindenbaum
Medium unknown, 4⅜ × 4⅜ in.
(11 × 11 cm)
Status unknown

Auguste Renoir, *Thicket, Brush,* or *Landscape*, date unknown
Looted from the collection
of Alphonse Kann, restituted
June 11, 1947
Oil on canvas, 8⅛ × 15 in.
(20.5 × 38 cm)
Status unknown

Auguste Renoir, *Dancer (En Pointe, Turned to the Left)*, or *Rosita Mauri in "La Farandole,"* c. 1881
Looted from the collection of
Paul Rosenberg
Chalk drawing, 15¾ × 9½ in.
(40 × 24 cm)
Status unknown

RIGHT PHOTOGRAPH

ON THE LEFT WALL

Possibly a work by
Fédor Löwenstein
Status unknown

Pierre Bonnard, *Woman Eating Breakfast*, date unknown
Looted from the collection of
Raymond Hesse
Medium unknown, 24⅜ × 19¾ in.
(62 × 50 cm)
Status unknown

Joaquín Torres-García,
title unknown, c. 1931
Looted from an unidentified
collection
Presumed destroyed

André Beaudin, *Pink Stairs, Two Figures*, or *Group of Female Nudes by the Stairs*, c. 1925–30
Looted from the collection
of Alphonse Kann, restituted
July 11, 1947
Medium unknown, 32¼ × 21⅝ in.
(82 × 55 cm)
Status unknown

Charles-Auguste Edelmann,
Painter's Table, date unknown
Looted from the collection of
Robert de Rothschild, restituted
Oil on canvas, 21⅝ × 31⅞ in.
(55 × 81 cm)
Status unknown

Henri Le Sidaner, *Table in the Garden*, or *Mid-Afternoon Snack, Gerberoy*, 1921
Looted from the collection of
Levy de Benzion
Oil on canvas, 28¾ × 36¼ in.
(73 × 92 cm)
Status unknown

Max Ernst, *Seashells*,
date unknown
Looted from the collection of
Peter Watson
Oil on canvas, 28¾ × 23¼ in.
(73 × 59 cm)
Destroyed in July 1943

Fédor Löwenstein, *The Modern City*, date unknown
Looted from the collection of
the artist, location unknown,
marked in Nazi records for
destruction
Oil on wood panel, 17¾ × 31⅞ in.
(45 × 81 cm)
Status unknown

ON THE STANDING SHELF,
LEFT TO RIGHT

Salvador Dalí, unidentified
work, c. 1937–39
Looted from an unidentified
collection, possibly that of
Edward James
Medium unknown, 19¾ × 30¾ in.
(50 × 77 cm)
Status unknown

Salvador Dalí, *Study of Horses and Women*, c. 1937
Looted from an unidentified
collection, possibly that of
Edward James
Medium unknown, 23⅝ × 28¾ in.
(60 × 73 cm)
Status unknown

Salvador Dalí, *Herodias*, 1937
Looted from an unidentified
collection, possibly that of
Edward James
Medium unknown, 18½ × 21⅝ in.
(47 × 55 cm)
Status unknown

Salvador Dalí, *Mountainous Southern Landscape with Cloudy Sky*, c. 1937
Looted from an unidentified
collection, possibly that of
Edward James
Medium unknown, 20⅛ × 30¾ in.
(51 × 78 cm)
Status unknown

Salvador Dalí, *Standing Figure, Leaning on an Elbow*, c. 1930–37
Looted from an unidentified
collection, possibly that of
Edward James
Medium unknown, 29½ × 17¾ in.
(75 × 45 cm)
Status unknown

Possibly Salvador Dalí,
unidentified diptych, variation
on *The Angelus of Millet*,
date unknown
Looted from an unidentified
collection, possibly that of
Edward James
Status unknown

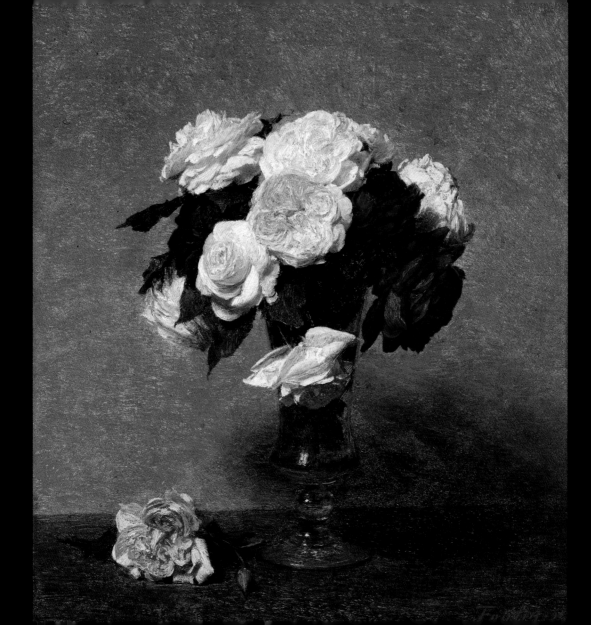

AFTERLIVES
THE SEIZURE, MOVEMENT, AND RECOVERY OF LOOTED ART

Darsie Alexander

The concept of life is given its due only if everything that has a history of its own, and is not merely the setting for history, is credited with life. In the final analysis, the range of life must be determined by history rather than by nature, least of all by such tenuous factors as sensation and soul. The philosopher's task consists in comprehending all of natural life through the more encompassing life of history. And indeed, is not the continued life of works of art far easier to recognize than the continual life of animal species? The history of the great works of art tells us about their antecedents, their realization in the age of the artist, their potentially eternal afterlife in succeeding generations.
—Walter Benjamin, 1921

Marking time in the present tense by excerpting a quote that is now over one hundred years old is both a risky venture and a daring provocation. The philosopher Walter Benjamin, a German Jew who was in his early thirties when he wrote this passage, was tackling nothing less than the forces of life and history—bold concepts, to be sure, and mutually reinforcing ones. Life is needed to make history, Benjamin reasons, and history has a life, in which great works of art are accorded a special place.

Yet Benjamin also recognized that history is comprised of what is "credited," and is thus, also, an expression of decision-making power. Few moments in our still-young century have accentuated that point more potently than the one in which we are currently living, which calls attention not only to how and by whom history is formed, but also what it suppresses along the way. At this moment of writing, Black Americans are actively inserting their experiences and everyday realities into the narrative, and demanding justice from our society, institutions, and government. The oftentimes slanted construction of history is under fire. Benjamin came of age just as Nazi ideology was overtaking his homeland. He understood that history may morph and change depending on its authors and their purposes, and is capable of inflicting blows not only on the people who get erased from its record but on things that either survive or don't. This publication is populated by the testimonies of those objects and the people who helped them survive to be seen today.

Benjamin's concern for the values of physical objects moving in and out of time *and* as documents of all they have seen is instructive. His concept positions works of art within a continuum of experience in which meaning is accrued from other periods and realities, imbuing them with a near-magical status. The concept of an artwork's "afterlife" is also associated with the Jewish cultural historian and theorist Aby Warburg, who used *Nachleben* to describe the perpetuation of a life force or energy that inhabits and animates an image over time.[1] Warburg's insights acquired an intense resonance in the aftermath of World War II. In that context, works that have intersected, lived through, or been imprinted by transformative moments acquire a charge: these objects have participated in and been touched by history in ways that are subtly visible not only in their

Henri Fantin-Latour, *Roses in a Glass Vase*, 1890 Oil on canvas, 16¾ × 14⅞ in. (42.5 × 37.8 cm) Museum of Fine Arts, Boston, bequest of Alice A. Hay

The painting belonged to Jean Ferdinand-Dreyfus, a French Jew. It was probably confiscated from him by the Nazis in 1942, recovered by the Dreyfus family sometime between 1947 and 1962, and later sold.

physical aging but in the additive signs of where they have been: damage and repairs, old labels, backside markings, frames of a certain period, inventory numbers, and the like. These marks are clues to an object's trajectory from the time it was created to today, together with the shifts in culture that shaped the way it was positioned and interpreted. In practical terms, such signs are helpful in placing an object at various chronological intervals and thus substantiating its provenance—literally a retelling of where an object has been and when. Yet on its surface, the history of how an object was understood, what it was used for, whether it was loved is not immediately visible to the viewer, requiring context, explanation, and a determined will to be uncovered.

The "afterlives" idea hinges on a process of activating these latent histories and associations; each new exhibition, wall label, lecture, or publication is a performative act of repositioning, one that can dramatically emphasize or downplay certain visual or thematic aspects of a work's ontology. Works of art allow for a wide variety of interpretations and modes of connectivity. Owners, collectors, curators—the caretakers—can become deeply invested in particular points of view, which can, in turn, inform the value, both material and intellectual, of the works as property. Writing about the particularly complicated process of deciphering the role of art in culture today, the contemporary artist and critic Paul Chan observes that "things are things because they help us belong in the world, even though their place in our lives can sometimes dispossess us of the sense of being at home with ourselves."[2] What Chan is getting at is that objects connect people to reality, to each other, and to themselves, tapping deep-seated emotions and personal feelings that can be difficult to explain or easily rationalize.

Works that are part of the history of the Holocaust are like this: they can be very challenging to talk about *as art* in light of their role in one of the most devastating events of modern times. In

Norbert Troller, *Hannover, Terezín,* 1942
Pencil and watercolor on paper, 11⅞ × 8⅛ in. (30.3 × 20.6 cm)
Leo Baeck Institute, New York

In 1942 the Austrian Jewish artist Norbert Troller was imprisoned by the Nazis in the Theresienstadt (Terezín) concentration camp, in the present-day Czech Republic. He made notes of its dire conditions, intended to be smuggled out, but was discovered in 1944 and sent to the Auschwitz extermination camp in Poland. He survived, as did some of his artworks.

a discussion of Nazi looting there is no linkage between what was happening in history—the rampant persecution of Jews, gypsies, gay people, and the physically or mentally vulnerable, among others—and the subject matter of the destroyed or confiscated works. And a work that shows violence or suggests an experience of loss or suffering produces a strange feeling; for example, Gustave Courbet's poignant 1857 painting of a dead deer (see page 195) deliberately evokes pathos, but what does one make of the fact that it was stolen by the Nazis from an unidentified collector in 1943? The theorist Boris Groys argues that while art can never be as powerful as physical destructive acts against human beings, it can offer an understanding of how those acts are represented through images. In unpacking the story of an artwork's survival, it is important to beware of the risk of constructing a false equivalence between objects and people, the destruction of an artifact and the destruction of a person. In addition to images of those works that exist to this day, others reproduced in this volume were destroyed or remain lost, surviving only as reproductions. Those are the most haunted illustrations.

Retrieving history is, of course, an editorial process, in which some stories are brought forward while others are notably omitted. This process of selection—of deciding in the present moment what will be preserved and what will be given up—is at the heart of the "afterlives" theme, which privileges those works that *have endured*. These are ones that, according to Groys, have passed "through the narrow gate of the here-and-now. . . . Art, literature, music, and philosophy have survived the twentieth century because they threw out all unnecessary baggage."[3] The pruning or preservation of culture can have many factors and agents, however, as this story makes clear; it is an unsettling fact that the Nazis also protected thousands of works by getting them out of Berlin and away from Allied bombing raids during the war. Do these details change how these works are received today? It is often in the fine print of a wall label that an eerie alternate is revealed: this work was saved from burning, this one is all that's left, this was Adolf Hitler's favorite. . . . Whatever their effects, these hints of past uses and contexts do not come out on their own; they are lost until discovered and voiced anew, distanced from the war but capable of expressing its reverberations, ethical dilemmas, and lessons so many decades later. As these objects are encountered today, they have an unmistakable aura. The existence of certain artworks and cultural relics from other eras, particularly ones shaped by war, genocide, and upheaval, remains one of the most astounding gifts to the present time: that they are here *at all*, that they can be seen and sometimes touched, and that they will be here in decades yet to come.

The vast and systematic looting of personal collections from Jewish families, patrons, and art dealers during World War II is one of the most unsettling and unresolved stories of twentieth-century culture. The scope, violence, and sheer volume of the theft remains as staggering today as when first reported; multiple millions of objects and books were coerced or stolen outright from Jews, with the most intensive looting taking place between 1937 and 1944.[4] While successful recovery efforts have brought some works back to descendants of their original owners, many stolen works remain in litigation, are still being discovered, or are presumed lost. The complexities associated with the return of seized items continue to make headlines, shape conferences, and fuel legal battles, raising a series of deeper questions about the historical impact of the Holocaust on culture at large. How have the histories and interpretations of stolen art and artifacts been framed and tarnished by their associations with an ominous past, in which more than six million Jewish lives were taken? How will future generations, increasingly separated in time and space from the events of the war, remember and interpret its history through the material objects that still exist? How does the story of art in the Holocaust influence the way both older and more recent tragedies of the destruction of art are viewed? Can an artwork take on an afterlife in which alternative understandings of its role as stolen property can be countered by narratives centered on hope and survival?

The tale of what happened to art and material culture in and after World War II is long and complex, marked by tragedy as well as moments of hope and the possibility of justice. Oftentimes the destruction was highly visible; in other cases it was hidden and corrosive, inflicted upon specific individuals or families in secret and with little recourse for its victims. Framed by the historical reality of the Holocaust, with its massive casualties, it is a sobering narrative, one that can be difficult to synthesize and assess against a bigger, unfathomable certainty of epic human loss. Yet it is a parallel story, synchronized with the world war and the rise of Nazi Germany, when Jewish communities, families, and individuals witnessed the vast pillaging not only of their personal effects—art,

Judaica, and domestic items—but their cultural heritage more broadly. The Nazis didn't just flagrantly steal art from prominent Jewish families; they destroyed huge swaths of Jewish culture, set countless synagogues on fire, pillaged vaults and archives, confiscated thousand-volume libraries, and tore prized items off museum walls throughout Europe. Behind the scenes and in public spectacles, the property of Jews and their communities was stolen outright, deployed as a bargaining tool for families to buy safe passage out of Germany, sold on the art market, or set aside as trophies of war. Many objects experienced prolonged periods of displacement, moving from one location to the next, leaving a broken path for future heirs and families to piece together in their quest to find and reclaim what had been lost decades before.

The phrase "Nazi looting" conjures images of dramatic seizures and sudden discoveries, but in fact the process had many different branches and tactics, which could be far more subversive and nuanced. Various players, including clandestine informants and well-known personalities, contributed vigorously to the ransacking. The infamous Einsatzstab Reichsleiter Rosenberg (ERR) was among the Germans' most instrumental pillaging entities. The program was led by Alfred Rosenberg, a chief strategist of the regime, known for his anti-Semitic racial theories. Others in the senior Nazi administration who took a close interest in the cultural spoliation included Joseph Goebbels, Minister of Propaganda, who amassed his own sizable art collection from Nazi thievery; Hermann Goering, Hitler's Reichsmarschall and second-in-command; Otto Abetz, ambassador to France, who led raids throughout Paris; and many additional personnel brought on for their contacts and expertise. Above them all was Hitler himself, the "failed artist," who fantasized about building a great museum in his honor featuring the world's masterpieces. With so many involved in this effort, including Nazi staff in

occupied territories, the looting did not occur in a uniform fashion, nor did these various factions always function in a coordinated way.[5] On the contrary, while Nazi looting is often thought of as highly organized—and it was, in many respects—its pervasive nature, diverse range of agents, and prolonged process make the nuances, sequence, and details at times challenging to sift through, making cases for restitution arduous indeed.

Further, while Nazi looting is a powerful narrative, it is essential to remember that looted objects attain that status because they once belonged to someone and thus existed in a unique and personal sphere, and that many of the original owners—whether individuals or communities—were killed in the war, stripped not only of their worldly possessions but also of their lives and individual stories. It is against this fact of history, this reverberating absence, that this investigation of what is *present*—these objects, documents, and pictures—unfolds in revelatory chapters.

THE LOOTING MIND-SET
Investigating how the plunder of cultural property came to play such a pivotal role in Nazi wartime strategy is a first step in framing the conditions under which certain objects endured into the present moment while others were destroyed or lost. Considered in global historical terms, the practice of despoiling cultures during periods of conflict and trauma was by no means a new phenomenon and it is one that continues to this day. Wartime conflict has eroded or destroyed ancient sites in Syria and Iraq; celebrated archaeological destinations like Angkor Wat have been looted by oppressive regimes as well as degraded by waves of tourism; and major hubs of cultural preservation, underfunded and fragile, have fallen victim to flood and fire. However, the Nazis took their attempts at cultural eradication to a heightened level of strategy, scope, and brutality, spawning a wide array of theories and a dose of inherited

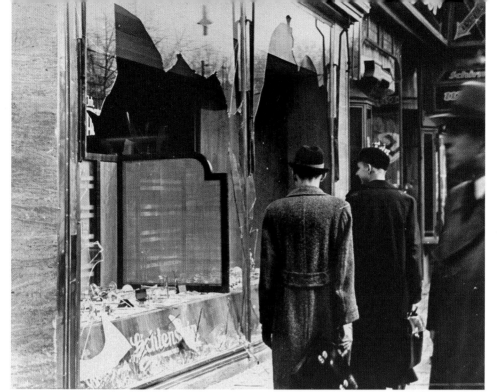

Lichtenstein
Leather Goods,
a Jewish shop
in Berlin, dam-
aged during
Kristallnacht,
November 9,
1938. The pogrom,
orchestrated
across Germany
and Austria just
after the start of
World War II, was
the first large-
scale Nazi attack
on Jews, both
economically and
culturally.

wisdom over why this was the case. It is widely recognized, for example, that the Nazis put great emphasis on symbols and understood the arresting power of visual images to communicate their ideological positions and ambitions. They were both skilled and innovative in deploying strict adherence to design principles, staged events, and posed photographs to exert power, to impose their authority, and to present a consistent narrative of promise and prosperity for a new Germany.

But there was much more. Art was a vehicle for attaining status and influence, generating revenue, articulating for-and-against ideological principles, and, most importantly, enacting a deep-seated anti-Semitism that had been brewing since well before Hitler's rise to power in 1933. An artwork could be taken because it was seen to represent Jewish identity, because it embodied Jewish achievement, because it belonged to a Jewish citizen, because it was created by a Jew. In addition, Jewish private citizens and religious leaders were the keepers of their own cultural and spiritual heritage, invested in the ceremonial and ritual objects belonging to synagogues and private homes, which were also targeted. There

was no way to escape the Nazi purge of anything that symbolized Jewish presence, creativity, and achievement.[6]

"The era of exaggerated Jewish intellectualism is now at an end. The triumph of the German revolution has cleared a path for the German way." So opened Joseph Goebbels's notorious speech in front of Berlin's opera house on May 10, 1933.[7] This was the moment, soon after Hitler's appointment as Chancellor of Germany, in which the new regime introduced the idea of cleansing the national spirit of unwanted influence and committing to flames the evil spirit of the past. The occasion drew some forty thousand people, gathered to burn twenty thousand books deemed unacceptable by Hitler. The event launched a full-on attack against any form of literature, music, art, and science that could be seen as a reflection of Jewish knowledge and accomplishment. Also demonized was the work of leftists, intellectuals, and foreigners.

Books were among the first victims of the Nazi war on culture, on modernism, and on Jews—first through public burnings and then through widespread and massive confiscation. The destruction of sacred texts, especially the

Torah, was among the most shocking acts undertaken during the 1930s and served as the most alarming signal of what was to come: the eradication not only of a population but of any trace of its centuries-old creative and spiritual presence in Europe.

While seeming to reflect two separate strategies—one designed as a rallying cry performed in public arenas with burnings and demonstrations, the other within the less visible scholarly sphere of libraries and institutional collections—the dual approaches worked in tandem to both ostracize and deride Jewish intellectual history. On the night of the demonstration in Berlin, for example, rallies occurred all over Germany, including Heidelberg University, where books from across the university and students' own libraries were set on fire amid great excitement. Though these events were themselves alarming, not least because they were engineered by students, they also underscored a rising tide of contempt and disdain aimed at Jews and outsiders, a phenomenon that was gripping Germany and further isolated its Jewish citizens from society at large. Between 1933 and 1938 the Nazis comprehensively removed Jews from everyday political, economic, social, and cultural life. This included barring physicians from receiving patients, judges from presiding over courtrooms, athletes from performing in a sports arena, editors from proofing texts, professors from pursuing scholarship, and collectors from retaining their precious artworks.[8] Over time and in escalating fashion, every activity became off-limits to Jews, including and especially their right to retain objects and lifestyles that reflected their status, independence, and standing within German society.

The segregation of Jews was enforced in a variety of ways. One distinctive strategy was to treat Jewish culture as the subject of historical inquiry, much as one might study a rare but obsolete specimen. Hitler called this an "anti-Semitism of reason," or "scientific anti-Semitism," which explicitly identified Jews in racial terms, rather than by religious affiliation.[9] By the late 1930s research centers, institutes, and university departments had been founded throughout Germany and Austria to accommodate this burgeoning field and to inspire the looting of works that were to be "saved" expressly for the purpose of spurious academic research. Prominent among these was Alfred Rosenberg's Institute for the Study of the Jewish Question. It housed an estimated five hundred thousand books and manuscripts stolen from synagogues, Masonic temples, and private collections. Key to his mission was to set up a great Nazi university on the Chiemsee, in Bavaria, from the spoils of his plunder, including masterworks of both art and literature that would be instrumental in forming the curriculum. But, as Elisabeth Gallas writes, despite the purported interest in the scholarly value of this material, "these initiatives were motivated less by illicit enrichment and avarice than the anti-Semitic conviction that taking Jewish books and other items was an important means of eliminating Jews' cultures of knowledge and intellectual traditions in Europe—and thus a component in the ideological struggle against them."[10] To further this point, the confiscation of books was not only an attack on Jewish literary history but also had personal consequences for Jewish communities in dire need of intellectual and social connectedness as the very fabric of their lives was unraveling.

Recent analyses of Nazi looting have positioned acts of destruction and pillage within a more conceptual framework of the reordering of time. That is, the Nazis sought to manipulate and reshuffle the past, emphasizing some historical chapters and erasing others; this had the effect of curtailing evidence of the influence of Jewish thinkers and creators on culture writ large, particularly as a new national identity was forming. This identity, in turn, required a history that

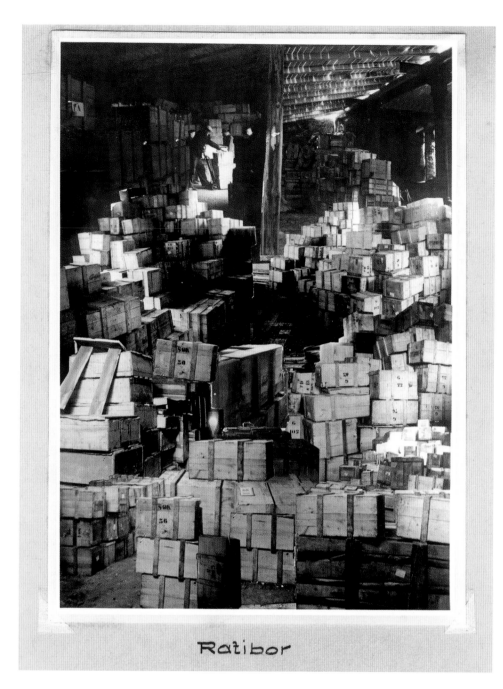

Ratibor

In 1943 the Nazis established a research and sorting operation for plundered libraries in the German town of Ratibor (now Racibórz in Poland). Eventually more than two million looted books were transported there. The Nazis' intention was to house the books in one of several anti-Semitic and anti-Bolshevik institutes. This photograph was later included by the Allies in the photographic records of the Offenbach Archival Depot (see page 145).

would be its foundation—a basis and set of antecedents that would, in some sense, pave the way for a newly imagined Nazified future. The period witnessed the emergence of the Heimatmuseum, for example, in which specifically German crafts and traditions were celebrated at small regional organizations through the display of ceramics, woodwork, and vernacular items, all decidedly isolated from foreign influence. These centers supported a powerful narrative of German

heritage and folklore designed to educate visitors on the customs of a largely fabricated monocultural "homeland." These museums offered stories about roots and origins, embedding in the popular imagination a version of Germany in which the presence of unwanted elements, especially Jews, was edited out.[11]

Yet when it came to thinking about new forms of creative expression that would embody a vision for the future, Nazi Party members were at a loss. Hitler's own tastes were conservative:

he liked neoclassical sculpture, genre painting, and academic figuration. But for all his proficiency in the construction of culture and understanding of the power of images, he could not inspire compelling new art. The National Socialists, it has been noted, "produced art that was mediocre, politically motivated, and aesthetically irrelevant; they undermined the preconditions for the creation of real art and destroyed artistic modernism through a spiteful and brutal campaign."[12]

Unable to advance a compelling art form that would adhere to Nazi promises and ideologies, the party embarked on a campaign to ransack major art collections, private and public. Its ambition was to create the world's largest and most comprehensive collection of artistic treasures in Linz, Hitler's hometown. As early as 1933 experts in art history were commissioned to draft inventories and lists of esteemed private and municipal collections that would be fitting for the Reich. The immense Kümmel Report of 1941, for example, identified some three hundred pages'-worth of items that, in its authors' view, had been robbed from Germany since 1500 and thus were its legitimate property.[13] In particular, the Nazis wanted Italian and French art that, according to them, had been stolen from Germany by Napoleon.

Originally Hitler had intended to destroy Paris entirely, but revised his plans: much could be gained from the spoils of such a great city. He made his first and only pilgrimage there the day after the armistice in 1940 (France surrendered on June 16), accompanied by the architect Albert Speer and the sculptor Arno Breker. Both knew the city well and arranged a full itinerary of visits to sites, including the Invalides, Eiffel Tower, and Montmartre. Hitler was awestruck, describing his encounter as the fulfillment of a long-standing dream. Paris immediately emerged as a prime target in his quest to populate his new museum with art of the highest

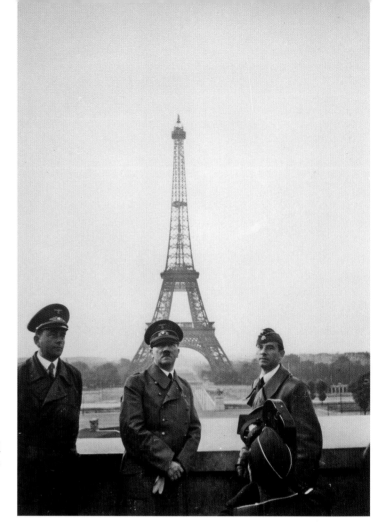

Adolf Hitler, the architect Albert Speer (left), and the artist Arno Breker (right) in Paris, June 23, 1940, shortly after the fall of France.

caliber. No time was wasted in setting up the infrastructure to carry out this scheme.[14]

The story of the Paris looting is gripping for its ambitious and relentless execution, directed at both French museums and the many prominent Jewish collectors of the city. The movement and dispersal of art leading up to the German Occupation and during its peak years was steady and deliberate. After war was declared in September 1939, French curators, museum directors, and collectors removed many cultural treasures from Paris, or hid them in subterranean storage rooms. The *Mona Lisa* was famously carried out on a stretcher to a protected van and driven to the countryside (see page 74). The Rothschilds moved some of their collection to the Louvre, where they believed it would be safe, at least temporarily, while other precious

items were sent to the family's rural residences; the collector Peggy Guggenheim frantically cut canvases from their frames and sent them to friends in Vichy, the unoccupied part of France.[15] But these hideouts—while in some cases remarkably effective—protected only a small fraction of the art in Paris. The swift formation of Nazi administrative programs charged with the cultural oversight of Occupied France, and working closely with the collaborationist French government, ensured that an organized confiscation effort followed, with the aim of sending these great treasures to Germany.

At first it appeared that caring for art (particularly against bombing raids) was taken seriously as a matter of German national security. The policy of *Kunstschutz*, or art protection, had been developed during World War I. In 1940, for example, a well-known and respected art historian, Count Franz Wolff-Metternich, was charged with the formation of a unit designed to minimize the potential damage to art in France. Indeed, he did much to protect buildings and valuable works of art during his tenure. But the emergence of more aggressive policies on looting soon thwarted any preservationist activities. Hitler announced on June 30, 1940, that all objects of special interest—particularly art and Jewish-owned cultural property—were to be "safeguarded" by Nazi officials. Otto Abetz in the German Embassy in Paris stepped into this assignment happily, for it amounted to a license to seize anything of interest to the Nazi leadership. He took the lead on the first wave of looting, going after French art in museums in Paris and in the provinces, as well as collections owned by Jews. The vast private collections of the Rothschilds were taken, as well as those of the art dealers Paul Rosenberg and the Bernheim brothers, among many other prominent names. Large numbers of desirable works were also shipped into Paris from other locations such as Brussels and Amsterdam, leading to a vast concentration of confiscated works in Paris and its environs.

One of the most significant repositories of looted art was formed at the Jeu de Paume, a rectangular building situated at the corner of the Tuileries Garden in Paris that became an exhibition venue in 1909. Its location in the middle of Paris rendered the site both privileged, being so close to the Louvre, and accessible. The first shipments of looted art, arriving in some four hundred crates in October 1940, were sorted and catalogued to fulfill an ambitious plan. A great many works were set aside to be sold; others were kept for display on-site, to be placed later in the hands of Nazi officials or German museums. Unlike the haphazard and crowded arrangements of other storage facilities, the Jeu de Paume was strikingly professional, with elegant salon-style installations, potted plants, carpeted floors, and display racks featuring highlights from the modern era as well as nineteenth-century art (see page 20).[16] Set up as a kind of showroom, the gallery attracted elite members of Hitler's inner circle—Joseph Goebbels came in to choose twenty-seven works for his own collection, while others visited to procure pieces for themselves or their families. Art was a valuable asset, a commodity capable of generating income through sale on the international market, and a perquisite for high-level officials seeking to build their own private collections. Detached from the personal stories and lives of their owners, the works operated within a market of desire and control, subject to the likes and dislikes, whims and wants of Hitler's inner circle.

Just as art was brought in for the delectation of Nazi officials, it was also expelled when not conforming to Nazi ideology, as was the case with much modernist art, which was attacked as an extension of Weimar (liberal, democratic) corruption and thus antithetical to German values. In June 1937 it was announced that the "president of the Reichskammer der Bildenden Künste,

Adolf Ziegler, [an artist and] professor at the Kunstakademie, has been charged by the Führer with impounding the products of the period of decay still found in museums, galleries, and collections belonging to the Reich, the states, and the municipalities."[17] Under this far-reaching decree, museums across the country were forced to give up their modern works and revise their exhibition programs. In truth, many knew this was coming, as museums had been subjected to Nazi censorship since the earliest days of the regime. (Indeed, the first exhibition of so-called degenerate art was held in Dresden in 1933.) Some, like the Museum Folkwang in Essen, were taken over entirely by Nazi officials; at other institutions, directors like Eberhard Hanfstaengl at the Nationalgalerie in Berlin had their exhibitions unceremoniously closed.[18] Museum directors deemed too supportive of experimental movements such as Expressionism and abstraction lost their jobs.

The size of the degenerate-art seizures was astounding, in keeping with Hitler's aim to radically reshape all of culture. Goebbels himself oversaw the removal of more than twenty-one thousand works, plucked from the walls of Germany's great museums.[19] From these spoils came the famous *Degenerate Art* exhibition, which opened at Munich's Haus der Kunst in July 1937. At the time it was one of the most visited art exhibitions in history, with over two million attendees (the show toured throughout Germany). Works spanning a wide range of "isms," from Expressionism and Fauvism to Dada, were laid out in galleries organized by theme; Paul Klee, Wassily Kandinsky, Emil Nolde, and many others associated with avant-garde practices were included. Many of these targeted artists had been celebrated for their modernity and sophistication only a few years earlier, and the shift in their status exemplified the speed and comprehensiveness of the regime's efforts to redesign culture.

Among them was Otto Dix, a Neue Sachlichkeit painter whose work harshly condemned the excesses and horrors of World War I in Germany. The Nazis marked him early on as "degenerate"; he was forced from his teaching position at the Dresden Kunstakademie in 1933 and his paintings were featured prominently in the 1937 exhibition. The modern artist Otto Freundlich was also initially an Expressionist, later embracing pure abstraction. Like many artists of his generation he was an ardent leftist, making him doubly anathema to the Nazis. His sculpture was included in the 1937 exhibition and shown on the cover of the catalogue (see page 128). He lived in both Germany and France, where he was arrested in 1943 and transported to the Majdanek concentration camp in Poland. He was murdered upon arrival. Significantly, German Expressionism, with which many of these persecuted artists were closely affiliated, often addressed themes of societal turmoil, psychological distress, and political upheaval—topics that resonated with Jewish collectors who had experienced many of those conditions firsthand. There was a connection between the "aesthetic and ideological contribution" of German Expressionist artists and German Jewish collectors who had encountered cultural differentiation and dislocation in their quest to assimilate into mainstream German culture. Collecting was a means of assimilating into German society and securing a degree of visibility there, but "the inordinate emphasis placed on collecting, and indeed on the arts in general . . . stood as a continual reminder to the collectors of the prejudices toward them and their own outsider status."[20]

The massive purge of museums and collections produced a glut of artworks, an unexpected logistical challenge in terms of their storage and management. The devised solution centered on converting expropriated artworks into cash, the *Verwertungsaktion,* or "action to make money." Many "overstocked" artworks

Otto Freundlich,
*The Unity of Life
and Death*, 1936-38
Oil on canvas,
46½ × 35½ in.
(118 × 90.2 cm)
Museum of Modern
Art, New York,
Lydia Winston
Malbin Bequest
in memory of
Alfred H. Barr Jr.

were sent to Schloss Schönhausen in Berlin, where they were held in temporary storage. Ever eager to exploit the commercial potential of the seized art, the confiscation committee agreed to auction some 125 objects at the Grand Hotel in Lucerne in June 1939. Four art dealers, Hildebrand Gurlitt, Ferdinand Mueller, Karl Buchholz, and Bernhard Boehmer, bought amply from the offerings, with Gurlitt taking a prized share.[21]

In addition to its renown as a sale of masterworks of the modern era, the auction also provided crucial records for future restitution cases and claims. In the end, however, it is estimated that around a quarter of all degenerate works, primarily works on paper, were destroyed, representing a staggering, irreparable cultural loss.[22]

Indeed, the widespread seizure of art, in its abundance and in tandem with other spoils, created substantial revenue opportunities for the Nazis.

The international art market not only turned a blind eye to the profiteering, but actively participated in it. The Paris art market in particular boomed during the war years and attracted many foreign investors. French dealers sold off works considered degenerate or too modern at steep prices; Jewish dealers were forced to give up their businesses and leave the country, so expertise was lacking; other Jewish art owners liquidated their collections quickly and at low prices in order to raise funds for their escape. Art changed hands quickly as multiple sellers and bidders joined the fray. Between 1941 and 1945, one French auction house sold more than a million objects that had been stolen or relinquished under duress.[23] While sales to America and Britain fell off, those countries still officially neutral—Austria, Belgium, Switzerland—soon started participating in a buyer's market, and many Germans indulged their love of Dutch, German, and Flemish art of the fifteenth, sixteenth, and seventeenth centuries.[24] These transactions were often handled in cash, minimizing the paper trail that might one day lead back to a point of origin, person, or auction house. It is easy to see how individuals involved in the looting personally benefited, and perhaps even rationalized their purchases as a way of protecting art from further damage by ferrying it across borders and through "safety" networks. None of this activity was illegal; indeed, German law, guided by principles of Aryanization and overseen by the Reich, made it possible.

The emptying out of art from German museums aligned with the exodus of modern artists from the country, which had been taking place since 1933. Early in the Nazi regime many artists, including Käthe Kollwitz and Max Liebermann, were asked to "voluntarily" step down from their university positions.[25] In 1935 the Nuremberg Race Laws stripped Jews of most civil rights and denied them the right to marry or form sexual partnerships with non-Jewish Germans, a tactic aimed at the separation of bloodlines. Artists who were not able to prove that they were "Aryan" (that is, Nordic and Germanic), or whose artistic practices were branded as degenerate, were forbidden to buy materials. This total isolation and

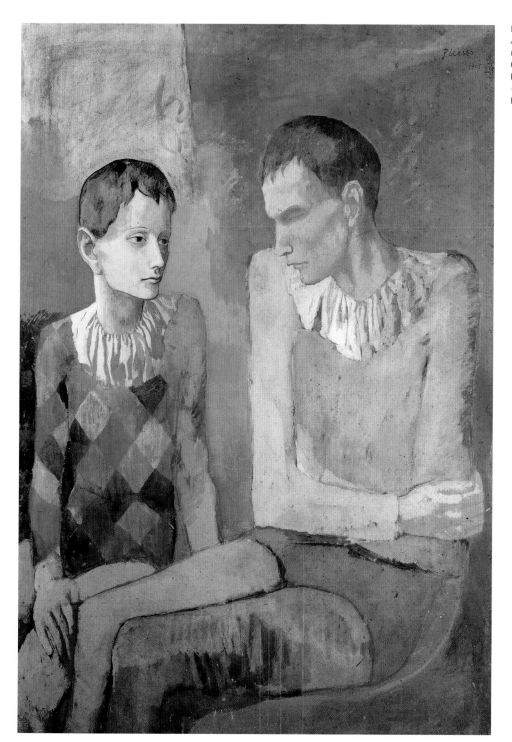

Pablo Picasso,
*Acrobat and Young
Harlequin*, 1905
Gouache on card-
board, 41⅜ × 29⅞ in.
(105 × 76 cm)
Private collection

outcast status forced many into a state of exile and desperation.

The rampant looting and persecution accelerated, and by 1938 Jewish dealers, collectors, art historians, and museum professionals had virtually disappeared—ousted, killed, or in exile—decimating the German art world.[26] Property owned by Jewish families and collectors, symbolic not only of wealth but of privilege and socio-economic standing, became available, assuming the status of "ownerless," subject to any fate imposed upon them. Against this backdrop, images of the spoils—the mountains of books forming unfathomable topographies; colossal warehouses filled with crates

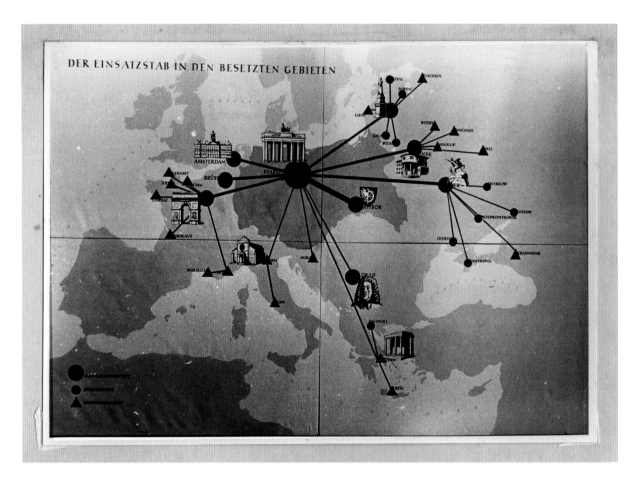

DER EINSATZSTAB IN DEN BESETZTEN GEBIETEN

as far as the eye can see; rows upon rows of framed paintings leaning helplessly along barren walls; furniture forming precarious pyramids in nameless storage facilities—are crushing (see pages 109, 142–59). These documents are instrumental in communicating the sheer magnitude of Nazi thievery and destruction and foreshadowing the expansive effort that would be necessary to piece back together the torn histories and lives so profoundly affected during this relentless purge.

REVERSING THE FLOW
The trafficking and movement of artworks, books, and objects through various depots, collecting points, and Nazi hideaways was one of the most complex and dynamic facets of the looting campaign and one that marked the itinerant nature of objects and their afterlives. Ever mindful of the power of visual communication, both the Nazis and the Allies relied on

images and documents to illustrate how material culture was first claimed and later restored to a point of origin, traveling through different channels and locations. This can be seen explicitly in the maps both sides created and, in particular, how these visual forms were designed to communicate a sense of logic and agency. The first example is a Nazi map of spokes and hubs denoting the trafficking of objects from various European capitals to Berlin, the visual center of the diagram. Strikingly reminiscent of a set of planets orbiting the sun, the image at once conveys the reach of the Nazis' ambition and their recurring use of neoclassical symbols to reinforce their prevailing aesthetic. The second example, produced later by the Allies, is graphically reminiscent of the first but structured around routes of reparation rather than theft. Boldly identified as an illustration of "Book Distribution from OAD Reversing the Flow Started by the Einsatzstab Reichsleiter

A map produced by the ERR probably between 1942 and 1944, labeled "Task Force for the Occupied Territories," with regional collecting points for the expropriation of cultural material. It was found after the war and preserved by the Allied restitution program at the Offenbach Archival Depot.

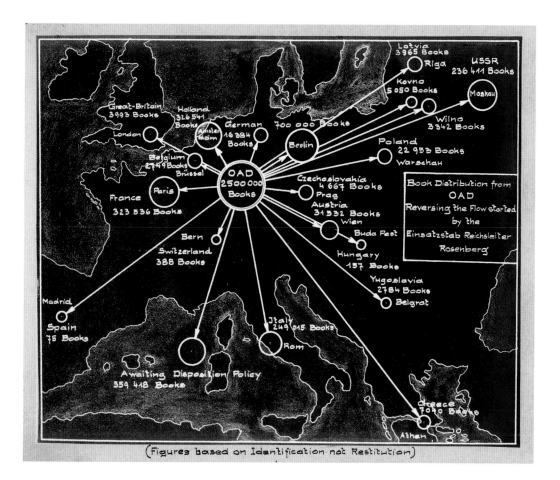

Map labels:
Latvia 3965 Books
Riga
USSR 236 411 Books
Kovno 5050 Books
Moskau
Great-Britain 3993 Books
Holland 316 541 Books
German 16 384 Books
700 000 Books
Amsterdam
Wilna 3342 Books
London
Berlin
Poland 22 953 Books
Warschau
Belgium 2749 Books
Brüssel
OAD 2 500 000 Books
Czechoslovakia 4 667 Books
Prag
Book Distribution from OAD Reversing the Flow started by the Einsatzstab Reichsleiter Rosenberg
Paris
France 323 536 Books
Austria 31 532 Books
Wien
Bern
Buda Pest
Switzerland 388 Books
Hungary 157 Books
Yugoslavia 2784 Books
Belgrat
Madrid
Spain 75 Books
Italy 249 045 Books
Rom
Awaiting Disposition Policy 359 418 Books
Greece 7040 Books
Athen

(Figures based on Identification not Restitution)

Rosenberg," the Allied map conveys its "reversals" with arrows pointing away from the concentrated hub (in this case not Berlin, but a collecting point for books and manuscripts). The unambiguous message is one of *undoing* the sphere of Nazi influence and marking the path of recovery, based on reversals.

The recovery initiative fell to a group of seasoned art historians and conservators who oversaw the retrieval and cataloguing of stolen goods as well as the fastidious documentation of their efforts through photography and written testimony. Among them, the so-called Monuments Men occupy a particularly privileged position in the historicization of this time and its activities. Known officially as the Monuments, Fine Arts, and Archives (MFAA) program, the group was assembled in 1943 as an outgrowth of the Roberts Commission, charged with "the protection and salvage of artistic and historic monuments in war

arenas."[27] The group's assignment was to safeguard sites and assets in harm's way, especially when airstrikes began to wreak havoc on areas that were full of ancient, medieval, and Renaissance treasures. Members of the unit, largely staffed with museum and academic art specialists, also worked on the ground to block the dispersion of art into the marketplace as much as possible and to prevent objects from being shipped to "safe haven" sites by the Nazis. At war's end, as the Allied Occupation of Germany got under way, some were tasked with the recovery of works and later with their repatriation. The unit was led by Paul Sachs, an esteemed Harvard professor and curator, and included the Fogg Art Museum conservator George Stout; the Italian Renaissance scholar Frederick Hartt; the curator James Rorimer, from the Cloisters of the Metropolitan Museum of Art; the poet and Librarian of Congress Archibald MacLeish; the architect Robert Posey; and Lincoln

A corresponding map prepared by the Offenbach Archival Depot, 1946.

Kirstein, a collector and modern-art specialist. Together, their deeds—including saving valuable works by artists such as Michelangelo, Jan van Eyck, and Johannes Vermeer—have accrued legendary status, suitable for popular novels and movies. These dramatizations, however, tell but one side of the story.[28]

Women comprised an essential part of the workforce charged with identifying, protecting, and ultimately restituting art and "lost" Jewish property. One of the most remarkable was Rose Valland, a French curator who continued her employment at the Jeu de Paume during its occupation by the Nazis. Amid the comings and goings of high-ranking Nazi officials wanting to look at the art, she kept copious records of the inflows and outflows of objects and confiscated collections. A quiet and unassuming presence, Valland possessed a strong knowledge of German, absorbing information as it was relayed in overheard conversations. She worked tirelessly: "At night she took home the negatives of the archival photographs being taken by the Nazis, and had them printed by a friend. In the morning they would be back in place. Every time there was a theft or damage she would be questioned . . . but she managed to stay on. Loyal French guards filled her in on details of events in those parts . . . which were off limits to her. Packers and drivers told her what they were doing."[29] Ever conscious of where works were headed, she tracked shipments and sent intelligence back to key contacts, including Jacques Jaujard, Director of the National Museums, and his assistant. In August 1944, just before the liberation of Paris, she prevented four large crates of art from being shipped to Germany, one of many interventions that earned her the post of chair of the Commission for the Protection of Works of Art after the war, as well as the Légion d'Honneur and numerous other orders of merit.

Women also became the bedrock of the workforce at the Allied collecting points. These repositories, including sites at Offenbach, Munich, Wiesbaden, and Marburg, as well as many smaller outposts, acted as intermediary stops for objects on their way back to their countries of origin. Images documenting the labors of these women attest to responsibilities ranging from the clerical to the scholarly and administrative, with participants from both sides having to collaborate with local experts after the war. The Wiesbaden collecting point, headed by an American, Walter I. Farmer, for example, was a blend of German and American personnel who were tasked with sorting through large quantities of material that had been moved out of German museums during the war and stored by the German army far from the zone of active conflict (see page 160).[30]

Collaboration between German and American art personnel after the war could be uncomfortable. Allied staff members, including Farmer himself, were dependent on the expertise of

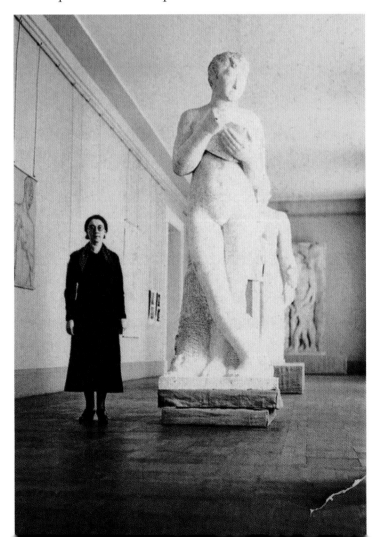

Rose Valland at the Jeu de Paume, Paris, in 1934, with a sculpture by the Argentinian artist José Fioravanti.

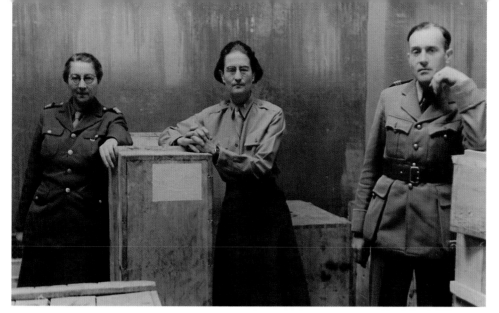

German curators, including many professional women who had been curators or administrators at the very collections that had been relocated during the war. Indeed, some of the Germans working at Wiesbaden had been the ones who packed and inventoried the crates prior to shipping them out of Berlin. In their postwar role, their primary concern was for the safe handling and return of works they knew intimately. This sometimes ran counter to a desire on the part of the American government to bring some of these impressive holdings to the United States. The stated purpose was to mount touring exhibitions advertising the success of the endeavor, though the Wiesbaden staff worried that a new instance of expropriation might occur. The most famous was a group of 202 masterpieces from Berlin museums that was sent to Washington, DC, in 1945, despite heated protests from many of the Monuments officers; these works were put in storage at the National Gallery, then toured around the United States in 1948.

A particularly vigilant presence was that of Irene Kühnel-Kunze, a curator from Berlin's Kaiser Friedrich Museum, who was in charge of the German team and guarded her notebooks and accession catalogues closely, insisting that curators with specific areas of expertise be on hand

as fragile works were being uncrated and inspected. Less glamorous than the much-lauded—and -documented— discoveries of the MFAA officers with whom she worked, Kühnel-Kunze and others like her played a crucial role in maintaining rigorous standards as well as detailed records that later proved invaluable to the flow of works back to the places from whence they came.[31]

The arduous task of taking stock of the contents of each collecting point was an enormous, exhaustive effort, and one that produced its own paper trail of images and reflections. These documents have become, in some ways, the narrative voice of mute objects whose fate, at the end of the war, was unclear. It took years to fully implement the return of these vast troves, and the work, as one account illustrates, was tiresome:

> If the cases received (most of them had markings with initials) were closed, it was determined whether the material therein belonged to one nation or that it was unsorted. Identifiable and unidentifiable items were separated: the identifiable sorted out by country of origin (France, Netherlands, Greece, Italy, Germany, small collections), the Nazi-material of the *Hohe Schule* [the planned Nazi university] put at the disposal of the Library of Congress Mission, while the unidentifiable modern items should be

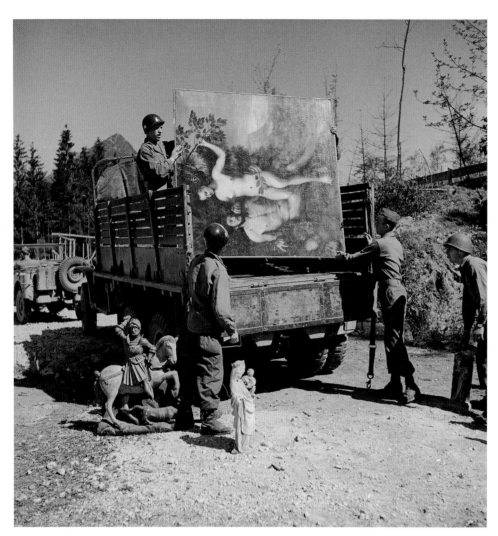

handled by Professor Pinson, for the Jewish DP's [displaced persons] in the camps.[32]

This description comes from a staff member at the Offenbach Archival Depot, tasked with the job of sorting through crateloads of books. Tens of thousands of volumes were received and catalogued there, eventually total-ing 2.5 million. There, in a building made of reinforced concrete, an array of immense book collections was gathered from Nazi caches unearthed across Europe, including the huge Rothschild library and the majority of the Prussian State Library's music collection, which arrived in twenty-three freight cars. In the immediate aftermath of the Holocaust, the impulse to restore possessions to their owners, many of whom were dead, took on the quality

of a cause. Books were seen to have particular restorative power, and many whose origins could not be determined were sent to the hundreds of displaced-persons camps that began to appear.[33]

Officers at Offenbach chronicled their work in photographic albums that provide a storyline and visual point of reference for the collecting points at this pivotal juncture. Four albums made in 1946 survive from this time.[34] They focus expressly on after-math themes: the arrival, unpacking, sorting, condition assessment, and eventual reorganizing of looted books. In stark contrast to images of Nazi wreckage and debris, they signal a new reality taking place at the collecting points, defined by an atmosphere of calm productivity (see page 145). The first album, the brainchild of Captain Seymour J. Pomrenze, director of the

Offenbach depot and a trained archivist, traces the arrival of books on trains and barges as well as their installment in the Offenbach warehouse; wide contextual photographs, most likely by a staff photographer, Otto Nischwitz, predominate. The third album, scrapbook style, collects documents and images salvaged from ERR files, without comment or captions. The fourth is a series of photographs of carefully arranged groups of unidentified Judaica.

Particularly striking is the second album, overseen by Captain Isaac Bencowitz, successor to Pomrenze

at Offenbach. It documents specific staff and their duties. Among the most remarkable features of this album are the numbers of images that show people reading, heads bent over desks, extracting volumes from piles of unsorted items, and turning pages of fragile manuscripts; most do not directly engage the camera. The images are hardly dramatic in their often intimate portrayals of people working in quiet solitude, but nonetheless communicate the crucial role that reading and research played in the recovery effort. Every picture is

Unknown artist, after Frans Floris, *Adam and Eve*, late sixteenth or early seventeenth century
Oil on canvas, 70½ × 70½ in. (179 × 179 cm)
Gallerie degli Uffizi, Florence

ALEXANDER

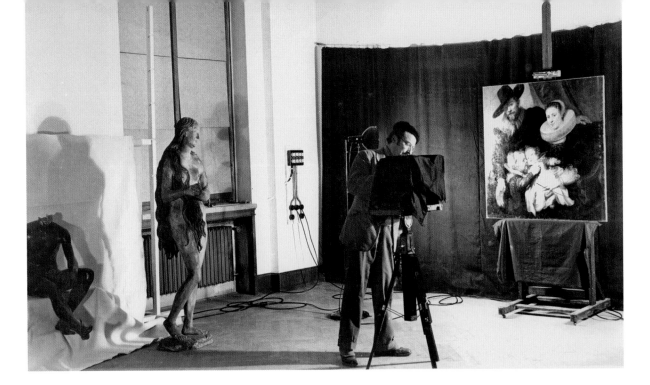

carefully explained in handwritten captions, so as to mark stages of progress from the arrival of materials to their crating and then "the final step—restitution." Significantly, this album too ends with images showing rows of unidentified books and oddities, including Masonic paraphernalia, and a picture of Bencowitz himself. Clearly the people involved at Offenbach wanted their recovery work to be seen as a vital marker of a new moment in which looted "spoils" reclaimed their standing as objects of deep and rigorous scholarship, worthy of sustained consideration. These albums were as much a record of this shift—from looted to recovered, worthless to valued, lost to found—as they were an illustration of one of the busiest collecting points in Europe (see pages 144–69).

Articulating changes in status as objects migrated through time and space was a functional role served by the many documents created by Allies engaged in the recovery effort; they were conscious that in their work and its attendant records they were producing new archives by which their contributions would be remembered. All of the books, photographs, logs, letters, and official transcripts attest to

the extraordinary efforts undertaken by the committed professionals working during the early postwar years, but they are also fascinating evidence of how documentation was understood, valued, and planned for. Those engaged in the work undoubtedly recognized that fastidious attention to detail would also help future generations restore objects to their rightful place. Items arrived at the collecting points with an equivocal identity: at first they were simply property in motion, plundered objects traveling across different registers of meaning and history, losing and regaining their status as possessions, as creative, expressive presences, and indeed as documents of an era as they moved from one place and one owner to another. Archiving was therefore not simply a matter of preserving the past, but, as the authors of *Artists in the Archive* noted, "*To archive* is to give place, order and future to the remainder; to consider *things*, including documents, as reiterations to be acted upon; as potential evidence for histories yet to be completed."[35] The Offenbach collecting point was the "archival" depot insofar as it served as a gateway for vast troves

A seventeenth-century family portrait by Anthony van Dyck is documented in the photography studio at the Munich Central Collecting Point, probably in 1947. At left are Gregor Erhart's *Mary Magdalen* and a Roman *Seated Hermes* (see pages 179, 173).

of manuscripts, books, photographs, and paper ephemera, but it was also a generative space where intellectual labor occurred, logistics were coordinated, and plans established, all geared toward the return of property and the restoration of humanistic values.

Photographs played an especially important role at these sites in that they provided visual evidence of what had happened and, for later viewers, the emotional trigger tied to loss and memory that is the purview of a technology designed to freeze time. Surviving images of works being carried out of mineshafts, removed from false walls, and extracted from wartime debris are visceral reminders of the fragility of artworks and the symbolism embodied in their rescue. But they also touch on a human level, tapping feelings and experiences that endure far beyond the moment these events were captured. Looked at so many decades later, these images provide a testimony of the scale of loss endured by Jewish communities and a potent reminder of the magnitude, force, and volume of the pillaging. They also enable today's audiences to project themselves back into history, to the places and events of the past, however conditionally, and in so doing shape perceptions of their significance. Writing about the psychological role of images, Maaike Bleeker notes that photographic "'truths' are not only a matter of how well or not images represent a reality . . . but of how [they], as simultaneously objects showing something and an address to the viewer's imagination, set the stage for ways of knowing."[36] The surviving images associated with the first wave of restitution, particularly at the collecting points, bear witness to this observation. The manner in which on-site personnel photographed and wrote about their activities in accompanying captions reflects a conscious act of planning for posterity by underscoring not only their role in administering stolen property but in promoting precise narratives around which their efforts would eventually be known.

The carefully orchestrated and annotated photographs produced at the collecting points were a stark contrast to the thousands of Nazi photographs that remain as documents of their plunder. These are images of the most banal sort—frontal views of individual artworks, often identified by name and point of origin. The largest trove of material, transferred from the Jeu de Paume, is now located at the Bundesarchiv in Koblenz, Germany, where over twenty thousand files are held. In addition to photographs documenting looted objects, there exists an abundance of material itemizing targeted works, including dozens of albums filled with pictures of art pursued, in all likelihood, to adorn the walls of Hitler's planned Führermuseum in Linz; thirty-nine of an estimated one hundred of these survive, and were used as evidence in the Nuremberg war-crimes trials (see page 106). Astounding in their volume and meticulous in their compilation, these albums also record works that remain unrecovered or presumed destroyed, and thus in many instances constitute their last known trace. Photographed in unmodulated black and white, they are among the most haunting images to survive the vast cultural plunder of World War II—not only because as poor reproductions they are so visually reduced from their original form, but because they seem to embody so much that remains unresolved from this time.

Yet one might also construe hope from the unsorted fragments that remain from this era. If "reversing the flow" was the aim of Allied troops entering Europe after the war and contending with its aftermath, it was a flow that had moments of disruption and digression; these bits

Nazi functionaries photographed and labeled the works pillaged by the ERR. Some were marked for destruction with a red slash. Records indicate that this painting by Salvador Dalí, looted from an unknown private collection, was destroyed, probably in 1941. The ERR albums of photographs later became important evidence in the Nuremberg war-crimes trial relating to the spoliation of art.

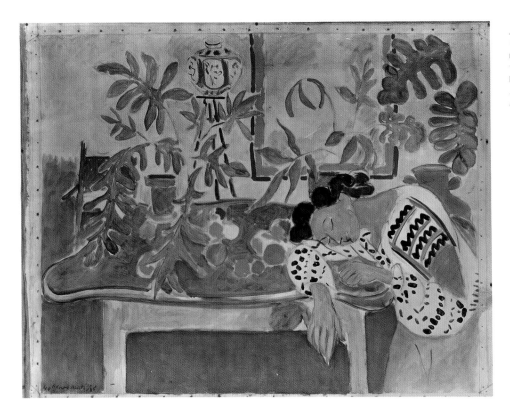

of photographic evidence have been critical in reconstructing sequences of events and making known the places and times through which objects traveled that would otherwise have done so invisibly. In a strange and at times uncomfortable twist, Nazi records have been particularly vital as finding aids to those who continue the work of restitution; they are, in some respects, uniquely valuable. And many have been fully integrated into the American narrative as evidence of what was found and "corrected." The fact that the Allied photographic albums produced at the collecting points often incorporated Nazi imagery in their presentations is not inconsequential; it signaled the submission of the German story to one focusing on Allied triumph, replete with documented acts of heroism and bravery. The deployment of photography by the Nazis and Allies in these instances inflects the afterlife theme assertively in two directions: one is a targeted and surgical approach, aimed at identifying works to be seized, sold, and destroyed; the other allows present-day spectators to witness the

mechanics of recovery as part of a larger system of order and cleanup, with art objects positioned as inanimate and displaced survivors. The possibility of a work enduring through time was a fragile proposition in both cases (even Allied officers were known to have destroyed certain works and taken "souvenirs" from the collecting points) and one that has inspired extraordinary attempts to locate and reclaim what was so senselessly taken during the war.[37] It is those stories that complete the picture.

RESTITUTING ART AND CONSTITUTING AFTERLIVES

One of the most enduring and charged topics that has shaped discourse around objects that survived the war centers on how and when confiscated objects were returned to the heirs of original owners. Restitution, the term most frequently invoked to describe this process, is outwardly a logistical problem. But it is also a deeply emotional mission that involves delving into chapters of history to trace the movements and whereabouts of works that were seized or unjustly

obtained. Immediately following the end of the war, motivation to return works and set the record straight for those most personally affected by the material losses of the war was high. As many as sixty-one thousand works were returned to France, of which forty-five thousand have reportedly been repatriated.[38] Since then, public attention to and scrutiny of the fate of Nazi-looted art has ebbed and flowed over time, alternatively galvanizing national attention and action plans and waning as matters of more pressing public urgency take precedence on the agendas of policymakers. Seventy-five years have passed since the end of the war and many of the individuals most invested in the return of stolen property have died, passing the burden of proof to heirs, who may not possess the time, resources, or documentation to take on the thorough research that restitution cases often require.

To fully understand the complexities associated with what happened to objects after the war is to grapple with the fact that people were trying to save art at the height of the conflict and often took action under great duress. These are the stories of individuals as well as larger communities. Many members of Europe's most prominent Jewish families, for example, anticipated the imminent and devastating consequences of Nazi rule and moved to protect vulnerable assets and belongings before the war began, and even as it was under way. Isolated instances tell of household staff (butlers, gardeners, domestic laborers, and others) who took it upon themselves to hide or relocate prized items, often at great personal risk. When the Nazis took up residence at the grand Rothschild home in Paris, the family's maid, Madeleine Parnin, removed family linens and bedspreads while doing the laundry, and the head butler, Félix Pacaut, staged a fire in one part of the house while others scurried out the back door with the family silver, which remained safely hidden for the remainder of the war.[39]

These actions were driven not only by a sense of duty but by a strong belief that objects, be they humble linens or valuable works of art, carry symbolic meaning inextricably bound to the lives of their owners and must be saved. To do so, swift action and covert coordination were often required. Nowhere were these attributes more vividly illustrated than in the story of the Jewish ceremonial objects saved from Danzig (now Gdańsk in Poland). The city was partly autonomous between Germany and Poland and had a large and well-established Jewish population. After Hitler took power in the 1930s its political status became hotly contested and the Jewish community faced increasingly aggressive persecution. By the end of the decade an invasion from Germany was imminent, and Jews began to leave in large numbers. By early 1939 the Great Synagogue was marked for destruction by the Nazi-dominated city government. Desperate to save its contents, which included objects for everyday use as well as a museum of prized metalwork, residents arranged to send everything they could to the United States, a delicate negotiation that required the support of a Nazi-controlled police force. Facilitated on the American side by the Joint Distribution Committee, a Jewish aid organization, the shipments left Danzig on February 8, 1939, and the synagogue was dismantled on May 2 (see page 10). The collection came to New York, where it was housed at the Jewish Museum in the hope that it could later be returned to the Jewish residents of Danzig. But by the end of the war the Jewish community of Danzig was gone. Many had died, but many had escaped or been evacuated. Without their remarkable foresight, the contents of the synagogue would most assuredly have been lost.[40]

The capacity to respond to the unfolding and at times unpredictable events of war, with decisive action geared to preserving cherished objects, illustrated the profound commitment of often unknown people to save

what they could of their history, if not themselves. Knowledge of the great adversity they faced as they struggled to preserve their culture makes viewing the works in the present a particularly moving experience. In light of the tremendous human sacrifice that attended the war, taking on matters of aesthetics and art-historical analysis—indeed, of appreciating a work for its ambition, subject matter, or resistance to trends and standards—can be complicated. This is notably the case when there is something about the work itself and its history that is contentious or unresolved, or that has not been fully disclosed.

Withholding or falsifying information that would later be necessary for restitution was a Nazi specialty. The Nazis were adept at making their ownership of stolen property look legitimate, complete with forged documents and "tax receipts" recognizing the transfer of art as payment from Jews who were in fact trying to survive. And the problem had many layers: for example, when Germany fell in 1945, the Soviet army removed to Russia countless items previously confiscated by the Germans, and Russia has been slow to enact measures for their return.[41]

These nuances have made the process of adjudicating restitution claims challenging. In most cases restitution is the result of principled decisions and not merely compliance with a set of legally enforceable rules. Over time, efforts have been made to streamline the task, with the establishment of support networks and the suggested protocols set forth by the Washington Principles on Nazi-Confiscated Art (1998)—including the need to identify confiscated works, make records publicly accessible, and encourage descendants to come forward—and the creation of foundations dedicated to setting up valuable resources, such as lists and databases—for example, the German Lost Art Foundation, established in 2015, and the International Foundation for Art Research (IFAR, founded in 1969). Even so, the burden of providing documentary evidence and substantiating provenance inevitably falls to claimants, who may or may not be prepared to take on this work. In one recent case, descendants of a famous Jewish art dealer, Lilly Cassirer, sought to reclaim a Pissarro painting from a museum in Madrid, one they say was sold under duress for a negligible sum in the early 1930s in exchange for the owner's safe passage out of Germany; they lost in court. In another, the family of the German Jewish publisher and art historian Paul Westheim, who had entrusted much of his collection of German Expressionist paintings to a friend when he fled persecution during the war, wanted it back. After years of exhausting litigation, they did not prevail.[42] While these attempts have been valiant and thorough, it can often be difficult to prove in a court of law that a sale was coerced, or an artwork left behind looted.

Yet there are also many positive developments. Inspired by the Washington Principles, the professional museum organizations have created standards and guidelines concerning the unlawful appropriation of objects during the Nazi era, updated periodically.[43] These highlight the importance of accountability and transparency; in recent years institutions and individual foundations have become more willing to say what they know about their collections. Some museums have set up their own research projects and have posted online works of uncertain provenance, while families and others have become more organized in providing details on lost or stolen objects. The release of classified files and historical records like those belonging to shipping companies during the war have also provided valuable information about the destinations of artworks being trafficked as part of looting campaigns.[44] For those disposed toward this research—a fascinating if at times seemingly endless proposition—these are indeed positive steps. As one attorney put it, restitution is "not always

about the value of the object. It's often just about the principle. . . . A younger generation is engaged with the question and that's important."[45]

The afterlives of objects are also perpetuated in exhibitions, unleashing new contexts by which works are assessed and presented both within the context of restitution-related themes or as advancements in art-historical scholarship, or both. There has long been a fascination with "looted art" themes, going back to the early government-sanctioned exhibitions that focused on the heroism and success of Allied recovery efforts. Quasi-propagandistic in tone, these shows included *Paintings Looted from Holland* (1946) and *Paintings from the Berlin Museums* (1948).[46] Positioned as acts of diplomacy, these projects were also publicity-generating ventures, in some cases attracting record attendance. More recently, scholarly

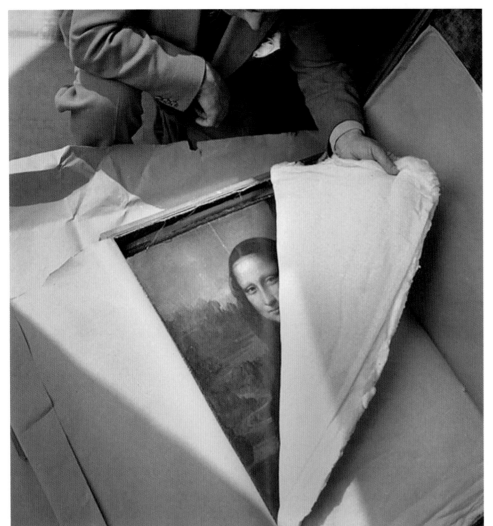

On August 28, 1939, a week before France declared war on Germany, Leonardo da Vinci's *Mona Lisa* was removed from the Louvre for safekeeping. During World War II it was moved six times around France before returning to the museum on June 16, 1945.

versions of the 1937 *Degenerate Art* exhibition have been restaged as well as in-depth curatorial investigations into specific individuals involved in (or affected by) pillaging campaigns, from the Jewish collector Paul Rosenberg to the Nazi art hoarder Hildebrand Gurlitt. These exhibitions have collectively contributed to public awareness of this period and its reverberations, widening the outlets through which works affected by the war can express new narratives. The challenge for the curator is to foster, and then critically assess, how these emerging perspectives are shaped and tempered by the brutal transgressions of the Nazis, who sought to destroy every last vestige of Jewish life and Jewish culture.

How are the spoils of war, recuperated or not, to be understood beneath the shadow of the Holocaust? Are their stories to be seen as ephemeral documents of comparatively minor consequence, or, conversely, are they the last prisoners of war in a conflict so profound in its reshaping of culture that it has never quite ended? These questions get to the heart of the divergent values and points of view that cultural objects tend to elicit, particularly when their status is tested against the backdrop of unfathomable trauma. Indeed, such conditions of history can silence aesthetic judgments and formal critiques, making them appear trivial or in bad taste. Yet it is through these worldly possessions, fragile as they are, that the presence of human loss is powerfully asserted.

The Nazis viewed the seizure of art and related works within a hierarchy of

ambitions centered principally on the disenfranchisement of Jewish communities; the potential to accrue wealth, prestige, and power through looting; and the desire to claim ownership of the world's creativity by racial right. Against this horrific vision, delivered with armies, and with many accomplices, the works themselves retain the power to resist, through the emotional and psychological charge they continue to exert decades later. In their presence, contemporary viewers are propelled toward the imaginary. How did these objects survive? "What cultural and material conditions made possible their production? What were the feelings of those who originally held these objects, cherished them, collected them, possessed them?"[47]

The afterlife of such objects and belongings affirms, emphatically, that the Nazi effort to extinguish Jewish culture, property, and history failed. Much was indeed lost, never to be retrieved or restituted. But a great deal was salvaged as obdurate and rich historical evidence for consideration today. The surviving books, the art, the furniture, and the heirlooms may not always bear the visible marks of war and displacement, but they have traveled, witnessed, and participated in profound episodes of human history, during which time they have performed a multitude of roles, from beloved object to cultural spoil to saleable commodity to treasured masterpiece to historical evidence. Within these evolving functions, the very dynamic movement of objects passing in and out of time becomes visible, flowing through countless realities and accruing new resonances. Each new era, way of thinking, and physical setting delivers a framework for understanding these enduring works that is unlike what came before, though capable of embracing and recontextualizing it. For works marked by an abundance of accreted, layered, and perhaps contradictory histories, the interpretations are endless and open.

Notes

Epigraph: Walter Benjamin, "The Task of the Translator: An Introduction to the Translation of Baudelaire's *Tableaux Parisiens* [1921]," in *Illuminations*, ed. Hannah Arendt, trans. Harry Zohn (New York: Schocken Books, 1968), 71.

1 Georges Didi-Huberman translates the term in French as *survivance*, "survival"; see his *The Surviving Image: Phantoms of Time and Time of Phantoms; Aby Warburg's History of Art*, trans. Harvey L. Mendelsohn (University Park: Pennsylvania State University Press, 2017), chapter 1, tracing Warburg's development of the idea of an artwork's *Nachleben* (initially with respect to ancient art, later more broadly). Warburg did not publish any general text on the concept of *Nachleben*, but articulated it across various writings, see Aby Warburg, "The Gods of Antiquity and the Early Renaissance in Southern and Northern Europe," in *The Renewal of Pagan Antiquity: Contributions to the Cultural History of the European Renaissance*, trans. David Britt (Los Angeles: Getty Research Institute for the History of Art and the Humanities, 1999), 559–60; "Italian Art and International Astrology in the Palazzo Schifanoia, Ferrara," *Renewal of Pagan Antiquity*, 563–92; and "Die Funktion der Nachlebenden Antike bei der Ausprägung Energetischer Symbolik," in *Bilderreihen und Ausstellungen,* eds. Uwe Fleckner and Isabella Woldt, Gesammelte Schriften 2, pt. 2 (Berlin: Akademie, 2012), 115–33. Not coincidentally, the Jewish Museum's home is the New York mansion built by Aby's uncle, Felix Warburg, and given to the museum in 1947, soon after the end of World War II.

While the notion of an artwork's *Nachleben* was particularly important for Warburg, the term arose in the nineteenth and early twentieth centuries as part of a reconsideration of the idea of historical and cultural transmission by several pioneering German thinkers, including Anton Heinrich Springer, Warburg, and Walter Benjamin.

2 Paul Chan, "What Art Is and Where It Belongs," *E-flux Journal*, no. 10 (November 2009), www.e-flux.com/journal/10/61356/what-art-is-and-where-it-belongs.

3 Boris Groys, "Comrades of Time," *E-flux Journal*, no. 11 (December 2009), www.e-flux.com/journal/11/61345/comrades-of-time.

4 Accurate numbers are difficult to reach. By one estimate more than 650,000 objects and 2.5 million books were recovered; far more were lost, destroyed, or never accounted for. See, for example, "Records Concerning the Central Collecting Points ('Ardelia Hall Collection'): OMGUS Headquarters Records, 1938–1951," M1941, United States National Archives, Washington, DC, 2004, online at https://www.archives

.gov/files/research/microfilm/m1941.pdf.

5 Hector Feliciano's *The Lost Museum: The Nazi Conspiracy to Steal the World's Greatest Works of Art* (New York: Basic Books, 1997) provides an invaluable analysis of the many arms of looting. He centers his analysis on Paris during the war, where the German army, embassy, and ERR were all engaged in a competition for the city's best art.

6 Alon Confino's *A World without Jews: The Nazi Imagination from Persecution to Genocide* (New Haven: Yale University Press, 2014) offers an exhaustive look at the long buildup to the mass murder of Jews and the behaviors and thought processes that produced a reality in which such an event became possible. His text informs a deep analysis of the ways in which time and history produced the Nazis, and then were rewritten by them.

7 Joseph Goebbels, speech published online by the United States Holocaust Memorial Museum, https://encyclopedia.ushmm.org/content/en/film/books-burn-as-goebbels-speaks; and cited in Confino, *World without Jews*, 50.

8 Confino, *World without Jews*, 107–11.

9 See Alan E. Steinweis, *Studying the Jew: Scholarly Antisemitism in Nazi Germany* (Cambridge, MA: Harvard University Press, 2009).

10 Elisabeth Gallas, *A Mortuary of Books: The Rescue of Jewish Culture after the Holocaust*, trans. Alex Skinner, Goldstein-Goren Series in American Jewish History (New York: New York University Press, 2019), 19–20.

11 See Confino, *World without Jews*, 66–67.

12 Olaf Peters, "From 'Degenerate Art' to 'Looted Art': Developments and Consequences of National Socialist Cultural Policy," in "Nazi-Looted Art and Its Legacies," edited by Andreas Huyssen, Anson Rabinbach, and Avinoam Shalem, special issue, *New German Critique* 44, no. 1 (February 2017): 12.

13 The secret Kümmel Report was named for its lead author, Otto Kümmel, Director General of the Berlin State Museums. A copy comprising 319 pages is at the library of the Metropolitan Museum of Art, New York, and online at http://libmma.contentdm.oclc.org/cdm/compoundobject/collection/p16028coll4/id/828/rec/1. Its title gives a sense of how the Nazis intended to recast German history (and art history) in order to legitimate their notion of a German identity: *Stolen Cultural Goods: Historically Important Works of Art Transferred into Foreign Possession since 1500 without Our Consent and on Dubious Legal Grounds*. The report was meticulously organized by categories: works whose location was known; desired works whose location had not yet been found; and works previously owned by Germans, removed through treaties after World War I. Works were

further grouped according to how much value the Nazi experts placed on them; see United States National Archives, blog post, July 14, 2015, https://text-message.blogs.archives.gov/2015/07/14/the-kummel-report/.

14 "Until 1940 Napoleon was the unquestioned record holder of carrying off confiscated art. Previous conquerors had simply taken things away which were later retrieved or not. . . . Napoleon complicated this traditional process by making the defeated agree to his confiscations in the humiliating peace treaties they were required to sign"; Lynn H. Nicholas, *The Rape of Europa: The Fate of Europe's Treasures in the Third Reich and the Second World War* (New York: Knopf, 1994), 122. Nicholas's study remains one of the most comprehensive analyses of Nazi looting to date; see 118–23 on Hitler's fascination with Paris.

15 Nicholas, *Rape of Europa,* 87–91.

16 Nicholas, *Rape of Europa,* 127.

17 Pamphlet produced by a regional office of the Reich Ministry of Public Enlightenment and Propaganda (Reichsministerium für Volksaufklärung und Propaganda), August 7, 1937, quoted in Peters, "From 'Degenerate Art' to 'Looted Art,'" 17 n33; Christoph Zuschlag, *"Entartete Kunst": Ausstellungsstrategien im Nazi-Deutschland* (Worms, Germany: Wernersche Verlagsgesellschaft, 1995), 207.

18 Nicholas, *Rape of Europa*, 12; Zuschlag, *"Entartete Kunst,"* cited in Stephanie Barron, *"Degenerate Art": The Fate of the Avant-Garde in Nazi Germany* (New York: Harry N. Abrams, 1991), 83–103.

19 Meike Hoffmann, "Hildebrand Gurlitt and His Dealings with German Museums during the 'Third Reich,' " in Huyssen, Rabinbach, and Shalem, "Nazi-Looted Art and Its Legacies," 48.

20 Robin Reisenfeld, "Collecting and Collective Memory: German Expressionist Art and Modern Jewish Identity," in *Jewish Identity in Modern Art History*, ed. Catherine M. Soussloff (Berkeley: University of California Press, 1999), 116.

21 On the Lucerne sale and Gurlitt's role, see Hoffmann, "Hildebrand Gurlitt," 48.

22 See Peters, "From 'Degenerate Art' to 'Looted Art,' " 28.

23 Sophie Gilbert, "The Persistent Crime of Nazi-Looted Art," *Atlantic*, March 11, 2018, www.theatlantic.com/entertainment/archive/2018/03/cornelius-gurlitt-nazi-looted-art/554936.

24 Feliciano, *Lost Museum*, 127.

25 The list of purged artists includes Ernst Barlach, Max Beckmann, Otto Dix, Karl Hofer, Ernst Ludwig Kirchner, Paul Klee, Oskar Kokoschka, Käthe Kollwitz, Max Liebermann, Ludwig Mies van der Rohe, Max Pechstein, and Karl Schmidt-Rottluff; see Nicholas, *Rape of Europa*, 12–13.

26 Julia Voss, "Have German Restitution

Politics Been Advanced since the Gurlitt Case? A Journalist's Perspective," in Huyssen, Rabinbach, and Shalem, "Nazi-Looted Art and Its Legacies," 62–63.

27 Records of the American Commission for the Protection and Salvage of Artistic and Historic Monuments in War Areas [The Roberts Commission], 1943–1946, United States National Archives, https://www.archives.gov/files/research/microfilm/m1944.pdf. The story of the Monuments Men has been thoroughly documented; see, inter alia, the websites of the Monuments Men Foundation, https://www.monumentsmenfoundation.org; the Holocaust Records Research Project of the United States National Archives, https://www.archives.gov/preservation/products/definitions/project-hrp.html; and Robert M. Edsel and Bret Witter, *The Monuments Men: Allied Heroes, Nazi Thieves, and the Greatest Treasure Hunt in History* (New York: Center Street, 2009).

28 "At war's end, it contained 6,577 paintings, 137 sculptures, and 484 cases with various other art objects, making it one of the most important repositories in the Reich," Jonathan Petropoulos, *The Faustian Bargain: The Art World in Nazi Germany* (New York: Oxford University Press, 2000), 40.

29 Nicholas, *Rape of Europa*, 135–36.

30 See Walter I. Farmer, *The Safekeepers: A Memoir of the Arts at the End of World War II,* Schriften zum Kulturgüterschutz / Cultural Property Studies (Berlin: Walter de Gruyter, repr. 2015), ch. 5, "Fine Arts and Archives."

31 I am indebted to Dr. Petra Winter, Director of the Zentralarchiv of the Staatliche Museen zu Berlin–Preussischer Kulturbesitz, for information on the Wiesbaden women.

32 F. J. Hoogewoud, "The Nazi Looting of Books and Its American 'Antithesis': Selected Pictures from the Offenbach Archival Depot's Photographic History and Its Supplement," *Studia Rosenthaliana* 26, nos. 1–2 (1992): 170.

33 On this impulse within the restitution process, see the essay by Sam Sackeroff in this volume.

34 *Photographs of the Operations of the Offenbach Archival Depot, 1945–1945,* United States National Archives, 541611, Records of U.S. Occupation Headquarters, World War II, record group 260; all four albums are online at https://catalog.archives.gov/id/541611. The first two are titled, simply, *Photographic History;* the third is titled *The Einsatzstab Reichsleiter Rosenberg of Which the Offenbach Archival Depot Has Become the Antithesis;* and the last is titled *Unidentifiable Loot from Jewish Synagogues Collected at the Offenbach Archival Depot.*

35 "Introduction: Inside and Outside the Archive," in *Artists in the Archive: Creative and Curatorial Engagements with Documents of Art and Performance,* eds. Paul Clarke, Simon Jones, Nick Kaye, and Johanna Linsley (New York: Routledge, 2018), 11.

36 Maaike Bleeker, "Resistance to Representation and the Fabrication of Truth: Performance as Thought-Apparatus," in *Artists in the Archive,* 248.

37 Jonathan Petropoulos calls Allied thefts and souvenirs the "uncomfortable topics" within the restitution story; see "Five Uncomfortable and Difficult Topics Relating to the Restitution of Nazi-Looted Art," in Huyssen, Rabinbach, and Shalem, "Nazi-Looted Art and Its Legacies."

38 James McAuley, "The Louvre Is Showing Nazi-Looted Art in a Bid to Find Its Owners, Some Wonder Why It Took So Long," *Washington Post,* February 2, 2018, www.washingtonpost.com/world/europe/the-louvre-is-showing-nazi-looted-art-in-a-bid-to-find-its-owners-some-wonder-why-it-took-so-long/2018/02/02/2964bbb8-06a4-11e8-aa61-f3391373867e_story.html.

39 Feliciano, *Lost Museum,* 50.

40 In 1939 the Jewish community of Danzig consigned its treasures to the Joint Distribution Committee (JDC) with the written agreement that the objects would be held for safekeeping for a period of fifteen years, after which, if the community had not been reconstituted, the collection would become a gift to the JDC to rehome. The Jewish Museum, in accepting the works, also agreed to these terms. In 1954 the JDC and the Jewish Museum determined that no claims had been made and that the original Jewish Community of Danzig no longer existed, and the works in the museum's possession were accessioned. Not all the Danzig material came to New York. The synagogue's archives were sent to Jerusalem and its library to Vilnius. Some furniture was sold.

In 1980 the Jewish Museum organized a traveling exhibition of objects from the Danzig collection, together with other material loaned or donated by Danzigers who had been members of the vanished community. See Joy Ungerleider-Mayerson, *Danzig 1939: Treasures of a Destroyed Community,* exh. cat. (Detroit: Wayne State University Press for the Jewish Museum, New York, 1980).

41 See Patricia Kennedy Grimsted, F. J. Hoogewoud, and Eric Ketelaar, eds., *Returned from Russia: Nazi Archival Plunder in Western Europe and Recent Restitution Issues* (Builth Wells, UK: Institute of Art and Law, 2007, rev. ed. 2013); Konstantin Akinsha and Grigorii Kozlov, *Beautiful Loot: The Soviet Plunder of Europe's Art Treasures* (New York: Random House, 1995).

42 See David Ovalle, "Miami Lawyer Leads Legal Charge against Spain to Return Pissarro Painting Looted by Nazis," *Miami Herald,* November 30, 2018, www.miamiherald.com/news/nation-world/national/article222261510.html; Claire Selvin, "Six-Year Challenge to Ownership of Art Historian Paul Westheim's Modernist Art Collection Dismissed in New York Supreme Court," *Art News,* June 28, 2019, www.artnews.com/art-news/news/paul-westheim-collection-lawsuit-resolved-new-york-supreme-court-12779; IFAR (International Foundation for Art Research) case summary, *Frenk v. Solomon,* https://www.ifar.org/case_summary.php?docid=1412201141. Conversely, in 2018 the collector Bruce Toll was forced by a French court to relinquish another Pissarro painting to the heirs of Simon Bauer, a French Jew whose collection had been seized in 1943 by the pro-Nazi Vichy government in France; see Vincent Noce, "Paris Court Orders US Collector to Turn Over Pissarro Painting," *Art Newspaper,* October 3, 2018, https://www.theartnewspaper.com/news/paris-court-orders-us-collector-to-turn-over-pissarro-painting. See, more generally, Michael R. Marrus, *Some Measure of Justice: The Holocaust Era Restitution Campaign of the 1990s* (Madison: University of Wisconsin Press, 2009).

43 "Washington Conference Principles on Nazi-Confiscated Art," United States Department of State, December 3, 1998, https://www.state.gov/washington-conference-principles-on-nazi-confiscated-art/; Association of Art Museum Directors, "Art Museums and the Identification and Restitution of Works Stolen by the Nazis," June 1, 2007, https://aamd.org/sites/default/files/document/Nazi-looted%20art_clean_06_2007.pdf; American Alliance of Museums, "Standards Regarding the Unlawful Appropriation of Objects During the Nazi Era," November 1999, amended April 2001, http://ww2.aam-us.org/resources/ethics-standards-and-best-practices/collections-stewardship/objects-during-the-nazi-era. In addition, the International Council of Museums (ICOM) has published guidelines produced by several nations as well as other resources, http://archives.icom.museum/spoliation.html#guidelines.

44 For example, the records of Schenker & Co., a Nazi-era shipping and storage firm.

45 Nicholas O'Donnell, a prominent lawyer who specializes in restitution cases, quoted in Barbie Latza Nadeau, "Museums Use 'Nazi Tactics' to Keep Art Stolen by the Nazis," *Daily Beast,* November 28, 2018, www.thedailybeast.com/museums-use-nazi-tactics-to-keep-art-stolen-by-the-nazis.

46 See *Paintings Looted from Holland: Returned through the Efforts of the United States Armed Forces; A Collection to Be Exhibited in . . . Ann Arbor, Michigan, Baltimore, Maryland, Buffalo, New York [Etc.],* exh. cat. (Washington, DC: National Gallery of Art, 1946); Farmer, *Safekeepers.*

47 The questions belong to Stephen Greenblatt, and signal what he calls "a turn away from the formal, decontextualized analysis . . . [in favor of] the embeddedness of cultural objects in the contingencies of history"; see "Stated Meeting Report: Resonance and Wonder," *Bulletin of the American Academy of Arts and Sciences* 43, no. 4 (January 1990): 14, 23.

RECONSTRUCTING CULTURE

Sam Sackeroff

On April 13, 1951, Hannah Arendt sent a memo to the Board of Directors and Advisory Committee of Jewish Cultural Reconstruction, Inc. "Out of the bookcases in the New York depot came unexpectedly two cartons with file cards, which apparently have some bearing on the genealogy of German Jews," she wrote. "They probably are part of a genealogy file of the NSDAP [the Nazi Party]. The Hebrew Union College in Cincinnati would be very glad to receive these cards. Archivists and faculty specialists, as you know, are available there for advice and scholarly research. Will you kindly cast your vote on the enclosed card?"[1]

The memo belongs to a dramatic moment in Jewish history. Not only did Arendt write it the same year she published *The Origins of Totalitarianism*, securing her reputation as one of the most important philosophers of the twentieth century, she did so while participating in a massive postwar recovery effort that remains unparalleled to this day. She wrote from a large brick-lined warehouse in Brooklyn, filled with cultural material that the Nazis had stolen from Jewish communities across Europe, which she and her colleagues had salvaged after the war and were preparing to ship to surviving communities around the world. In a few short lines, Arendt raised a series of questions that shaped the recovery effort and the Jewish postwar experience more broadly. Surrounded by hundreds of wooden crates containing the remnants of European Jewish culture, she asked not only what should be done with the material piled high all around her but also what she

could do to respond to the violence that had brought it there.

Responsible for the material remains of the Jewish past, compelled to work in an archive that had been assembled in a moment of rupture, Arendt was forced to consider whether she, now working not as a political philosopher but rather as a historian, could do anything to counter the Nazi assault.

She did not waver in her answer. In a single typewritten page she established the archive as a place for action, where history was not only stored but made. She described first how the genealogical cards had seemed to leap from the shelves, bringing with them an entire chapter of the German Jewish past, then the role that the cards had likely played in one of many Nazi research institutions, where they would have been used to investigate the so-called Jewish Question, and finally the very different role they would soon play in the libraries of Hebrew Union College, where they would be used by future generations of scholars. Like all documents, the file cards belonged to a specific moment. Their ink dried and set, they were concrete evidence of the instant when they had been produced. However, when they joined the folders, boxes, and crates that lined the depot walls, they entered another time that was more dynamic, contested, and complex—a layered time in which the historian could intervene.

Arendt spent more than a decade working in that layered time. As Executive Secretary of Jewish Cultural Reconstruction (hereafter the JCR),

Hannah Arendt in New York in 1944, the year she became research director for the Conference on Jewish Relations. Among other tasks, she compiled information for the Commission on European Jewish Cultural Reconstruction that was used after the war to recover Jewish books and artifacts.

she helped redistribute cultural material that had been orphaned by the war, searching for books and artifacts that had belonged to destroyed Jewish communities across Europe and shipping them to other Jewish communities in the United States, Israel, and around the world, where they were put to new use. In doing so she opened a space where the process of recovery in the broadest sense could be pursued. As the material passed from community to community, it connected a Jewish past that had been wrenched open, exposed and vulnerable in the millions of objects that had been stripped from their owners and piled in Nazi storehouses, to a Jewish future that provided a chance to repair and renew.

By tracing the history of the JCR, we can get a sense of what motivated Arendt and her colleagues. Examining how the organization developed, the terms its members used to describe their aims, and the political and intellectual context in which they worked, we can see how an international network of scholars-turned-activists stepped into time, taking the frayed edge of tradition and, in a moment of intense pain, weaving it into a remarkable period of radical innovation.

The foundations of the JCR were laid as the first news of the Nazi persecution of Jews reached America in 1933. As Hitler signed into law prohibitions limiting Jewish participation in German society, the Jewish intellectual community in New York began to organize. A leading figure was the historian Salo Baron. Born in 1895 in Tarnow, then part of the Austro-Hungarian Empire, Baron had moved to Vienna in 1914. Having earned three doctorates in philosophy, political science, and law at the University of Vienna, he emigrated to New York in 1926, lecturing at the progressive Jewish Institute of Religion before becoming professor of Jewish history and literature at Columbia University in 1929. As the first round of anti-Semitic measures were being passed, Baron held a

meeting of Jewish community leaders at the Free Synagogue House at 40 West 86th Street in Manhattan. "The recent occurrences in Germany show how national hysteria can violate the most fundamental human rights of the Jews," he declared. That hysteria could only be countered, he argued, by a concerted global effort to confront the mounting threat. A summary of the meeting appeared in *The New York Times* the next day under the headline "Jewish Action Is Urged."[2]

Baron took action immediately. That same year, he and Morris Raphael Cohen, a professor of philosophy at the City College of New York, laid the groundwork for an organization that would use the combined resources of Jewish intellectuals around the world to confront the Nazi threat. The Conference on Jewish Relations was established in 1936 during a meeting at the New School for Social Research in Greenwich Village, presided over by Albert Einstein. It aimed to counter Nazi propaganda while also building solidarity between Jews and non-Jews. To that end, Baron and Cohen founded a journal, *Jewish Social Studies*, in 1939.

Cohen described the journal's mandate in the first issue. "The problems that face the Jews today are fateful not only for their own continued existence as a group but also for the future of progressive civilization," he wrote. "For wherever the ideal of a totalitarian or ultra-nationalist state appears, antisemitism is one of its cardinal points." The journal sought to counter the "tumult of prejudice and pseudo-scientific assertions" that the Nazis were producing by publishing "accurate and verifiable information" on "anthropological, economic, political and cultural" matters. "The destruction of important centers of Jewish learning in Eastern and Central Europe makes it imperative," he concluded, "that the United States, with the largest and richest Jewish community in the world today, should do its share to see to it that Jewish studies and research do not perish."[3]

As the crisis in Europe got worse, the way Baron and Cohen approached that crisis changed. Increasingly, they understood the events unfolding around them in temporal terms. They recognized that the Nazi attack on Jews was occurring not only in the present but also, through the assault on the centers of Jewish learning that Cohen mentioned, in the past and future as well. As the scope of that attack became apparent, the journal served as a place where accurate information about the Jewish community could be both published and preserved. The painstaking studies of population size, economic standing, and professional status that appeared in the journal in 1939 became the first pieces of an archive that was being built in the present and that looked both backward and forward— backward to a past that was suddenly in peril and forward to a future that was at best uncertain.

Baron and Cohen made their deepening preoccupation with time explicit. In the inaugural issue both included essays that explored what approaches to history were most appropriate for their moment. In "Emphases in Jewish History," Baron described history as "pliable," something that was not only shaped by current events, but that could also shape current events in turn. "The main purpose of history is not to restate isolated facts," he argued, "but to serve as a *magistra vitae*, as a teacher and guide in meeting contemporary situations. It is this elasticity of history which makes it so easily applicable to new situations and establishes its position not only in the realm of theoretical studies . . . , but as an applied social science which is of practical significance to statesmen, men of affairs, and the intelligent public at large."[4]

The pliability Baron described was a product of the interpretive dimension that distinguished "history" from mere "chronology." While Baron did not specify what interpretive perspective historians should adopt, he insisted that it was not enough for them to merely record; they also

had to respond. They had to abandon "outworn historical conceptions" and assume a stance that would allow them to satisfy the "new intellectual requirements" and "modern social needs" that the contemporary situation presented.[5]

Cohen made a similar case in "Philosophies of Jewish History." Presented as a survey of trends in Jewish historiography, at a deeper level his essay was a criticism of the still too-common presumption that "human events take place according to some all-embracing design or law."[6] This view was dangerous because it encouraged historians to play a passive rather than active role. Dismissing the "prophetic" approach to history that Jewish historians had, in his view, traditionally taken, Cohen called for a more engaged stance. "The future is at least as uncertain as the remote past," he insisted. Faced with that uncertainty, historians had to not only "study history," convinced that it followed a preset course. They also had to "reflect critically" on the deeper questions that were raised when it became clear that no such course existed, including the question of "good" and "evil."[7]

By founding both the Conference on Jewish Relations and *Jewish Social Studies*, Baron and Cohen established the basis on which the postwar recovery effort would be built. In addition to an organizational infrastructure that would reach across space, eventually connecting intellectuals in New York, Jerusalem, and Berlin, they were also developing an archival infrastructure that would reach across time, connecting the millennia of Jewish experience distilled in salvaged books and artifacts to a Jewish vanguard that would carry those millennia of experience forward.

The urgency of their task became more apparent as laws prohibiting Jewish participation in daily life were followed by violent episodes of harassment and theft. The first large-scale instance of looting, the November 1938 pogrom known as Kristallnacht, was reported in the *Contemporary Jewish*

Record, founded earlier that year by the American Jewish Committee to address the growing danger. The report appeared as a special supplement, hastily prepared as the issue went to press, under the headline "Latest Nazi Wave of Terror."

> On Thursday [November 10], an unprecedented wave of anti-Jewish violence, arson, looting, and destruction broke out all over Greater Germany. Beginning in the early hours of the morning, in Berlin, at 2 A.M., and continuing through the entire day, wrecking crews of Storm Troopers and Nazi Party members in uniform, in many cases under police protection, carried on a systematic and thorough campaign of pillage and destruction of Jewish-owned stores and synagogues in virtually every town and city in the country. . . . The destruction of stores and shops was accompanied by the burning of synagogues throughout the country, while fire-fighting units took precautions only to prevent the fires from spreading to neighboring buildings. In Vienna, all the 21 synagogues were attacked and 18 were wholly or partly destroyed. A total of 75 Scrolls of the Law were dragged from the Vienna synagogues and desecrated in the streets. The famed library of the Vienna Jewish Community, containing a great number of irreplaceable manuscripts and rare books, was burned. At the end of the day there was hardly a Jewish-owned shop, cafe, office or synagogue that was not either wrecked, burned, or severely damaged.[8]

Although it was the first major instance of looting, Kristallnacht was by no means the last. In addition to the thousands of opportunistic thefts and extortions that occurred on a daily basis throughout the Reich, the looting of cultural material from Jews soon became practiced on an industrial scale. The special task force Einsatzstab Reichsleiter Rosenberg (ERR), led by the Nazi ideologue Alfred Rosenberg, and the Ahnenerbe, or Ancestral Heritage, unit, led by Reichsmarschall Hermann Goering,

focused on books, pillaging millions of volumes from private homes, community libraries, and synagogues, in some cases tearing open walls to find caches of precious volumes hidden inside (see page 152). Many of these books were pulped; countless others were shipped to Nazi research institutions whose purpose was to recast Jewish history and culture in Nazi terms. Lining the shelves of the Office for Ideological Research and Evaluation of Worldviews, the Reich Institute for the History of New Germany, and the Institute for the Study of the Jewish Question, the stolen books were used to train senior Nazi officers in *Gegnerforschung*, or "enemy science."

With each book, manuscript, and ceremonial object wrenched from its proper place, a tear appeared in the temporal fabric of Jewish life. By destroying or appropriating Jewish cultural material, the Nazis aimed to erase or corrupt the Jewish tradition, wiping it out completely or preserving it as a distorted component of their ideological program, producing what one commentator described as a "Nazified" version of Jewish history.[9]

As reports of the catastrophe reached New York, Baron began developing a subsidiary of the Conference on Jewish Relations dedicated to the recovery and redistribution of Nazi-looted material. In 1944 he established the Commission on European Jewish Cultural Reconstruction. The new organization confronted the Nazi threat by intervening in history directly. The theoretical issues that Baron had raised in the years leading up to the war were suddenly concrete. In addition to reforming the methodological frameworks with which Jewish history was conceived, he and his colleagues began rescuing the physical objects in which that history inhered.

Hannah Arendt was among the first people Baron hired. Born in Hannover in 1906, she had studied philosophy at Marburg University with Martin Heidegger, at Freiburg University with Edmund Husserl, and at Heidelberg

with Karl Jaspers. She left Germany during the first anti-Semitic wave following Hitler's appointment as chancellor, moving to Paris in 1933. There she worked for the refugee organization Youth Aliyah, helping thousands of Jewish children flee Germany for Palestine, until she was arrested and sent to the Gurs concentration camp in southwest France in 1940. She escaped the camp in 1941 and fled to New York, where she soon became a fixture in the city's literary circles, and was a regular contributor to *The Menorah Journal* and *Partisan Review*.

Arendt served as the new organization's research director, working with a small team at the Manhattan office of the Conference on Jewish Relations at 1841 Broadway. Her first task was to compile a comprehensive survey of the kinds of Jewish cultural material that were vulnerable to Nazi seizure in Europe. She circulated more than 250 questionnaires to Jewish refugees who had fled Europe and whose memories were the most reliable indexes of the material now stranded there. Respondents were asked to describe the cultural institutions they were familiar with, including "libraries, museums, archives, literary societies, book clubs, etc.," providing the name and address of each, as well as "details as to present fate."[10]

The information she assembled became a series of lists published in *Jewish Social Studies* beginning in 1946. With titles like "Tentative List of Jewish Cultural Treasures in Axis-Occupied Countries," they added to the activist archive that Baron was building.[11] They too looked both backward and forward—backward to a time before the Jewish community had been subjected to Nazi violence, and forward to a time when the reconstruction of that community could begin.

Initially, Baron, Arendt, and their associates used the term "reconstruction" to mean the physical reconstruction of Jewish communities in Europe. Like many of their colleagues, they did not immediately comprehend the scale of the destruction the Nazis would eventually inflict. At first they worked under the assumption that at least some portion of the European Jewish population would survive and return to their homes. In 1943, the year before Baron established the Commission on European Jewish Cultural Reconstruction, the American Jewish Committee released a study—*Relief, Reconstruction and Migration*—produced under that same assumption. It offered proposals to reconstruct the Jewish communities in Europe through a combination of economic aid and mass migration.

> The task of reconstructing the lives of the war victims, both Jews and non-Jews alike, is generally divided into two periods. The first is the period of immediate relief, when the starved populations of Europe, especially in the war zones, will require food, clothing, shelter and health accommodations. The second period will encompass the basic problems of reconstruction. It will be devoted to planned restoration of normal economic conditions with a consequent raising of production and the standards of living. . . .
>
> While few will question special Jewish needs for relief . . . there is no complete agreement among Jews on either the advisability or the method of the permanent reconstruction of the life of the Jews in Europe and other war areas. Opinion is divided among two lines. There are those who believe that reconstruction can and should be achieved primarily or exclusively through the emigration of Jews. There are others who hold that the task of reconstruction should be conducted primarily so as to restore Jews to a useful and productive economic life in the places where they lived before the outbreak of the war or where they are residing today.

"Some pessimists," the authors noted, "even venture to predict the complete doom of all the Jews under Nazi rule." They were convinced, however, that

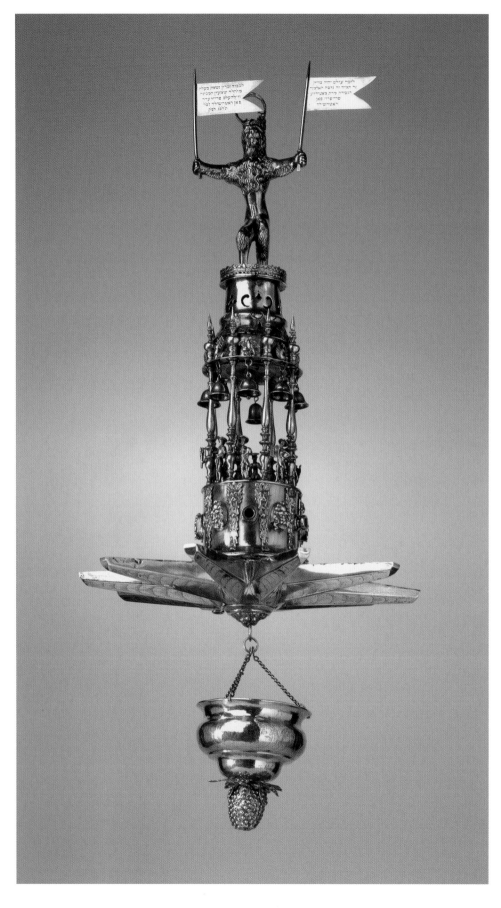

Johann Valentin Schüler, Sabbath and festival lamp, Frankfurt am Main, 1680–1720
Cast, repoussé, and engraved silver, 22¼ in. (56.5 cm) high
Jewish Museum, New York, Jewish Cultural Reconstruction

This ornate Baroque star-shaped lamp entered the Jewish Museum collection through the JCR in 1952. It was originally a Sabbath lamp for a Jewish home, but was later modified to be used in a synagogue as a *ner tamid,* or eternal light. The history of its previous ownership and looting is lost, but it bears an inscription recording that in 1902 or 1903 it was dedicated by Hanne Mathilde Freifrau von Rothschild to the memory of her husband, "Shimon, known as Willie Freiherr von Rothschild." Baron Wilhelm Carl von Rothschild, who died in 1901, had been the head of the Frankfurt branch of the Rothschild family, and it is therefore possible that the lamp was looted from a Frankfurt synagogue.

"at least several millions in addition to those who have managed to flee the Nazis' territories will somehow survive the war."[12]

By the end of the war, when the scale of the devastation was becoming clear, the meaning of "reconstruction" began to change. Baron described the shifting meaning of the term in "The Spiritual Reconstruction of European Jewry," the first essay published in the first issue of *Commentary* in November 1945. "Although the blackout is slowly lifting from the areas where once flourished the largest centers of Jewish life in Europe, only fragmentary reports concerning the survivors have filtered through to the outside world," he wrote. The limited information that had made it through convinced him that the physical reconstruction that he and his peers had described a few years earlier was no longer possible. Instead, what was needed was "spiritual reconstruction." Distinguishing his program from those that preceded it, he explained, "The very phrase 'spiritual reconstruction' can be subtly misleading in that it evokes rebuilding in terms of bricks and mortar." That rebuilding was no longer possible both because so few Jews in Europe had survived, and because those who had survived, like the Jewish community as a whole, now required something much more profound than economic and migration policies.[13]

The "reconstruction" Baron described involved rebuilding the foundations of Jewish culture as such. The first step in that process was to recover what the Nazis had stolen, including the "enormous collections of Judaica" that they had stockpiled in warehouses and mines throughout Germany as well as the millions of volumes that had "always been the very life-blood of the 'people of the book.'" Aware that only a small fraction of that material could be returned to its original owners, he called for a program that would also allow for redistribution. He and his colleagues first had to locate the Nazi loot and then either restore it to its rightful owners or, if they could not be found, "make the wisest disposition possible for the benefit of the general cultural reconstruction of European Jewry."[14]

Like Baron's other interventions, that cultural reconstruction took place in both space and time. The damage that had been done by Nazi looting would be repaired only when the past that inhered in the looted objects was reconnected to the future in such a way that those objects would once again become a source of innovation.

Baron insisted as much. The process of reconstruction "must endeavor to stimulate the 'creative élan' of the masses and of their as yet unknown intellectual vanguard," he explained. Those engaged in the recovery effort should provide the cultural tools necessary for that vanguard, while avoiding "laying down for them any definitive course of thought or action; least of all by forcing them to conform to old, accustomed and partly petrified modes of Jewish historic experience."[15]

"The term 'cultural reconstruction' is not to be interpreted in any too narrow a sense," he continued the following year. Although he encouraged his partners to recover the looted holdings of European libraries, museums, and archives, he warned that "in view of the wholesale destruction of Jewish life and property by the Nazis," reconstruction could not be achieved through the "mechanical restoration" of those institutions "in their original form." It could only be achieved by redistributing what remained of the cultural treasures those institutions had held, sending them to communities around the world "in accordance with the new needs created by the new situation of world Jewry."[16]

The process of cultural reconstruction began at a series of collecting points that the Allies had established in the American Zone of Occupied Germany in the weeks and months after the war to sort through the huge volume of material the Nazis had stolen. The largest collecting points were in

Munich, Offenbach, and Wiesbaden. While they initially handled a variety of material, each soon specialized. The Munich Central Collecting Point handled material that was subject to restitution to countries outside Germany and processed more than a million objects. The Wiesbaden Central Collecting Point managed material the Nazis had stolen from German public collections (primarily museums) and processed over seven hundred thousand objects. The Offenbach Archival Depot focused on Jewish material and processed over 2.5 million objects, most of them books.

During its four years of operation, from July 1945 to June 1949, the Offenbach depot was one of the most important Jewish intellectual centers in the world. In addition to housing the largest concentration of Jewish literature ever assembled, including the recovered collections of the renowned Bibliotheca Rosenthaliana in the Netherlands and the YIVO Institute for Jewish Research in Lithuania, it also employed some of the most revered Jewish thinkers of the period as consultants. Working in what was, in effect, the most comprehensive Jewish archive ever built, they mounted a sustained counteroffensive against the Nazis not in the war-torn landscape of Europe, where the damage was permanent, but in the war-torn landscape of history, where some damage could perhaps be undone.

Among those employed at the depot was the renowned historian and philosopher Gershom Scholem. Author of *Major Trends in Jewish Mysticism* (1941) and a friend of Hannah Arendt, Scholem was born in Berlin in 1897. Repulsed by German nationalism and sympathetic to the growing Zionist movement, he studied Judaica, submitting as his doctoral thesis an annotated translation of the *Sefer ha-Bahir* or *Book of Illumination*, an early Kabbalistic text. He emigrated to Palestine in 1923, where he became a librarian and professor at Hebrew University in Jerusalem.

Although he spent most of his time at the Offenbach Archival Depot identifying Hebrew manuscripts, on one occasion Scholem asserted himself more directly. In December 1946 he secretly filled five crates with what he considered to be the most precious material in the depot, including eighteenth-century rabbinical texts and death registers from several Jewish communities, and had them shipped to Palestine. The clandestine shipment demonstrates the degree to which Scholem, like many of his peers, took personal responsibility for the material that he was cataloguing. Surrounded by the literary remains of European Jewish culture, he felt that the fate of the books and the history they contained now rested on his shoulders. The centuries of heritage collected between their covers became concentrated in the decisive instant

Gershom Scholem works to identify rare Hebrew manuscripts at the Offenbach Archival Depot, 1946.

An album of book-
plates collected
by Jewish Cultural
Reconstruction,
used by staff
at the Offenbach
Archival Depot
between 1946 and
1949 to identify
the countries of
origin of looted
and recovered
books. In addi-
tion to being
inventories of the
variety of mark-
ings associated
with Jewish col-
lections across
Europe, this album
and others like
it were impor-
tant tools in the
recovery effort.
Many pages include
handwritten notes
indicating how
many books had
been returned to
a given location.

when administrators at Offenbach determined where those books would be sent. Scholem's decision to intervene was motivated by a conviction that Jewish cultural material recovered after the war should not be sent to countries that had been complicit in the extermination of Jews. Because international law held that when claimants were no longer living their property should be returned to their nation of origin, unless immediate action was taken many of the books at the depot would have become the property of the countries that had murdered their owners.

The same concern motivated the founding of Jewish Cultural Reconstruction on April 30, 1947. The JCR replaced the Commission on European Jewish Cultural Reconstruction and demonstrated the degree to which the emphasis had shifted away from returning material to Jewish communities in Europe to redistributing that material to Jewish communities around the world. The JCR became the cultural arm of the Jewish Restitution Successor Organization (JRSO), authorized by the American and German governments to take possession of heirless Jewish property on May 12, 1947. With its incorporation, the JCR became the

first body to make a legally recognized, nonterritorial claim to act on behalf of the Jewish people.

The first and largest collections the organization took custody of were the hundreds of thousands of heirless books stored at the Offenbach Archival Depot (see page 145). By this time the staff at the depot had been working for more than a year to catalogue books and identify their owners, intending to restock ransacked Jewish libraries across Europe. To that end, they sorted books by nation of origin, using bookplates, library stamps, places of publication, and other identifying markings. While this allowed them to return many books to their owners, many more remained unclaimed, either because no owner could be identified or because they belonged to institutions that had been destroyed. Some were sent to displaced-persons camps, where they were eagerly received by what remained of the European Jewish community. Most, however, were shipped to academic institutions around the world.

The books themselves are powerful deposits of the layered time that defined the recovery effort more broadly. For example, a single copy of *Kriegspredigten* (War Sermons) by Rabbi David Herzog, contains buried

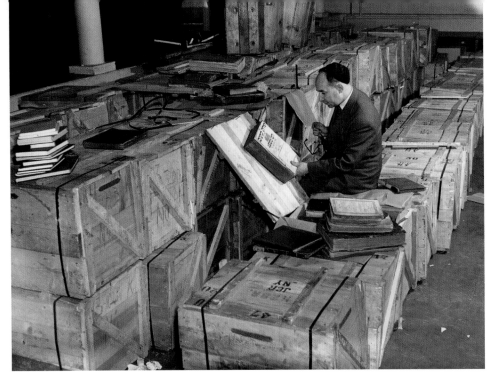

within it many sedimented traces of the long ordeal that persecuted Jews endured during the twentieth century. The book was written during the First World War as a call to arms, encouraging Austrian Jews to support war against Russia, both as revenge for the many pogroms that had been committed there and as a demonstration of their patriotic loyalty to the Habsburg monarchy. The book then belonged to a personal library that was pillaged by the Nazis. (Herzog's own library was looted during Kristallnacht.)[17] After the war the book was recovered and sent to the Offenbach Archival Depot, where it was given a red circular stamp, still visible on its front cover. It then passed to the JCR and was finally sent to the New York Public Library. There, it was given a blue and white Jewish Cultural Reconstruction bookplate that was meant, as Hannah Arendt explained in September 1949, to remind "present and future readers" of the "extraordinary history" of the books and "of those who once cherished them before they became victims of the great Jewish catastrophe."[18]

In some cases that sedimentation defined whole caches of books. In 1950 the JCR arranged for the shipment of the so-called Streicher Collection to Yeshiva University in New York. It comprised more than eight thousand volumes, including many rare books from the seventeenth and eighteenth centuries, that had been looted from private and public libraries throughout Europe and used by Julius Streicher, publisher of the Nazi tabloid *Der Stürmer*, for anti-Semitic research. The acquisition of the collection meant more than the addition of valuable books to the library. It meant a victory over Nazi aggression—a victory that was achieved in the contested space of the archive. "Streicher and his staff collected the tomes in order to take out of context passages in the books that they could pervert to promote Hitler's anti-Semitic campaign," the university's librarian explained when the collection was acquired. "Streicher would probably turn over in his grave if he knew his collection was resting in a Jewish library."[19] That victory remains visible in the books to this day. Many include, pasted on their opening pages, German-language translations of their Hebrew titles typed directly onto scraps of *Der Stürmer*. In one example, a volume of Talmudic commentary by the Lithuanian rabbi Aryeh Leib ben Asher Gunzberg, the book's

Far left: The title page of Rabbi David Herzog's *Kriegspredigten* (War Sermons), 1915, bears an Offenbach Archival Depot stamp.

Left: A Jewish Cultural Reconstruction bookplate is inside the front cover. The volume is now in the New York Public Library, Dorot Jewish Division.

Far left: The title page of Aryeh Leib ben Asher Gunzberg's *The Roar of the Lion: Questions and Answers,* an 1855 edition of a Talmudic commentary first published in 1755.

Left: On the back of the title page is the German label, typed on the reverse of a page of the Nazi newspaper *Der Stürmer,* whose masthead is dimly legible; below it, as if in response, a Jewish Cultural Reconstruction bookplate has been added. The JCR researchers and later librarians took care not to remove this residue of the Nazis' effort at intellectual erasure. The book is now at the library of Yeshiva University, New York.

Orphaned Jewish ceremonial objects in temporary storage at the Jewish Museum in New York, 1949. The large paper tags seen on many objects bear numbers assigned by JCR workers at the Offenbach depot. The question of how to rehome these works, and to whom, occupied the JCR organization for several years. Steeped in the history of the institutions that had been looted—and in the centuries-old debates about the identity and nature of the Jewish community—Salo Baron, Hannah Arendt, and their colleagues were also aware that those institutions could never be rebuilt in their original form.

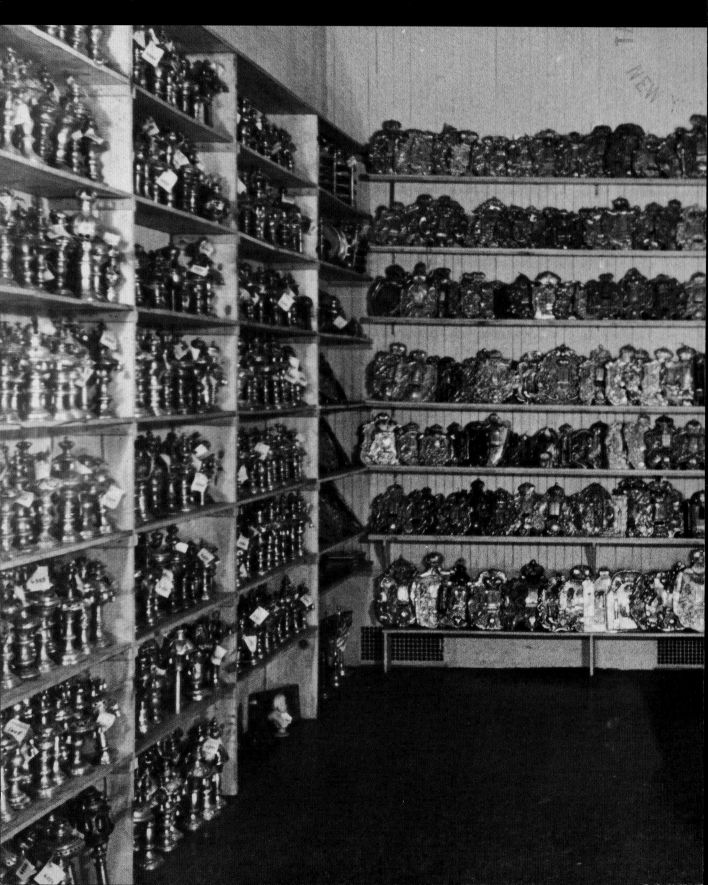

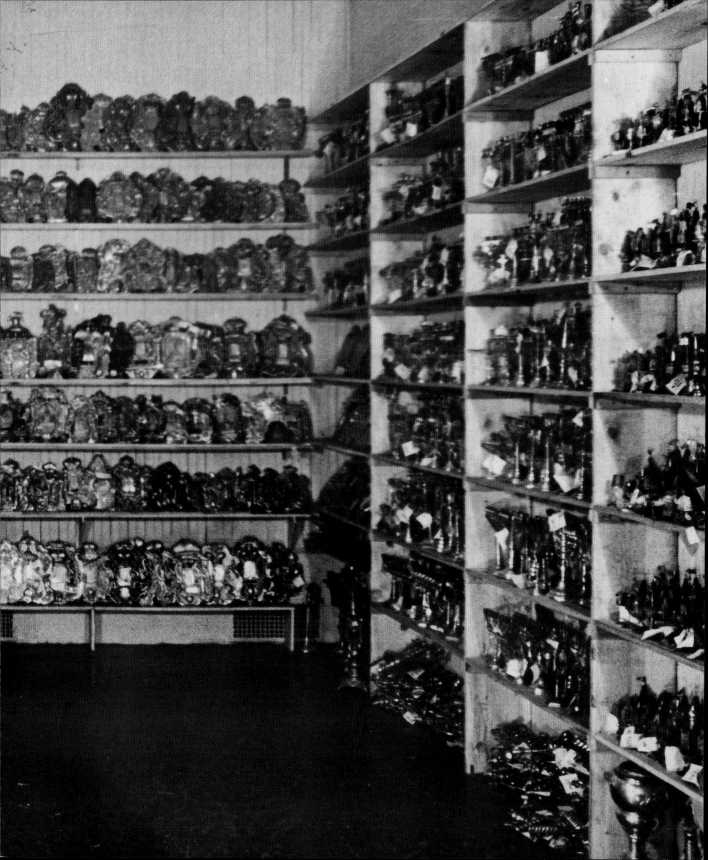

August 22, 1949

Dr. Stephen S. Kayser
Jewish Museum
1109 Fifth Avenue
New York, N. Y.

Dear Dr. Kayser:

Now that the Jewish Museum has received the 83 cases
of ceremonial objects, you may be interested in
seeing two reports by Mr. M. Narkiss, Director of
the Bezalel Museum, who accomplished the very dif-
ficult task of sorting and selecting this material
in Wiesbaden.

With kindest regards,

Very sincerely yours,

Hannah Arendt
Executive Secretary

HA:s

Letter from Hannah
Arendt to the
Jewish Museum
curator Stephen S.
Kayser, describ-
ing the arrival
of a shipment of
Judaica in 1949.

publication information is typed on
the back side of a piece torn from the
tabloid's front page, the large black
lettering of its masthead still dimly vis-
ible underneath. Pasted directly below,
as if in response, is a Jewish Cultural
Reconstruction bookplate.

When the Offenbach Archival Depot
closed in 1949, the JCR shipped the
remaining material to two smaller
depots in New York. One, dedicated to
books, was at a warehouse in Brooklyn,
where Arendt discovered the NSDAP
file cards. The other, dedicated to
ceremonial objects, was at the Jewish
Museum in Manhattan.

As a JCR depot, the Jewish Museum
became another site where Arendt and
her colleagues could play an active
role in history, participating in the
delicate task of remaking a culture
that had been damaged and restoring
a tradition that had been attacked.
In August 1949 eighty-three crates
containing more than 3,500 cere-
monial objects from the Wiesbaden
Central Collecting Point arrived at

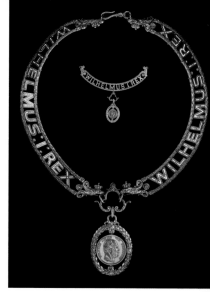

the museum.[20] Photographs taken shortly after the shipment arrived show hundreds of Torah shields and Hanukkah lamps, each providing enduring testimony, painstakingly salvaged, of the community to which it had once belonged. In addition to being an inventory of the items received, the photographs also capture another instance when the archive, here in the form of a museum storage room, became a space where history could be molded and shaped. Stilled momentarily under a Jewish Museum stamp, the objects appear suspended between the past they had participated in during their prewar existence, and the future they would enter following their postwar redistribution.

Like the books, the ceremonial objects redistributed by the JCR were given markings to ensure that the connection between past and future would endure: a small aluminum disc etched with a Star of David and the letters JCR.[21]

As its Hebrew name, T'kumah le-Tarbut Yisrael, implies, the organization intended to "revive," "renew," and "raise up" the culture of Israel. That raising-up was accomplished, in part, by sending the ceremonial objects to communities where they would be put to new use. Although over two hundred objects were accessioned by the museum, more than three thousand were sent to institutions throughout the United States and the world.

In addition to New York-based institutions, including the Library of Judaica and Hebraica at New York University, the Brooklyn Museum, Yeshiva University, the National Jewish Welfare Board, and the B'nai Brith Hillel Foundation, material that had been temporarily stored at the Jewish Museum was also shipped to the Committee on Restoration of Continental Jewish Museums, Libraries, and Archives in London; the Canadian Jewish Congress in Montreal; the South African Jewish Board of Deputies in Johannesburg; and the Delegación de Asociaciones Israelitas Argentinas in Buenos Aires. Special consideration was given to institutions where the material would be put to active use. Large institutions representing vibrant Jewish communities were favored, along with smaller institutions representing communities that were less established but growing.

Taking objects from the storage rooms at the Jewish Museum and shipping them to communities around the world, Arendt and her JCR colleagues took another step in the process of recovery. By removing the objects from the historical register that the Nazis had put them in and introducing them back into the current of Jewish life, the JCR repaired, item by item, moment by moment, some of the harm that had been done.

Above left: Judaica recovered by the JCR in storage at the Jewish Museum, c. 1949. Some pieces entered the permanent collection, including a nineteenth-century chain with medallions on the bottom shelf at left, and the Sabbath lamp reproduced on page 84, on the top shelf at center.

Above: Sy and Wagner, silversmiths, medallions and chain of Wilhelm I of Prussia, presented to Baroness Hanne Mathilde von Rothschild, Berlin, 1896 Gilt, pierced, cast, chased, engraved, and enameled silver and gold, necklace 11½ × 9¼ in. (29.2 × 23.5 cm), medal 3⅛ × 2½ in. (7.9 × 6.4 cm) Jewish Museum, New York, Jewish Cultural Reconstruction

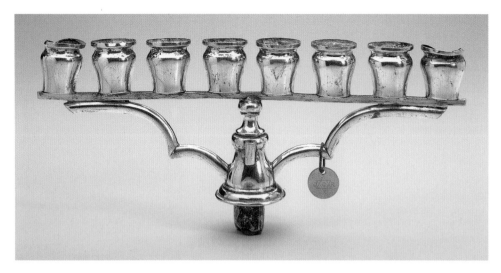

Hanukkah lamp
converter, Central
or Eastern Europe,
late nineteenth or
early twentieth
century
Cast silver,
4⅝ × 10⅜ × 1½ in.
(11.6 × 26.2 ×
3.9 cm)
Jewish Museum,
New York,
Jewish Cultural
Reconstruction

This Hanukkah
lamp converter,
designed to be
inserted into a
candlestick, is
one of count-
less ceremonial
objects orphaned
by the Holocaust
and recovered by
Jewish Cultural
Reconstruction. It
arrived, missing
its base, at the
Jewish Museum in
August 1949. Today
it retains both
its aluminum JCR
tag and the dents
and fractures it
suffered during
the war — signs
of the immense
distance, both
geographic and
conceptual, that
it has traveled.

Recovery did not happen all at once. It was a protracted process with many interruptions and delays. Years after the war Hannah Arendt and her JCR partners were still traveling back and forth across Europe searching for material that either remained hidden in secret caches or was being withheld by government agencies.

Moving from country to country, they tracked the reserves of Jewish memory. In Berlin they found part of the Gesamtarchiv der Deutschen Juden, or Central Archives of the German Jews, a massive compilation of the records of German Jewish communities established in 1905 and presumed lost after its seizure by the Nazis. Over time they also managed to locate what remained of the libraries of the Jewish communities of Berlin, Frankfurt, Hamburg, Munich, and Vienna. With each find they retroactively restored another piece of the Jewish tradition.

In December 1949 Arendt wrote a field report describing some of the complications she and her team were encountering. Staff at German collections were sometimes obstructive, resenting the time and effort that restitution involved, or perhaps hoping to keep the stolen books. More daunting was the sheer volume of material to be dealt with, and the prospect that recovery might take decades. "Large quantities of books which have come back from caches are not yet unpacked and nobody knows what is in the cases," she noted. "It is quite possible that Jewish property will turn up during a number of years." In another field report in February 1950, she described a librarian who "did his best" to "prevent [her] from climbing the stairs" to a hidden room where she found "mountains of paper" that she identified as another piece of the Gesamtarchiv.[22]

In some rare cases, Jewish communities in Europe assembled their own archives before their belongings could be looted. On January 19, 1939, members of the Jewish community of Danzig began packing more than three hundred precious ceremonial objects from their synagogue for shipment to America. Two days earlier, they had received a permit from the Nazi-staffed police allowing them to make the shipment and sell their synagogue, provided the proceeds be used for emigration.[23] The community used the funds as the permit stipulated, paying for, among other things, the extortive Reich Flight Tax. On July 26, 1939, ten crates, weighing two tons, arrived at the Jewish Theological Seminary in New York. One month later the Nazis invaded Poland.

The inventory that the community produced while preparing the shipment reads like a letter sent from the far side of a deep historical break. It lists the contents of the shipment crate by crate, each item confirmed by

a small check mark carefully drawn in pencil, followed by a sober declaration by one of the community's elders: "Packed and sealed under my supervision." The customs form for the shipment is no less striking. Issued on February 8, 1939, stamped by the Danzig police, and listing the destination of the shipment as "New York U.S.A.," it is one of the last statements associated with the Danzig community before it was forced to disband, a message addressed to an audience miles, and decades, away.

The collection came to the Jewish Museum when it moved into the Warburg mansion in 1947 and had more storage space. The material was formally accessioned in 1954, when it became clear that the community would not rebuild.[24]

The story of the Danzig collection is one of remarkable courage and forethought in the face of disaster. Other objects followed a more erratic path through the war, their fate determined by accident, chance, and the sheer piling up of events. The sedimentation of moments that is found in so many works that endured the war can be seen in a portrait of Adolph Carl von Rothschild painted by Moritz Oppenheim around 1850. It is one of seventeen family portraits (most by Oppenheim) that the Nazis confiscated from a Rothschild property in Frankfurt in 1938. The painting was then sent to the Institute for the Study of the Jewish Question, which the Einsatzstab Reichsleiter Rosenberg had established in the Frankfurt municipal library, where it remained until 1943. From there it was moved to a high-school attic in the nearby town of Hungen, where it was hidden along with more than one hundred other paintings that had been seized from Jewish families. The painting was finally discovered in July 1945 and sent to the Offenbach Archival Depot. It was then sent to the Wiesbaden Central Collecting Point, and in 1951 passed through both the Munich Central Collecting Point and the Nuremberg offices of the JRSO, before being loaded onto a ship in Bremen and sent to the Bezalel National Museum in Jerusalem.[25]

In August 1951 Guido Schoenberger, an art historian working with the Jewish Museum and the JCR, traveled to the Munich Central Collecting Point to survey a number of paintings, sculptures, and ceremonial objects that had not yet been restituted. Among them were the Rothschild portraits, which he noted in his field report were "unclaimed" by their former owners.[26]

Portrait of Adolph Carl von Rothschild bears the marks of its dramatic journey. The cracks and tears that line the painting's surface could have occurred as it was being transferred between sites in Germany or as it was being shipped from Germany to Israel. In addition to documenting the

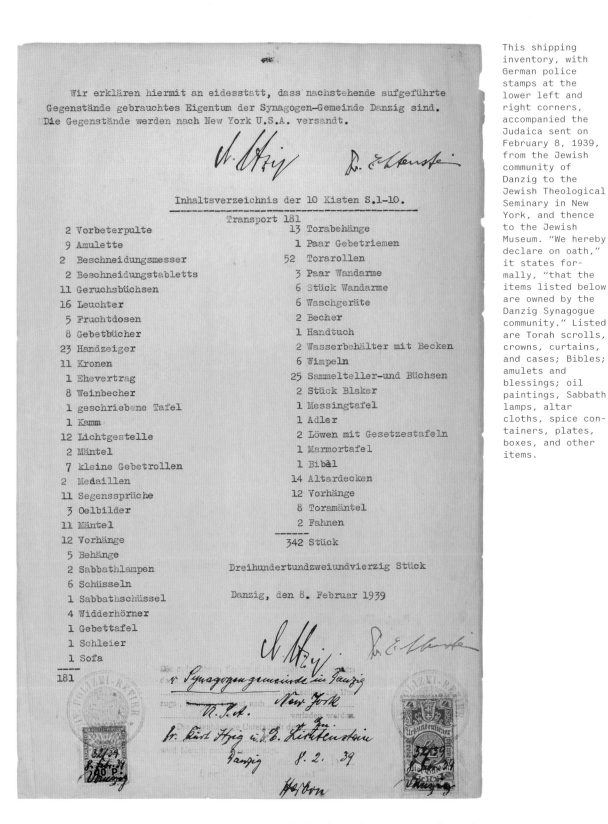

painting's movement through space, those cracks and tears also document its movement through time. An arresting representation of a member of a prosperous family, the painting was made during a period when German Jews had achieved an unprecedented degree of success and security. A century later, the status of both the painting and the family had changed. When it arrived at the Bezalel National Museum in 1952, the painting was not

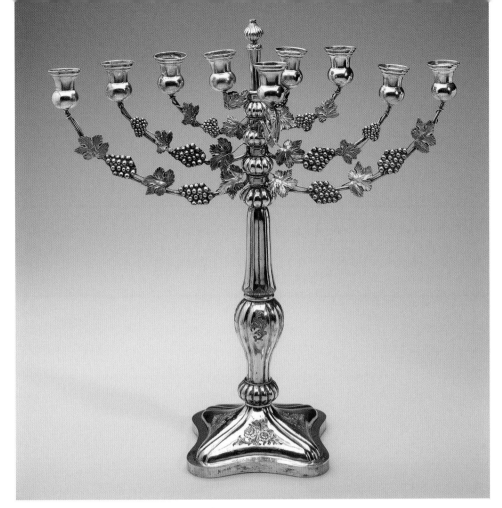

Hanukkah lamp,
probably Germany,
second half of the
nineteenth century
Engraved, traced,
punched, appliqué,
and cast silver,
21¾ × 18⅞ × 6 in.
(55.2 × 47.8 ×
15.2 cm)
Jewish Museum,
New York, gift of
the Danzig Jewish
Community

A Latin inscrip-
tion on this
lamp, GIELDZINSKI
DEDIT, indicates
it was part of a
gift of Judaica
from Lesser
Gieldzinski, an
affluent merchant
in Danzig, to the
Great Synagogue
in 1904 (see page
184).

only a portrait of a notable sitter from the mid-1800s but also an index of the tumultuous events that had occurred since then, each fissure a concrete record of history as it accrued.

While much of the recovery effort was focused on the past, it was also forward-looking. Faced with the historical rupture caused by the Nazi assault, the scholar-activists of the JCR stepped into time, reordering history not only by redistributing the cultural material they had retrieved from Nazi warehouses and bunkers, but also by making that material the basis for a new and vital chapter in Jewish cultural life. As Baron insisted in 1945, to be successful, reconstruction would have to do more than salvage the scores of looted books and objects that contained within them the accumulated centuries of Jewish tradition. It would have to stimulate a Jewish vanguard that would continue to grow and

change. The culture that he and his JCR peers were reconstructing would have to allow the Jewish community to simultaneously remember and create.

The archival infrastructure they built became the foundation for that culture. The relationships that were formed through the circulation of the memos, reports, and letters that defined the day-to-day operation of the JCR developed into a thick social fabric that not only allowed Baron, Arendt, and their colleagues to track the remnants of past Jewish cultural production across Europe, but also provided a context in which future cultural production could take place.

This was stated explicitly in the articles and essays that were published as that infrastructure was being built, many of which recognized that the recovery effort was contributing to Jewish and non-Jewish communities alike. By reconstructing Jewish culture in the wake of fascism, Jews

Moritz Oppenheim,
*Portrait of
Adolph Carl von
Rothschild*,
c. 1850
Oil on canvas,
23⅞ × 20⅛ in.
(60.5 × 51 cm)
Israel Museum,
Jerusalem,
received through
the Jewish
Restitution
Successor
Organization

were also participating in the reconstruction of a democratic culture that was, in their view, distinguished by a ceaseless drive to invent. Writing on behalf of the Conference on Jewish Relations in April 1941, Morris Raphael Cohen insisted, "Our basic interest is entirely identical with that of our fellow American citizens, who wish to maintain the principles embodied in the Declaration of Independence and in the concluding sentence of Lincoln's Gettysburg Address. . . . Wherever we find anti-democratic forces arrayed against liberal civilization and against its conception of human freedom we find anti-Jewish measures a major part of the program," Cohen explained. "As

we have more opportunity to become aware of the various anti-Semitic movements, we have the greater obligation to keep our fellow-citizens informed of the danger which these movements pose to our traditional American way of life. . . . We must," he concluded, "join our truly patriotic fellow-citizens in repelling the forces that would overthrow the traditional American democratic spirit of equal opportunity for all."[27]

Baron had made a similar argument two years earlier. In an address delivered at the annual meeting of the Jewish National Welfare Board in 1939, just as the necessity for cultural reconstruction was becoming

apparent, he argued against defining that culture too narrowly. "I am quite convinced that we cannot possibly agree as to what Jewish culture is or ought to be," he explained. While many of his peers were calling for a return to the kind of uniformity that had defined the Jewish community in the past, he urged them to embrace the "multiformity" that he saw in the cultural pluralism of American democratic society. "Cultural pluralism is and has been greatly enriching American culture," he continued. "Cultural pluralism must now also become an acknowledged factor working for mutual toleration within the Jewish group as well." Reflecting a commitment to innovation that is all the more remarkable given the devastating moment in which he was speaking, Baron called for the creation of a Jewish American culture based on that pluralism. "One of the great duties of all Jewish organizations," he insisted, "is to help evolve a composite American Jewish culture; one of cultural plurality within and without. . . . It is cultural nihilism which we all have to combat. . . . Cultural pluralism is to be welcomed by all."[28]

No one was more invested in aligning Jewish culture with democratic culture than Hannah Arendt. Being democratic, in her view, meant encouraging productive dissent. The culture that she and her colleagues were reconstructing would cultivate vigorous argument and exchange.

Arendt described her position in an essay in *Commentary* in November 1947, six months after the JCR was formed. Culture, she argued, was a product of the processes of invention that began when values that had long been sacrosanct in religion were called into question. "Culture is by definition secular. It requires a kind of broad-mindedness of which no religion will ever be capable," she explained. For a number of reasons, Jews had not shared in the process of secularization that took place during the Renaissance and Enlightenment "out of which modern culture was born." This meant

that, when it encountered the secular cultural trend, the Jewish tradition could not accommodate it. "Jews who wanted 'culture' left Judaism at once, and completely, even though most of them remained conscious of their Jewish origin. . . . Secularization and then secular learning became identified exclusively with non-Jewish culture, so that it never occurred to these Jews that they could have started a process of secularization with regard to their own heritage." The result of this "sudden and radical escape by Jewish intellectuals" was destructive. While these intellectuals thrived, their exiled position meant that the Jewish tradition did not benefit from their efforts, causing that tradition to become more fragile. To reverse that trend and stop the hemorrhaging of "Jewish talent," Jews had to create what Arendt called a "cultural atmosphere" that would "make room for all those who either came, and come, into conflict with Jewish Orthodoxy, or turned their backs on Judaism." Rather than weakening the Jewish tradition, incorporating those figures would strengthen it because they would provide models of how older traditions could be reinvigorated by "new impulses." That cultural atmosphere would, in all likelihood, be produced in America, a country that, in Arendt's words, would "annul its own constitution if ever it demanded homogeneity of population and an ethnic foundation for its state."[29]

The democratic emphasis running through these statements was woven into the day-to-day work of the JCR as well. When a cache of material was being prepared for redistribution, members deliberated about where it would be sent, using ballot cards circulated by mail. Prepared by Arendt, the cards were marked on the front with the organization's New York address and a green Thomas Jefferson stamp, and on the back with descriptions of the matter being considered and a space for members to cast their votes.

Newspapers were another means of reaching the Jewish community

as a whole, in all its heterodoxy. In spring 1951 Arendt published lists of "Books Looking for Their Owners" in the classified section of the New York-based Jewish newspaper *Aufbau* (Reconstruction). Appearing alongside editorials by some of the most influential Jewish intellectuals of the century, the lists produced hundreds of successful claims, reassembling the tattered pieces of Jewish culture even as that culture was producing new and radical ideas.

By not only salvaging the remains of Jewish culture but also opening that culture up to an ever-widening array of new contributions, Arendt and her peers provided what was, perhaps, the deepest and most lasting response to the Nazi assault. Whereas the Nazis had sought to either erase Jewish culture or turn it into a static piece of their ideological program, Arendt and her associates demonstrated, in a moment of intense suffering, that that culture could not only survive but flourish.

Hannah Arendt intervened in history. With her JCR colleagues, she contributed to the recovery effort by working in the layered time of the archive, repositioning the remains of the European Jewish community, connecting a past that had been attacked to a future that was being created.

That recovery was, necessarily, partial. On January 13, 1952, Salo Baron met members of the Synagogue Council of America at the Beth El Cemetery in New Jersey to bury Torah scrolls that had been damaged beyond repair. Photographs of the burial, with Baron and his fellow rabbis gathered around an open grave, serve as reminders of the devastating loss of life from which no recovery was possible. Nine years later Baron testified at the trial of the Nazi official Adolf Eichmann, one of the principal organizers of the Holocaust.

Although partial, the recovery effort was still essential. It was only by balancing remembrance and resolve, salvaging the cultural material that

had been orphaned by the war and redistributing it to Jewish communities around the world that the destruction of Jewish life could be resisted.

Something like that balance is conveyed in a passage from the 1931 essay "Unpacking My Library" by the Jewish philosopher Walter Benjamin. A close friend of both Hannah Arendt and Gershom Scholem, Benjamin did not survive the war. Having escaped Occupied France in 1940, he traveled on foot through the rocky cliffs of the Pyrenees to Spain. There he was notified at the last moment that the documents he had planned to use to sail to New York would not be accepted. Faced with the prospect of capture, he took his own life.

Although written before the war, while Benjamin was still in Germany, the essay rings through time. When it appeared in English as part of a collection published in 1968, the volume's editor was none other than Arendt,

Survey card distributed by Hannah Arendt on behalf of the JCR to members of the organization's board of trustees and other affiliates, asking them to vote on the proposed distribution of the recently recovered Hochschule Collection.

Bücher suchen ihre Eigentümer

In Deutschland gefundene Bücher werden zurückerstattet

Jewish Cultural Reconstruction, Inc., New York, wurde zum Zwecke der Rettung und Sammlung des von den Nazis konfiszierten jüdischen Kulturguts gegründet. Dank der aktiven Hilfe der amerikanischen Militär-Regierung ist es der J.C.R. gelungen, grössere Buchbestände aus vormals jüdischem Besitz in der amerikanischen Zone Deutschlands zu erfassen und ihnen wieder eine Heimat in den Zentren jüdischen geistigen Lebens und Lernens in Israel und den Ländern der Diaspora zu sichern.

Unter diesen Beständen befindet sich eine Anzahl von Büchern, die mit Namen gezeichnet sind, die diejenigen ihrer ehemaligen Eigentümer sein könnten. Sie wurden der J.C.R. von der amerikanischen Militär-Regierung übergeben, weil sie nicht gemäss den Bestimmungen des amerikanischen Rückerstattungsgesetzes No. 59 angefordert worden sind und ehemalige Eigentümer oder ihre Erben rechtliche Ansprüche nicht mehr geltend machen können.

Um über die Bestimmungen des allgemeinen Rückerstattungsgesetzes hinaus eine Rückgabe von Büchern an Eigentümer oder Erben zu ermöglichen, veröffentlichen wir im Folgenden alle Namen, die in den Büchern gefunden wurden. Die Zahl, die dem Namen oder der Ortsangabe folgt, zeigt die Anzahl der aufgefundenen Bücher oder Broschüren an. Für diese Zahl kann jedoch eine Gewähr nicht übernommen werden.

Ansprüche müssen bis zum 30. Juni 1951 angemeldet werden. Interessenten werden gebeten, sich schriftlich bei Jewish Cultural Reconstruction, Inc., 1841 Broadway, New York 23, N. Y., zu melden und die von uns für die Anerkennung von Ansprüchen festgesetzten Bestimmungen einzufordern. Die J.C.R. ist bereit, einen moralischen Anspruch in den Fällen anzuerkennen, in denen der Antragsteller 1. zur Zufriedenheit der J.C.R. nachweisen kann, dass er der ehemalige Eigentümer oder dessen rechtlicher Nachfolger ist; und 2. bereit ist, die mit der Rückerstattung entstehenden Kosten zu tragen.

Abraham, Lotte, Berlin-Grunewald — 6; Abramowitz, R., Berlin-Schöneberg, Bozenstr. — 26; Adler, Anna — 17; Adler, Elkan Nathan — 6; Adler, Erwin, Böhmerstr. — 10; Adler, Familie, Steinbach b. Hall — 17; Adler, Karl — 13; Adler, S., Benesisstr. — 7; Aliezer, Baruch, Riga — 9; Altman, Dr. S. P., Berlin und Mannheim — 15. Angerthal, Dr. Max, Königsberg i. Pr., Schönstr. — 20; Apt, Rabb. Dr. N., Allenstein u. Filene — 97; Aron, Dr. Arno — 74; Ascher, Luis u. Johanna, Frankfurt a. M., Brentanostr. — 7; Asser, Cath. — 7; Aumann, Georg, Frankfurt a. M., Baumweg — 38.

B. E. — 6; Bachmann, A., Nürnberg, Spittlerthor-Mauer, Scheurlstr., Kohlengasse — 14; Baer, Joseph — 13; Baer, Leo u. Anni — 15; Bagg, Sch. M., Riga — 8; Balet, Dr. Leo — 14; Ball, Dr. — 17; Baloscher, A., Kowno — 110. Bamberger, Elisabeth — 10; Bamberger, Dr. J., Königsberg i. Pr. — 9; Bamberger, L. — 6; Bamberger, Otto — 24; Bamberger, Dr. Salomon, Frankfurt a. M., früher Würzburg — 189; Bamberger, Willi — 9. Banta, Kenneth u. Mildred, Berlin — 15; Barischnik, Meier, Riga — 6; Barkmanes, Rabb. S., Gostino — 42; Baron, Inge — 8; Baron, Dr. S. — 66; Bass, J. A., Kowno — 9; Bassfreund, Mirjam, Halberstadt — 8; Bauer, Hans J. — 10. Becker, W. — 15; Beer, Hugo L., Frankfurt a. M. — 30; Beerman, Siegfried u. Elly — 6; Behrens, Geh.-Rat Prof. Dr. — 8; Beines, Benjamin, Bauske — 14; Bender, Paul — 20; Bender, Peter — 23; Berenzweig, Bernhard — 34; Berg, Lucas, Warburg — 17; Berkman, Sz., Wilna — 6.

Berlin, Siskind, Riga — 23; Berliner, Ludwig u. Caecilie — 6; Bermann, Victor u. Anny (geb. Polenz), Dr. Ing. — 68; Bermbach — 52; Bernhardt, Paul u. Dorothea, Potsdam — 19; Bernstein, Nathan — 8; Berringer, Gustav, Charlottenburg — 7; Berstein, Yehezkeel, Slobodka — 14; Besser, Alexander, Breslau — 7. Bier, Max, Frankfurt a. M. — 41; Bier, Maximilian, Frankfurt a. M. — 7; Bier, Nathaniel M., Frankfurt a. M., Hölderlinstrasse — 51; Birnbaum, Moses, Frankfurt a. M. — 7; Blau, Bruno u. Justizrat Dr. J., Frankfurt a. M., Seilerstr., Hochstrasse — 27; Blau, Ernst, München — 40; Bloch, Rabb. B., Riga — 25; Bloch, G. S. — 19; Bloch, Levin S., Königsberg — 13; Blum, Leopold u. Liselotte — 9; Bluth, Erika, Ernst u. Gretl — 10. Bodenheimer, Hermann, Frankfurt a. M., Am Tiergarten — 18; Bodenheimer, S. L., Biblis — 6; Boehm, Alois Robert — 9; Boehm, Moriz, Fürth — 6; Bombach, J., Berlin, Lilienstr., Weberstr. — 6; Bondi, Max — 7; Borchardt, Marion — 8; Bossak, Maurycy — 13; Bowitz, Aba Leib, Riga — 70; Bramson, A. M. — 13. Brandt, Siegfried — 6; Brauer, Elly, Kattowitz, O.-S. — 7; Braude, H., Königsberg i. Pr. — 6; Braun, Kaethe — 7; Brenson, Ellen — 8; Brodnitz, Julius u. Hedwig — 6; Brodreich, Lionell, Einartshausen — 9; Broida, Ahron, Kowno — 95; Bromberger, Berthold, Erwin, Esriel, Siegmar Esriel, Berlin, Linienstrasse, Münzstr. — 25. Bruchsaler, Karl, Bühl (Bad.) — 45; Bruenn — 7; Bruzkus, Ju., Arzt — 9; Buday-Goldberger, Dr. Leo — 8; Burnstein, S., Tuckum — 14; Busch, Augusta — 29; Butkiewicz, J., Bulduri — 8. Cahn, Dr. Ernst — 6; Caro, Prof. Dr. Josef, Frankfurt a. M. — 12; Caro, Oscar — 85; Casparius, Kaete — 7; Cats, Dr. Alex — 13; Cazes, David L. — 22; Charig, Dr. jur. — 19; Cheim, Rudolf — 6; Coblenz, Henni, Hildesheim — 32; Cohen, Dr. S. — 54; Cohen, Dr. med. W. — 11; Cohn, Emil — 6; Cohn, Prediger u. Kantor Erich, Leobschütz — 10; Cohn Cantor Hermann — 15; Cohn, Jacob — 22; Cohn, Dr. Ludwig — 6; Cole — 7; Colling, Jakob F. — 26; Coq, Geh.-Rath G. v. Le — 6; Cramer, Clem., Frankfurt a. M. N 8. Danluschewski, M., Baltrumanz — 23; Danski, Shabbetai, Kowno — 25; Davids, Bz. L. — 7; Davidsohn, Kultusbeamter A., Rastenburg u. Tilsit, Gartenstr. — 6; Dekelbaum, B., Kowno — 6; Dessauer, S., Karlsruhe i. B. — 13; Deutsch, Adolf — 25; Deutsch, Annie — 10; Deutsch, Julius — 6.

(Fortsetzung folgt.)

Der Wochenabschnitt

"Schemini"

„Dann brachte er das Ganzopfer dar und tat damit nach Vorschrift" (Leviticus 9,16).

In der vorigen Wochenabschnittsbetrachtung sprachen wir vom Uebergang von der Sphäre des religiösen Erlebnisses zur Sphäre des rituellen Exerzitiums und detaillierten Opferdienstes als einer der entscheidenden Entwicklungsphasen jeder historischen Religion. Wir bemerkten, dass das primäre Erlebnis, welches das Anfangsstadium der Religion kennzeichnet, Platz macht der Form und Formel, welche die Merkmale des zweiten

Detail of a page from the March 30, 1951, issue of *Aufbau* (Reconstruction), publishing a list of "Books Looking for Their Owners" posted by Hannah Arendt on behalf of the JCR.

who no doubt read the essay with images of crate-filled depots still fresh in her mind. It begins:

> I am unpacking my library. Yes, I am. The books are not yet on the shelves, not yet touched by the mild boredom of order. I cannot march up and down their ranks to pass them in review before a friendly audience. You need not fear any of that. Instead, I must ask you to join me in the disorder of crates that have been wrenched open, the air saturated with the dust of wood, the floor covered with torn paper, to join me among piles of volumes that are seeing daylight again after two years of darkness, so that you may be ready to share with me a bit of the mood—it is certainly not an elegiac mood, but, rather, one of anticipation—which these books arouse in a genuine collector.[30]

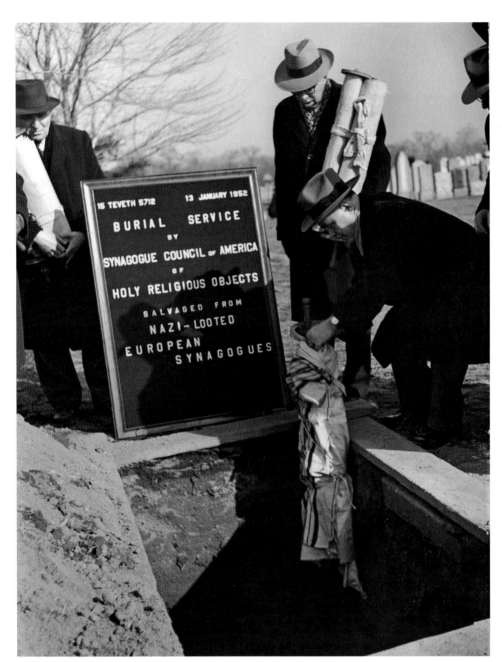

It was in the space between elegy and anticipation, among the wrenched-open crates and paper-covered floors of the archives that were found and formed in the wake of the war, that the JCR did its work.

CODA

That work continues to this day. While history concerns events that have occurred in the past, it is communicated through objects that exist in the present. When we encounter those objects, we become responsible for them and, in some sense, for history itself.

The connection between history and responsibility is distilled in one of the few works of art that Walter Benjamin owned, *Angelus Novus*, painted by Paul Klee in 1920. Benjamin purchased the painting in 1921 and referred to it repeatedly in his writing, associating it with a complex theory of history that he refined over the course of his career. In "On the Concept of History," an essay completed shortly before his death, the figure came to represent

history itself. Like Baron, Arendt, and Scholem, Benjamin understood history not as a dispassionate record of events, but rather as the product of profound moments of rupture, when the meaning of the past is grasped in the present. "To articulate the past historically" meant more than merely providing an account of it. It meant "to seize hold of a memory as it flashes up at a moment of danger." Benjamin saw that moment reflected in Klee's painting. In one of the essay's most moving passages, he described it in detail:

> A Klee painting named "Angelus Novus" shows an angel looking as though he is about to move away from something he is fixedly contemplating. His eyes are staring, his mouth is open, his wings are spread. This is how one pictures the angel of history. His face is turned to the past. Where we perceive a chain of events, he sees one single catastrophe which keeps piling wreckage upon wreckage and hurls it in front of his feet. The angel would like to stay, awaken the dead, and make whole what has been smashed. But a storm is blowing from Paradise; it has got caught in his wings with such violence that the angel can no longer close them. This storm irresistibly propels him into the future to which his back is turned, while the pile of debris before him grows skyward. This storm is what we call progress.[31]

By 1940 the angel of history had assumed a tragic connotation it did not have in 1921. Instead of taking an active role in shaping the course of events, those in power had embraced a notion of progress that rendered them passive—contributing, in Benjamin's view, to the rise of fascism and the catastrophe that followed. Like the angel of history who was being blown helplessly into the future, they had proven incapable of responding to the situation unfolding around them, reduced to being observers watching the wreckage piling higher and higher at their feet.

When Benjamin fled Paris, he left *Angelus Novus* with the philosopher Georges Bataille, who stored it, along with the rest of Benjamin's belongings, at the Bibliothèque Nationale. After the war, it was recovered and given to the theorist Theodor Adorno, who passed it on to Gershom Scholem. When Scholem died in 1982, his widow donated it to the Israel Museum.

Seen with these later developments in mind, the painting begins to change. While it remains a depiction of a figure blown helplessly through time, it also takes on another, more bracing aspect. Battered and worn, it looks like something that has been hidden and retrieved—seized in a moment of danger. This gives it a dual status, allowing it to speak both to its moment and ours. It is both a record of the catastrophe that Benjamin saw consume Europe during the war, and of the steps Arendt and her peers took, first to resist that catastrophe as the war was raging and then to recover from it; the painting is a warning against passivity and a call to action.

Paul Klee, *Angelus Novus*, 1920
Oil transfer and watercolor on
paper, 12½ × 9½ in. (31.8 ×
24.2 cm)
Israel Museum, Jerusalem, gift
of Fania and Gershom Scholem,
Jerusalem, John Herring, Marlene
and Paul Herring, Jo-Carole and
Ronald Lauder, New York

Notes

Two recent groundbreaking works provide detailed accounts of the organizational and intellectual history of Jewish Cultural Reconstruction: Dana Herman, "*Hashavat Avedah*: A History of Jewish Cultural Reconstruction, Inc.," PhD diss., McGill University, Montreal, 2008; and Elisabeth Gallas, *A Mortuary of Books: The Rescue of Jewish Culture after the Holocaust*, trans. Alex Skinner, Goldstein-Goren Series in American Jewish History (New York: New York University Press, 2019).

1 Hannah Arendt, memorandum to members of the Board of Directors and Advisory Committee of Jewish Cultural Reconstruction, Inc., April 13, 1951, Archives of the Jewish Museum, New York.

2 "Jewish Action Is Urged: Dr. Salo Baron Says World Agency Should Demand and Direct It," *New York Times* 82, no. 27,484 (April 24, 1933).

3 Morris R. Cohen, "Publisher's Foreword," *Jewish Social Studies* 1, no. 1 (January 1939): 3–4.

4 Salo W. Baron, "Emphases in Jewish History," *Jewish Social Studies* 1, no. 1 (January 1939): 15.

5 Baron, "Emphases in Jewish History," 38.

6 Morris R. Cohen, "Philosophies of Jewish History," *Jewish Social Studies* 1, no. 1 (January 1939): 41.

7 Cohen, "Philosophies of Jewish History," 72.

8 "Latest Nazi Wave of Terror," *Contemporary Jewish Record* 1, no. 2, special suppl. (November 1938): 56a–c.

9 Bernard D. Weinryb, "Jewish History Nazified," *Contemporary Jewish Record* 4, no. 2 (April 1941): 148–67.

10 "Reconstruction of European Jewish Cultural Institutions" questionnaire, Manuscripts, Archives, and Rare Books Division, New York Public Library, Archives, RG7, Research Libraries, Jewish Division, Chief, Joshua Bloch External Organization Files, box 2.

11 "Tentative List of Jewish Cultural Treasures in Axis-Occupied Countries," *Jewish Social Studies* 8, no. 1, suppl. (1946): 1–103.

12 *Jewish Post-War Problems: A Study Course*, vol. 7, *Relief, Reconstruction and Migration* (New York: Research Institute on Peace and Post-War Problems of the American Jewish Committee, 1943), 10.

13 Salo W. Baron, "The Spiritual Reconstruction of European Jewry," *Commentary* 1, no. 1 (November 1945): 4–12, online at https://www.commentarymagazine.com/articles/commentary-bk/the-spiritual-reconstruction-of-european-jewry.

14 Baron, "Spiritual Reconstruction of European Jewry."

15 Baron, "Spiritual Reconstruction of European Jewry."

16 Salo W. Baron, "Introductory Statement," in "Tentative List of Jewish Cultural Treasures in Axis-Occupied Countries," 6.

17 Joshua Starr, "Jewish Cultural Property under Nazi Control," *Jewish Social Studies* 12, no. 1 (January 1950): 29.

18 Hannah Arendt, letter to associates of Jewish Cultural Reconstruction, September 1949, Yeshiva University Library, New York, Archives, box 6, "Jewish Cultural Reconstruction" folder, Jacob Dienstag Records.

19 Jacob Dienstag, Yeshiva University librarian, in "Nazi Streicher's Library Winds Up at Yeshiva U," *New York Post* (May 10, 1950): 44.

20 Joshua Starr, letter to Stephen S. Kayser, July 18, 1949, and Hannah Arendt, letter to Stephen S. Kayser, August 22, 1949, Archives of the Jewish Museum, New York. Starr, a historian of Byzantine Jewish history and editor at Schocken Books, served as the JCR's first executive secretary, succeeded by Arendt.

21 The JCR disc is always included when these works are displayed in the Jewish Museum.

22 Hannah Arendt, Jewish Cultural Reconstruction Field Report no. 12, December 1949, and no. 16, February 18, 1950, Archives of the Jewish Museum, New York.

23 The arrangement was negotiated with the help of the American Joint Distribution Committee, which provided funds for the "purchase" (in reality, a bribe to the Nazi authorities). See Gershon C. Bacon, "Danzig Jewry: A Short History," in *Danzig 1939: Treasures of a Destroyed Community*, exh. cat. (Detroit: Wayne State University Press for the Jewish Museum, New York, 1980), 34; the permit is reproduced on 19.

24 "The community stipulated that The Jewish Theological Seminary was to house the collection for a period of fifteen years; and if the Danzig Jewish community were to be reestablished before that time, the collection would be returned to the Free City. If, after fifteen years there would be no safe and free Jews in Danzig, the collection would remain in America for the education and inspiration of the rest of the world," Joy Ungerleider-Mayerson, "Preface," *Danzig 1939,* 9.

25 Shlomit Steinberg, "On the Road to Recovery: World War II and the Retrieval of Looted Artworks," in *Orphaned Art: Looted Art from the Holocaust in the Israel Museum*, exh. cat. (Jerusalem: Israel Museum, 2008), 7–17.

26 Guido Schoenberger, Jewish Cultural Reconstruction Field Report no. 22, August 8–September 7, 1951, Archives of the Jewish Museum, New York.

27 Morris R. Cohen, "Jewish Studies of Peace and Post-War Problems," *Contemporary Jewish Record* 4, no. 2 (April 1941): 110–11.

28 Salo W. Baron, "Cultural Pluralism of American Jewry," in *Steeled by Adversity: Essays and Addresses on American Jewish Life*, ed. Jeannette Meisel Baron, 1st ed. (Philadelphia: Jewish Publication Society of America, 1971), 504–5.

29 Hannah Arendt, "Jewish Culture in This Time and Place: Creating a Cultural Atmosphere," *Commentary* 4, no. 5 (November 1947): 424–26.

30 Walter Benjamin, "Unpacking My Library: A Talk about Book Collecting," in *Illuminations*, ed. Hannah Arendt, trans. Harry Zohn (New York: Schocken Books, 1968), 59.

31 Walter Benjamin, "Theses on the Philosophy of History [1940]," in *Illuminations*, 201.

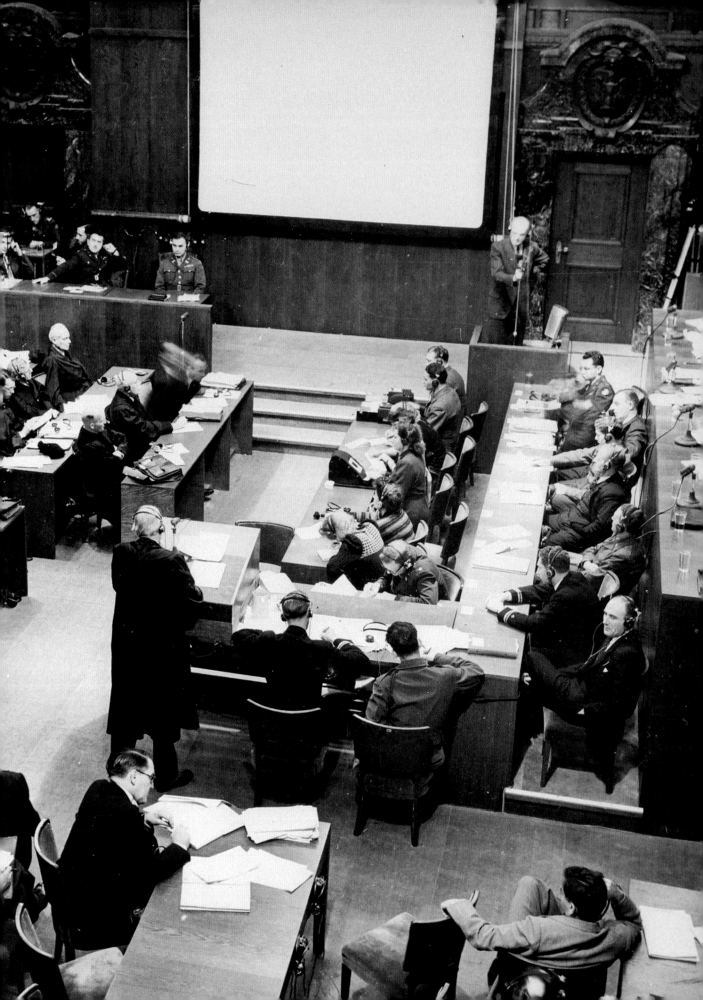

THE ARCHITECTURE OF DISPOSSESSION

Mark Wasiuta

ART TO ATROCITY

In what must have appeared to many as an uncanny art-historical interlude, on Tuesday, December 18, 1945—the twenty-second day of the Nuremberg war-crimes trials—the courtroom lights dimmed, a projector switched on, and the American prosecutor Colonel Robert Storey presented a slideshow of paintings by Diego Velázquez, Jean-Antoine Watteau, Anthony van Dyck, Sir Joshua Reynolds, and other European masters. Along with the paintings, Storey projected images of tapestries, jewelry, furniture, and a sample inventory of other artworks and artifacts to expose and illuminate the logic, extent, and implications of the Nazi campaign of cultural dispossession. The media structure of the trials pivoted around the spatial configuration of the courtroom, the looming white rectangle of the projection screen, and the appearance of films, photographed documents, and critical evidence, such as Storey's slide projections, that aligned art with atrocity and plunder with extermination.

RELOCATION

As the slides flashed onto the projection screen, they slid along an axis of signification that spanned the distance between art conceived as repository of cultural value to art understood as the marker of cultural violence. Yet despite the historical importance and evidentiary particularity of the trial, the shifting identity of the artworks projected at Nuremberg was far from a singular or isolated event. The trial was only the most visible instance in a longer sequence of physical, syntactic, semantic, and cultural relocations. As the plundered artworks and artifacts were moved from space to space during the war and its aftermath—a mobility initiated by Nazi theft and confiscation—they were subjected to drastically different systems of evaluation and called upon to perform markedly different tasks. As they were transported in and out of war zones and spaces of occupation, they were also mobilized along new vectors of interpretation. These were often jarring and discordant. At one extreme the art was read, especially within the trials, as evidence of the rapacious brutality of the Nazi war machine. At another end, especially through the processes of recovery and restitution, the art was read as a strategic instrument for German normalization, Jewish cultural revitalization, and therapeutic recuperation.

SCENES

In these different circumstances and networks of relocation, the works followed a fitful itinerary: from sites of sale, plunder, exchange, or farcically "legal" processes of requisition to various waystations, storage depots, and collecting points. Along their path the works were repeatedly displayed, documented, unpacked, repacked, and shown within different scenes and scenarios of viewing. These ranged from private showings for members of the Nazi Party at museums in Paris to postwar exhibitions staged at the Allied collecting points and throughout Europe and the United States. Some of these scenes could indeed be

The Nuremberg trials courtroom, with its central projection screen, November 1945. A film made on December 18, 1945, shows a detail that this photograph misses: an assistant illuminates the projector and mounts the glass slides with which the American prosecutor Storey will inventory the plundered paintings and artifacts. The Nuremberg trial film is now in the United States National Archives, labeled PARIS. [NO.] 453, WAR CRIMES TRIALS, NUREMBERG, GERMANY, misdated 12/12/1945.

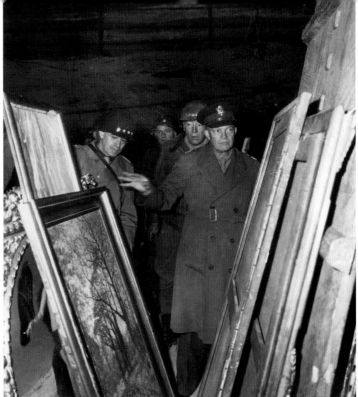

considered proper exhibitions, in the sense of coordinated spaces of display, and some in the postwar period were discursive operations in dialogue with the propagandistic pageants staged by the Third Reich. Yet many were little more than a photo-op or a moment of verification. The artifacts were photographed, tagged, and entered into distinct systems of registration that orchestrated the vast pilfering and salvaging operations.

ARCHITECTURE

The architecture of dispossession comes into view through these scenes of exposure, documentation, and mobilization. Across them architecture was rarely an inert or accidental site. At the very least, because of some form of structural utility or functional affinity, buildings were conscripted into service. Notoriously, castles and salt mines were put to work as Nazi storage vaults, and museums in Paris and elsewhere were bent toward coordinating and documenting the stolen artworks.

Yet even in cases such as these—governed, in part, by a blunt military rationality or by bureaucratic

expediency—architecture was often both an active organizer of the scenes of viewing and a cultural object subjected to similar shifts in interpretation as the artworks it contained. Most notably, the Central Collecting Point in Munich, from which the Allies conducted the massive project of assembling and redistributing plundered works, was housed in a building designed and used as a Nazi headquarters during the war and that doubled as one of the many Nazi art depots near the end. Hence, the American army's occupation of the Nazi command center bridged its military rationality and a new, distinct rationality that attempted to reverse and recode the spaces of Nazi occupation.

This reversal—integral to the Allies' denazification enterprise—sought to erase the symbols and structure of the Nazi Party while reconstructing postwar Germany as a state attuned to and aligned with western democracy. In some instances, reversal was due less to strategy than to the odds of encountering spaces and fragments of the Nazi military and corporate armature. For example, the Allied Offenbach

Above left: Reichsmarschall Hermann Goering visits the *Art du Front* exhibition of approved German art at the Jeu de Paume, Paris, November 30, 1941.

Above: United States generals Omar N. Bradley, George S. Patton Jr., and Dwight D. Eisenhower inspect stolen artwork in the Merkers salt mine, Occupied Germany, July 12, 1945.

THE ARCHITECTURE OF DISPOSSESSION

Archival Depot was installed in the IG Farben complex near Frankfurt.

IG Farben was the synthetic chemical and pharmaceutical conglomerate that fabricated the rubber for Nazi military tires, fuel for Nazi vehicles, the drugs fed to Adolf Hitler, and Zyklon B, the poisonous gas used in Nazi extermination camps.[1] Against this scale of complicity and atrocity, the Allies' occupation of the building might not seem to have offered much of a response and may have been less considered, cultural recalibration than ghastly coincidence. The Offenbach building became the site at which the largest concentration of Jewish texts, relics, and books were processed for return, and where the most concerted effort at reversing the damage and violence of Nazi looting was conducted.[2] Traces of Nazi methamphetamine and chemical munitions came into contact with more than 3.5 million pilfered items, the largest collection of Jewish material in the world.[3]

The architecture of dispossession encompassed the radical irreconcilability of the Offenbach building's two regimes of objects and atmospheres, subsequent reversals and recodings, as well as the channels and networks through which the stolen artworks and artifacts traveled. It included the forms of exhibition, documentation, and techniques of viewing that punctuated the spatial itinerary of looting. It choreographed the scenes and instruments of observation that marked the recuperation and return of the artworks. And it described the circuit between recoded artifacts and reconstituted spaces: as buildings, sites, and infrastructures became the architecture of dispossession, they too spoke and performed differently. By the end of the war and during its aftermath, this meant that the buildings and scenes comprising the architecture of dispossession had to become newly fluid in order to shed past histories, help script denazification, and frame both postwar urban reconstruction and Jewish cultural reconstruction.

Dispossession was designed around and for evacuation and accumulation. As spaces were emptied and filled with artworks and artifacts, they were evacuated of previous identities and associations. A diagram of dispossession would link Parisian houses and apartments (from which many of the works shown in the slides at Nuremberg were looted) to the castles, salt mines, and other caches in which art was secreted. It would connect synagogues, churches, and institutions stripped of their contents to museums planned by the Nazis to attest to the power of the Third Reich. And with lines of evacuation and accumulation it would map the architectural coordinates and the postwar topoi of recovery and return (see the maps on pages 62–63).

Despite these proliferating reversals, the double direction of architectural dispossession does not suggest that there was a simple symmetry between plunder and return or

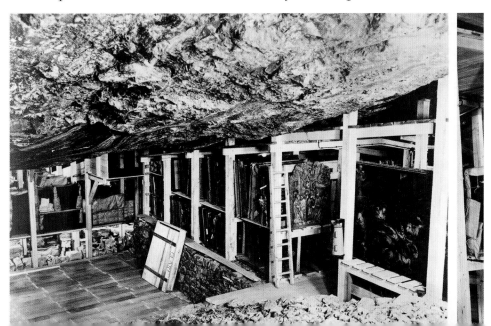

Paintings found in the salt mine at Altaussee, Austria, at the end of World War II, photographed July 1945.

that the problem and legacy of dispossession was easily resolved. Rather, just the opposite. It suggests that, like the broader dilemma of postwar reconstruction and restitution, the architecture of dispossession was marked both by the gap between art and atrocity and, at the same time, by their historical alignment. For the Nuremberg court, this meant inserting looted art into a general pattern of Nazi war criminality. After the war it meant asking how to return—including to which parties, nations, and cultures—and questioning the limits or impossibility of restitution.[4] Return and the attendant issues of reconstruction were lodged within, yet exceeded, the administrative authority of the court and the bureaucratic restructuring of postwar Germany and Europe.

The architecture of dispossession was not just one thing or even one space. Dispossession operated simultaneously at multiple scales: at specific buildings, across the territory of the Nazi military apparatus and its occupied regions, and within different zones of postwar geopolitics. Because of its expanse and extent, it appeared diffuse. But it also coalesced and came into view in specific sites, including the courtroom of the Nuremberg trials, evacuated apartments, looted art caches, Allied collecting points, and exhibitions during and after the war.

COURTROOM SCREENING

At the end of the war images of art recovery circulated widely through press photographs and newsreels. At the Nuremberg trials the artworks flashed again into view alongside evidence of the crimes to which they attested. Much like the problem of human witnessing that arose in the trials, the question of how the works could speak and what they could speak about was critical for their attestation.[5] To help resolve this dilemma, their introduction to the courtroom elided the form of art-historical presentation, the legal structure of the tribunal, and the background of genocide they were asked to address.

In the Nuremberg trials the projection screen was hung perpendicular to the prosecution and the defendants and placed directly across from the press galleries. Underscoring its rhetorical and juridical importance, the historian and filmmaker Christian Delage describes the axis of projection—to screen from slide projector—as a symbolic line that separated the court and the accused.[6] While working for the Presentations Branch of the Office of Strategic Services (OSS), Dan Kiley—later one of the most prominent American landscape architects of the postwar era—designed the courtroom around this axis and as the setting for "a world spectacle trial."[7] Reading and preparing the court as a media system compelled Kiley to insert into the courtroom three glass-faced camera chambers positioned at different viewing angles from which the trial was filmed. The prosecution assembled thousands of documents related to the war crimes of the accused as evidence *in* the trial, and in turn the court produced film recordings and other documents as evidence *of* the trial. Evidence came into the court to be shown, displayed, or projected, and evidence left the trial through film records, transcripts, and published rulings.

As Delage narrates, the prosecutors intended to screen films produced by the Schutzstaffel (SS) unit that included footage of human testing, concentration camps, and forced labor.[8] While the trial was being prepared, Allied troops searched for the SS films. They learned that—along with much of the art looted by the Nazis—the films were stashed in German salt mines. The search squadron arrived to find the SS reels recently burned and largely destroyed. An Allied film crew under the American director John Ford had been shooting its own footage of the arrival of American troops at the concentration camps that chronicled their discovery of the scale of the Nazi extermination enterprise.[9] Four hours of this footage was instead screened at a pivotal moment early in the trial. The

The model of Dan
Kiley's design
for the renovation
of the Nuremberg
Hall of Justice,
the site of the
Nuremberg trials,
1945.

American film marked the importance of the projection screen within the court as a site of heightened documentary proof and evidentiary potency. It also served as a response, or as a documentary double, to the self-indictment of the missing SS films, and entered into the mediatic, evidentiary economy of the trial.

The trial was a privileged and prominent example of the architecture of dispossession. Its projection screen organized the court spatially and perceptually to link juridical vision, documentary evidence, and press exposure. Constructed as both media compiler and record generator, the court illustrated and amplified the confluence of architecture, art, and documents within the World War II narrative of dispossession. Put differently, the architecture of dispossession was built on a record-dominated foundation. Not surprisingly, this informational concentration was central to the trial in the form of records presented as evidence. It also relied upon and reflected the wider data ecology of the Third Reich. Nazi bureaucracy inherited and modernized a Prussian

obsession with files and their administrative epistemologies.[10] Census rolls processed by IBM punch-card readers located Jewish residents who were targeted and swept up by Nazi raids.[11] The merging of census data, early computation, and street addresses guided the precision of Nazi looting and deportation.

In the trial, the slides of the looted works were projected as demonstration of the crimes of Alfred Rosenberg and the Einsatzstab Reichsleiter Rosenberg (ERR), the Nazi unit tasked with acquiring the artworks for the proposed Hitler museum in Linz, Austria, and for Hermann Goering's personal collection. Rosenberg was tried not only for theft and plunder but also for a broader campaign of cultural dispossession and annihilation that would be framed in the years following the war as cultural genocide. The trial sought to illustrate that as the ERR extracted artworks, it also participated in the effort to exterminate entire cultures, especially that of the Jews of Eastern Europe. Storey attempted to give some sense of the scale of dispossession by naming the expanse of plunder and spoliation from Eastern Europe to France and beyond, and by citing the vertiginous number of works and artifacts believed to have been accumulated by the Third Reich, and their "incalculable" value.[12]

The prosecution presented the Nazi loot within the frame of its art-historical and financial value to expose the hypocrisy of the "fascist vandals" who postured as "bearers of culture."[13] Arguing that "never in history has a collection so great been amassed with so little scruple," Storey read the works as the material remnants of a vast campaign of extermination and, consonant with the prosecution's objectives, positioned the art as evidence of a general pattern of conduct.[14] Assistant Soviet Prosecutor M. Y. Raginsky continued the case against the ERR by proclaiming that "plunder and destruction were aimed at one goal only—extermination," opening a line of argument that led scholars

such as Thérèse O'Donnell to assert much later that for the Nazis "looting both presaged, and resulted from, genocide" and that "looting reified the negation of those deemed unworthy of treasures."[15]

At the Paris headquarters of the ERR—the requisitioned and occupied Jeu de Paume gallery—Rosenberg's task force had catalogued and photographed the process of Nazi plunder. These documents were assembled into albums sent to Hitler as progress reports. Whereas the SS films had been destroyed, thirty-nine of the Rosenberg albums were discovered intact and used as evidence in the trial. The slides Storey projected reproduced photographs from those albums. Their presentation on the courtroom screen may have been an issue of simple communicative utility. After all, Kiley's design integrated the screen into the courtroom as part of an evidentiary media system that organized the attention of the court and allowed documents to expand more fully into the space of the trial. Nonetheless, following soon after the screening of the Allied films of the concentration camps, the slides not only appeared on the same surface of projection, they also appeared juridically and ethically on the same plane of meaning. In the courtroom, then, three scales of the architecture of dispossession converged: the territories of pillage, the plan of the courtroom itself, and the mediatic architecture of the projection screen.

EVACUATED APARTMENTS

If one mission of the Nuremberg trials was to ensure that the works were viewed and understood as a registration of Nazi criminality, for the Third Reich the agenda was quite the opposite. The Germans willingly and consciously misread their plundered collection as a sign of aesthetic cultivation and the removal of works from homes and museums as a gesture toward the security and stewardship of Europe's cultural treasures. Where the trials served as a scene of public

exposure for the role of art within Nazi violence, in Paris, transformed by the Germans into a panorama of prodigious extraction, the architecture of dispossession hinged on private interiors and their invisible vacancy.[16]

The extent of the ERR campaign in France was summarized and analyzed by the American OSS Art Looting Investigation Unit in its 1945 Consolidated Interrogation Report no. 1. Attempting to unravel the self-serving justifications of Rosenberg and others associated with the plunder operations in France, the report reproduced and commented on a paper prepared for the German High Command that the OSS authors characterized as a "pinnacle in the literature of political treachery."[17] The terms of this treachery emerge through the ERR's formulation of a series of arguments responding to French museum officials' demand that the looting and deportation of works cease. The French officials insisted on access to German-guarded storage and permission to track and inventory art removed from museums and private collections. The German paper claimed that these museum experts must be denied such access because otherwise "the door would be wide open for French espionage."[18] Further, it argued that the French had no legitimate concern for the safety of the artworks versus the ERR and the German staff whose interest was the "safeguarding and sequestration of Jewish works of art . . . important to the preservation of European works of culture."[19]

In response to the French demand that the works remain in France, the German paper asserted that the property of Jews—or any other French citizen who fled France—was not protected under the Armistice Convention (established at the close of World War I) because of their "expatriation." Another argument defending the amassing of these collections was that if ownership were left with Jews who had fled, the works could be sold

for "planes and tanks" to combat Germany.[20]

Through the figuration of emptiness and evacuation, architecture was pulled into the OSS report—via the Nazi arguments it cites—as an active legal and rhetorical participant. When the Nazis discovered abandoned apartments and houses in Paris, they were marked and sealed by the German-controlled police for two months before their contents were extracted. Framed as a safety measure to protect valuable cultural artifacts from damage during air raids, the police marking initiated a transference of criminal associations from empty apartments read as deserted, to objects often identified as "degenerate," to their absent owners. Evacuation was interpreted as an abandonment of citizenship rights even when forced through deportation.[21] Empty apartments were recoded as sites of degeneracy and as tacit submission to new ownership and occupation laws. Just as the violence of art looting was masked by the self-fashioning of the Germans as men of culture, the concern for the safety of art masked evacuation as the direct consequence of deportation. As the apartments were emptied of bodies and artworks, their double absence testified to the ERR agenda of sweeping evacuation and extermination.

In and through the empty residences two facts become apparent. First, the Nazis used the apartments as the foundation for both a legal justification and a moral cultural justification. Second, as the art was "secured" from air raids, it was also converted into various threats, including the opportunity for espionage and military support by Jews in America. The specter of this convertibility initiated a pernicious paranoid argument, the spatialization of that argument (through the transport networks, storage locations, exhibition venues, and caches of works), and a set of rationales that facilitated the expansion of Nazi territories of control and seizure.

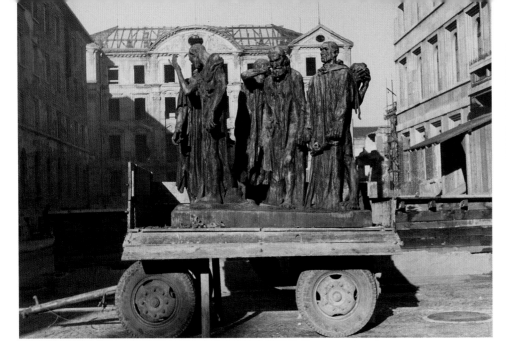

MOBILITY AND CONVERSION

The mobility of the work was clearly more than its physical movement. Plundered art and architecture moved along several axes of interpretation and signification: from emptiness to accumulation, from cultural artifact to sign of genocide, from private collection to military threat. The works moved through active channels of reconstruction and through various covert and overt methods of translation and conversion. Although architecture is generally less mobile—its mobility usually limited to the removal and carting away of insignia, ornamentation, and spolia—the architecture of dispossession skimmed along a series of redefinitions and a sequence of locales that jumped from homes to offices, synagogues, salt mines, imagined museums, and concentration camps. The architecture of dispossession was in constant semantic circulation. Yet architecture was also made, suddenly and dramatically, physically mobile through its encounter with aerial bombs and artillery. Despite the lunacy of the Germans posturing as preservationists, they were correct that much of Europe was made explosively mobile during the war.

If we were to track the movement of looted art along a map of dispersion—to castles and salt mines, including Neuschwanstein and Altaussee, where they were discovered by the Allies—it would meld into the vast logistics operation of wartime supply lines. Between April 1941 and July 1944, 4,173 crates of artworks were transported from Paris alone for storage in the six German art depots.[22] In these moments of transit and relocation, the works were indistinguishable from other wartime matériel. The scale of looting throughout the German zone of occupation confirms this transitory desublimation. Rose Valland, the heroine of the Jeu de Paume who secretly photographed and logged the French works pilfered by the ERR, recognized that the quantity of theft and the relative indifference of the ERR erased distinctions among the works. Some were carefully documented and photographed—the process that supplied Hitler and the Nuremberg trials with the thirty-nine ERR albums. Others were crated and shipped anonymously, losing all connection to owners and sometimes to artists and authors.[23] This was a conversion that stripped the stolen art of its specificity and rendered it a wartime industrial commodity.

LISTING PROTECTION AND PLUNDER

The haste, scale, and bureaucratic confusion of this relocation was in part prompted by aerial bombing and the

organization of Europe into territories exposed to or relatively safe from attack. How to protect cultural artifacts from destruction was a concern for both Germany and the Allies, even with the caveat that German notions of protection did not extend to the cultures and peoples targeted by their decimation campaigns. The Third Reich viewed protection through plunder. While acknowledging the ethical slipperiness of their position, the architectural historian Lucia Allais persuasively demonstrates that the Americans, conversely, conceived of a war fought with "battles designed to preserve."[24]

The tools of protection conceived by the American Roberts Commission were maps that identified monuments to be avoided and urban zones to be skirted during bombing campaigns. The commission comprised art historians, scholars, and curators who, in tandem with the Allied military, sought to limit the destruction of the European cultural landscape and, after the war, helped organize the return of looted art. They mapped lists that ranked European monuments and designated those to be spared. Through listing, the artworks and monuments of Europe were written into plans for destruction and survival that integrated bombing raids, buildings, and cities. These monument lists entered a general wartime scriptural economy in which they circulated with Rose Valland's secret records of stolen works, the registries of Jewish residents, and the ERR inventories of works purchased and plundered. Listing guided the fate of artifacts and the lives of those victimized and targeted. As they multiplied and intersected, these lists formed a series of cascading enumerations that connected and conjoined art object, ownership, extraction, bodies, lives taken, shifts in power in postwar Europe, the devastation of cities, and the emerging discourse on war crimes and on cultural genocide. Although their referents are materially concrete, the lists are an abstraction that allows for translation, reorganization, and reinscription. As the Nuremberg trials confirmed, they also allowed the move from accounting to accountability.

Lists of stash locations also led to astonishing newsreel footage of uniformed troops lugging art objects out of underground storage. Photographs of *The Burghers of Calais* rolling through the streets of Munich in a horse cart are arresting because they offer some insight into the preposterously vast extent of plunder and because of the sculpture's precarious mobility. Contemporary transportation and insurance protocols not only secure artworks, they also secure them *as* works. The recovery images are startling because they allow us to glimpse how the objects were seen and located immediately after the war as both art and as something other. We see the objects, momentarily, simultaneously as material documents and as art. We see them in motion between their identity as artifacts and as materializations of ledgers. We see these objects in motion but also adrift within their semiotic space of dispossession and recovery.

REENLISTMENT

As the Allied forces entered Europe, they located more than 1,800 caches of looted art. Together, the American Monuments, Fine Arts, and Archives group (MFAA, an adjunct of the Roberts Commission), their counterparts in the Allied Vaucher Committee, and the British Macmillan Commission were primarily responsible for locating

American soldiers at Schloss Neuschwanstein with recovered paintings from French collections, 1945.

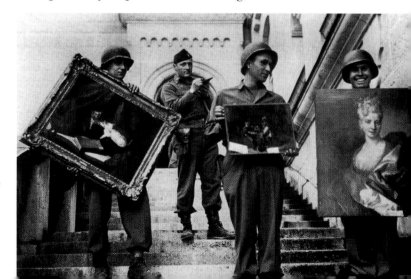

and preparing the works for return and restitution. They were also responsible for the art-historical labor of identifying and classifying. As the objects were transferred from the salt mines and other Nazi depots to one of the four Allied collecting points where they were tagged and prepared for return, they slid from list to list. At the same time, they moved into a monumental system of classification that coordinated the Allied recovery effort and that impacted postwar culture in Europe and beyond. In this sense, they also moved toward their immediate future as emblems of Allied victory and as "image[s] of redemptive beauty" amid the damage and destruction of the last phase of the war, in which vast swaths of Europe were flattened.[25]

Whereas *The Burghers of Calais* and other celebrity art pieces seemed momentarily adrift in this process of return, the architecture of the Central Collecting Point in Munich was all too obdurately fixed to its past identity. Surprisingly, given the scale of Munich's wartime demolition, two buildings on the Königsplatz built for the National Socialist Party were found relatively intact. The twin Führerbau and Verwaltungsbau, designed by the architect Paul Troost, Hitler's first favored architect, served as administrative headquarters for the party and as the Bavarian center of the "National Socialist cult."[26] The buildings had also been used by the Germans as processing stations for looted artworks on their path into Germany, as record depots for the Nazi Party, and as art-storage vaults in the last months of the war. Later, they were occupied by the Americans as stations for conducting the art-return campaign.

The American occupation of the Königsplatz complex was perhaps the most direct and legible instance of architecture's reversal within the wartime dispossession economy. Most accounts of the decision to claim the buildings focus on United States military pragmatism and relative indifference to its past use. But for the German staff and visitors, the

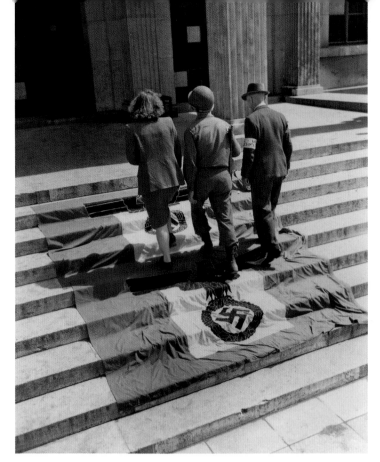

buildings were still haunted by their role as architectural propaganda pieces and remained saturated by signs of the Third Reich. As the process of return met the emerging program for denazification, the building was converted into a site from which to participate in these two campaigns and, simultaneously, in which to enact them. Hence, when the Nazi eagles, drapes, and other insignia of the Third Reich were ceremoniously removed, and when a swastika banner was symbolically trod over in a gesture of "taking" the buildings, the Führerbau and the Verwaltungsbau were not only reoccupied and recoded but were also dramatically reenlisted as American and Allied cultural agents.

In occupying these Nazi buildings, the Allies also occupied a spatial pocket of accident and imprecision. Allais argues that as the Roberts Commission's maps identified select monuments for survival it implicitly targeted others for destruction.[27] In Germany this ratio leaned toward more comprehensive obliteration

Representatives of the United States military government enter the Führerbau in Munich, 1945.

than elsewhere in Europe. That the twin Nazi buildings escaped shelling and bombing attests to the inherent indeterminacy of war technologies and armaments. The reenlistment of the buildings resulted from the postwar calculation of what had been saved, what could be saved, and what could not. Then, how to keep the buildings and dismantle the remainders of the Third Reich? At question was how the new task of cultural redistribution countered and overwrote the recent past.

The accident of the buildings' survival resonated with the survival of the artifacts pulled from the mines and returned through Munich. The reenlistment of the Führerbau and Verwaltungsbau helped frame and secure the reenlistment of the recovered artworks. When the ERR seized art collections in Paris, its staff compiled comprehensive photographic records. These ERR photographs—discovered with other Nazi inventories at Neuschwanstein, used by the Munich Central Collecting Point staff, and supplemented with new photographs where necessary—were the image foundation of the salvage operation.

Inherited ERR photographs and information cards were absorbed, written into the Central Collecting Point files, and recoded within new inventories that tracked and catalogued the artworks. The denazification of the building communicated and amplified the purpose of the work occurring within. Similarly, the labor of the MFAA team not only catalogued and relisted looted artifacts, it also overturned the recent history of the building as a plunder depot. In short, the document reinscription happening inside performed the resignification of the building as legibly as the removal of symbols and insignia from its exterior. The reenlistment of the building merged with the rewriting of documents and a counterbureaucracy that endeavored to reverse the direction and the signification of plunder and prepare it for motion once again. If at the Nuremberg trials the vast territories

of extermination, violence, and evacuation could be condensed and coded in projected images, then at Munich (and the other collecting points in Offenbach, Wiesbaden, and Marburg) the files, records, and lists that released and returned the works expanded to fill and move the objects into the newly inscribed territories of postwar geopolitics. In Nuremberg dispossession collapsed onto the plane of the projection screen in a singular scene of viewing—only one of many distributed scenes that proliferated from the Munich Central Collecting Point.

EXHIBITION THERAPY

This expansive return of looted art was also figured as a redeployment of sorts. In the newly divided Europe, organized into administration zones by the Allies and the Soviet Union, the visibility of the returned works was magnified by a series of exhibitions at the collecting points, launched almost immediately

Rose Valland's numerous travel passes serve as an index of the reorganization and jurisdictional division of Europe at the end of the war. This pass was issued by the Allied authorities on May 4, 1945, four days before the official end of the war in Europe. Valland is listed as secretary of the Commission de Récupération Artistique; under the auspices of the French army she was sent on a fact-finding mission to Füssen, a town in Bavaria near Schloss Neuschwanstein, seeking looted French art.

The big painting hall of the Museum Fridericianum, *Documenta 1*, 1955. *Composition in Front of Blue and Yellow* (1955), a large work by the former Bauhaus student and newly prominent German abstract modernist Fritz Winter, hung at the far eastern end of the gallery. It was positioned to face *Girl Before a Mirror,* an important 1932 painting by Pablo Picasso. In his text on the history of the first *Documenta,* the artist and author Ian Wallace argues that this pairing amounted to an "engineering of visual spectatorship" that ratified German modernism.

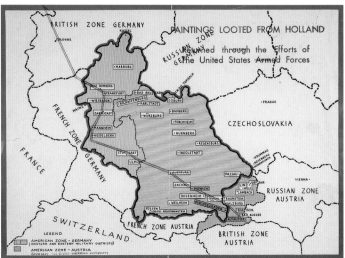

after the war. These exhibitions served multiple purposes, ranging from broadcasting the success of the Allied recovery mission to reconstructing a German exhibition-viewing audience. Initial exhibitions in Germany focused on the works of old masters in an attempt to use recovered art as a means toward recovery from the trauma of Nationalist Socialism and as a return to and continuation of prewar German culture.

A similar therapeutic exhibition effect manifested beyond Germany. The catalogue text for the exhibition *Paintings Looted from Holland* suggested that the art and "Holland's past" might offer the viewer a moment of "inner rest."[28] Subtitled *Returned through the Efforts of the United States Armed Forces*, the exhibition was conceived as an expression of gratitude to the MFAA staff at the Munich Central Collecting Point. The catalogue repeats the trope of postwar reversal through a pair of photographs: first the abandoned disarray of the collecting point with "leftover Nazi propaganda," then a well-ordered art storage vault under American command. The disorder of Europe under Nazi control and the return to order under American intervention is channeled through the Munich Central Collecting Point, representative of and synecdoche for American postwar presence in Europe and in global affairs.[29]

Other exhibitions of returned works circulating in the United States and Europe in the years after the war made similar claims about the remarkable effort undertaken to reverse dispossession. Exhibited at the Orangerie in Paris in 1946, *Les Chefs-d'Oeuvre des Collections Privées Françaises* showcased paintings that had been looted from private collections. The catalogue text written by Albert Henraux, president of the Commission de Récupération Artistique, noted the precision of the cataloguing and documenting process in Munich at the Verwaltungsbau, "the very place where all of the invasion, all the pillages were

prepared, then decided by Hitler and his men."[30]

Later exhibitions at the Munich Central Collecting Point turned toward modern art, starting in 1949, as a more emphatic expression of the reconstruction of the German political and cultural landscape and its new viewing subjects. The modern-art exhibitions were explicit responses to Nazi vilification of "degenerate" art. Sponsored by the United States military, shown at the Haus der Kunst in Munich and the Munich Central Collecting Point, these exhibitions signaled the use of art for a new political purpose in Germany—its alignment with the west—and as a different instrument for overcoming and obscuring the Nazi era. As Ian Wallace demonstrates, even by the first *Documenta* in Kassel in 1955, the connection between modern art and "un-Germanness" persisted. Strategically similar to the earlier Munich Central Collecting Point exhibitions that read premodern art as a registration of German cultural continuity in which the Nazi era was an aberration, the 1955 *Documenta* positioned modern art as authentically

THE ARCHITECTURE OF DISPOSSESSION

German. Wallace argues that for this modernist turn to take hold, the shadow of Nazism had to be both evoked and suppressed.[31]

DOUBLE VISION

Along with the German art-viewing public, modernism was reconstructed at *Documenta*, doubly coded as the future of Germany and as its recent past. Modernism in Germany split between a pre-Nazi modernism and another modernism conceived as the antithesis of Nazi aesthetic ideology. A sequence of double images formed around modernism in Germany as the expression of recovery and as the mechanism of cultural memory.

During and after the war, the architecture of dispossession was also framed by a roster of double images. By the time the photographs of plundered art flashed onto the screen in the Nuremberg trials, they were coded simultaneously as signs of Nazi criminality and as signs of recovery. On the Nuremberg screen, it was as though two images condensed and overlapped. Similarly, as returned art circulated through museums and exhibition halls in the postwar period, it appeared momentarily as both the image of atrocity and the image of therapeutic recovery. Jonathan Crary refers to different formulations of the "after-image" in the history of perception, citing how from Henri Bergson to Walter Benjamin the afterimage is seen through its retinal, psychological, and historical manifestations.[32] The afterimage lingers in the chemicals of our eyes, in the complex of personal associations, and as cultural, historical memory. The flash of the projected slides at Nuremberg excited a retinal echo and induced a form of double vision that mapped art and atrocity onto and into each other. Yet, just as retinal afterimages begin to fade, after the 1955 *Documenta* this lingering association was soon to be suppressed. In the United States the acceleration of trade in international art, some of it dislodged and put into circulation through Nazi dispossession and dubious sales, buttressed the burgeoning power and popularity of museums. The exchange between plunder and recovery was neither simple nor clean, but rather a process that left remainders and residue of restitution. These came into view through different channels and spaces, with the double vision the court induced now corrected. What persists, still, is the question of how to see past this correction and suppression to recall and reinforce the afterimage of art and atrocity and the double vision of the architecture of dispossession.

Notes

1 Peter Hayes, *Industry and Ideology: IG Farben in the Nazi Era*, 2nd ed. (New York: Cambridge University Press, 2000), xxi.

2 For a thorough description of the Offenbach Archival Depot and the process of restitution conducted there, see Elisabeth Gallas, *A Mortuary of Books: The Rescue of Jewish Culture after the Holocaust*, trans. Alex Skinner, Goldstein-Goren Series in American Jewish History (New York: New York University Press, 2019); see also the essay by Sam Sackeroff in the present volume.

3 The assessment that the Offenbach Archival Depot represented the largest collection of Jewish material in the world appeared in the Monuments, Fine Arts, and Archives report of March 5, 1946; see United States National Archives and Records Administration, College Park, Maryland, M1949, MFA&A Records, roll 3, folder OAD 2, cited in Gallas, *A Mortuary of Books*, 28. The figure of 3.5 million differs from other published estimates.

4 See Michael J. Kurtz, *America and the Return of Nazi Contraband: The Recovery of Europe's Cultural Treasures* (Cambridge, UK: Cambridge University Press, 2006).

5 Thomas Keenan and Eyal Weizman refer to the lead prosecutor Robert Jackson's decision to privilege documents over human testimony in the trials because of concern over the "bias and faulty memories of survivors." See Thomas Keenan and Eyal Weizman, *Mengele's Skull: The Advent of a Forensic Aesthetics* (Berlin: Sternberg Press, 2012), 11.

6 Christian Delage, *Caught on Camera: Film in the Courtroom from the Nuremberg Trials to the Trials of the Khmer Rouge*, ed. and trans. Ralpha Schoolcraft and Mary Byrd Kelly, Critical Authors and Issues (Philadelphia: University of Pennsylvania Press, 2014), fig. 23, n.p.

7 Dan Kiley cited in Mark Somos and Morgan Gostwyck-Lewis, "A New Architecture of Justice: Dan Kiley's Design for the Nuremberg Trials' Courtroom [April 19, 2018]," *Max Planck Institute for Comparative Public Law and International Law (MPIL) Research Paper Series*, no. 2018-04 (Rochester, NY: Social Science Research Network, April 20, 2018), https://papers.ssrn.com/abstract=3165374.

8 Christian Delage, dir., *Nuremberg: The Nazis Facing Their Crimes* (Paris: CPB Films, 2006).

9 The film screened during the trials, *Nazi Concentration Camps*, was initially known as the *Army Signal Corps Atrocity Film*. Christian Delage explains the directives the Signal Corps film crews received regarding the necessity of making "atrocities" (crimes against persons) legible and impactful in the films. At issue was the psychological preparation of the film crews for encountering the atrocities and, then, once prepared, how to record the Nazi crimes so that the films could appear as evidence in the trials; Delage, *Caught on Camera*, 85–88.

10 On Prussian files and filing systems, see Cornelia Vismann, *Files: Law and Media Technology*, trans. Geoffrey Winthrop-Young (Palo Alto, CA: Stanford University Press, 2008).

11 See Götz Aly and Karl Heinz Roth, *The Nazi Census: Identification and Control in the Third Reich*, trans. Edwin Black and Assenka Oksiloff, Politics, History, and Social Change (Philadelphia: Temple University Press, 2004), and Edwin Black, *IBM and the Holocaust: The Strategic Alliance between Nazi Germany and America's Most Powerful Corporation* (New York: Crown Publishers, 2001).

12 In the trial Storey inventoried the "21,903 Works of Art" extracted from France by the ERR, including "5,281 paintings, pastels, water colors, drawings; 684 miniatures, glass and enamel paintings, illuminated books and manuscripts; 583 sculptures, terra cottas, medallions, and plaques; 2,477 articles of furniture of art historical value; 583 textiles (tapestries, rugs, embroideries, Coptic textiles); 5,825 objects of decorative art (porcelains, bronzes, faience, majolica, ceramics, jewelry, coins, art objects with precious stones); 1,286 East Asiatic art works (bronzes, sculpture, porcelains, paintings, folding screens, weapons); 259 art works of antiquity (sculptures, bronzes, vases, jewelry, bowls, engraved gems, terra cottas)." See Robert Storey in Nuremberg Trial Proceedings, Twenty-Second Day, Dec. 18, 1945, *Avalon Project: Documents in Law, History and Diplomacy* (New Haven: Lillian Goldman Law Library, Yale Law School, 2008), vol. 4, https://avalon.law.yale.edu/imt/12-18-45.asp. These numbers are a small fraction of the full scale of ERR looting and seizure in other territories throughout the war. As for the cost, Storey may have been entirely correct that it was incalculable. At the end of the war, estimates of the value of Nazi plunder ranged from $144 million to $2.5 billion dollars; see Kurtz, *America and the Return of Nazi Contraband*, 42.

13 M. Y. Raginsky in Nuremberg Trial Proceedings, Sixty-Fourth Day, Feb. 21, 1946, *Avalon Project: Documents in Law, History and Diplomacy* (New Haven: Lillian Goldman Law Library, Yale Law School, 2008), vol. 4, vol. 8, https://avalon.law.yale.edu/imt/02-21-46.asp.

14 Storey in Nuremberg Trial Proceedings, Twenty-Second Day.

15 Thérèse O'Donnell, "The Restitution of Holocaust Looted Art and Transitional Justice: The Perfect Storm or the Raft of the Medusa?" *European Journal of International Law* 22, no. 1 (2011): 58.

16 Although the Nazi plunder campaign extended throughout Europe, the details of art theft in Paris are especially well documented, in part due to the perceived value of the French collections for the Reich and because of the careful and secret notes kept by Rose Valland, art historian and curator at the Jeu de Paume.

17 Consolidated Interrogation Report, no. 1, Activity of the Einsatzstab Reichsleiter Rosenberg in France (Washington, DC: Office of Strategic Services [OSS], Art Looting Investigation Unit, August 1945), 18.

18 Consolidated Interrogation Report, 19.

19 Hermann Bunjes, "Safeguarding of Works of Art Belonging to Jews Who Fled from Occupied France," in Consolidated Interrogation Report, attachment 9, 10.

20 Consolidated Interrogation Report, 11.

21 The status and implications of evacuated apartments were central to Assistant Prosecutor Henri Monneray's questioning of Alfred Rosenberg on the one hundred and tenth day of the trial, April 17, 1946. Monneray tied evacuation to extraction by illustrating that one result of the ERR's Paris strategy was "first to get rid of the people in order to be able afterwards to seize their property." See Henri Monneray in Nuremberg Trial Proceedings: One Hundred and Tenth Day, Wed. April 17, 1946, *Avalon Project*, vol. 11, https://avalon.law.yale.edu/imt/04-17-46.asp.

22 Consolidated Interrogation Report, 21. The six depots were located in five castles and a monastery: Schloss Neuschwanstein, Schloss Herrenchiemsee, and Kloster Buxheim in Bavaria; Schloss Kogl and Schloss Seisenegg in Austria; and Schloss Nikolsburg (Mikulov Castle), now in the Czech Republic. The transport required 138 freight trains from Paris.

23 See Consolidated Interrogation Report, 15: "The manner in which collections of works of art were obtained by the Einsatzstab in its early stages of activity is described by all informants as chaotic." The report includes descriptions of crates of seized art packed by "irresponsible men" arriving to the Jeu de Paume at such a pace in 1940 and 1941 that they could not be properly inventoried. These works and their sources were often simply marked "unknown." This imprecision contrasts with attempts to fastidiously mark, inventory, and photograph every piece brought to the Jeu de Paume and acquired for the Reich. Hence, ERR art acquisition in Paris oscillated between that art pushed through the Nazi supply line as unknown matériel and specific and famous pieces carefully photographed, recorded, and destined for exhibition or collection by Goering or Hitler.

24 Lucia Allais, *Designs of Destruction: The Making of Monuments in the Twentieth*

Century (Chicago: University of Chicago Press, 2018). See particularly chapter 2, " 'Battles Designed to Preserve': The Allies' Lists of Monuments in World War II," 87. Allais refers to the two Letters on Monuments (1943, 1944) written by Dwight D. Eisenhower, Supreme Commander of the Allied Expeditionary Forces, and reads them as a guide to shifting Allied policy on monuments, cultural preservation, and the transfer of "art-historical knowledge" to "military information"; 89.

25 Allais, *Designs of Destruction*, 159.

26 Iris Lauterbach, *The Central Collecting Point in Munich: A New Beginning for the Restitution and Protection of Art*, trans. Fiona Elliott (Los Angeles: Getty Research Institute, 2018), 52. Lauterbach carefully traces the restitution work performed at the Munich Central Collecting Point and the evolution of the building from Nazi headquarters to Allied restitution center to its current use as home of the Zentralinstitut für Kunstgeschichte (Central Institute for Art History), founded in 1946.

27 On the process by which decisions were made about destruction and preservation, see Allais, *Designs of Destruction,* ch. 2, "Battles Designed to Preserve," and ch. 3, "Unwitting City Planning."

28 *Paintings Looted from Holland: Returned through the Efforts of the United States Armed Forces; A Collection to Be Exhibited in . . . Ann Arbor, Michigan, Baltimore, Maryland, Buffalo, New York [Etc.]*, exh. cat. (Washington, DC: National Gallery of Art, 1946), 15, 11.

29 In further gestures of gratitude, the catalogue lists the MFAA members who helped in the recovery operations, and the exhibition traveled to museums where they worked. This gratitude was confirmation of the American belief that restitution was an important and necessary political and public-relations act. It also reveals the surprising prominence of the MFAA in American postwar museums.

30 Albert Henraux, *Les Chefs-d'Oeuvre des Collections Privées Françaises, Retrouvés en Allemagne par la Commission de Récupération Artistique et les Services Alliés*, exh. cat. (Paris: Commission de Récupération Artistique, 1946), iv.

31 Ian Wallace, *The First Documenta, 1955 / Die Erste Documenta, 1955*, 100 Notes, 100 Thoughts 2 (Ostfildern, Germany: Hatje Cantz, 2011), 5.

32 Jonathan Crary, "Spectacle, Attention, Counter-Memory," *October* 50 (Autumn 1989): 103.

THE HISTORY OF GERMAN ART POLITICS

FROM 1933 TO 2019, TOLD IN TEN EXHIBITIONS

Julia Voss

In 1913 Aby Warburg purchased a painting by Franz Marc with funds bequeathed to him a few years before by his brother-in-law, who had died young. The bequest came with the recommendation that he "treat himself to something he could take personal delight in." Warburg was not an art collector and is on record as saying that his luxury was his library. The thousands of books he acquired each year left him with no time to indulge any other passion. For Marc's painting, however, he made an exception. The work, *Mare with Foals*, was being offered by the Hamburg art dealer Ludwig Bock & Sohn at a time when no one could have predicted that work by members of the Blaue Reiter group would one day become museum pieces. Warburg's decision initially met with criticism from his colleagues, who regarded the acquisition as an unnecessary expenditure. They subsequently revised this view, however, leading Warburg to comment later, "It's exactly the same as back then with the purchase of the Marc picture. Whereas at the time it was considered a 'waste,' now they all want it to have been them."[1]

For many years, the art historian kept the painting as his private property, but in 1926 he gave it to his new institute, the Kulturwissenschaftliche

Bibliothek Warburg at 116 Heilwigstrasse, Hamburg. He intended it to have a prominent position in his cultural studies library. Marc's horses were to hang above the entrance to the reading room, reached from the lobby after one passed through a foyer door with the legend *mnemosyne* (Greek for "memory") carved in stone on the lintel. Thus image was to follow upon inscription, the contemporary upon the antique, contemplation upon memory.

This plan was never realized, however. Aby Warburg died in 1929, and in December 1933 his library, complete with all its shelving and catalogues, had to be shipped to England on two freighters in order to secure it from the Nazis. This led to the founding of the Warburg Institute in London. Marc's painting was separated from the library and sold, at an unknown date, by Warburg's son-in-law Peter Paul Braden. In 1953, after two further changes of ownership, the work was acquired by the Bührle collection in Switzerland.[2]

Warburg could not have known that his institute would need to be uprooted and that his concept of *Nachleben* would come to apply to the history of his own library and the painting he had chosen for it. In his own lifetime he had followed the growth of fascism

The reading room of the Kulturwissen- schaftliche Bibliothek Warburg, Hamburg, February 1927, displaying Aby Warburg's panels of images arranged in sequences to illustrate their "afterlife"—the persistence and metamorphosis of cultural ideas from antiquity to the present.

Franz Marc, *Mare with Foals,* 1912 Oil on canvas, 29⅞ × 35⅜ in. (76 × 90 cm) Private collection, Switzerland

closely, and early on had subjected the public appearances of the Italian dictator Benito Mussolini to iconographical analysis.[3] Nevertheless, the waves of murder, violence, and destruction later unleashed by the Nazis surely exceeded anything he could have imagined.

Nachleben can be translated as either "survival" or "afterlife," and Aby Warburg's cultural possessions were to experience both. His library and the painting were placed in great peril by the Nazi regime but survived, embarking in exile upon an afterlife that has lasted to the present day and continues to endure and flourish. Warburg's belongings share this history with millions of other cultural artifacts, both artistic and religious, that had to be moved

abroad during the Nazi period or were snatched from their Jewish owners in acts of theft, blackmail, and murder. The disrupted nature of their history is nowhere more visible than in the exhibitions in which, from 1933 to the present day, art and cultural objects have been brought together—first for the eyes of thieves and murderers or fellow travelers and opportunists, later for unsuspecting art lovers, and ultimately for individuals demanding justice and a reckoning with the past. An exhibition can serve to present and display objects, but its purpose may also be to deflect the gaze in order to conceal. I propose to tell this Janus-faced story in ten episodes.

1. AN EXHIBITION AT THE GERMAN MINISTRY OF PROPAGANDA IN BERLIN, 1933

In the summer of 1933 an ambitious exhibition opened at the Ministry of Propaganda for the benefit of just two viewers: Adolf Hitler and his propaganda minister, Joseph Goebbels. The initial idea and concept came from Hans Weidemann, an artist and advisor to Goebbels. The show was held in the ministry's Schinkelsaal, a room accessible only to government employees, and comprised five works: one each by Emil Nolde, Ernst Barlach, Erich Heckel, Wilhelm Lehmbruck, and Karl Schmidt-Rottluff. It is not known which particular works by these artists were selected. Weidemann had borrowed them either from the artists themselves or from their gallerists or collectors. With this show, Weidemann had intended to bring the dictator around to a positive view of German Expressionism, the artistic movement that included, most prominently, the Brücke group and also Franz Marc and August Macke of the Blaue Reiter. Looking back after 1945, Weidemann claimed to have "already convinced" Goebbels.[4]

This exhibition had been preceded by rapid, drastic changes in Germany's cultural life. In April 1933, a few months after the Nazi takeover of power, the so-called Law for the Restoration of a Professional Civil Service had been enacted in order to remove Jews and political undesirables from office. Consequently, the Jewish art historian Georg Swarzenski had to resign as director of the Städtische Galerie in Frankfurt, and in Hamburg Erwin Panofsky was stripped of his professorship. In total, more than thirty museum directors were dismissed. The following month the German Students' League called for book burnings. In numerous university towns, pyres were lit into which the works of Jewish authors and writers who had taken a political stance against Nazism were thrown, including those of Carl von Ossietzky, Kurt Tucholsky, Erich Maria Remarque, Karl Marx, and Sigmund Freud. July saw the founding of the Kulturbund Deutscher Juden (Cultural Federation of German Jews), an effort by Jewish cultural workers to provide their colleagues in the fields of music, art, and theater with opportunities to work, exhibit, or perform in this newly restricted environment. From the outset, the organization was subjected to repeated acts of repression until it was broken up for good by the secret police, the Gestapo, in 1941.[5]

Even before 1933, however, a heated debate had erupted over German Expressionism and its position within the nation's cultural life. Weidemann hoped this could be decided once and for all—and at the highest level—by his exhibition. On the one hand the Expressionists had been subjected to repeated hostility over the preceding years, accused of emulating an "un-German"—indeed, French—style, as were many other artists who had turned their backs on an academic style of painting. On the other, an increasing number of voices in the conservative and even *völkisch* (nationalist) camps argued that Expressionism merited a special and favored position within the avant-garde and in German culture on the grounds that it drew from a Gothic stylistic tradition and was the expression of a northern sense of form. Weidemann wanted to convince the leader of this position and win him over to Expressionism. In this he was unsuccessful. Hitler, he recalled, "did not even look at the exhibition but simply threw me out."[6]

2. THE PROPAGANDA SHOW *ENTARTETE KUNST* IN MUNICH, 1937

When the exhibition *Entartete Kunst* (*Degenerate Art*) opened in Munich in 1937, it became apparent that the defenders of German Expressionism had achieved little during the intervening four years. Six hundred paintings and sculptures were crammed into the galleries, including works by Franz Marc, Ernst Ludwig Kirchner, Wassily Kandinsky, Otto Freundlich,

Max Ernst, Paul Klee, Marc Chagall, and Emy Roeder. Among them were forty-eight works by Emil Nolde alone—the best-known member of the Brücke group. The exhibition venue was the Archäologische Institut, which occupied two stories of the Hofgarten arcades. A collection of plaster casts of antique sculpture on the first and second floors was moved out to make room for the denunciatory exhibition, with additional partition walls installed to accommodate the mass of objects as well as to hide the rooms' original decoration and paint-work. Inflammatory slogans, some daubed directly onto the walls, told the viewers what to think of the artworks on display. The pictures and sculptures had all been confiscated from German museums—in some cases over the objections of the directors, in others with their active support.[7]

To promote an impression of chaos and overload, the works' frames and plinths were often missing. The wall texts decried the purchase of these artworks as an alleged waste of taxpayer money; to exaggerate this, the purchase prices were denomi-nated in the exorbitant inflationary sums that had been the norm prior to the introduction of the Reichsmark, and deliberately not converted.[8] The artist Karl Schmidt-Rottluff, a founding member of the Brücke group, expressed astonishment at the exhibition: "That Adolf Hitler would take such a firm position after he had avoided doing so for so long is surpris-ing and could not have been foreseen."[9]

Although it appeared to pillory modern, antiacademic styles of art, most importantly the exhibition car-ried forward the Nazi regime's racist cultural policies. In the title *Entartete Kunst*, the organizers had chosen a battle cry that sought to interpret artistic form as an expression of eth-nicity. This correlation was drummed into visitors again and again. Thus the sculpture *Large Head* by the Jewish sculptor Otto Freundlich was placed in a vestibule on the ground floor at the beginning of the route, with a

malicious comment in the exhibition guide: "Here among other things is 'The New Man,' as dreamt up by the Jew Freundlich."[10]

Of the exhibited artists only a minority were Jewish, including Freundlich, Jankel Adler, Ludwig Meidner, Hans Feibusch, Lasar Segall, and Marc Chagall. However, works by non-Jewish artists were also called Jewish. "German peasants—a Yiddish view" was the slogan written on the wall above Kirchner's *Peasants' Meal* (1920) and Schmitt-Rottluff's *Evening* (1912), while the wall text relating to Nolde's *Nudes with Eunuch (Harem Guard)* (1912) and Otto Mueller's *Gypsy Woman* (c. 1926) read "The expression of the Jewish yearning for the desert."[11]

In a speech given around the same time, Adolf Hitler held the Jews

The cover of the gallery guide for the *Degenerate Art* exhibition in Berlin, 1938, featuring Otto Freundlich's 1912 sculpture *Large Head*.

explicitly responsible for this "degeneracy" by

> appropriating the means and institutions . . . that form public opinion, thereby ultimately gaining control over it. By exploiting their position in the press, the Jews, with the help of the so-called art critics, succeeded not only in gradually befuddling people's natural ideas about the essence and purpose of art, but above all in destroying the widespread healthy response to it.[12]

Hitler's address was given for the opening of the *Grosse Deutsche Kunstausstellung* (*Great German Art Exhibition*), the propaganda counterpart to *Entartete Kunst*. German art loyal to the party line was shown just a few minutes' walk from the Hofgarten arcades in the magnificent spaces of the newly built Haus der Kunst, the works spruced up and handsomely framed or set on plinths and presented against whitewashed walls.[13] Nobody who saw even one of the two exhibitions in Munich could fail to understand their purpose: to promote Nazi racial policy.

This goal had already been promoted for almost five years by the Reichskammer der Bildenden Künste (Reich Chamber of Fine Arts), founded in November 1933 and overseeing all aspects of art, from production to trade. Applicants for membership were required to present a certificate of Aryan origin, while Jews were barred from joining as a matter of principle—an exclusion that amounted, for artists, to a ban on working. This debarment also extended to the art market. By 1935 most Jewish gallerists, dealers, and auctioneers in Germany had had to cease business as a result of not being able to join the professional body. Moreover, when the Nuremberg Race Laws were passed that same year, numerous Jewish collectors were compelled to auction or sell off works. Together with this avalanche of discriminatory laws and decrees came boycotts, defamation, and violent attacks sponsored by the state, with the aim of "Aryanizing" Jewish property and businesses.[14]

Some two weeks after the opening of *Entartete Kunst*, a letter of complaint was sent to Bernhard Rust, the Minister of Science, Education, and Culture. Its author was the painter Emil Nolde, a member of the Reichskammer der Bildenden Künste and since 1935 of the Nazi Party as well. Nolde protested the inclusion of his artworks in the exhibition, taking the same line as Hitler: his art was "strong, healthy, and heartfelt," he declared. He distinguished himself from the element of society that, in his view, should be seen as harmful to art: "In the years around 1910 I was more or less the only German artist doing battle with the shady art mongers, with the foreignizing of German art, and with the power of the likes of Liebermann and Cassirer—and I lost."[15]

Nolde was not alone in protesting. The German Officers' Association condemned the defamation of Franz Marc, killed in action as a frontline soldier in the First World War. Included in the exhibition was Marc's famous work *The Tower of Blue Horses* (1913), painted a year after Warburg's *Mare with Foals*. The officers demanded, successfully, that Marc's paintings be removed from the show. The exhibition proved extremely popular, and at the end of its run in Munich, it was sent on tour.

3. THE TOURING *ENTARTETE KUNST* EXHIBITION, 1938–41
By the time the touring version of *Entartete Kunst* opened in its second venue, Berlin, it had changed considerably. In addition to the removal of Marc's paintings, the works of various other artists, including Ernst Barlach, Lovis Corinth, Käthe Kollwitz, Wilhelm Lehmbruck, and August Macke, had also vanished from the show. The profile of the exhibition and its propagandistic message were given a sharper focus. Politically engaged artists were now targeted and the racial hatred intensified. An image of Freundlich's *Large Head*

was moved from inside the exhibition guide to the title page. A new wall slogan read: "The 'masters' of decadent art praised to the skies by Jews and the hysterical twitterers!" A new section was added in which more than a hundred works from the Prinzhorn Collection were shown. These were pictures and sculptures created by psychiatric patients and collected by the doctor and psychiatrist Hans Prinzhorn, who had died in Munich in 1933.

On December 6, 1938, Emil Nolde sent another letter, this time to Otto Dietrich, the Reich press chief. Once again he explained that his art should not be regarded as "degenerate" and again took a stance against Jewish dealers and collectors. This time his protest produced an immediate reaction: just two days later, the Ministry of Propaganda issued a press release confirming that Nolde was "no Jew," but indeed a member of the Nazi Party. At the end of the year his works were removed from the *Entartete Kunst* exhibition and by spring 1939 there was no further mention of his name in connection with it.[16]

On the other hand, Alfred Flechtheim, a Jewish art dealer, gallerist, and publicist who had been forced to flee Germany in 1933 and died in London in March 1937, was added. In 1938, when *Entartete Kunst* was shown in the Festspielhaus in Salzburg, a life-size photograph of Flechtheim was displayed alongside Freundlich's sculpture *Large Head*, an arrangement that was retained at the exhibition in Stettin.

Somewhere between one tour venue and another, Freundlich's plaster sculpture was destroyed, although exactly when is not known. This is because the press frequently published photographs previously supplied by the Ministry of Propaganda. By 1941 at the latest, however, two years into the Second World War, when the exhibition arrived in Beuthen (present-day Bytom, in Poland), the Freundlich on view was a replica. A newspaper photograph reveals a sculpture that differs

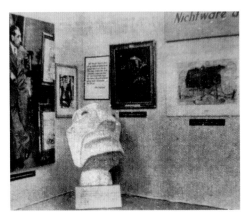

Freundlich's *Large Head* on view in the *Degenerate Art* exhibition at the Landeshaus, Stettin, 1939. The art dealer Alfred Flechtheim appears in a life-size photograph at left. On the walls are works by Ernst Ludwig Kirchner, Ludwig Meidner, and Emil Nolde, among others.

appreciably from the original around the eyes and mouth. The propaganda value of the sculpture was so great that the Nazis were reluctant to dispense with the work and therefore had a fake made.[17]

This work, on whose vilification so much energy was expended, had originally belonged to Anna Blumfeld, a Hamburg cousin of Aby Warburg. After Blumfeld's death in 1930, her son presented it to the city museums, from whence it was confiscated on July 5, 1937. Freundlich was arrested in France in February 1943 and deported to the Sobibor extermination camp. His precise date of death is unknown.[18]

4. EXHIBITIONS FOR HERMANN GOERING IN THE JEU DE PAUME

Exclusion, denigration, and destruction formed one pillar of Nazi cultural policy; theft, murder, and self-enrichment the other. June 1938 saw the establishment of the so-called Führervorbehalt policy, which gave Hitler first pick of all the collections plundered in Austria as a direct result of the country's forcible annexation. The stolen objects were to form the basis of the planned Führermuseum, Hitler's megalomaniacal museum project destined for the Austrian city of Linz. Further works were pillaged in Germany in November, when Jewish homes, institutions, and synagogues were raided during the Kristallnacht pogrom. In 1940, following the German invasion and occupation of France, the plundering continued there, and in all the occupied regions. A special

unit was set up, the Einsatzstab Reichsleiter Rosenberg (ERR), with the express task of organizing and carrying out this spoliation.

The enormous volume of looted property presented the Nazi occupiers with space problems. They initially used rooms in the German embassy in Paris and the Louvre for storage; later the stolen items were transferred to the Jeu de Paume gallery, whose central location offered easy access for shipping trucks. From June 1940 to November 1942, Reichsmarschall Hermann Goering traveled to Paris twenty times to select artworks for himself and for Adolf Hitler at the Jeu de Paume. These were earmarked for either the Führermuseum or Goering's monumental private villa Carinhall (named for his deceased first wife) at Schorfheide, not far from Berlin. To give him a rapid overview, personnel were instructed to arrange the works in exhibitions. The staff at the Jeu de Paume included the Frenchwoman Rose Valland, a curator at the museum who was kept on by the Nazi occupiers and who, over the following years, maintained a secret register listing the provenance of the works delivered there. Whenever she could obtain the information, she recorded the names and addresses of the dispossessed owners. Valland was also a witness to the shows put on at the Jeu de Paume

for Goering's benefit. Regarding his first visit, she wrote:

> Goering looked at all the paintings one by one, taking an interest in each. The fortunes of war were placing at his mercy some of the most famous paintings by Rembrandt, Teniers, Vermeer, Renoir, and Gauguin. Such a show for him alone! Had the Reichsmarschall not been dazzled by this first exhibition, it seems likely that the history of Rosenberg's unit and the confiscated art would have taken a different course.[19]

Each time Goering visited the Jeu de Paume, he instructed the staff to put together another exhibition of confiscated works for him. The same division was implemented in the gallery's rooms that had previously been used in Munich in 1937, when "degenerate" art had been shown in the Hofgarten arcades and state-approved works at the Haus der Kunst. Goering was mainly interested in old-master paintings and medieval wood sculptures, which were presented to him in rooms separated from the "decadent" art. A record of stolen goods put aside for Goering was maintained by members of the ERR. Those in charge of the presentations at the Jeu de Paume were ERR section chief Kurt von Behr and the art dealers Walter Andreas Hofer and Bruno Lohse, who was

also a captain in the Waffen-SS, the Nazis' paramilitary force. Their task was to transform the den of thieves that the Jeu de Paume had become under their auspices into a treasure chamber for their boss. The items selected by Goering during his inspections were loaded onto special trains, four of which stood at his disposal for the transporting of art to Germany. During the occupation of France the ERR amassed some twenty-two thousand artworks from more than two hundred Jewish collections.[20]

5. THE ROOM OF THE MARTYRS

The two photographs (see page 20) of the so-called Room of the Martyrs in the Jeu de Paume give an idea of the vast number of modern artworks that were stolen or stockpiled in order to be exchanged for old masters or sold to raise foreign currency. They show the walls plastered from floor to ceiling with paintings, and even the display stand set up in the middle of the room is stacked with double rows of pictures. Also visible is a curtain concealing a door, apparently with a window in it. This prevented anyone seeing into the room from the outside, since the ERR attached great value to secrecy. The Room of the Martyrs was on the second floor of the Jeu de Paume, isolated at the end of a long corridor.

By contrast with the *Entartete Kunst* exhibition, however, most of the works were left in their opulent frames and a comparatively homely atmosphere was created, with carpets on the floor. The purpose of the Jeu de Paume display differed from the Munich exhibition. This art was not simply thrown on view for the consumption of a whipped-up mob; it was consigned to a hand-picked coterie of dealers charged with monetizing the stolen items. In the Room of the Martyrs, the value of the loot was assessed by well-connected specialists whose aim was to generate as high a profit as possible, and who did not care where the goods had come from. The process had already been tested with the confiscations in Germany of paintings, sculptures, and graphic works

deemed "degenerate." In 1938 four art dealers had been tasked with selling such works abroad. In June 1939 an auction had been held in Lucerne, conducted by the Swiss art dealer Theodor Fischer on behalf of the Nazis, into whose coffers the best part of the proceeds flowed.[21]

There were no wall slogans in the Room of the Martyrs. All hints of who the rightful owners might be were deliberately obliterated. Instead they were given inventory numbers in the ERR register. For example, UNB 353 was Henri Matisse's famous painting *Seated Woman*. UNB stood for *unbekannt*, unknown, and was thus the code for a lie. The ERR had stolen the painting from the art dealer and gallerist Paul Rosenberg, whose property had been systematically plundered from 1941 onward—first his safe-deposit box and holdings in Floirac in southern France, then repositories in Libourne and Paris. A total of 337 works were stolen. In September 1940 Rosenberg managed to escape via Spain to New York. Matisse's *Seated Woman* was not found again until March 2012. The stolen painting was discovered in a Munich apartment, part of a cache of works amassed by the Nazi art dealer Hildebrand Gurlitt and subsequently bequeathed to his son Cornelius. *Seated Woman* was returned to Paul Rosenberg's heirs in 2015, seventy-five years after it was stolen.[22]

6. EXHIBITIONS AT THE CENTRAL COLLECTING POINT IN MUNICH

When the Allies brought the war to an end in May 1945 and divided Germany into four occupation zones, the enormous scale of the organized plundering of art became apparent. Previously there had been only horrifying rumors and isolated reports. It was now possible to gain an overview of what had been going on, as the Nazi storage depots began to be discovered, many of them in the American sector. Items amassed by the ERR were found, for example, in Schloss Neuschwanstein and at the monasteries of Buxheim

THE HISTORY OF GERMAN ART POLITICS

and Herrenchiemsee. Special trains, in which Goering had attempted as late as February 1945 to transport works from Carinhall to southern Germany were found standing in tunnels at Berchtesgaden, where they had been parked out of the way of bombing raids.[23]

In order to be able to view and organize the vast quantities of stolen goods, and ultimately return them to their rightful owners, the Americans established a new authority, the Central Collecting Point (CCP). The CCP ran three sites, at Marburg, Wiesbaden, and Munich. Its headquarters was in the Verwaltungsbau, the former administration building of the Nazi Party, on Munich's Königsplatz. "The palace of darkness became a castle of light," announced the information bulletin of the United States Office of Military Government for Germany.[24]

The first restitutions, in August 1947, were to museums in Venice, Florence, and Naples. It was discovered that many works had been badly damaged during their confiscation by the Nazis. An antique bronze roebuck from the Museo Archeologico Nazionale in Naples had had its ears and legs broken off and the *Seated Hermes* from Pompeii was missing its head, which had shattered into sixty-two fragments (see page 172).[25] To momentarily pay the objects the attention and respect they had enjoyed before they were looted, the CCP staff began to organize exhibitions. In summer 1947, for example, three paintings were displayed in the Bibliothekssaal. Two were from the Museo Nazionale di Capodimonte in Naples: Titian's *Danaë* and *The Parable of the Blind Leading the Blind* by Pieter Bruegel the Elder. The third work, at the center of the display, was Bartolomé Esteban Murillo's *Santa Rufina*, which had been stolen from the Rothschilds in Paris in 1941. In a photograph that captures this small meeting of three masterpieces, the unframed paintings, admired by a solitary viewer, are propped on chairs, waiting to be packed for shipment.

When photographing at the CCP for the magazine *Heute* in April 1946, Herbert List called the facility a "museum without visitors."[26] Although it was true that there was no access for the public, the photographer's description was not quite accurate. More than a hundred members of staff, Americans as well as Germans, were at work there unraveling the Nazi art thefts. Furthermore, representatives from France, Holland, Belgium, Czechoslovakia, Austria, Greece, and Hungary were invited by the United States authorities to occupy offices at the center while helping to investigate the provenance of the artworks. Together, all these constituted the audience for the modest exhibitions that were put on for a few days at a time. Rose Valland, the Jeu de Paume curator who had secretly compiled lists of the origins of stolen works, also visited the Munich CCP in 1945 and the following year Wiesbaden, where she was photographed with the art historian Edith A. Standen (see page 65).[27]

7. *DOCUMENTA 1* IN KASSEL, 1955

Once exhibition activity resumed in the postwar years, the German museums focused their attention primarily on the works and artists previously condemned as "degenerate." Art once proscribed became the new state art. In September 1949, the founding year of the Federal Republic of Germany, the exhibition *The Blaue Reiter: Munich and the Art of the Twentieth Century* opened in Munich.

Recovered artworks on view in the library of the Munich Central Collecting Point, summer 1947. Titian's *Danaë* (1544–45, left) and Pieter Bruegel the Elder's *Parable of the Blind Leading the Blind* (1568, right) were looted from the Museo Nazionale di Capodimonte, Naples; Bartolomé Esteban Murillo's *Santa Rufina* (c. 1665, center), was stolen from the Rothschild family in Paris.

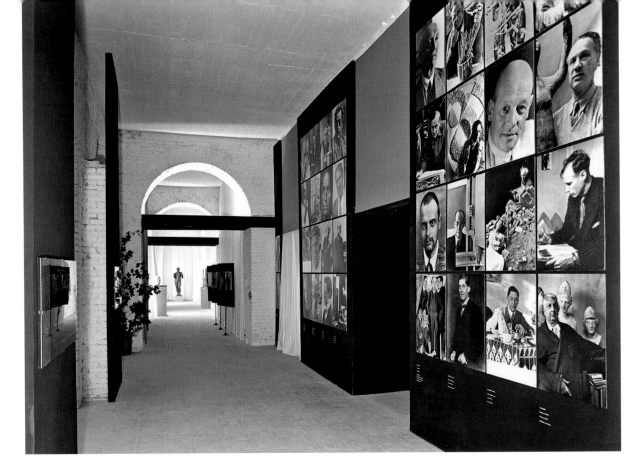

In keeping with the nature of the event, the venue chosen was the Haus der Kunst, the erstwhile temple to Nazi artistic ideology, where an annual exhibition of "Germanic" artistic production, the *Grosse Deutsche Kunstausstellung*, had been held from 1937 to 1944. The Blaue Reiter group was now presented as the international movement Aby Warburg had considered it to be, with paintings by Wassily Kandinsky, Franz Marc, August Macke, Paul Klee, Alexej von Jawlensky, Gabriele Münter, Marianne von Werefkin, and Robert Delaunay. This Munich gesture established a precedent, serving over the following years as a model for other exhibitions. In 1950 the German Pavilion at the Venice Biennale again showed works by the Blaue Reiter artists, and in 1952 it was the turn of the Brücke group. In 1955, the inaugural *Documenta* opened its doors in Kassel, again showcasing modern art.

The more modern art was exhibited, the more a pattern developed. Of the thousands of individuals who had disappeared from Germany's artistic life during the Nazi period, only a small minority were commemorated. There was little mention of Jewish museum directors or curators, of Jewish dealers, gallerists, collectors, or patrons, or of Jewish artists, critics, or art historians. The absence of these was passed over without a word. Instead, the act of remembering focused unwaveringly on the group of German Expressionists whose works had been shown in the initial incarnation of *Degenerate Art* in 1937, with Emil Nolde in the vanguard. Nolde's failed effort to ingratiate himself with Nazi cultural policy makers was now reconstrued as an "internal emigration." In his preface to the 1955 *Documenta* catalogue, the art historian Werner Haftmann described the life of artists under the Nazi regime: "The artist went underground, painting in laundry rooms, modeling in dilapidated factories, and nourishing himself like the lilies of the fields."[28]

This romantic depiction of the artist's life left out of the picture those

Portrait photographs of German artists in the entrance hall of the Museum Fridericianum for the *Documenta 1* exhibition, 1955.

THE HISTORY OF GERMAN ART POLITICS

artists, men and women, who faced deportation to the concentration camps. It did not acknowledge the murdered artist Otto Freundlich or take into account the systematic plundering, expulsion, destruction, and killing by the Nazi regime. That Werner Haftmann had joined the Nazi Party himself in 1937, a few months after the *Degenerate Art* exhibition had opened, has only recently been discovered.[29]

As the visitors to *Documenta* streamed into the foyer of the Fridericianum in Kassel, they encountered a photographic wall featuring blow-up portraits of modern painters and sculptors dressed in either a suit and flannel shirt or the kind of white coat worn by scientists. The previously ostracized avant-garde had returned as members of a conservative gentlemen's club. Women were absent, as were any artists gassed by the Nazis as part of the euthanasia program, such as the Expressionist painter Elfriede Lohse-Wächtler.[30] Well-known Jewish modern artists, such as Jankel Adler, Felix Nussbaum, Gert Wollheim, Ludwig Meidner, and Otto Freundlich, were nowhere to be seen. One exception was Marc Chagall, who had managed to escape from France to the United States with the help of Varian Fry and the Emergency Rescue Committee and had thus survived the Holocaust. From the reactionary side, the modernists were still being accused of undermining society and bringing about the "loss of the center," in the phrase of the art historian Hans Sedlmayr—another former Nazi Party member—in a 1948 book.[31]

Out of this confused situation sprang the Janus-faced cult of the modern in postwar Germany. On the one hand modernism had to withstand accusations that simply perpetuated the Nazi invective; on the other, the Nazi involvement of many outstanding proponents and exponents of modernism came back to haunt them after 1945, making them keen to whitewash their past.

The transfiguration was consummated at *Documenta 3* in 1964. When

it opened, Werner Haftmann continued to hold a position of art-historical responsibility in Kassel. In a room apart he showed thirty small-format watercolors by Nolde, who had died in 1956. Haftmann had invented the term "Unpainted Pictures" for these works, along with the narrative that Nolde had created them in secret, in the hope of one day being able to execute them in oil on canvas, despite having been banned from painting in 1940. This has recently been exposed as a myth. In 1941 Nolde was expelled from the Reichskammer der Bildenden Künste after his tax return revealed him to be one of the top-earning German artists. His record years for sales had been 1937 and 1940. His expulsion meant that he was forbidden to exhibit or sell his work. He was not prohibited from painting, nor were there any spot-checks by the Gestapo, a story invented by Nolde after 1945.[32] The artist remained an ardent supporter of the regime to the very end of the war, and regarded himself as sorely misjudged.

8. THE HILDEBRAND GURLITT COLLECTION ON TOUR, 1956

Just how pronounced was the continuity within the art world before and after 1945 is demonstrated by an exhibition entitled *German Watercolors, Drawings and Prints, 1905–1955*, which toured the United States in 1956. This exhibition brought together 112 works on paper. The name of its biggest lender featured prominently in the title of the catalogue: Hildebrand Gurlitt, then director of the Kunstverein (Art Association) for the Rhineland and Westphalia in Düsseldorf.[33] For the touring exhibition he loaned pictures by Max Beckmann, Ernst Ludwig Kirchner, Wassily Kandinsky, and Erich Heckel. Gurlitt had been one of the four art dealers invited by the Nazis in 1938 to sell "degenerate" art abroad.

Now he sought to put a new slant on the services he had performed for the Nazi regime, wanting to be seen as having "rescued" proscribed

Hans Haacke, *Manet Project '74,*
installed at Galerie Paul Maenz,
Cologne, 1974
Ten panels in black frames under
glass, each 31½ × 20½ in. (80 ×
52 cm), and a color reproduction
of Manet's *Bunch of Asparagus*
in its museum frame (photograph
by Rolf Lillig), 32⅝ × 36⅝ in.
(83 × 93 cm) Museum Ludwig,
Cologne

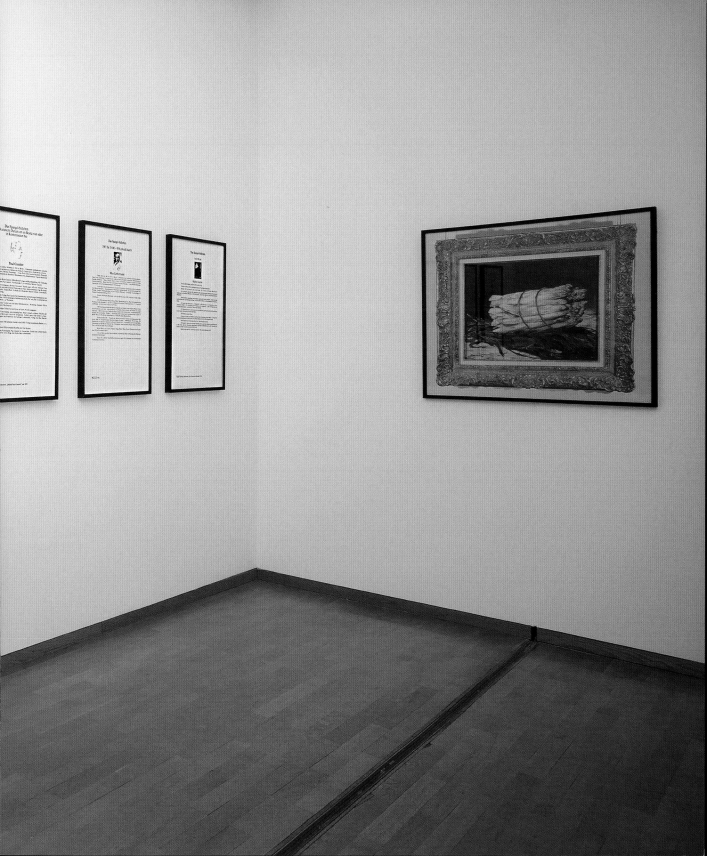

works. As early as 1950 Gurlitt had lied about his involvement in Nazism and had been able to reclaim more than a hundred works seized by the Americans. He kept quiet the fact that in 1943 he had risen to become one of the most important art dealers for Adolf Hitler's Führermuseum in Linz. Nor did he reveal that since the war he had been dealing in stolen works, and that many—including Matisse's *Seated Woman* from the Paul Rosenberg collection—remained in his possession. Radically distorting the facts, he wrote in a foreword to the catalogue: "I regard the collection, which, after so many perils, has, I can only say, devolved back to me unexpectedly, not as my own property, but as a kind of fief, given to me that I might do something worthwhile with it." His past was only discovered, and his career reappraised, long after his death, when his son Cornelius's collection was exposed in 2013 as including numerous stolen artworks.[34]

In the 1950s restitutions were still being bitterly resisted in the German art world. In 1952 West German museum directors composed a memorandum demanding the "setting of a proximate date for the end of restitution" and the "immediate cessation of all restitutions of objects acquired on the open art market."[35]

9. HANS HAACKE'S *MANET PROJECT '74*
Almost two decades later, in Cologne, a critical voice rose from an unexpected quarter. The conceptual artist Hans Haacke was invited by the Wallraf-Richartz Museum to participate in *Project '74*, an exhibition commemorating the institution's 150th anniversary. He submitted a sketch for an installation centering on a single painting, Edouard Manet's famous still life *A Bunch of Asparagus* (1880), which had been acquired by the museum in 1968. Haacke proposed to show Manet's work together with a series of panels that documented the painting's afterlife, recording all its former owners in sequence.

The provenance begins with the banker and art critic Charles Ephrussi, who bought the picture from Manet (and whose family story Edmund de Waal has told in his 2010 book *The Hare with Amber Eyes*). It then passed to Alexandre Rosenberg, father of the art dealer Paul Rosenberg, and then to the publisher and art dealer Paul Cassirer, followed by the Impressionist painter Max Liebermann—whose wife, as Haacke records on the relevant panel, committed suicide in 1943 "in order to avoid impending imprisonment." In 1935, Liebermann bequeathed the painting to his daughter Käthe Riezler, who fled Germany with her family in 1938. In New York Riezler in turn passed it to her daughter. In the panels, Haacke reconstructs how Manet's still life moved from individual to individual and generation to generation along a long chain of Jewish owners until it was eventually acquired for the Wallraf-Richartz Museum at the instigation of Hermann J. Abs, chair of the board of trustees. Abs's biography is also detailed on one of Haacke's panels, which does not neglect to mention his rapid rise as a banker and business lobbyist under the Nazis. In just ten stages Haacke's Manet project tells of the expulsion and murder of Jewish cultural protagonists and their eventual replacement by leaders who had enjoyed successful careers under the Third Reich. The museum refused to show Haacke's piece or include it in the catalogue. On the opening day of the exhibition, *Manet Project* was instead shown at Galerie Paul Maenz in Cologne.[36]

10. THE EXHIBITION *EMIL NOLDE: A GERMAN LEGEND* IN BERLIN, 2019
The exhibition *Emil Nolde: A German Legend; The Artist during the Nazi Regime* opened at the Hamburger Bahnhof museum of contemporary art in Berlin in April 2019. It was curated and researched by the art historian Aya Soika, a professor at Bard College Berlin, and Bernhard Fulda, a historian at Cambridge University. On behalf of the Nationalgalerie and

the Nolde Foundation in Seebüll, the researchers unraveled the tangled web that had caused Emil Nolde, the failed National Socialist and anti-Semite, to be regarded after 1945 as an icon of the Resistance. The exhibition thus marked a turning point in the way Nazi cultural policy is assessed and remembered in Germany.[37]

As a result, Nolde's paintings are now stripped of the myths with which, over the decades, his every brushstroke was charged, and which transformed them into false gestures of resistance. What remain are the works of a painter who dreamed of winning Nazi approval and who remained a lifelong, committed anti-Semite. In December 1942 Nolde wrote: "The exhibitions of so-called degenerate art put on in Germany in 1937, with pictures and sculptures of recent date from all the German museums, comprised, in my view, one-third truly degenerate, one-third indifferent—that is to say neither good nor bad—and one-third good, and in part especially good, art."[38] Nolde had no hesitation in denouncing works of art as "degenerate." What upset him was to be placed in this category himself.

The Berlin exhibition included Nolde's painting *Breakers* of 1936, a work that hung in the German chancellery between 2006 and 2019, on loan from the Federal State of Berlin. For most of this time, high-ranking politicians on visits to Germany, including the former president of the United States, Barack Obama, in 2016, were invited to take a seat beneath the picture alongside the German chancellor. In April 2019 Angela Merkel had Nolde's painting removed. The wall has remained empty ever since.

Notes

I wish to thank Andreas Beyer, Walter Grasskamp, and Aya Soika for the information they provided for this essay.

1 Carl Georg Heise, *Persönliche Erinnerungen an Aby Warburg*, eds. Björn Biester and Hans-Michael Schäfer, Gratia 43 (Wiesbaden: Harrassowitz, 2005), 16–17; Aby Warburg, *Tagebuch der Kulturwissenschaftlichen Bibliothek Warburg*, eds. Karen Michels and Charlotte Schoell-Glass, Gesammelte Schriften, sec. 7, 7 (Berlin: Akademie, 2001), 325. On Warburg as book collector see Karen Michels, *Aby Warburg: Im Bannkreis der Ideen*, ed. Christian Olearius (Munich: Beck, 2008), 70.

2 On the provenance of *Mare with Foals* see Annegret Hoberg and Isabelle Jansen, *Franz Marc: The Complete Works*, vol. 1, *The Oil Paintings* (London: Philip Wilson, 2004), 220, no. 194. For a recent assessment, see Ulf Küster, "Franz Marc: Pferde, Malerei," in *Kandinsky, Marc und der Blaue Reiter*, ed. Ulf Küster, exh. cat. (Basel: Fondation Beyeler; Berlin: Hatje Cantz, 2016), 103. On the painting and the Warburg context, see Andreas Beyer, "Denken in Bildern: Was Franz Marc und Wassily Kandinsky mit Aby Warburg Verband," in Küster, *Kandinsky, Marc und der Blaue Reiter*, 22.

3 See Jost Philipp Klenner, "Mussolini und der Löwe: Aby Warburg und die Anfänge einer Politischen Ikonographie," *Zeitschrift für Ideengeschichte*, no. 1 (2007): 83–98.

4 Hans Weidemann, letter to Emil Nolde, May 23, 1949, reproduced in *Emil Nolde: Eine Deutsche Legende; Der Künstler im Nationalsozialismus*, eds. Bernard Fulda, Christian Ring, and Aya Soika, vol. 2, Aya Soika and Bernhard Fulda, *Chronik und Dokumente*, exh. cat. (Munich: Prestel, 2019), 270–71, doc. 101.

5 Dana Smith, "Die Arbeit des Jüdischen Kulturbunds," in *1938: Kunst, Künstler, Politik*, eds. Eva Atlan, Raphael Gross, and Julia Voss, trans. Herwig Engelmann, exh. cat. (Göttingen: Wallstein, 2013), 241–58.

6 On the dispute over German Expressionism, see Aya Soika and Meike Hoffmann, *Escape into Art?: The Brücke Painters in the Nazi Period*, eds. Meike Hoffmann, Lisa Marei Schmidt, and Aya Soika, trans. Brian Currid and Jane Michael, exh. cat. (Munich: Hirmer, 2019), 70–73. On Weidemann's letter to Nolde, see note 4 above. Weidemann was not dismissed but was transferred internally to the Ministry of Propaganda's film department. See Soika and Hoffmann, *Escape into Art?*, 28–29, note 20.

7 The confiscated works included loans from private collections, for example Paul Klee's famous painting *Swamp Legend*, the property of Sophie Lissitzky-Küppers, which was removed from the Provinzialmuseum in Hannover. See Melissa Müller and Monika Tatzkow, *Lost Lives, Lost Art: Jewish Collectors, Nazi Art Theft, and the Quest for Justice*, trans. Jennifer Taylor and Tammi Reichel (London: Frontline, 2010), 99–101.

8 See Christoph Zuschlag, "An 'Educational Exhibition': The Precursors of *Entartete Kunst* and Its Individual Venues," trans. Stewart Spencer, in Stephanie Barron, *"Degenerate Art": The Fate of the Avant-Garde in Nazi Germany*, exh. cat. (Los Angeles: Los Angeles County Museum of Art; New York: Abrams, 1991), 84.

9 Karl Schmidt-Rottluff to Friedrich Schreiber-Weigand, August 30, 1937, quoted in Soika and Hoffmann, *Escape into Art?*, 31.

10 Mandy Wignanek, "Faked Icon: *The Large Head* in the Propaganda Exhibition *Degenerate Art*," in *Otto Freundlich: Cosmic Communism*, ed. Julia Friedrich, trans. Malcolm Green and Jim Gussen, exh. cat. (Cologne: Museum Ludwig; Basel: Kunstmuseum Basel; Munich: Prestel, 2017), 211.

11 Mario-Andreas von Lüttichau, reconstruction of the exhibition *Entartete Kunst*, Munich, July 19 to November 30, 1937, in *Nationalsozialismus und "Entartete Kunst": Die "Kunststadt" München 1937*, ed. Peter-Klaus Schuster, exh. cat. (Munich: Prestel, 1987), 132, 134.

12 Adolf Hitler, "Programmatische Kulturrede des Führers," *Völkischer Beobachter*, July 19, 1937, quoted in *Reden zur Kunst- und Kulturpolitik, 1933–1939*, ed. Robert Eikmeyer (Frankfurt am Main: Revolver, 2004), 122–43.

13 On the *Grosse Deutsche Kunstausstellung*, held annually from 1937 to 1944, see the database *GDK Research: Research Platform for Images of the Great German Art Exhibitions, 1937–1944*, in Munich / GDK Research: *Bildbasierte Forschungsplattform zu den Grossen Deutschen Kunstausstellungen, 1937–1944, in München* (Munich: Zentralinstitut für Kunstgeschichte; Haus der Kunst; Berlin: Deutsches Historisches Museum, 2011), http://www.gdk-research.de/db/apsisa.dll/ete.

14 A striking example of the escalation of state violence is provided by the case of Hugo Helbing; see Meike Hopp, *Kunsthandel im Nationalsozialismus: Adolf Weinmüller im München und Wien*, Veröffentlichungen des Zentralinstituts für Kunstgeschichte in München 30 (Cologne: Böhlau, 2012).

15 Emil Nolde, draft of a letter to Bernhard Rust, Minister for Science, Education, and Culture, August 8, 1937, reproduced in Fulda, Ring, and Soika, *Emil Nolde: Eine Deutsche Legende*, vol. 2, 123, doc. 38. In 1934 Nolde joined the National Socialist Workers' Association of Northern Schleswig (NSAN), which was subsumed into the National Socialist German Workers' Party—Northern Schleswig (NSDAP-N) in 1935. See Bernhard Fulda, "Nolde's Autobiography: The Misunderstood Genius in the Struggle for German Art," in *Emil Nolde: The Artist during the Third Reich*, eds. Bernhard Fulda, Christian Ring, and Aya Soika, trans. Sean Gallagher, Cynthia Hall, Allison Moseley, and Bronwen Saunders, exh. cat. (Munich: Prestel, 2019), 84.

16 Emil Nolde, letter to the Reich press chief and others in the Ministry of Propaganda, December 6, 1938, carbon copy of draft to Hans Fehr with corrections in Nolde's hand, reproduced in Fulda, Ring, and Soika, *Emil Nolde: Eine Deutsche Legende*, vol. 2, 137, doc. 48; Fulda, Ring, and Soika, *Emil Nolde: The Artist during the Third Reich*, 62.

17 The fake was discovered and first described by Mandy Wignanek; see Wignanek, "Faked Icon," 212.

18 "Biography and Exhibitions," in Friedrich, *Otto Freundlich*, 315.

19 Rose Valland, *Le Front de l'Art: Défense des Collections Françaises, 1939–1945*, rev. ed. (Paris: Réunion des Musées Nationaux, 2014), 85.

20 See Jonathan Petropoulos, *Art as Politics in the Third Reich* (Chapel Hill: University of North Carolina Press, 1996), 136; Thomas Buomberger, *Raubkunst, Kunstraub: Die Schweiz und der Handel mit Gestohlenen Kulturgütern zur Zeit des Zweiten Weltkriegs* (Zurich: Orell Füssli, 1998), 46–47.

21 See Buomberger, *Raubkunst, Kunstraub*, 57–58.

22 See the provenance report by Ingeborg Berggreen-Merkel, 'Provenienzbericht zu Henri Matisse, 'Sitzende Frau,' " in *Taskforce Schwabinger Kunstfund*, http://www.taskforce-kunstfund.de/fileadmin/_downloads/TFK_2014-07-07_Schlussbericht_Matisse_Sitzernde_Frau.pdf.

23 See Iris Lauterbach, *The Central Collecting Point in Munich: A New Beginning for the Restitution and Protection of Art*, trans. Fiona Elliott (Los Angeles: Getty Research Institute, 2018), 48.

24 Lauterbach, *Central Collecting Point*, 62.

25 Lauterbach, *Central Collecting Point*, 153.

26 The article "Museum ohne Besucher" appeared in *Heute* on April 1, 1946; see Lauterbach, *Central Collecting Point*, 87.

27 On the personnel, see Lauterbach, *Central Collecting Point*, 68–93; on Valland, see 114.

28 Werner Haftmann, "Einleitung," in *Documenta: Kunst des XX. Jahrhunderts*, exh. cat. (Munich: Prestel, 1955), 16.

29 See Fulda, Ring, and Soika, *Emil Nolde: The Artist during the Third Reich*, 232.

30 On the photograph wall and the artists' portraits see Walter Grasskamp, *Die Unbewältigte Moderne: Kunst und Öffentlichkeit*, Beck'sche Reihe 386

THE HISTORY OF GERMAN ART POLITICS

(Munich: Beck, 1989), 89, 96. The photograph wall is also illustrated in Harald Kimpel and Karin Stengel, *Documenta*, vol. 1, *Documenta 1955: Erste Internationale Kunstausstellung; Eine Fotografische Rekonstruktion* (Bremen: Temmen, 1995), 20. On Lohse-Wächtler, see Cara Schweitzer, "Elfriede Lohse-Wächtler," in Atlan, Gross, and Voss, *1938: Kunst, Künstler, Politik*, 42–43.

31 Hans Sedlmayr, *Verlust der Mitte: Die Bildende Kunst des 19. und 20. Jahrhunderts als Symbol der Zeit* (Salzburg: O. Müller, 1948), published in English in 1957 under the title *Art in Crisis: The Lost Centre*.

32 See Bernhard Fulda, "The 'Unpainted Pictures': Genesis of a Myth," in Fulda, Ring, and Soika, *Emil Nolde: The Artist during the Third Reich*, 179–220; and Bernhard Fulda, "Nolde's War," in Fulda, Ring, and Soika, *Emil Nolde: The Artist during the Third Reich*, 156. Werner Haftmann's *Emil Nolde: Ungemalte Bilder* (Cologne: Dumont Schauberg, 1963) appeared in English as *Emil Nolde: Unpainted Pictures* (New York: Praeger, 1965).

33 *German Watercolors, Drawings and Prints, 1905–1955: A Mid-Century Review with Loans from German Museums and Galleries and from the Collection of Dr. H. Gurlitt, Duesseldorf* (New York: American Federation of Arts, 1956).

34 Hildebrand Gurlitt, quoted in Meike Hoffmann and Nicola Kuhn, *Hitlers Kunsthändler: Hildebrand Gurlitt, 1895–1956* (Munich: Beck, 2016), 302. On the Gurlitt scandal and its consequences, see Julia Voss, "Have German Restitution Politics Been Advanced since the Gurlitt Case?: A Journalist's Perspective," in "Nazi-Looted Art and Its Legacies," ed. by Andreas Huyssen, Anson Rabinbach, and Avinoam Shalem, special issue, *New German Critique* 44, no. 1 (130) (February 2017): 57–74.

35 This document was displayed in the exhibition *Raub und Restitution: Kulturgut aus Jüdischem Besitz von 1933 bis Heute* at the Jüdisches Museum Berlin, 2008, and Jüdisches Museum Frankfurt, 2009; see Julia Voss, "Kulturgut aus Jüdischem Besitz: Restitution Ist Keine Stilfrage," *Frankfurter Allgemeine Zeitung*, April 22, 2009, https://www.faz.net/aktuell /feuilleton/kunst/kulturgut-aus -juedischem-besitz-restitution-ist -keine-stilfrage-1790678.html.

36 Matthias Flügge and Robert Fleck, eds., *Hans Haacke: For Real; Works, 1959– 2006*, trans. Hans Haacke and Steven Lindberg, exh. cat. (Düsseldorf: Richter, 2006), 119–20.

37 Earlier, in 2014, the catalogue of a Nolde exhibition at the Städel Museum in Frankfurt examined the artist critically, but with little impact. See Felix Krämer, ed., *Emil Nolde: Retrospective*, trans. Jane Michael et al., exh. cat. (Munich: Prestel, 2014).

38 Aya Soika, "The Long Dispute over Expressionism around Nolde," in Fulda, Ring, and Soika, *Emil Nolde: The Artist during the Third Reich*, 62.

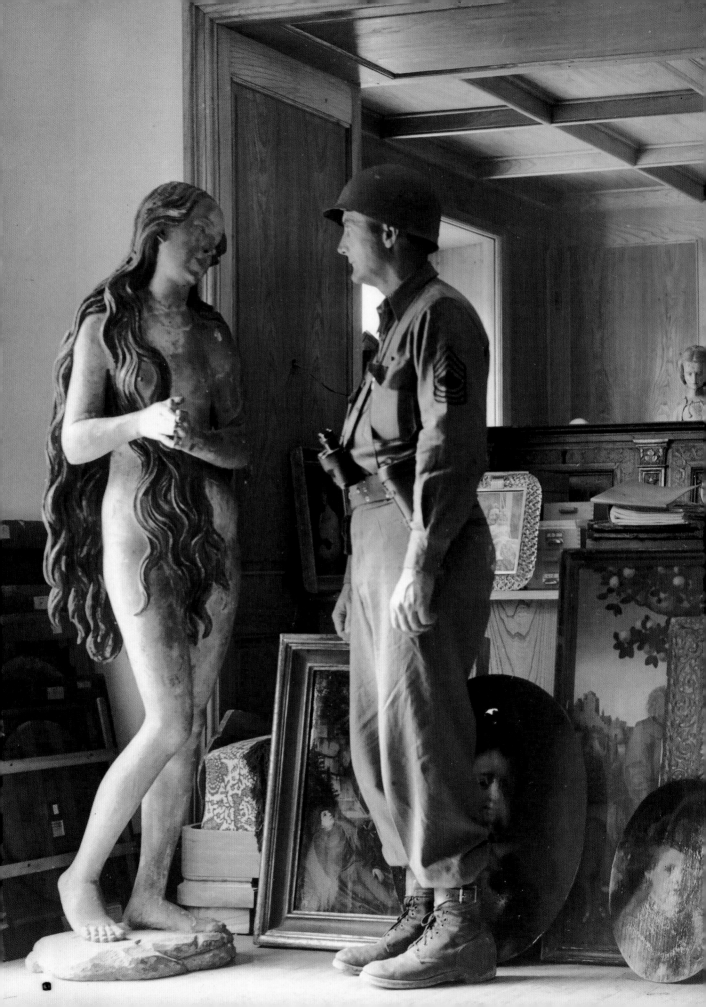

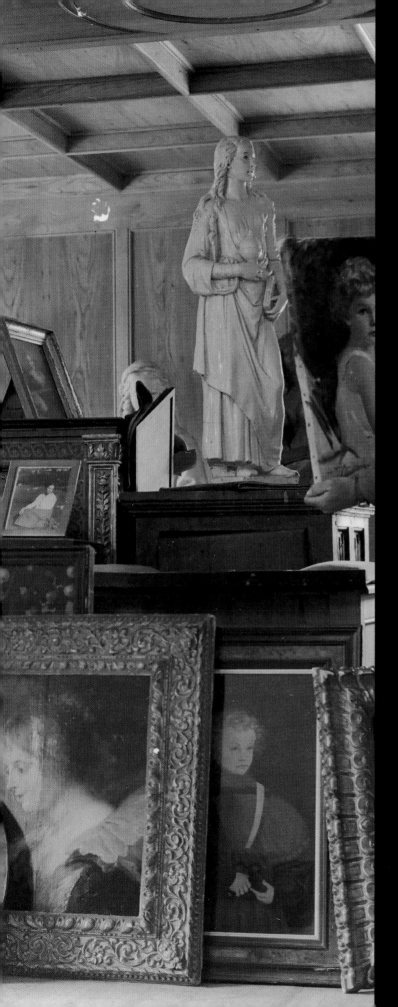

Collection and Redistribution

The Allied Collecting Points in Germany

In the weeks and months following the end of World War II, Allied forces established several temporary collecting points in Germany to process the return or placement of cultural material that had been seized by the Nazis. The restitution program was explicitly designed to reverse the collection process established by the Germans during the war.

The three largest facilities were the Offenbach Archival Depot, the Munich Central Collecting Point, and the Wiesbaden Central Collecting Point. These installations were the core of a recovery effort of unprecedented scale. In them countless works of art, as well as books, manuscripts, and other objects, were received, identified, sorted, and, where possible, returned to their countries of origin and, ultimately, owners or heirs. The collecting points were sites for processing history, seeking to repair the deep cultural ruptures inflicted by the Nazis across Europe.

The international cadre of curators, conservators, and registrars at the collecting points understood their work in both practical and philosophical registers. In addition to producing voluminous administrative and legal records, they documented their work in albums of photographs that convey their activities in personal, anecdotal, human terms. The task of finding and returning some of the most treasured works of art in the world, the effort to intervene restoratively in history, is expressed in poignantly intimate and casual images of men and women in crate-lined hallways and overflowing storage rooms, working to piece together the fractured cultural traditions of Europe. These albums remain among the most powerful and enduring records of the recovery effort.

THE OFFENBACH ARCHIVAL DEPOT

Each collecting point served a particular function. The Offenbach Archival Depot dealt mainly with Jewish material, predominantly books. It operated from July 1945 through June 1949, located in a former factory belonging to IG Farben, the chemical manufacturer responsible for the production of the Zyklon B gas used in the Nazi extermination camps. The depot, which processed some 2.5 million objects, handled more than thirty thousand books a day, with teams of scholars and librarians using bookplates and collection stamps to identify owners.

During its three years of operation the depot became, temporarily, one of the largest collections of Jewish literature ever assembled and a center of Jewish learning. It employed some of the most prominent Jewish intellectuals of the twentieth century, including the historian and philosopher Gershom Scholem. When the depot closed, more than three hundred thousand books remained "orphaned," either because they had no identifying markings or because the communities to which they had originally belonged had been destroyed. Some of these books were sent to displaced-persons camps in Europe. Most, however, were taken into the possession of the restitution organization Jewish Cultural Reconstruction and sent to Jewish communities around the world where they could be put to new use.

The Offenbach album was produced in multiple copies and given to institutions that participated in the recovery effort; the images that follow are sequentially excerpted from those volumes. One is in the archives of Yad Vashem, the World Holocaust Remembrance Center, Jerusalem; others are at the National Archives and Records Administration in Washington, DC, and the New York Public Library, Dorot Division. The photographers are not identified.

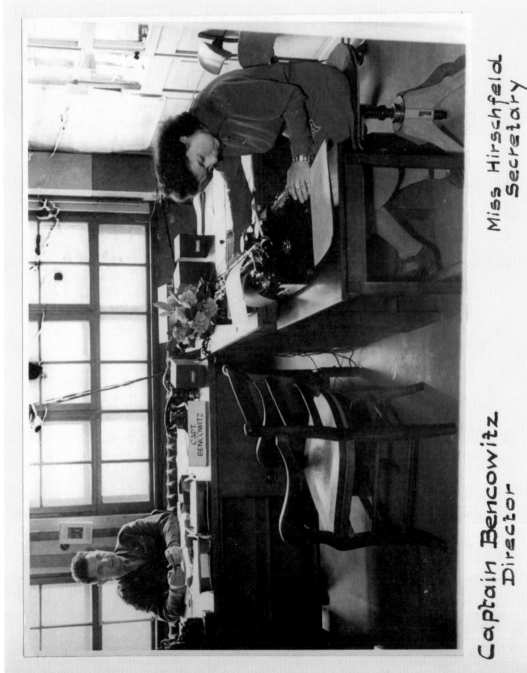

Captain Bencowitz
Director

Miss Hirschfeld
Secretary

THE ALLIED COLLECTING POINTS IN GERMANY

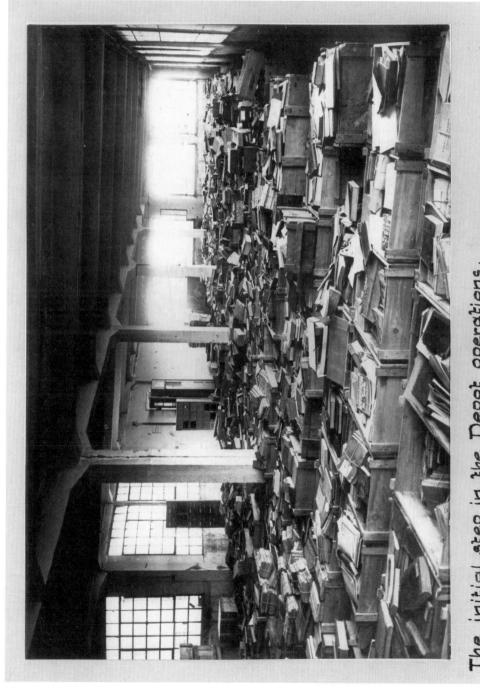

The initial step in the Depot operations. Books and other archival material as they arrive in the Depot.

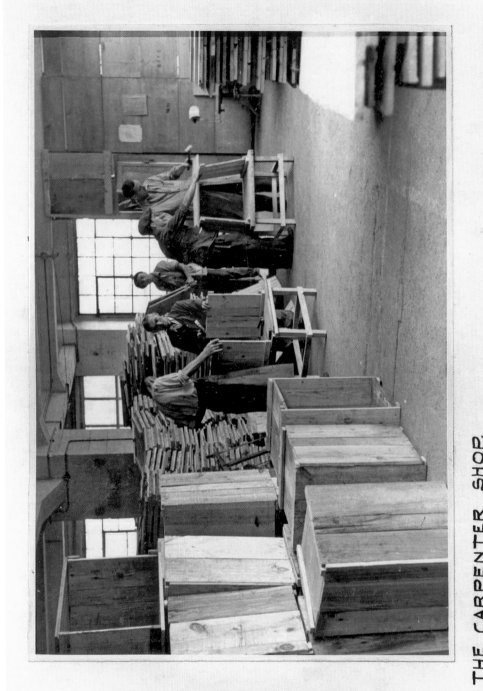

THE CARPENTER SHOP.
Old boxes are repaired and parts of new boxes, brought from the box factory, are put together. More than 6000 boxes were made using up about 100 000 board feet of lumber.

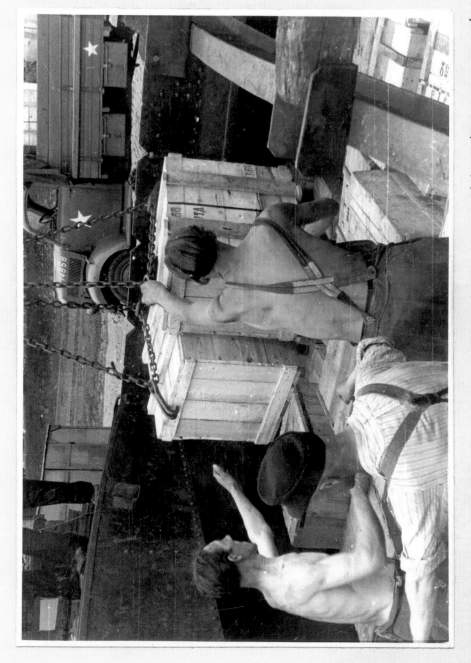

Five hundred and twenty cases of books, some old paintings and old furniture, all looted from Holland are in this barge ready to go, 6 July 1946.

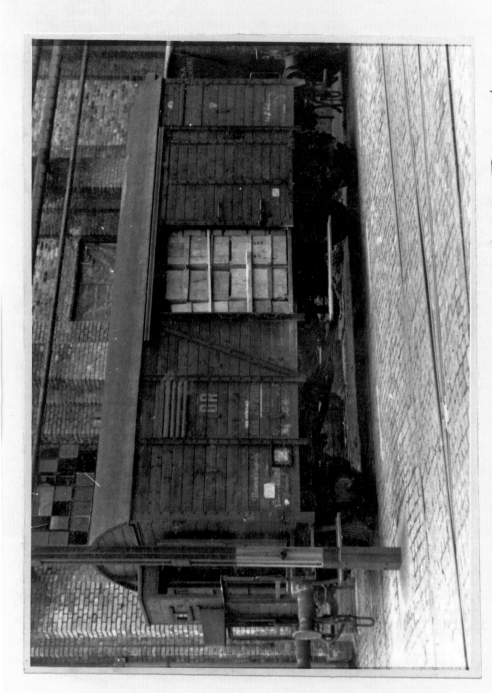

A Box car of Books Ready to leave for Poland.

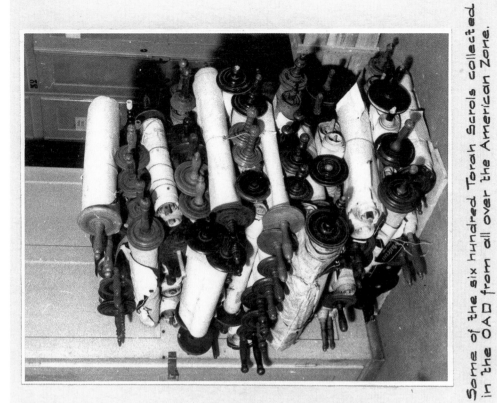

Some of the six hundred Torah Scrolls collected in the OAD from all over the American Zone.

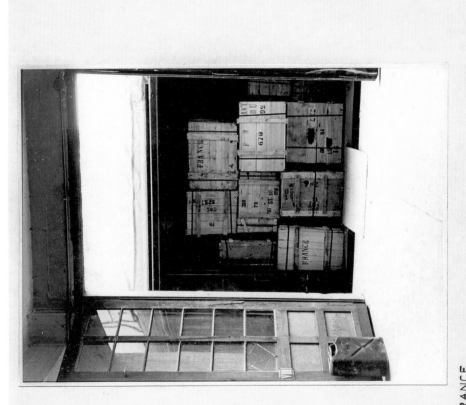

BACK TO FRANCE
The last of eleven freight cars, 319 000 books shipped back to libraries in France from which they were looted by the Nazis.

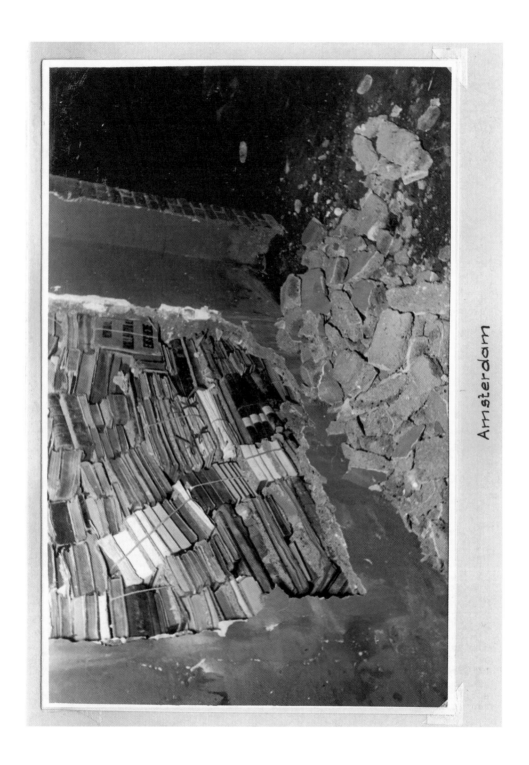

Amsterdam

THE ALLIED COLLECTING POINTS IN GERMANY

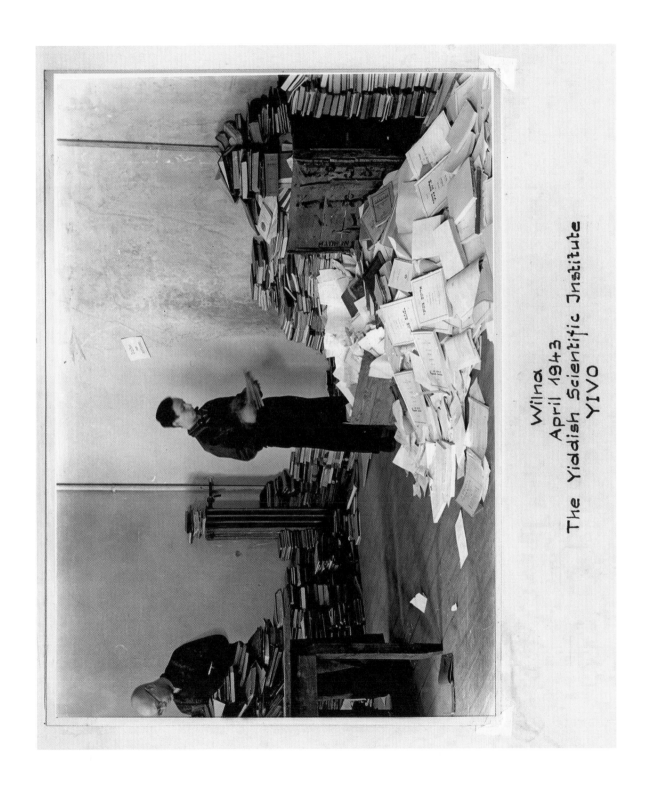

Wilna
April 1943
The Yiddish Scientific Institute
YIVO

THE MUNICH CENTRAL COLLECTING POINT

The Munich Central Collecting Point was open from July 1945 through August 1951. Housed in the Verwaltungsbau, a sprawling colonnaded structure that had been one of the Nazi administrative buildings in Munich, it managed material that was subject to restitution outside Germany, particularly art. For a time the nearby Führerbau, Hitler's own head-quarters, was also used. Munich was the largest of the collecting points and processed more than one million objects recovered from scores of secret storage facilities throughout Nazi-occupied Europe, including thousands of works that had been intended

for Hitler's and Goering's private collections. In November 1946, while the recovery effort was still under way, the depot also became the home of the Zentralinstitut für Kunstgeschichte, an inter-nationally oriented center for art-historical research that is still housed there today.

This selection of Johannes Felbermeyer's photographs of the Munich depot is from a set in the collection of the United States National Archives, Washington, DC; duplicates are in the archives of the Getty Research Institute, Los Angeles.

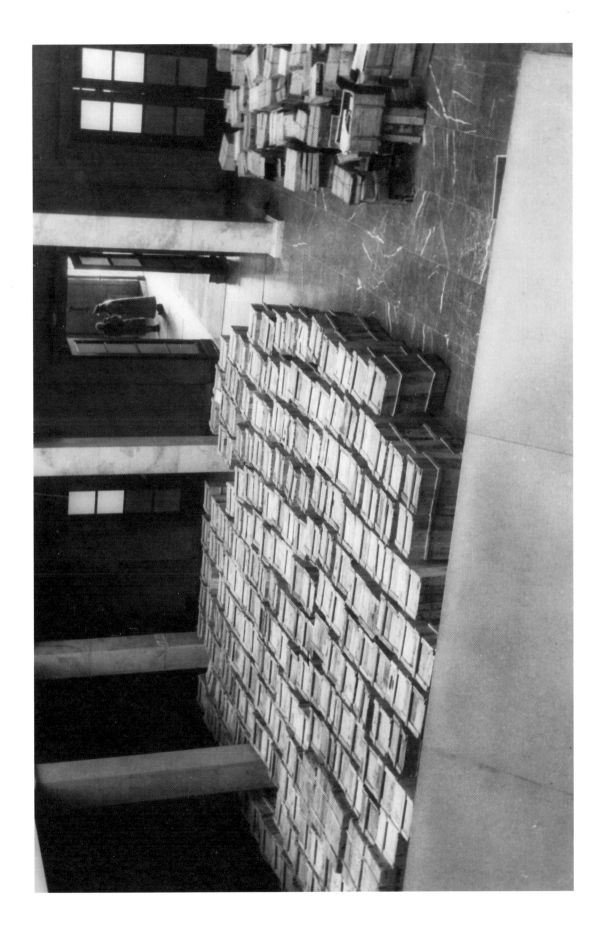

THE MUNICH CENTRAL COLLECTING POINT

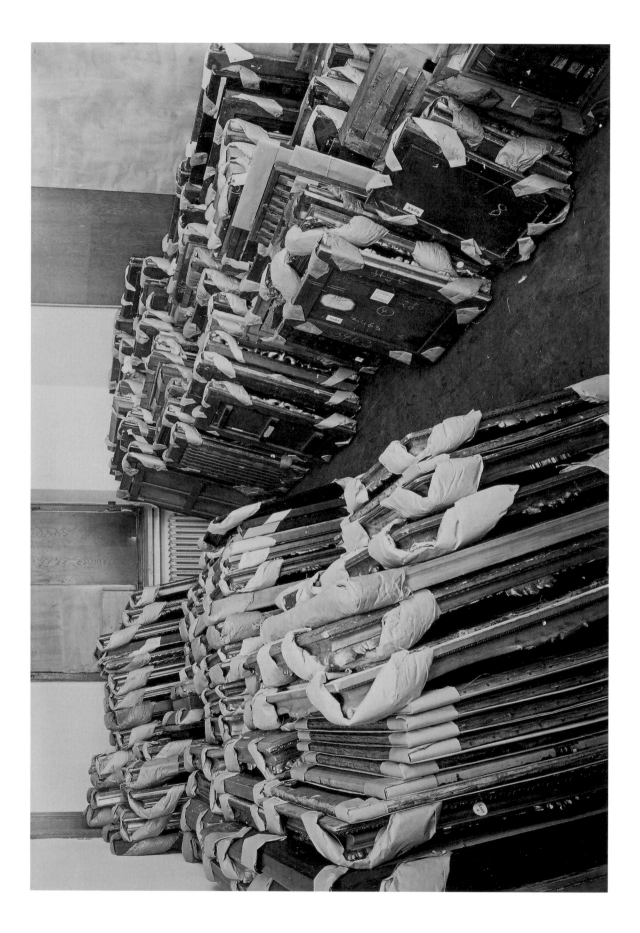

THE ALLIED COLLECTING POINTS IN GERMANY

THE MUNICH CENTRAL COLLECTING POINT

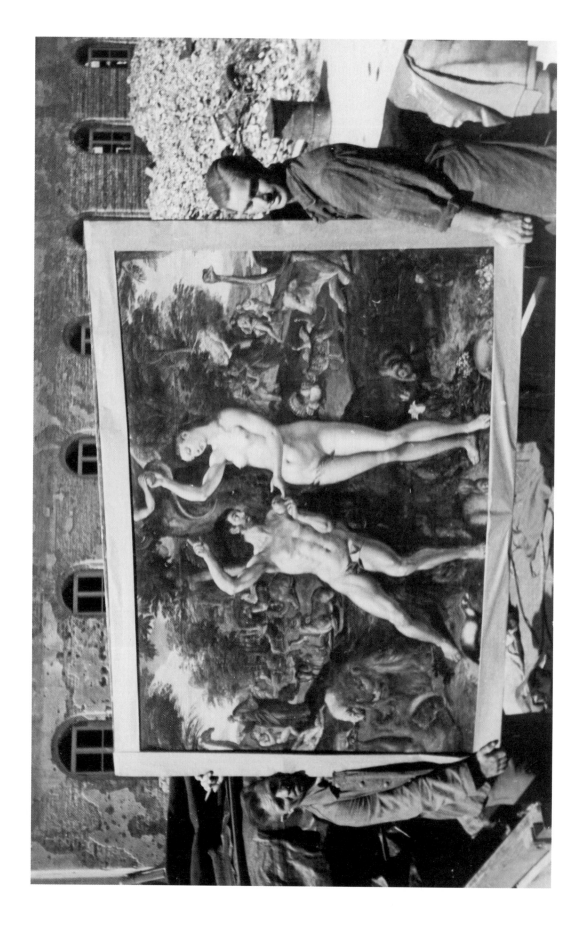

THE MUNICH CENTRAL COLLECTING POINT

THE WIESBADEN CENTRAL COLLECTING POINT

The Wiesbaden Central Collecting Point operated from June 1945 through August 1951. It sorted works of art owned by German museums, churches, and private collectors, especially those belonging to the Prussian State Museums. The building processed more than seven hundred thousand objects, many of which had been secreted by the Nazis in salt mines and bunkers to protect them from Allied bombing.

Located in the Wiesbaden Landesmuseum, the collecting point employed a mixed staff of American military and civilian and German curators, provenance experts, and scholars, many of whom were women. In addition to processing objects from

German collections, the site also hosted a series of exhibitions of looted works of art that were about to be restituted to collections in England, France, and the Netherlands; as such, it was an important center of diplomacy.

The album was a personal scrapbook made by Renate Hobirk, a member of the Wiesbaden staff. Photographers are not identified. The volume is in the archives of the Staatliche Museen–Preussischer Kulturbesitz, Berlin. Numbers in parentheses are those handwritten next to each photograph in the original pages.

THE ALLIED COLLECTING POINTS IN GERMANY

THE WIESBADEN CENTRAL COLLECTING POINT

THE ALLIED COLLECTING POINTS IN GERMANY

THE WIESBADEN CENTRAL COLLECTING POINT

THE ALLIED COLLECTING POINTS IN GERMANY

THE ALLIED COLLECTING POINTS IN GERMANY

The Allied Collecting Point Albums

Page 142: A United States soldier stands next to looted art in a former German military barracks at Königssee, May 1945. Works by Gregor Erhart (see page 178), Lucas Cranach, and Rembrandt van Rijn, among many others, were recovered from a Nazi cache in a cave at Königssee in southern Germany, hidden there by Hermann Goering during the war.

THE OFFENBACH ARCHIVAL DEPOT

Page 146: Isaac Bencowitz, a captain in the US Army's Monuments, Fine Arts, and Archives program, was director of the Offenbach Archival Depot from May to November 1946, succeeding Capt. Seymour J. Pomrenze.

Page 147: The depot sorted and consigned massive quantities of books and other archival material—an indication of the immensity of both the looting perpetrated during the war and the recovery effort after. Many of the books came from Nazi research libraries like the Institute for the Study of the Jewish Question; others from secret Nazi bunkers and caches throughout Europe.

Pages 148-51: Crates of books processed for restitution or consignment.

Page 152: Some of the photographs in the Offenbach album had been taken earlier by the Einsatzstab Reichsleiter Rosenberg (ERR), the Nazi looting task force, and were included for documentary purposes. This photograph, simply labeled "Amsterdam," shows a synagogue wall demolished by the Nazis, revealing volumes hidden inside. The photographer is unknown.

Page 153: Under duress, Jews sift through books and papers at a Yiddish scientific institute in Vilnius, April 1943. Much of the material was either destroyed or incorporated into Nazi research libraries. Some, however, was hidden and saved. The photographer of this ERR image is unknown.

THE MUNICH CENTRAL COLLECTING POINT

Pages 155-57, 159: Artworks and objects at various stages of processing: awaiting sorting, stacked in temporary storage, and being loaded onto a freight car for return. All photographs are by Johannes Felbermeyer, c. 1947.

Page 158: Workers carry Marten de Vos's sixteenth-century painting *Adam and Eve in Paradise*. The artwork was probably looted from a French collection, but was erroneously identified as having been stolen from Yugoslavia and was restituted there, through an intermediary, in 1949. Its present location is unknown. The photograph is by Johannes Felbermeyer, c. 1947.

THE WIESBADEN CENTRAL COLLECTING POINT

Page 161: Ferdinand Kutsch, an archaeologist and director of the Wiesbaden Landesmuseum (10); Ernst Holzinger, director of the Städelsches Kunstinstitut in Frankfurt, who came to the collecting point once or twice a week to help with inspection of artworks, condition reports, conservation, and identification of looted works that had found their way into the Frankfurt museum collections (11); a staff draftsman, Alo Altripp, a Neue Sachlichkeit artist labeled as "degenerate" by the Nazis, who made technical drawings of recovered artworks (12); Annemarie Flinsch, staff conservator, at work on a painting belonging to the Kaiser Friedrich Museum, Berlin (unnumbered); Lohenbier (an artist) (13).

Page 162: Wulfhild Schoppa, acting director of the Wiesbaden Gemäldegalerie and exhibition manager for the depot, with a recovered reliquary cross (14); an unknown person (left) with Renate Hobirk, staff translator and interpreter (right) (15); Lore Hengstenberg, an art student and staff typist (16); Lore Hengstenberg with Sgt. Kenneth C. Lindsay, a staff member (17).

Page 163: Unknown (18); Renate Hobirk, staff translator and interpreter (19, 20); Lore Hengstenberg, an art student and staff typist (21).

Page 164: A guard; Pvt. Francis Waterhouse Bilodeau, staff member and later director of the depot; and Renate Hobirk, staff translator and interpreter, with recovered metalwork (41); Irene Kühnel-Kunze, a curator at Berlin's Kaiser Friedrich Museum, and other German specialists examine paintings and sculptures belonging to the Staatliche Museen (42-46).

Page 165: Staff members pose with the bust of Nefertiti: Walter Farmer, director of the depot (51, 52, 54); Alo Altripp, staff artist (53); Kenneth C. Lindsay, a staff member (56); Josef Kohlmaier, the building superintendent (57).

Page 166: Documenting the royal coronation regalia of Hungary: Alo Altripp with the Crown of Saint Stephen (62); staff photographers Christine Joost and Eva-Maria Czako prepare to photograph the coronation orb (63); Lore Hengstenberg with a brush, perhaps documenting the crown (64); the crown (65).

Page 167: Capt. Rose Valland, representing the French government, examines a looted painting (75); Valland and French art representative Capt. Hubert de Brye with Edith A. Standen, director of the depot, preparing a shipment to France, May 17, 1946 (76); Valland and Lt. Hans Jaffé, a representative of the Dutch government, visiting to identify works looted from collections in the Netherlands (77); staff preparing a transport of returning objects (78).

Page 168: Rose Valland and Edith A. Standen prepare Auguste Rodin's *Walking Man* for return transport to France as part of the first restitution shipment there, May 24, 1946 (79); the sculpture is loaded onto a truck (80-84).

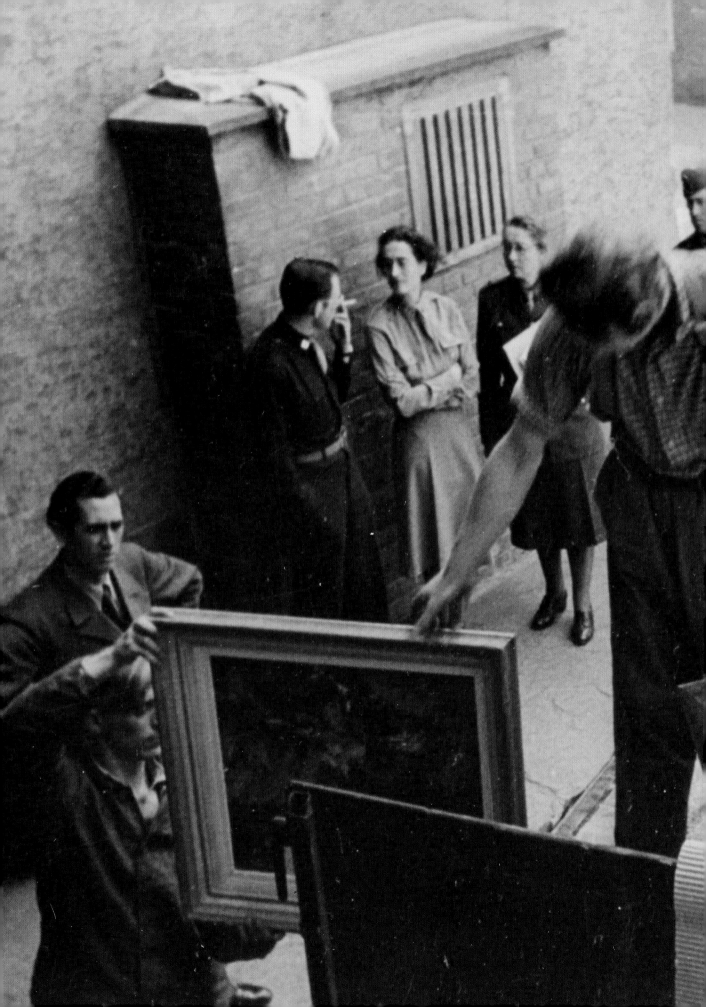

Recovered Works and Their Histories

The story of the fate of artworks in World War II is one small thread in the immense tale of the war's carnage, in which whole communities were destroyed, millions died, and vast reservoirs of culture were obliterated. Some precious works of art were saved through the heroic efforts of individuals, or by chance; others were lost through malice or accident. Some of those that survived still bear the traces of the traumatic events they passed through, while others show no outward sign of their fraught histories. Whether visible or not, those traces persist, taking their place in the many-layered record of each object.

Seated Hermes, Roman, Herculaneum, before 79 CE

The Greek god of messengers, travelers, and thieves, Hermes is distinguished by the winged sandals that allowed him to cover great distances instantaneously. In this bronze sculpture we see the god at rest. A Roman original inspired by the Greek sculptor Lysippos, the sculpture was buried in 79 BCE when Mount Vesuvius erupted, covering the city of Herculaneum in thick layers of ash.

The sculpture was excavated in the eighteenth century, when Herculaneum was rediscovered. In 1738 the king of Naples employed a team of engineers to explore the site, where they soon found countless buildings and artifacts as well as the skeletons of inhabitants caught at the moment the eruption occurred.

This sculpture was unearthed in 1758 at the Villa of the Papyri and installed in a museum until war forced it to travel again. In 1798 the armies of Revolutionary France approached Naples, and the Bourbon monarch, Ferdinand IV, fled to Sicily, taking royal treasures with him. The *Hermes* was evacuated through an underground passage to the coast, where it was loaded onto a ship and sent to Palermo. The king and the statue returned to Naples the following year. The process was repeated in 1805, when the French launched a second invasion.

The sculpture was evacuated once again during the Second World War. In anticipation of increased Allied bombing, 187 crates containing works from the National Archaeological Museum, including the *Hermes,* were sent to the Abbey of Montecassino in the rocky mountains of Lazio for safekeeping in September 1943. Shortly afterward the sculpture was seized by German troops of the Hermann Goering Division, who transported it to a villa near Spoleto in October. It thus survived the Allied bombing that destroyed Montecassino in February 1944. In January

1945, as the Germans retreated up the Italian peninsula, they sent it to Berlin, where they intended to present it to Goering as a gift. It was exhibited in Berlin until March of that year.

As Allied troops marched on the city the sculpture was taken underground once more, this time deep into a salt mine at Altaussee in Austria, where the Nazis stored a large quantity of stolen art. The cache was found by the Allies in May 1945 and, in an uncanny repetition of its initial excavation centuries earlier, it was once again pulled from the earth, placed in a crate, and shipped to the Munich Central Collecting Point.

When the sculpture arrived in Munich its head had broken into sixty-two pieces, which lay in a heap at its feet. It was photographed and then returned to Italy. When it arrived in Rome it was shown without its head, a powerful record of the traumatic journey that it had endured. The sculpture was restored in 1948 and put on view at the Museo Archeologico Nazionale in Naples, where it remains to this day, less than ten miles from the site where it was first buried and exhumed.

Right: Bronze, 41⅜ in.
(105 cm) high
Museo Archeologico Nazionale,
Naples

Above: *Seated Hermes* in storage
at the Munich Central Collecting
Point, March 1946. The missing
head was found in fragments in
the shipping crate.

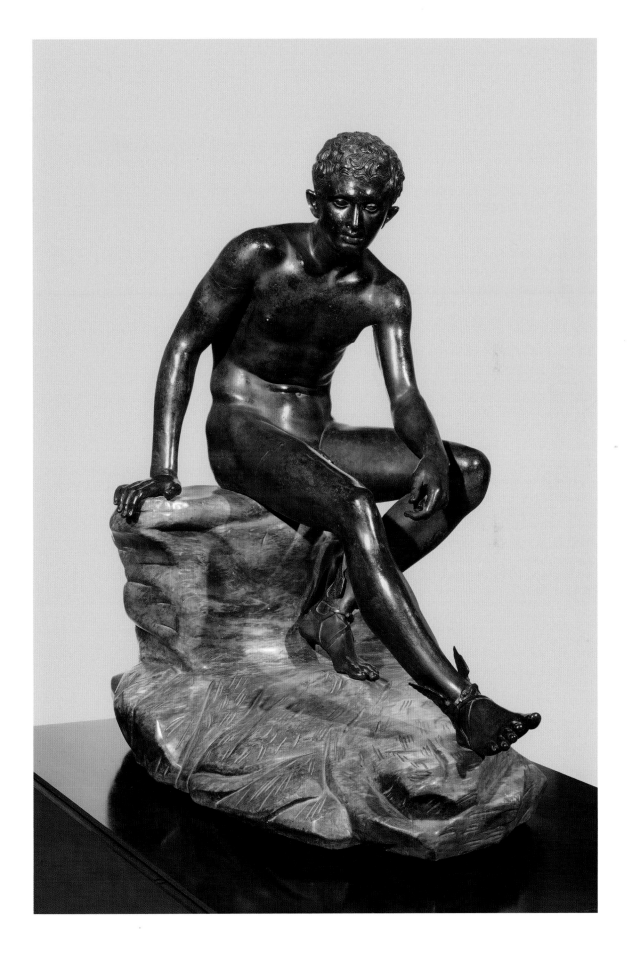

Strongbox, probably Germany, 1769

This ornate eighteenth-century strongbox was owned by the Mayer-Dreyfuss family of Mannheim, Germany. It was probably made for their ancestor Mayer Elias, court jeweler or factor to Karl Theodor, Elector Palatine. The family was wealthy and prominent in the Jewish community of the city, with synagogue records showing generous donations. The box, which according to family tradition held important records and documents, was a symbol of their status and prosperity. With its elaborate decorations, it was not merely utilitarian, but an *objet d'art,* meant to be displayed prominently.

The box was probably purchased ready-made, as the blank cartouche at the top of the inner lid (where a name or inscription might go) is decorated with a cross, although the family was Jewish. The fine lock mechanism, set inside the inner lid and masked by ornate pierced scrollwork, was made by Leclerc. The initials of a Dreyfuss family member, JAD, are inscribed at lower left and the date of purchase or making, 1769, at right. The Rococo appliqués were originally in gold leaf, later touched up with gold paint—a hint at the box's history of use.

After Hitler's rise to power the family fled Germany; although the box was a beloved heirloom, it was large and heavy, and they were forced to leave it behind in their home. During the war, it was used by a Nazi military official, who stamped his initials, ROV, and the date 1939 under the original inscriptions. A family friend retrieved the box after the war and returned it to the family, by then settled in the United States. The alterations made to the strongbox over time recount a family history, visible but incomplete, from rise to fall to renewal.

Right: Iron with gold leaf (later overpainted with gold paint), brass, bronze, and silver, 20¾ × 26 × 16⅞ in. (52.7 × 66 × 43 cm) Jewish Museum, New York, gift of Catherine E. Dreyfuss-Kovacs

Above: Details of the two inscriptions on the inner lid of the strongbox.

RECOVERED WORKS AND THEIR HISTORIES

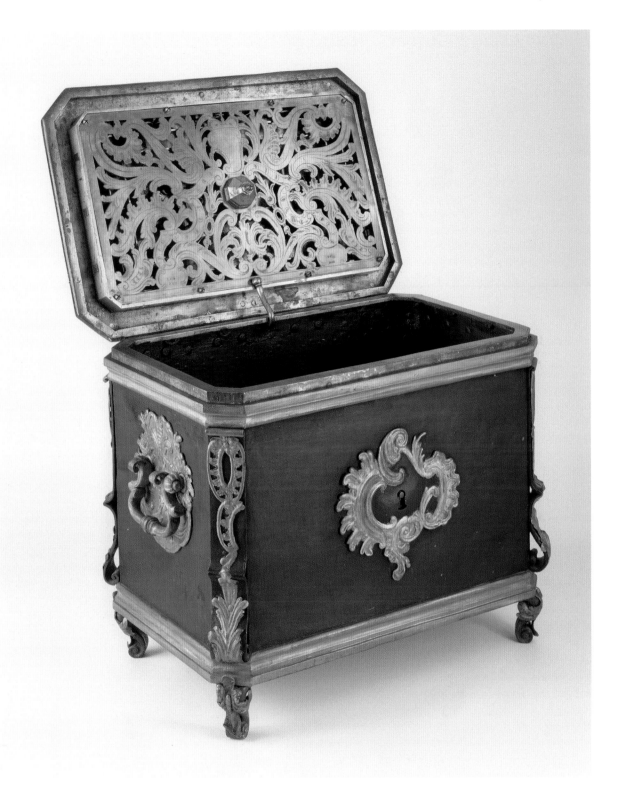

Herri met de Bles, *Landscape with Burning City*, c. 1500

Little is known about the mysterious Flemish painter Herri met de Bles. Probably born around 1480 in Dinant, in present-day Belgium, he was described by two contemporary art historians: Karel van Mander called him "difficult" and Giorgio Vasari gave him the nickname "Civetta," a reference to the small owls that he included in many of his compositions. Although we have few details about his life, Bles was prolific, producing some one hundred known paintings. Many feature catastrophic or apocalyptic scenes; in the small panel *Landscape with Burning City* a rolling landscape leads to a distant harbor consumed in flame, packing into a compact space a striking sense of crisis and foreboding.

The painting's wartime history is no less dramatic. At that time it was owned by the German Protestant businessman Franz W. Koenigs, who used his art collection as collateral for a bank loan. In 1940 he could not repay the loan and Lisser and Rosenkranz Bank took ownership, consigning it for sale to the Dutch Jewish art dealer Jacques Goudstikker on April 19. On May 15, as the Battle of the Netherlands ended with a Dutch surrender, Hermann Goering visited Goudstikker's Amsterdam gallery with the Nazi banker and art dealer Alois Miedl. Miedl purchased thirty-one works, including *Landscape with Burning City*. Meanwhile, Goudstikker had fled with his family on the SS *Bodegraven*, the last ship to England. That same night, as the vessel sailed without lights to avoid German guns, Goudstikker stumbled in the dark and fell, dying on board.

Much of his collection, totaling more than 1,400 paintings, was left behind and looted. Goering returned to the gallery weeks after Goudstikker's death, seizing eight hundred artworks for his personal collection. Miedl also sold nineteen of the paintings that he had purchased from Goudstikker, including *Landscape with Burning City*, to Goering, delivering them to his north German estate, Carinhall, on June 10, 1940. In 1945 Goering attempted to ensure the safety of his collection by sending it on a train to Berchtesgaden in Bavaria. The train was intercepted by Allied forces and many of the works were either recovered or, in some cases, kept by Allied soldiers for themselves. It is likely that *Landscape with Burning City* was taken in this way.

The painting was sold by Aram Gallery in New York to the Boston Museum of Fine Arts in 1946. Although the gallery claimed that the painting had been in the collection of Julian Acampora, a restorer in New York, and before that in the possession of the Count d'Urbania and a collector in Chicago, it is likely that some or all of this history was fabricated. Soon after the purchase, the Museum of Fine Arts became aware that the painting had been in Goering's hands and was sought by the Dutch government, who transferred the question of its disposition to the General Commission of Recuperation in Amsterdam. The commission did not contact the museum, and for half a century the matter remained dormant. In 1998, following the publication of the Washington Principles on Nazi-Confiscated Art, the museum resumed communication with the Dutch government. Discussions were suspended when the heirs of Franz Koenigs and Jacques Goudstikker both claimed ownership on the grounds that the 1940 repossession and sale were both coerced. The Dutch government rejected the Goudstikker claim in 1999 and the Koenigs claim in 2003, leaving the question of the painting's ownership open. The Museum of Fine Arts has publicized the complete known modern provenance of the work.

Oil on panel, 5⅛ × 10⅛ in.
(13 × 25.7 cm)
Museum of Fine Arts, Boston,
Seth K. Sweetser Fund

Gregor Erhart, *Mary Magdalen*, c. 1515–20

This life-size figure of Mary Magdalen is thought to have been made for a Dominican convent in Augsburg. It is attributed to the German artist Gregor Erhart, one of the preeminent wood sculptors of the German Renaissance and the most famous of a family of artists. He trained in Ulm in the workshop of his father, Michael Erhart, but spent most of his career in Augsburg, whose mercantile culture and importance as a trading city brought contacts with Italian artists.

Mary Magdalen was originally suspended from the vault of a church, as if the saint were being transported to heaven. She is shown clothed only in her long, flowing hair, following a tradition with sources in the classical figure of the Venus Pudica (seen, for example, in Sandro Botticelli's *Birth of Venus,* c. 1485).

Like other German artists of the early sixteenth century, Erhart retained elements of the High Gothic in his style, here seen in the Magdalen's graceful, swaying pose and refined features. At the same time, the statue is naturalistic and lifelike, balancing Gothic delicacy with Renaissance realism, perhaps influenced by Albrecht Dürer. Indeed, the work is known informally as *La Belle Allemande*, the German beauty.

Around the turn of the twentieth century the Munich antiques dealer Siegfried Lämmle found the sculpture, reportedly in Ulm. He restored the feet and base (and may have retouched the original polychrome paint), and then sold it to the Louvre in 1902.

The work was coveted by the Nazis. For Adolf Hitler and Hermann Goering a priority in the looting of art from occupied countries was the acquisition—characterized by them as repatriation—of artworks considered to have been part of German patrimony. During the German Occupation of France Goering made elaborate arrangements for an exchange between the Louvre and Berlin of French and German masterpieces—which he saw as an act of great generosity. *Mary Magdalen* was sent to Germany in 1944, not long before the Allies liberated Paris on August 19; Goering added the statue to his collection. At the end of the war it was found by the Allies in Berchtesgaden, along with much of Goering's collection—a thousand paintings, eighty sculptures, and sixty tapestries. The figure had two broken fingers. On August 4, 1945, it was brought to the Munich Central Collecting Point, where it was photographed, probably in 1947, before being returned to the Louvre (see pages 68, 142).

Siegfried Lämmle himself was targeted by the Nazis. He had been an art and antiquities dealer in Munich since 1894, specializing in medieval and Renaissance sculpture. A Jew, he was forced by the Reichskammer der Bildenden Künste (Reich Chamber of Fine Arts) to shutter his shop in 1936 and to sell his collection at drastically reduced prices. Many works were acquired by Adolf Weinmüller, a Nazi Party member who oversaw the theft and forced sale of numerous artworks owned by Jews. Others were purchased by the Munich Stadtmuseum. Lämmle and his family left Germany after the November 1938 pogrom known as Kristallnacht, moving to Los Angeles, where his brother Carl Laemmle was a film producer (having founded Universal Studios in 1912). There, Siegfried and his son, Walter, reopened their art and antiquities business. In 2008 Weinmüller's heir in Germany used archival auction records to identify 897 works taken from Lämmle and sold at auction to benefit the Reich. In 2016 several German museums came to an agreement with Lämmle's heirs, returning some works and formally purchasing others.

Limewood with polychromy,
69⅝ × 17⅜ × 16⅞ in.
(177 × 44 × 43 cm)
Musée du Louvre, Paris

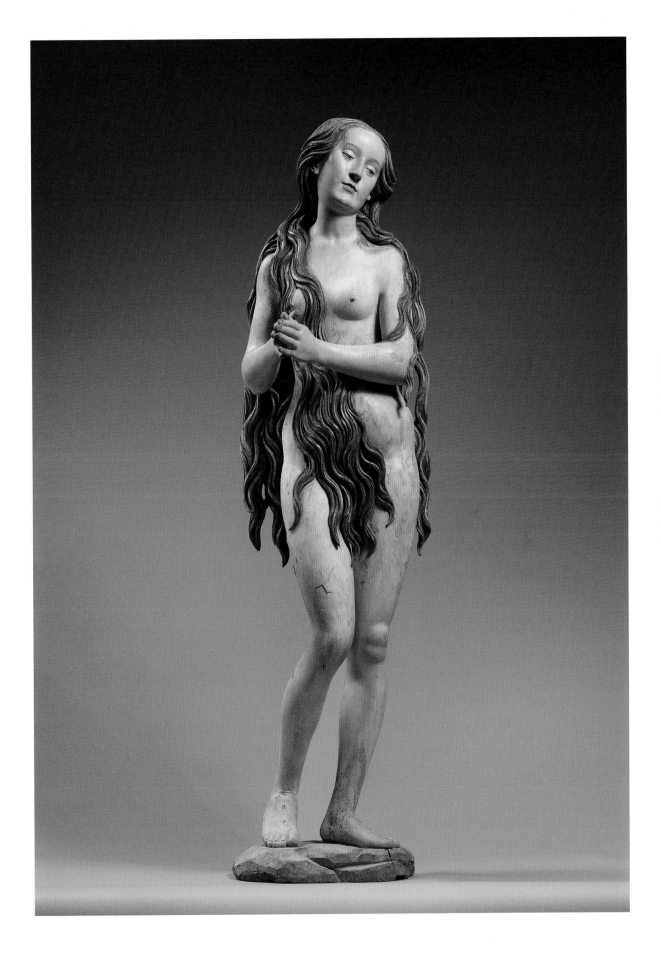

Claude Lorrain, *Battle on a Bridge*, 1655

The battle in question is that between Emperor Constantine and his rival Maxentius, which took place on the Milvian Bridge near Rome on October 28, 312 CE. In addition to being an illustration of a pivotal scene from Roman antiquity, the result of which was the conversion of the Roman Empire from paganism to Christianity, the painting is also a layered exploration of history itself. In the foreground a placid landscape, rendered in even passages of light and shadow, evokes the steady rhythms of nature. In the middle ground the desperate struggle on the bridge alludes to the violent eruption of human events.

For many decades the painting hung in Irish and British estates, first in the collection of the Earl of Leitrim, and then in that of Lady Winifred Renshaw. It was sold in London on July 14, 1939, and by 1941 it was in the collection of the Paris art dealer Georges Wildenstein. Wildenstein, who was Jewish, had fled the city by that time and was in Aix-en-Provence, waiting for documents that would allow him to travel to America. He had loaded much of his collection onto a ship also destined for America, but it was intercepted by a Nazi submarine and forced to return to Bordeaux, where its contents were confiscated by the Einsatzstab Reichsleiter Rosenberg, the Nazi art-looting task force. Wildenstein then negotiated with the Germans in an effort to keep at least a portion of his collection. He agreed to "Aryanize" his firm, a process that entailed giving the Nazis first choice of select items in his stock at prices well below market value. He further agreed to work on their behalf to secure additional objects from private collections. The arrangement was managed by Karl Haberstock, a former friend and associate of Wildenstein's from before the war who also served as a member of the Nazis' Degenerate Art Disposal Commission.

One of the paintings that Wildenstein sold under these circumstances was *Battle on a Bridge,* which was chosen for inclusion in the Führermuseum, Hitler's planned personal museum in Linz. The Linz inventory number 2207 remains visible on its stretcher. A painting acquired through threat of force, by members of a regime intent on remaking the very fabric of Europe, *Battle on a Bridge* is not only itself a work about the reshaping of history but also one that was pulled into a violent contest to remake it once again.

Both a study of a critical moment in the western tradition and a four-and-a-half-foot piece of canvas that could be easily moved, the painting satisfied the Nazi desire to physically possess history by possessing historical artifacts. Indeed, many of the works the Nazis prized most featured scenes of forced possession. Claude's *Coast View with the Abduction of Europa* was also stolen by the Nazis from the influential Jewish collector Jacques Goudstikker. The myth of the Greek nymph Europa being carried away by the god Zeus was popular with Baroque artists and seems to have appealed to Hermann Goering, who kept the painting in his personal collection from 1940 to 1945, while he was overseeing similar abductions across the Continent.

The Führermuseum was never built. After the war *Battle on a Bridge* was discovered in the salt mine at Altaussee, which the Nazis had converted into an enormous underground storage bunker. It was sent to the Munich Central Collecting Point and then repatriated to France on April 18, 1946, and, finally, restituted to Georges Wildenstein, who later sold it.

Oil on canvas, 41 × 55 in.
(104.14 × 139.7 cm)
Virginia Museum of Fine Arts,
Richmond, Adolph D. and
Wilkins C. Williams Fund

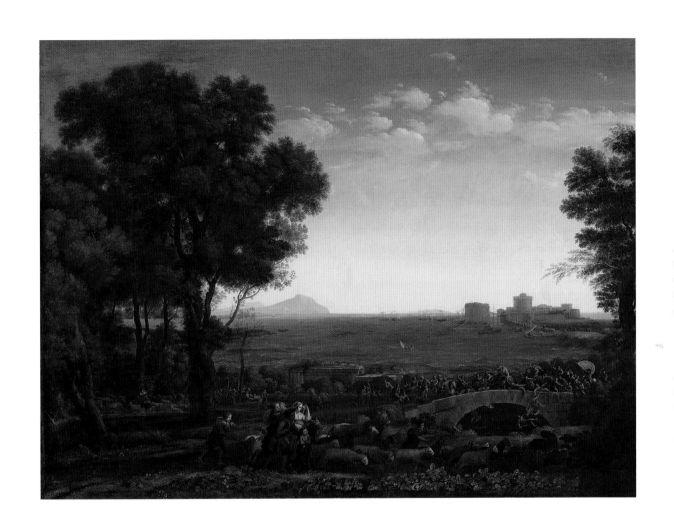

Emanuel de Witte, *Interior of the Portuguese Synagogue in Amsterdam*, 1680

Scenes of church interiors, both real and imaginary, were popular in seventeenth-century Holland. They gave painters an opportunity to play with perspective and scale, and to offer moral lessons, showing modern people as diminutive within monumental spiritual spaces. Often, casual visitors are shown wearing the lavish dress of the wealthy, and strolling about in a social rather than devotional manner. A dog (suggesting impiety) is a common element. Such scenes were a specialty of Emanuel de Witte. Unusually, however, this scene is of the interior of the Esnoga, one of the largest synagogues in Amsterdam. The synagogue, built in 1675, served the city's thriving Sephardic (largely Portuguese) community. Modeled on the imagined features of Solomon's Temple, the building was of great interest among Jews and non-Jews alike, and de Witte painted it three times. In the foreground, visitors marvel at the structure, separated from worshipers by a wooden railing.

At the beginning of the war, the painting belonged to Nathan Katz, a Jewish art dealer who had inherited his family's business in 1930. In 1940 Nathan and his brother Benjamin were contacted by Hans Posse, a curator who had been personally commissioned by Hitler to secure works for his Führermuseum in Linz. Posse tasked the Katz brothers with monitoring the Dutch art market for works of interest. Fearing reprisal, they eventually helped Posse acquire hundreds of paintings, many for Hitler's own collection. As conditions in Amsterdam worsened, Nathan and Benjamin sought the means to escape the Netherlands. They began exchanging paintings from their own collection for documents that would allow their families to flee to Switzerland. Among the works they traded to Posse was *Interior of the Portuguese Synagogue in Amsterdam*.

The exchange is a stunning reminder that for all the Nazis' professed "scientific" understanding of Judaism, a profound ignorance defined Nazism. Despite the large Torah Ark in the background, the painting was mistaken for a church interior and deemed suitable for the Führermuseum. Nathan Katz survived the war, and many of the works that Posse extorted from him and his family were returned. The Esnoga survived the war as well. On May 9, 1945, less than a week after the liberation of the Netherlands, services resumed there, and the synagogue became a meeting place for the Jewish community in Amsterdam as it began to rebuild.

Oil on canvas, 42½ × 48¾ in.
(108 × 123 cm)
Israel Museum, Jerusalem,
purchased through the gift of
Paris friends of the Bezalel
National Museum, through Morris
Fischer (1903-1965), Israel's
first ambassador to Paris

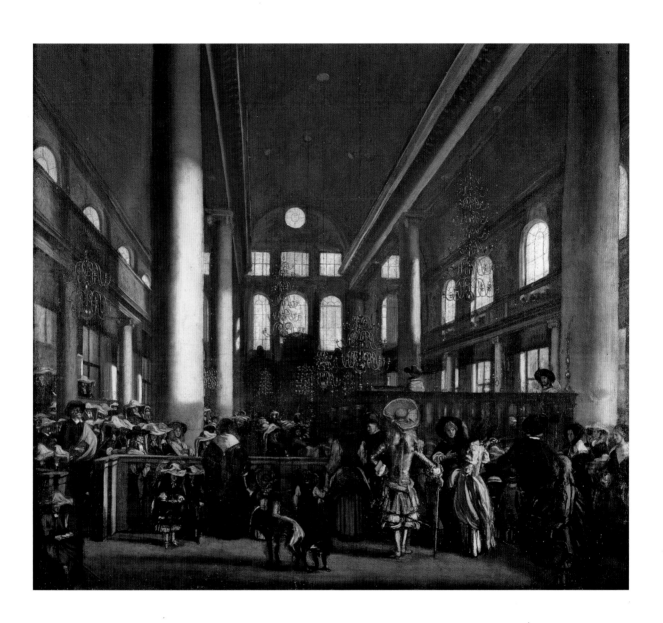

Torah crown, Bolzano, Italy, 1698 or 1699

In Jewish tradition the scrolls of the Torah, the first five books of the Hebrew Bible, are often embellished with ornamental metalwork—a crown or finials, and a shield. The crown marks the Torah as regal and authoritative.

Nothing is known of the maker of this beautiful crown, with its intricate Baroque vine and flower motifs, but inscriptions do give us its origin story. It comes from Bolzano, a town in the Tyrol, the Alps that run from far northeastern Italy into Austria, where German was and is spoken as much as Italian. A small settlement of Jews has lived there steadily since at least the early 1300s, although rarely consisting of more than a few families. Despite periodic expulsions, by the late seventeenth century, the community was well rooted enough to sustain a synagogue and a cemetery. This crown, made of copper rather than the more expensive and typical silver, bears a partially effaced Hebrew dedication in the small cartouches that surround the base: *Donation of the heirs of the late Zalman son of S., my sons are blessed to God [the fair of ?] . . . Bolzano, year 5459*. The year in the Jewish calendar corresponds to either 1698 or 1699.

How and when the crown left Bolzano is unknown, but its travels were extensive and dramatic. At some point it was damaged, losing part of its top edge. In the mid- or late nineteenth century it was purchased, somewhere, by an affluent Polish Jewish grain merchant, Lesser Gieldzinski, who traveled widely and filled his grand home in Danzig with an immense collection of artworks, porcelain, Judaica, and furniture. In 1904 he gave the Judaica to the Great Synagogue of Danzig, where it was displayed at his request in a room apart, which thus became one of the first formal Jewish museums in the world. A handwritten note that once accompanied the crown recorded, intriguingly, that it had been "looted during a pogrom in Russia and gotten back again."

The Great Synagogue of Danzig was destroyed by the Nazis in 1939, along with the city's rich Jewish history and culture. But its treasures escaped, shipped in July of that year to New York (see pages 71, 95–96). The Bolzano crown, with its enigmatic label, crossed the Atlantic to its present home.

Repoussé, pierced, traced, and
engraved copper, 6⅛ × 7¾ in.
in diameter (15.5 × 18.7 cm)
Jewish Museum, New York,
gift of the Danzig Jewish
Community

Friedrich Olivier, *Shriveled Leaves*, 1817
Julius Schnorr von Carolsfeld, *A Branch with Shriveled Leaves*, 1817

These two delicate drawings of shriveled leaves were made in winter 1816–17 by Friedrich Olivier and Julius Schnorr von Carolsfeld. Friends and relations by marriage, the two artists belonged to the Nazarene movement, artists associated with German Romanticism and committed to a revival of the spirituality that animated art of the Middle Ages. The drawings were made using techniques that mimicked those of medieval and early modern German art, which they believed possessed special power.

In addition to pointing backward in time, the drawings were also carried forward in time, passed from generation to generation as precious family heirlooms. Eventually they came into the possession of Marianne Schmidl, the great-granddaughter of Olivier and great-grandniece of Schnorr von Carolsfeld and the first woman to receive a doctorate in ethnology from the University of Vienna. She inherited the drawings from her mother in 1933, and they were in her possession when the Nazis annexed Austria in March 1938. Following the annexation, Schmidl, a librarian

at the Nationalbibliothek in Vienna, was compelled to prove her Aryan descent. Because her father, Josef, was Jewish by birth, she was forbidden to work and in September 1938 was forced to register her assets, among which she included "metal, jewelry, luxury items, art, and collections." Like many Jews, Schmidl was then required to pay a series of extortive taxes, designed by the Nazis to expropriate Jewish property. Eventually, on April 28, 1939, she was forced to sell the drawings at an auction in Leipzig. The lot was simply listed as "Collection W." In spring 1942 Schmidl was deported to Izbica, Poland, a temporary holding point for the Belzec concentration camp. That is the last record we have of her. She was declared dead in 1950.

In 2016 the National Gallery of Art restituted Schnorr's *A Branch with Shriveled Leaves* to Schmidl's heirs, who then sold it. The Olivier drawing was also in the National Gallery, and the heirs agreed that it should remain there. The passage of time that carried the drawings backward to the practices of medieval German art making, across three generations of familial life, through the traumatic events of World War II, and forward to restitution and gift, finds a subtle but unmistakable rhyme in the drawings themselves. Shriveled leaves rendered in soft wash and taut lines, they are powerful emblems of both fragility and endurance.

Right: Black and gray-black ink
over graphite on paper,
8⅝ × 6½ in. (21.9 × 16.4 cm)
National Gallery of Art,
Washington, DC, Wolfgang
Ratjen Collection, Patrons'
Permanent Fund

Above: Black ink over graphite
on paper, 3⅝ × 10⅛ in. (9.1 ×
25.6 cm)
Fiona Chalom and Joel Aronowitz
Collection, Los Angeles

den 31ͭᵉⁿ Januar 1817.

den 8ͭᵉⁿ Februar.

Camille Pissarro, *Portrait of Minette*, 1872

Pissarro painted his daughter Jeanne-Rachel, nicknamed Minette, as both a token of gratitude and a memento of grief. In 1870 Pissarro and his family were living in the town of Louveciennes, on the outskirts of Paris. When the Franco-Prussian War broke out in July they were forced to flee west, taking refuge on a farm owned by the artist's friend Ludovic Piette near the town of Melleray. The house they had abandoned was promptly occupied by Prussian soldiers, who destroyed much of its contents, including some 1,500 of Pissarro's paintings, which they laid on the muddy ground outside the house to make a walkway.

In Melleray Pissarro's third child, Adèle-Emma, was born on October 21, dying on November 5. Pissarro painted *Portrait of Minette* two years later. He gave the work to Piette in thanks for his aid to the family during a time of need and as a record of the experience the friends had shared. Although Pissarro regarded it as a mere sketch and not a finished work, Piette treasured it, appreciating in particular its loose and vibrant handling, which would come to define Pissarro's Impressionist style.

Sadly, *Portrait of Minette* also captured Minette in one of the last years in her life. She became sick in October 1873 and died in 1874. When Piette was told of Minette's death he returned the painting to Pissarro, for whom it served as a symbol of mourning for a second time. Pissarro's widow, Julie, kept the canvas following the artist's own death in 1903. In 1928 it was purchased by the Jewish art collector Paul Rosenberg. By the outbreak of the Second World War, *Portrait of Minette* was in the collection of Bruno Stahl, whose father, Heinrich, was the chairman of the Jewish Community of Berlin during the Nazi regime.

Heinrich Stahl was deported to Theresienstadt in 1942 and later died there, but Bruno was able to flee Germany in 1933, traveling first to Brussels and then America. Before he left, he stored his paintings, including *Portrait of Minette*, in a Paris bank vault, along with works belonging to the prominent Jewish gallerist Georges Wildenstein. The Nazi art-looting task force Einsatzstab Reichsleiter Rosenberg discovered the vault in 1940 and stole its contents. Although *Portrait of Minette* was at one point selected for Reichsmarschall Hermann Goering's personal collection, it remained for three years at the Jeu de Paume gallery in Paris, which the Nazis had converted into a temporary storage depot. As the Allies entered France and approached Paris, the painting was slated for transport to a second storage depot at Schloss Nikolsburg, in the present-day Czech Republic, on August 1, 1944. The train broke down outside Paris and the painting was recovered as Paris was liberated. Based on an error in how the Nazis had catalogued it, *Portrait of Minette* was restituted after the war to Wildenstein, who returned it to Stahl. Stahl then sold the painting to Wildenstein in 1949. It entered the collection of the Wadsworth Atheneum nine years later.

Oil on canvas, 18 × 13⅞ in.
(45.7 × 35.2 cm)
Wadsworth Atheneum Museum of
Art, Hartford, Connecticut,
the Ella Gallup Sumner and Mary
Catlin Sumner Collection Fund

F. van Groeningen, *Woman Sitting on a Trunk*, 1896

A woman seated on a large wooden chest wears a diaphanous drapery, delicately painted. Her hands arched on the sloping lid, she turns away, concealing her face. Her identity is unknown and the painter, F. van Groeningen, is almost as mysterious, lacking even a confirmed first name. But the artwork itself has a traceable history of transit through the postwar recovery system.

Before the war it belonged to Max Hirsch, a Jewish art collector who fled Germany after the 1938 Kristallnacht pogrom. He found safe haven in a London boardinghouse for war refugees run by Hannah Wallach, herself a German Jewish refugee who had also come to London after Kristallnacht. Hirsch died in London during the war, leaving the painting to his landlady in his will as an expression of his gratitude.

The painting, however, had been left behind in Germany and was confiscated by the Nazis, who stored it at Kloster Beuerberg, near Munich. It was found after the war and since neither Hirsch's death nor his gift were known at the time, it was sent on July 23, 1946, to the Wiesbaden Central Collecting Point, where recovered material that had not yet been restituted was being consolidated and sorted. On July 12, 1951, it was transferred again to the Munich Central Collecting Point. On the transport memorandum the painting was listed as Item 251; next to "Max Hirsch" an administrator had jotted, "No claim." When the collecting point closed later that year, the painting was placed in the custody of Jewish Cultural Reconstruction and shipped once more, along with other artworks whose owners were dead or unknown, to the offices of the Jewish Restitution Successor Organization in Nuremberg, where new homes were being identified for orphaned art. In 1952 it was shipped one last time to the Bezalel National Museum (now the Israel Museum) in Jerusalem.

Hannah Wallach's heirs were found in 2018 and the painting was finally consigned to them.

At some point during its travels from Wiesbaden to Israel, the painting was damaged, leaving a white scar running down the middle of the composition that partly obscured the sitter's face. It was restored in 2019, so that she has recovered her features, if not her name. Still, the artwork bears the traces of its passage through the war and its aftermath.

Right: Oil on canvas, 36¼ × 23⅝ in. (92 × 60 cm) Private collection, formerly on deposit at the Israel Museum, Jerusalem, received through the Jewish Restitution Successor Organization

Above: The painting before its conservation by the Israel Museum in 2019.

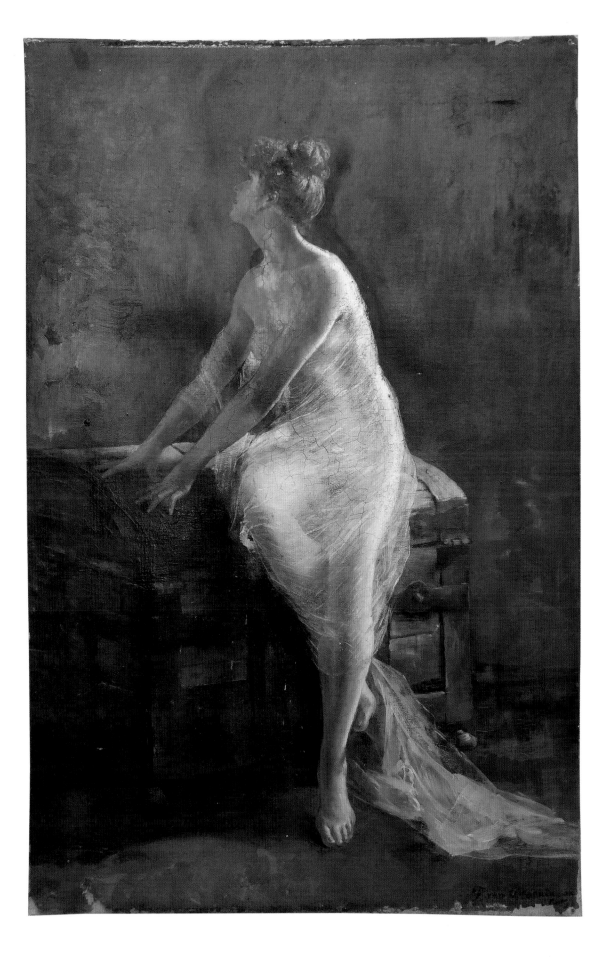

Hanukkah lamp, Germany, c. 1900

Before the 1930s the Franconia region of Germany had a large, well-established Jewish population. Most of its numerous synagogues were destroyed on Kristallnacht, the anti-Semitic pogrom of November 9, 1938. As the buildings were looted and burned, the Jewish ritual objects belonging to them were collected in crates and placed in storage in the Mainfränkische Museum in Würzburg. An Allied bombing raid and firestorm on March 16, 1945, razed the city and destroyed the museum, but the crates were recovered from the ruins. Most of the ritual objects were turned over in 1947 to the Jewish Restitution Successor Organization, the postwar agency, based in Nuremberg, charged with redistributing Judaica when the former owners were dead or could not be identified. The Jews of Franconia were gone—forced to emigrate or deported and murdered.

However, seven crates were apparently overlooked and remained forgotten in museum storage. They were rediscovered only in 2016, when the museum performed a thorough audit of its collections. Among the 158 works of Judaica rediscovered then were some in fine condition, and some that were twisted, burned, or broken, including this badly bent and charred Hanukkah lamp, missing its three feet and the Shammash candle branch. Although no maker's hallmark remains, the form is very similar to a lamp sold by the firm of Johannes Rominger in Stuttgart.

Such objects, marred beyond repair, are stark representations of the violent destruction of war, important for a museum to preserve. Records suggest that the lamp survived Kristallnacht intact and was crushed in the 1945 bombing. Whether the fact that it was

reduced to an unusable artifact by the Allied bombing that brought World War II to an end makes its survival bittersweet or doubly bitter is a matter of interpretation.

Right: Brass, 6½ × 10⅞ × 2 in.
(16.5 × 27.7 × 5.2 cm)
Israelitische Kultusgemeinde
Würzburg, on loan to the Museum
für Franken, Staatliches Museum
für Kunst- und Kulturgeschichte,
Würzburg

Above: Johannes Rominger,
Hanukkah lamp, Stuttgart, early
twentieth century
Cast, spun, and gilt copper
alloy and white metal, 6⅜ × 6¾ ×
3⅜ in. (16.1 × 17.1 × 8.5 cm)
Jewish Museum, New York, gift of
Dr. Harry G. Friedman

Gustave Courbet, *Dead Doe*, 1857

Dead Doe was stolen from an anonymous Jewish residence in Paris in the fall of 1942. This oil sketch was a study for a much larger painting, *Deer Forced Down in the Snow,* which Gustave Courbet exhibited at the 1857 Paris Salon.

In 1942 the work was expropriated through a massive Nazi program known by the code name Möbel-Aktion (Furniture Action). Executed by the looting task force Einsatzstab Reichsleiter Rosenberg (ERR), the operation seized works of art, articles of furniture, and other precious belongings from more than seventy thousand homes belonging to French, Belgian, and Dutch Jews who had either fled or been deported to concentration camps. The spoliation was carried out on an industrial scale, with ERR officials breaking into more than thirty-eight thousand homes in Paris alone. Each item seized during the Möbel-Aktion was given an inventory number; that of *Dead Doe,* MAB 105, is still visible on the back of the painting (see page 16). Although works of art were singled out for special treatment, much of the other property was sent to Germany, where it furnished homes of citizens of the Third Reich who had been displaced by Allied bombing.

Dead Doe was moved between a number of temporary storage facilities, including the Jeu de Paume in Paris, which the Nazis had converted into a temporary storage depot, a castle in Nikolsburg, in the present-day Czech Republic, and a second castle in Austria, northeast of Salzburg. After the war, Allied forces recovered the painting and sent it to the Munich Central Collecting Point, where it was processed and repatriated to France. It then became one of more than two thousand unclaimed works that entered the temporary custodianship of the French government through the Musées Nationaux Récupération, an inventory of spoliated or possibly spoliated works. Many of them were then hung in French national museums.

In 1951 the French government assigned *Dead Doe* to the Musée du Louvre; in 1954 the painting was reassigned to the Ahmed Zabana National Museum in Oran, Algeria, which was a French colony at the time. It remained there until the night of October 24, 1985, when it was stolen a second time. In 2001 French authorities found it once more at a Paris auction house and transferred it to the Musée d'Orsay. Like thousands of other heirless works, it remains there, under the temporary custodianship of the French government, until a claimant can be found.

Needless to say, Courbet could not have anticipated the traumatic events that would befall his painting. A representation of a fragile creature whose life has been cut short, the work is rich with unanticipated meanings that have accrued to it over time. While no direct historical reference was intended by its maker, these meanings also belong to the pathos of the painting and shape how it is seen in the present.

Oil on canvas, 13 × 16⅜ in.
(33 × 41.5 cm)
Musée d'Orsay, Paris

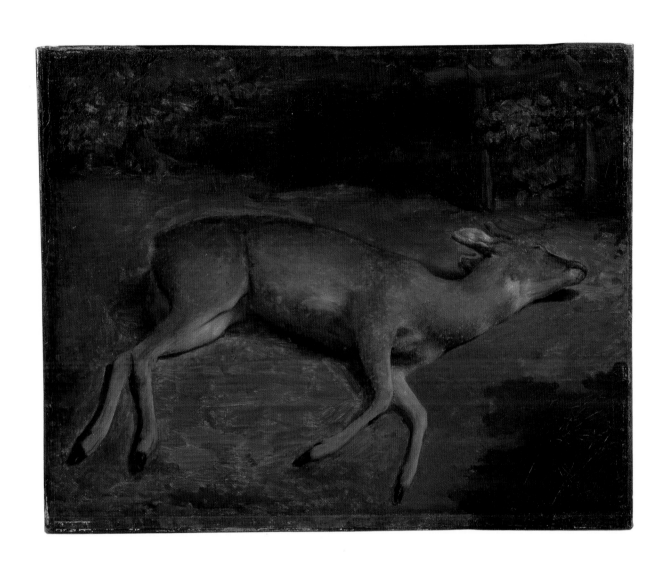

Gustav Klimt, *Szerena Pulitzer Lederer*, 1899

Gustav Klimt painted members of the Lederer family many times. The Lederers, Viennese industrialists and prominent members of the Jewish community, were among his most consistent patrons. Wealthy Jewish connoisseurs at the turn of the twentieth century often supported artists whose styles were too radical for the conventional tastes of more aristocratic clients. This was particularly true for Klimt, who had rejected the academic and cultural establishment that dominated the Austro-Hungarian Empire.

Szerena Pulitzer Lederer was the wife of the family patriarch, August. A notable figure in Viennese society and a relative of the American journalist Joseph Pulitzer, she was twenty-six when she posed for this ethereal portrait. It was one of the first works she commissioned from Klimt and was pivotal in establishing their long, close relationship.

Following the German annexation of Austria in 1938, Nazi soldiers stormed the Lederer home on Bartensteingasse in the center of the city and confiscated the family's business and property, including their art collection. Szerena fled to Budapest, where she became ill and died three years later. Her daughter Elisabeth, who was in her forties, remained in Vienna, where as a Jew she was in ever-growing peril. In an attempt to mask her Jewish parentage, Szerena signed an affidavit before her death claiming that Elisabeth had been conceived during an affair with Klimt, who, while long since dead, was classified as "Aryan." Szerena's plan worked and allowed Elisabeth to continue living in Vienna until her own death in 1944.

When the Nazis seized the Lederer collection, they divided it into several parts, storing groups of works in temporary depots around Germany and Austria. As Allied forces began advancing on Nazi positions later in the war, some were evacuated to a salt mine at Altaussee for safekeeping. Many of those works were later recovered by Allied forces and restituted. Another portion of the collection was stored at Schloss Immendorf, a castle in southern Austria. In May 1945, on one of the last days of the war, the retreating Nazis set the castle on fire, destroying sixteen works by Klimt, including the allegorical paintings *Jurisprudence* and *Philosophy*. In one of the many ironies of history that define the period, the only works from the Lederer collection that were spared the trauma of Nazi looting were the family portraits, including that of Szerena. While the Nazis seized the other works from the collection with the intention of selling them to fund the war machine, they deemed the family portraits "too Jewish" to be worth taking. Szerena's son Erich was able to take them with him when he fled Vienna for Geneva.

Oil on canvas, 75⅛ × 33⅝ in.
(190.8 × 85.4 cm)
Metropolitan Museum of Art,
New York, purchase, Wolfe Fund,
and Rogers and Munsey Funds,
gift of Henry Walters, and
bequests of Catharine Lorillard
Wolfe and Collis P. Huntington,
by exchange, 1980

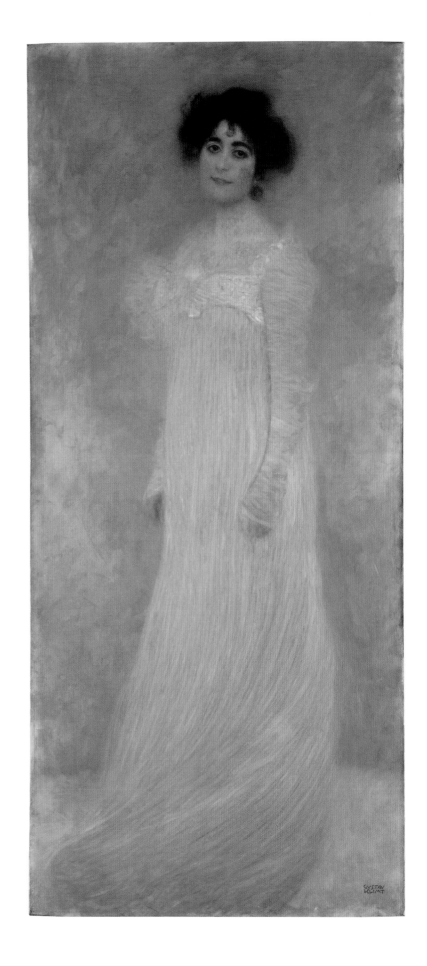

Edouard Manet, *In the Conservatory*, 1879

The sitters for this portrait, Jeanne and Jules Guillemet, were friends of Manet's who owned a shop on rue du Faubourg Saint-Honoré in Paris. Manet's portraits are unrivaled in their ability to convey nuanced social commentary. This scene of an elegant, fashionably dressed couple is a monument to chic Parisian modernity. Identified as married by their wedding rings, they are caught in a moment of intimate conversation. But just what is occurring between the two has been the subject of endless debate: the husband appears more engaged than his wife, who stares distractedly past him. His pose is natural, hers formal, and the artist has placed the back of the bench between them, like a barrier or the bars of a cage. Within the tight framing, their ungloved hands, not quite touching, mark the center of the composition.

By the time of Manet's death in 1883 *In the Conservatory* was considered one of his masterworks. In 1896 it was purchased for the Nationalgalerie in Berlin, his first work to be acquired by a museum. In March 1945, as the Battle of Berlin was poised to begin, the Nazis evacuated the painting, along with many other priceless works from the German state museums, to an enormous underground bunker that they had built in a salt mine at Merkers, two hundred miles to the southwest. The art cache was discovered by the American Third Army on April 7, 1945, along with one hundred tons of Nazi gold.

The artworks were initially shipped to collecting points in Germany, but unlike art looted from the victims of Nazi aggression, they were owned by the German nation, and their status soon became a matter of dispute. In December 1945 many of the most valuable, including *In the Conservatory*, as well as paintings by Titian, Rembrandt, Botticelli, Vermeer, and others, were sent for safekeeping to the National Gallery of Art in Washington, DC—

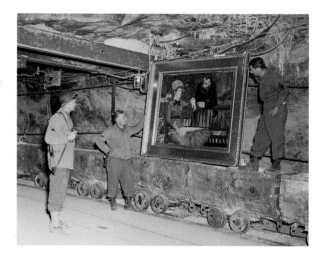

a decision that aroused angry criticism, as it looked uncomfortably similar to the Nazis' treatment of art as war booty. There they spent two years in storage, until the Department of the Army mounted a traveling exhibition of 202 works, *Paintings from the Berlin Museums*, which toured the United States in 1948. In Washington, DC, the show drew 964,970 visitors in forty days, more than any other comparable exhibition in the world at the time, and 67,490 on April 11 alone, setting an all-time single-day attendance record. As a gesture of goodwill, admission fees were donated to the German Children's Relief Fund.

In addition to showing dozens of masterpieces to American audiences, the exhibition was a landmark in postwar diplomacy: despite calls from some quarters for the United States to retain the works as compensation for expenses incurred during the war and in postwar reconstruction projects, all were returned to Germany in 1949, establishing a precedent in which the looting of art was rejected by the international community as a matter of principle.

Right: Oil on canvas
45¼ × 59 in. (115 × 150 cm)
Alte Nationalgalerie,
Staatliche Museen, Berlin

Above: American soldiers with
Manet's *In the Conservatory* in
the Merkers salt mine, Germany,
April 25, 1945.

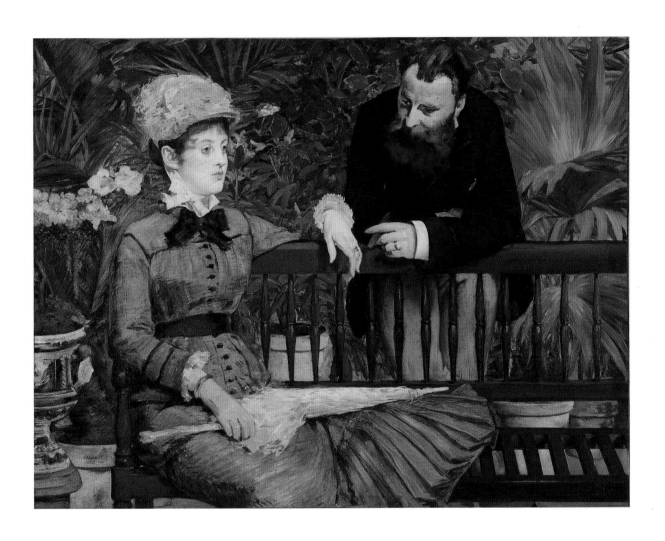

Pierre Bonnard, *Still Life with Guelder Roses*, 1892, reworked 1929

Pierre Bonnard began *Still Life with Guelder Roses* when he was twenty-five, applying the thick, unhurried passages of lush green and ivory white that delineate the leaves in 1892. He returned to the painting thirty-seven years later, adding the dappled cream highlights that give shape and volume to the blossoms in 1929. The product of two moments of making separated by almost four decades, what may otherwise have seemed to be a static work is filled with a subtle and unexpected sense of movement, capable of carrying viewers backward and forward in time with a single stroke.

The painting was defined by another kind of movement during the Second World War. One of more than two thousand works stolen from the influential French American banker, collector, and philanthropist David David-Weill, it spent the war years moving in and out of secret storage facilities and underground bunkers across Europe. David-Weill had shipped portions of his collection to the United States and moved there himself in 1939. He hid the rest in various locations throughout France, but some were discovered in 1943 by the Nazi looting task force Einsatzstab Reichsleiter Rosenberg. The still life was one of sixteen paintings by Bonnard taken from him by the Nazis. It was brought to their depot at the Jeu de Paume gallery in Paris, and from there was transferred by train to Schloss Nikolsburg in what was then Czechoslovakia, which the Nazis had converted into a makeshift warehouse. As Allied forces advanced, the painting was moved again, this time to a series of subterranean bunkers that the Nazis had constructed in a salt mine at Altaussee in central Austria. Following the discovery of the salt mine by Allied forces in May 1945, it was moved once more, to the Munich Central Collecting Point, where it was processed and restituted to David-Weill. The painting did not stop moving. As soon as its ownership was restored to him, David-Weill lent it to one of many exhibitions of artworks that had been recovered after the war. In the summer of 1946 it was on view at the Musée de l'Orangerie, the twin building next to the Jeu de Paume gallery in the Tuileries gardens of Paris, where *Still Life with Guelder Roses* had been inventoried by the Nazis six years earlier.

Oil on canvas, 16⅛ × 13 in.
(40.9 × 33 cm)
Nelson-Atkins Museum of Art,
Kansas City, Missouri, gift of
Mr. and Mrs. Herman R. Sutherland

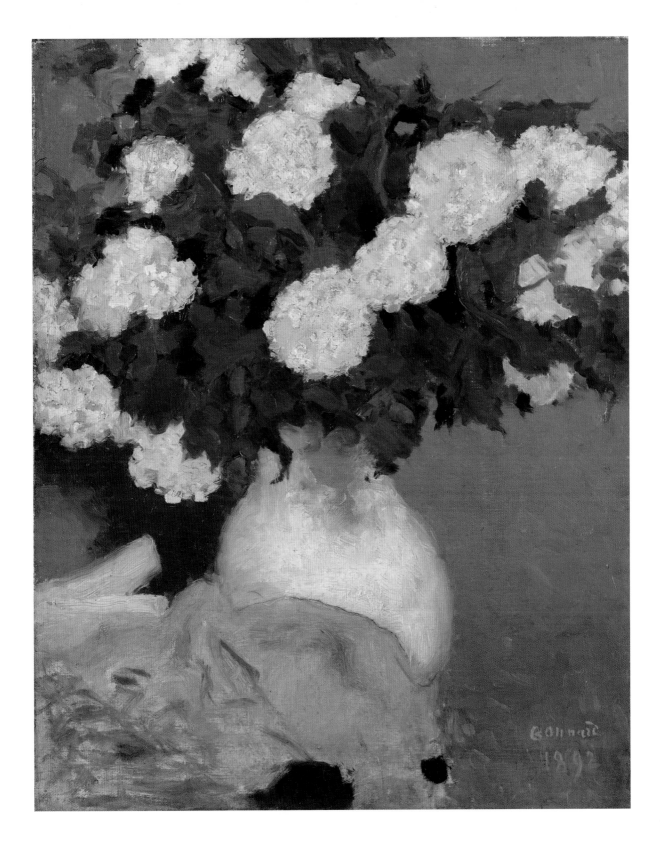

Samuel Hirszenberg, *The Black Banner,* 1905

Samuel Hirszenberg was an academically trained Polish Jewish painter who studied in Munich and Paris and worked in a Realist style, with touches of Symbolist influence. Like other Polish painters at the turn of the twentieth century, he had a taste for panoramic historical scenes, but chose specifically Jewish topics—yeshiva students, refugees, and, here, the aftermath of an anti-Semitic pogrom—one of many that Jews suffered in Russian-dominated Poland at the turn of the twentieth century.

Beneath a stormy sky a crowd of mourners processes behind a coffin draped in a black cloth. Hirszenberg, who may have inserted his own portrait as the young man at left, looking with terrified disbelief at the viewer, was one of the first artists to represent the horrors of the pogroms. He exhibited the painting in 1906 at the Salon of the Société des Artistes in Paris, where he had already become an established figure known for representations of Jewish history.

Hirszenberg emigrated to Palestine in 1907 and died in Jerusalem in 1908. *The Black Banner* entered the National Museum of Poland, and by 1939 was in the possession of Benjamin Mintz, an antiquities collector and dealer from Warsaw. As Nazi troops marched into Poland that year, Mintz packed his collection, including *The Black Banner,* and shipped it to America. To

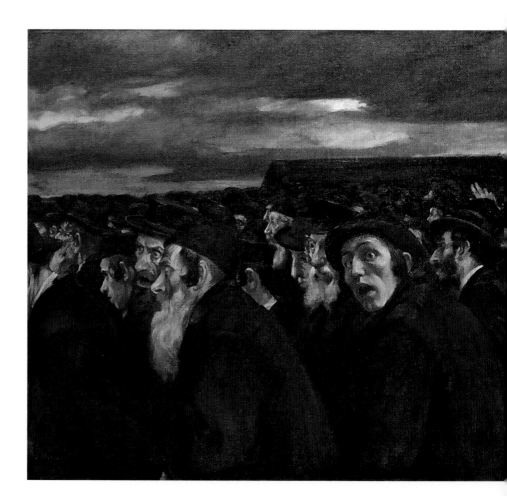

Oil on canvas, 30 × 81 in.
(76.2 × 205.7 cm)
Jewish Museum, New York,
gift of the Estate of
Rose Mintz

receive permission to do so, and to leave the country himself, Mintz explained to customs officers that the works were scheduled to be shown at the New York World's Fair. While it is not clear whether an exhibition was indeed planned, or whether Mintz invented the story, the works were never displayed. The collection remained with Mintz in New York until his death in 1940, and in 1947 his widow, Rose Mintz, sold the collection to the Jewish Museum.

Like many works that were exposed to the turmoil of the Second World War, *The Black Banner* occupies a complex position in time. A representation of one episode of persecution that narrowly escaped a second episode of persecution decades after it was completed, it brings together multiple layers of history. Indeed, the figures who stare out from the painting, making direct eye contact with the viewer, seem to be aware of those layers. With faces full of anxiety and concern, they gaze at us from their own historical moment, and also past us to those who will encounter the painting in the years to come.

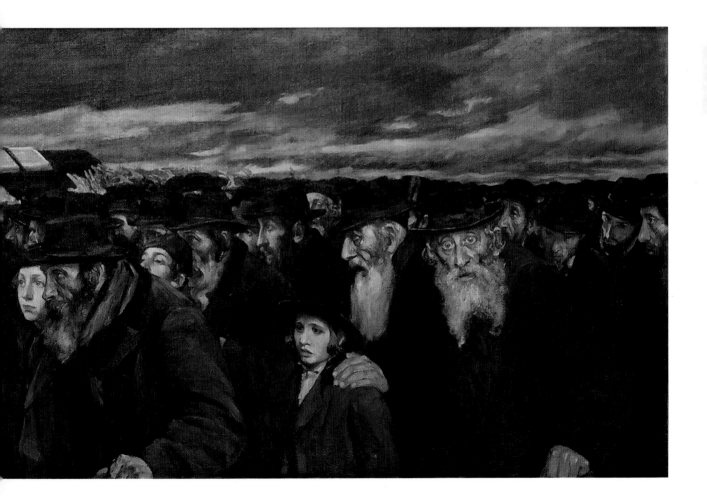

Leopold Fleischhacker, alms container, Vohwinkel, Germany, c. 1910–15

A tzedakah box, or alms container, is an important piece of equipment in Jewish communities and synagogues. The Jewish obligation to do what is right and just includes an ethical duty to perform acts of charity and goodwill. The family who owned this alms container fled from Russia to Germany in 1919, at the time of the Russian Revolution and acquired it sometime between their arrival and 1923.

The Judischer National Fonds, or Jewish National Fund, had been founded in Switzerland in 1901, during the fifth Zionist Congress, at a time of growing interest among European Jews in the idea of establishing a Jewish homeland in Palestine. The organization raised money to purchase land there from the Ottoman Empire. One of its most successful fund-raising campaigns involved the distribution of more than a million alms containers to Jewish households worldwide, so that families could donate easily and often from the security and comfort of home. Though later versions of the box were simple blue-printed aluminum, this early copper piece was designed by the sculptor Leopold Fleischhacker using a shape, material, and letterforms in the Jugendstil, or German Art Nouveau, style.

For the family that owned this box, safety and security were fleeting. They settled briefly in Germany but spent decades traveling across Europe from city to city. In 1923 they moved from Germany to Paris, then to Rotterdam, and finally to Antwerp. When the Nazis invaded Belgium in 1940, the family was forced to abandon its home and move once again, fleeing to the United States. They returned to Belgium in 1946 and found that, although the apartment had been stripped bare by Nazi soldiers, some of their possessions had been left behind, including the alms container.

Die-stamped, engraved,
and embossed copper alloy,
5⅞ × 3⅛ × 3⅛ in.
(14.9 × 8.1 × 8.1 cm),
manufactured by Homann-Werke
Jewish Museum, New York, gift of
Thamar Luksenberg

Franz Marc, *The Large Blue Horses*, 1911

Franz Marc showed *The Large Blue Horses* in the first exhibition of the Blaue Reiter, or Blue Rider group, in Munich in 1911. The exhibition formally inaugurated one of the most important artistic movements of the early twentieth century—a group of German and émigré Russian artists working in an Expressionist style, in parallel to the emerging Cubists and Fauves in France. Cofounded by Marc and Wassily Kandinsky, the Blaue Reiter was committed to the principles of spiritual expression and experimentation in art, emphasizing the mystical power and symbolism of color. It drew together a remarkable group of painters: Marc, Kandinsky, André Derain, Lyonel Feininger, Alexej von Jawlensky, Paul Klee, August Macke, Gabriele Münter, Maurice de Vlaminck, and Marianne von Werefkin.

The Large Blue Horses captures many of Marc's core ideas: three closely packed horses are set against an expressionistic landscape. The animals and background are a series of strong, solid shapes—the black and white curves of manes and trees and the round, brilliant blue and red of bodies and hills—that move together across the expanse of the canvas.

The Blaue Reiter's break with the traditions of naturalism in painting both startled and, eventually, delighted viewers. Marc's love of animals and pleasure in color gave many of his canvases a gentle, sweet quality, though he later turned to a more hard-edged and abstract style. The movement itself was short-lived. It disbanded on the eve of the First World War in 1914. Marc joined the German army, where at first he painted camouflage. But he was soon deployed to the front and was killed in combat near Verdun on March 6, 1916, age thirty-six.

After the war, Marc's posthumous reputation grew, until his style ran afoul of Nazi antimodernist aesthetics. In 1937 he was branded a "degenerate" artist. Many of his paintings were purged from public museums in Germany and either sold at auction or destroyed. Works by him were included in the infamous *Degenerate Art* exhibition in Munich in 1938 but subsequently removed, following protests by war veterans because he had died fighting for Germany. Although *The Large Blue Horses* was in private hands, and thus spared seizure, these events informed how the painting was seen in subsequent years. In 1938 it was included in *Exhibition of Twentieth Century German Art*, a show mounted in London in opposition to the German one, and a year later was included in *Twentieth Century Banned German Art*, which toured the United States. Both shows belonged to an emerging genre of exhibitions that featured works of art no longer permitted in Nazi-controlled territory.

Oil on canvas, 41⅝ × 71¼ in.
(104 × 180 cm)
Walker Art Center, Minneapolis,
gift of the T. B. Walker
Foundation, Gilbert M. Walker
Fund, 1942

El Lissitzky, *Proun 2 (Construction)*, 1920

A composition dominated by heavy volumetric slabs suspended in space and seen from multiple and in some cases contradictory perspectives, *Proun 2 (Construction)* is a distillation of the avant-garde Constructivist principles that flourished in post-Revolutionary Russia. Lissitzky coined the term "Proun" not only to describe his own radical artistic theories, which combined advances in painting, architecture, philosophy, and physics, but also to refer to the process of artistic innovation as such. The term is an acronym of the Russian words meaning "project for the affirmation of the new."

Proun 2 was recognized as a major modernist achievement almost as soon as it was completed. It was one of a select group of works exhibited in the groundbreaking Abstract Cabinet at the Provinzialmuseum Hannover. Lissitzky designed the gallery in 1928. Featuring modular walls that could be moved at will and built using a variety of materials that interacted with the works on display, the Abstract Cabinet was a physical realization of many of the principles that Lissitzky had explored in his paintings, and served not only as a cutting-edge exhibition venue but also as a laboratory for artistic exploration. In addition to works by Lissitzky, the gallery exhibited paintings by many of his influential peers, including Piet Mondrian, Ludwig Mies van der Rohe, Pablo Picasso, and others.

A space dedicated to radical artistic experimentation located in the heart of Germany, the Abstract Cabinet was one of the first targets in the Nazi campaign against "degenerate" art. It was destroyed in 1936, and many of the works that had hung there were seized by the Reichsministerium für Volksaufklärung und Propaganda (Reich Ministry of Public Enlightenment and Propaganda) and later displayed prominently in the Munich *Degenerate Art* exhibition. The "EK" (*entartete Kunst*, or degenerate

art) inventory number 14283 is still visible, stamped on the back of the painting. As one of the founders of artistic abstraction and an artist of Jewish descent, Lissitzky was singled out by the Nazis with particular ferocity and zeal.

After *Proun 2* was seized it was sold to the Galerie Buchholz in Berlin, run by Karl Buchholz, one of four art dealers authorized by the Nazis to sell confiscated work. The painting was transferred to the gallery's New York branch, run by Buchholz's protégé Curt Valentin, who, while of Jewish heritage, had been permitted to leave Germany in 1937 in order to continue selling such art in America on the Nazis' behalf. In 1939 the painting was purchased by the influential American abstract painter Albert Eugene Gallatin. Gallatin hung it in his Museum of Living Art, the first American museum devoted exclusively to modern art, which Gallatin opened in New York City in 1927, the same year Lissitzky began working on designs for the Abstract Cabinet, thousands of miles away.

Oil, paper, and metal on panel,
23½ × 15⅝ in. (59.5 × 39.8 cm)
Philadelphia Museum of Art,
A. E. Gallatin Collection, 1952

Moïse Kisling, *Portrait of Renée Kisling*, 1921

Born in Kraków in 1891 to Jewish parents, Moïse Kisling spent most of his career in France. He moved to Paris in 1910 and joined the bohemian art community of Montmartre, living briefly in the Bateau-Lavoir, a building that also housed the artists Juan Gris, Kees van Dongen, Amedeo Modigliani, and Pablo Picasso. During the First World War, Kisling volunteered to serve in the French Foreign Legion and was seriously wounded fighting the Germans at the Battle of the Somme in May 1915. For his service he was granted French citizenship. He returned to Paris and resumed painting at a studio in Montparnasse, where his neighbors were Modigliani and Jules Pascin and his friends included Jean Cocteau, Marie Laurencin, and Kiki de Montparnasse. In 1917 he married Renée Gros, a painter, model, and photographer.

Kisling became particularly known for his portraits, in which elements of Expressionist distortion and Cubist stylization enhance rather than diminish the accuracy of the likeness. He painted his wife several times. This version was purchased in 1925 by Josef Haubrich, a lawyer in Cologne who collected modern art, especially the German Expressionists.

When the Nazi regime began to purge "degenerate" modern art from museums in the 1930s, armed soldiers searched homes for works deemed unacceptable. Haubrich concealed some of his collection in his apartment and hid the rest in the country. He also purchased paintings discarded by museums and works by persecuted artists to spare them from destruction. Although Haubrich was able to preserve much of his collection, he and his family suffered profoundly during the war.

His wife, Alice Gottschalk, was Jewish, and the family was under constant threat by the Nazis. In 1943 Alice's daughter from a prior relationship, Anneli, was forced to flee Cologne for Vienna. There she worked for a time as a governess for a Nazi official whom Haubrich had managed to bribe; later she escaped to Denmark. Alice was less fortunate. On February 10, 1944, the day that she and her husband were summoned by the Gestapo to be expelled from their home and moved to a district for couples in mixed marriages, she took her own life.

Kisling found his own ways to resist Nazi oppression. In 1940 he volunteered to fight the Germans a second time, enlisting in the French army. Following the French surrender he fled through Lisbon to New York and then California, where he lived until 1946. That same year, Haubrich donated his collection to the city of Cologne. "I feel a special duty to youth," he explained at the time. "I want to give our youngsters, who are unaccustomed to liberty, or are largely unaware of what liberty is, the opportunity to take a long, close look at all the things that were kept forcibly from them over these twelve years." Soon after the donation, the collection, including *Portrait of Renée Kisling*, traveled across Germany, giving many Germans their first look at modern art since the war began.

Oil on canvas, 25⅝ × 20⅞ in.
(65 × 53 cm)
Museum Ludwig, Cologne

Ernst Ludwig Kirchner, *Street Scene in Front of a Hair Salon*, 1926

In the 1920s Ernst Ludwig Kirchner often painted urban German street scenes, using an energetic palette of reds, blues, and yellows that contrasts sharply with other, more somber elements. It is evening; a half-dozen people pass by a brightly lit window that frames three women—perhaps mannequins—with low bodices. Outside, three men cluster, leering. Other pedestrians, their faces masklike, their posture hunched, appear isolated and alone; all are alienated denizens of modern Berlin.

Kirchner made the painting soon after his return from a sojourn in Switzerland, recovering from a nervous breakdown he had suffered as a German soldier during World War I. In the 1920s he was one of the most admired artists in Germany. He was celebrated as a founding member of the German Expressionist group Die Brücke (The Bridge), an artistic movement that sought to "bridge" the past and the present, regrounding contemporary experience by using sturdy, primitive forms borrowed from medieval German woodcuts. Subjects were often harsh and sexually provocative, colors acidic.

In the 1910s and 1920s this approach was seen as an exciting return to a Germanic art tradition while being at the same time daringly avant-garde. Kirchner and his fellow German Expressionists were embraced as the German answer to French modernism. Indeed, the city of Dresden quickly bought *Street Scene in Front of a Hair Salon* from Kirchner.

However, demonstrating how volatile a force German nationalism proved to be, Kirchner fell violently out of favor in the early 1930s. His work was deemed "degenerate" by the ascendant Nazis, and *Street Scene in Front of a Hair Salon* was included in the 1933 exhibition *Degenerate Art*, one of the earliest of such shows, mounted to shame and ridicule the reviled category. It was installed at the Dresden

City Hall and then toured to several German cities, including Nuremberg, Berlin, and Munich. After the exhibition in Dresden, the painting was put into storage at the Städtischen Galerie until it was officially confiscated by the Nazis and sold in 1937. The dramatic change in fortune was both jarring and, by that point, familiar. Indeed, in one of many historical ironies that made the period so bewildering, the same man who had overseen the purchase of Kirchner's painting, Hans Posse, was personally appointed by Hitler to manage his planned Führermuseum in Linz.

The designation of his work as "degenerate" was catastrophic for Kirchner. More than six hundred of his works were sold or destroyed, contributing to his decision to kill himself in 1938. Although Kirchner met a tragic fate, *Street Scene in Front of a Hair Salon* has had a redeeming afterlife. In another historical irony, after decades in private collections, the painting was purchased a second time by the Staatliche Kunstsammlungen in Dresden in 2016, and hangs there today.

Oil on canvas, 47 × 39⅝ in.
(119.5 × 100.5 cm)
Galerie Neue Meister, Staatliche
Kunstsammlungen, Dresden

Francis Picabia, *Judith*, 1929

The French experimental artist and poet Francis Picabia painted *Judith* in 1929. The work belongs to a series of paintings that Picabia called "transparencies" and is unique in his oeuvre in that it presents a subject rooted in Jewish tradition: the biblical figure Judith moments after she has decapitated the invading Assyrian general Holofernes. Like the other works in the series, the painting is composed of layered, semitransparent images that Picabia drew from reproductions of antique and Renaissance works. He found these in the hundreds of art books that lined his studio in the south of France, as well as in more popular material such as magazines and postcards. The sources for many of the works remain intentionally obscure, separated from their original contexts and suspended ambiguously in space and time.

The painting itself also underwent a traumatic separation. In 1943 the Nazis raided and looted the Paris home, at 53 rue Dominique, of Jean Louis-Dreyfus, a member of a prominent French Jewish family that owned one of the largest agricultural trading firms in the world. On April 7 it was sent to Bruno Lohse, the personal art dealer in Paris of the Nazi leader Hermann Goering, before being transferred to the Jeu de Paume gallery, which the Nazis had converted into a temporary storage depot. While it was there, German staff photographed the painting, writing "DRD" (Dreyfus rue Dominique) in pencil on the back of the photograph. On November 18 it was moved a third time, to a Nazi storage depot at Schloss Seisenegg in Austria. After the war the painting was recovered by Allied forces and returned to its owner.

Picabia's own experience during and after World War II was also fraught. He had been a Cubist and then a central figure in the Dada movement, and his radical style was labeled "degenerate" by the Nazis. Nevertheless, he continued to paint during the German Occupation of France, and spent the early 1940s producing figurative paintings based on photographs from popular magazines that seemed similar in content and style to the official imagery of the Third Reich. After the liberation of France, Picabia was suspected of collaboration with the Nazis and served four months in jail before being cleared due to a lack of evidence.

```
Oil on canvas, 76¾ × 51⅛ in.
(195 × 130 cm)
Private collection
```

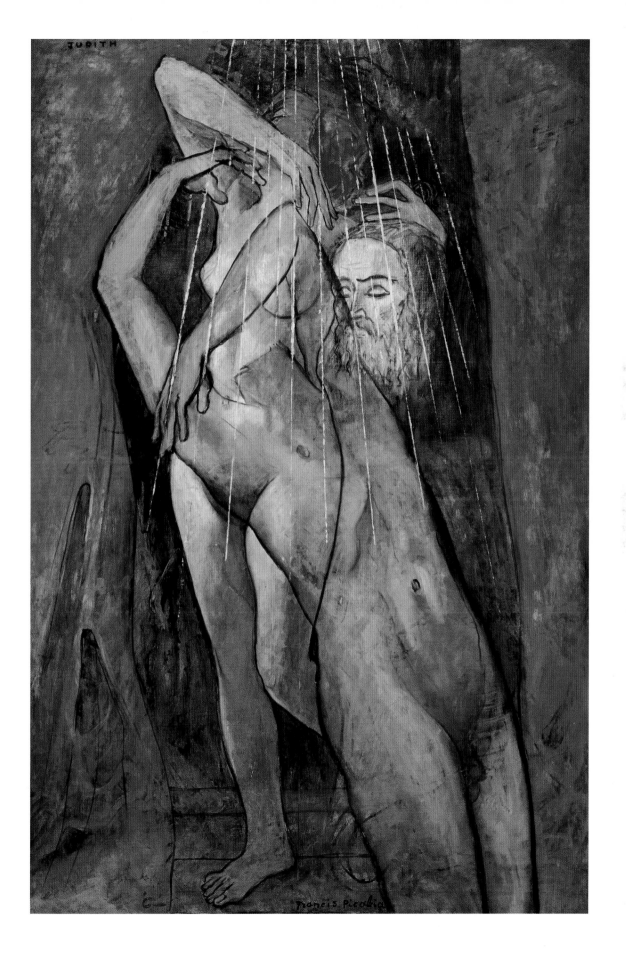

Kurt Schwitters, *Opened by Customs*, 1937 or 1938

A dense accumulation of torn paper, discarded trash, and oil paint, *Opened by Customs* derives its title from three Nazi labels reading "Zollamtlich geöffnet," pasted in a diagonal line along the upper part of the composition. Kurt Schwitters was a master of the formal aspects of collage—layering, clever juxtapositions, Cubist splintering of space, a rich tactility of surface—and used these techniques to organize the material world according to the anarchic ideas of the Dada movement. For him, the impact of World War I was profound: "In the war," he later recalled, "things were in terrible turmoil. Everything had broken down and new things had to be made out of the fragments." Throughout the 1910s and 1920s he explored a radical art that frequently incorporated reading and language.

With the advent of Hitler's regime, this kind of art was no longer possible in his native Germany. Schwitters made *Opened by Customs* in exile in Norway, having been forced to flee in 1937 after his work was deemed "degenerate" and shown in the mocking *Degenerate Art* exhibitions.

Combining scraps of text written in multiple languages, the collage is a refugee work by a refugee artist and records the displacement that was experienced by so many under the Third Reich. In a number of places, that displacement is referred to explicitly. In addition to Nazi customs labels, phrases can be found throughout the composition that allude to Schwitters's forced movement, including the words "Norwegen," "airline boarding pass," "baggage insurance," and "sleeping car." The sense of displacement is made more acute by a circular black postal cancellation stamp beneath the Nazi labels that includes the inscription "Hannover 3.8.37," a reference to the city where Schwitters was born and the year the Nazis began purging works of modern art en masse. Schwitters never returned to Germany. His home in

Hannover was destroyed by an incendiary bomb in 1943, and when Nazi troops invaded Norway he fled again to England. After spending eighteen months in an internment camp, he was released and settled in London, where he remained until his death in 1948.

Schwitters did, however, return to Germany after death. He was initially buried in the small town of Ambleside in northwest England, but his remains were reburied in Hannover in 1970, with a second headstone based on a sculpture that Schwitters made in the 1920s, *The Autumn Crocus*. His son Ernst had intended this sculpture to mark his father's burial place in England, but it was rejected by the local vicar. In a reversal of the censorship that Schwitters endured during his life, this time the authorities in Germany proved more permissive. Although the original sculpture had, like Schwitters's home, been destroyed in a bombing raid in 1943, a plaster copy was produced in 1958 based on surviving archival photographs. A stonemason then used that copy to make a marble headstone, which was finally installed at Schwitters's burial place as his son had wished.

```
Paper, printed paper, oil, and
graphite collaged on paper,
13 × 10 in. (33.1 × 25.3 cm)
Tate, London
```

Den danske minister Kaufman.

Henri Matisse, *Girl in Yellow and Blue with Guitar*, 1939
Henri Matisse, *Daisies*, 1939

In July 1940 members of the Nazi looting task force the Einsatzstab Reichsleiter Rosenberg (ERR) raided a gallery and adjoining apartment at 21 rue La Boétie in Paris. In September 1941 they broke into a bank vault in Bordeaux. Both belonged to the influential collector and dealer Paul Rosenberg. Rosenberg had represented many of the most important painters of the early twentieth century, including Pablo Picasso, Fernand Léger, and Henri Matisse. Among the works the Nazis stole were *Girl in Yellow and Blue with Guitar* and *Daisies*, both of which Matisse had completed the previous year. Painted in his inimitable style, the paintings capture the last moments of calm in France, soon to be broken.

Rosenberg managed to flee the country with his family, passing through Spain and Portugal to New York with the aid of Alfred H. Barr Jr., the director of the Museum of Modern Art. But he was forced to leave his immense collection behind. Along with countless other works, *Girl in Yellow and Blue with Guitar* and *Daisies* were temporarily stored in the German Embassy in Paris and the Musée du Louvre, before being transferred in September 1941 to the Jeu de Paume gallery, the largest Nazi depot for stolen art. Traveling companions since 1939, the paintings were separated in November 1942, when the Nazi art dealer Gustav Rochlitz chose *Girl in Yellow and Blue with Guitar* for the personal collection of Reichsmarschall Hermann Goering. By July 1944 it had been sent to the town of Baden-Baden in southwest Germany, while *Daisies* remained in Paris.

Meanwhile, in one of the conscious cruelties that pleased Nazi administrators, the ERR moved into the gallery at 21 rue La Boétie under the supervision of the chief Nazi ideologue Alfred Rosenberg, who converted it and the adjoining apartment into the

office of the explicitly racist Institute for the Study of the Jewish Question. There, in the same space where Paul Rosenberg had been showing the most advanced art of the twentieth century less than a year earlier, they began to plan one of the largest anti-Semitic exhibitions ever conceived, *Le Juif et la France* (*France and the Jew*). The show was on view in Paris from September 1941 to January 1942 and was attended by as many as five hundred thousand visitors.

By an accident of history, *Girl in Yellow and Blue with Guitar* and *Daisies* were reunited decades later. Following the war, both works were returned to Rosenberg and later sold independently. After passing through several private collections, both entered the collection of the Art Institute of Chicago, *Daisies* in 1983 and *Girl in Yellow and Blue with Guitar* in 2007. There, they share a space for the first time since they were stolen by the Nazis more than sixty years earlier.

Right: Oil on canvas, 25 × 19½ in. (63.5 × 49.5 cm) Art Institute of Chicago, Brooks McCormick Estate

Above: Oil on canvas, 36⅛ × 25⅝ in. (92 × 65 cm) Art Institute of Chicago, gift of Helen Pauling Donnelley in memory of her parents, Mary Fredericka and Edward George Pauling

Arthur (Asher) Berlinger, Jewish calendar for the year 5704, Theresienstadt (now Czech Republic), 1943

This calendar, written in German and Hebrew, was made by Asher Berlinger while he was imprisoned at Theresienstadt. In a blue leather binding made by a fellow inmate, Wilhelm Toch, it features an illustration of the twelve signs of the zodiac on its cover and inside lists the most important dates of the Hebrew year 5704 (1943–44), including various holidays, details about the Sabbath, and the times of sunrise and sunset. This is one of several copies that Berlinger produced, using a blueprint technique, and circulated to his fellow inmates in the camp. Pocket-size, it was designed to be easily concealed by prisoners, allowing them to continue worshiping in secret.

Berlinger had been a cantor and art teacher in Schweinfurt, Germany, until 1942, when he and his wife were deported to Theresienstadt, in what was then Czechoslovakia. This was a transit center where deported Jews were held before being sent to extermination camps. But it also served an important propaganda role for the Third Reich. It was designed to look like a model village, with gardens, sports fields, and workshops, to be shown to visiting Red Cross inspectors and others who had heard rumors of the death camps. Prisoners were forced to participate in this elaborate sham, designed to hide the horror of the Holocaust.

Prisoners at Theresienstadt sometimes had access to art materials, and used them to mount heroic acts of resistance, recording the real conditions at the camp on scraps of paper that they smuggled out to foreign newspapers when they could.

Berlinger made such drawings and produced ritual objects that allowed the Jews of Theresienstadt to continue religious practice. He also helped decorate a hidden synagogue on the grounds of the camp-ghetto, its ceiling painted with stars and images of lit

candles. He included illustrations of it in the calendar, one showing the open scrolls of the Torah on a lectern before an ark.

This synagogue was rediscovered on the grounds of Theresienstadt in 1989; it is now a memorial site. Still visible on one wall is an inscription taken from the *Tachanun*, an ancient text frequently used in morning prayers: "God, relent from the evil meant for your people. . . . Look from Heaven and perceive that we have become an object of scorn and derision among the nations; we are regarded as sheep to slaughter, to be killed, destroyed, beaten, and humiliated. But despite all this we have not forgotten Your Name— we beg you not to forget us."

Neither Berlinger nor Toch survived the Holocaust. Toch died in Theresienstadt in 1944. Berlinger was deported to Auschwitz on September 28 of that year. His wife, Berta, was deported there one week later. Both were murdered soon after they arrived. However, his calendar did survive, with copies at the Jewish Museum, New York, and Yad Vashem, in Israel.

Right: Ink on paper with leather binding, 5 × 3⅜ in. (12.7 × 8.6 cm), book fabricated by Wilhelm Toch
Jewish Museum, New York

Above: A drawing of the hidden synagogue

כסלו חשון תשרי

טבת אלול

לוח
לשנת
תש"ד
Jüdischer
Kalender
für das
Jahr
5704

שבט אב

אדר חשון

ניסן אייר סיון

Artists' Portfolios

These pages are devoted to four portfolios made by contemporary artists expressly for this publication. Maria Eichhorn, Hadar Gad, Dor Guez, and Lisa Oppenheim created or adapted work to address the themes explored in *Afterlives*, drawing upon their personal memories, archival research, and the provenance of particular objects. Unpacking complex histories, they have produced work that is also very much of this moment and invested in its possibilities. They reaffirm the capacity of artistic expression to give form to an understanding of the past that operates on visceral, emotional, and aesthetic levels all at once.

Maria Eichhorn

Born in Bamberg, Germany, in 1962
Lives and works in Berlin

In a field that relies on the circulation of marketable objects and high-end contemporary-art experiences, the work of Maria Eichhorn is quiet and ephemeral. Drawing upon the intertwined legacies of interventionist performance art and Conceptualism, her work has addressed a wide array of research-oriented themes, including the flow of capital, the legalities of ownership, and the mediating authority of institutions. While ambitious in scope, these topics are crystallized as specific case studies and investigations that inhabit her forms in a variety of ways, including as films, site-specific performances, and behind-the-scenes agreements. For the current context, Eichhorn delves into the question of property and, specifically, how books are an expression of personal identity and accrued knowledge. She looks into the redistribution of orphaned books left over from the war and the coordination of institutional and individual efforts involved in their repatriation.

Eichhorn is often compelled by histories engendered by the activism of intellectuals at transformative moments of history. Two are particularly relevant here: Rose Valland and Hannah Arendt. Valland, whose covert tracking of the movement of art during the Nazi occupation in France led to the recovery of countless works after the war, inspired the artist's *Rose Valland Institute*, dedicated to researching and documenting "the expropriation of property formerly owned by Europe's Jewish population."[1] The Institute, founded on the occasion of *Documenta 14* in Kassel, offers a framework for discourse and research into histories of loss and recuperation. This is a recurring interest that dates back to the artist's exhibition *Politics of Restitution* (2003, Lenbachhaus, Munich), which took up related themes of misappropriation and displacement. Such projects foreground the complex and often unresolved histories of seizure while featuring the work of agents seeking to return them to the families, collectors, and institutions that were pillaged. Arendt served as research director of the Commission on European Jewish Cultural Reconstruction and executive secretary of Jewish Cultural Reconstruction, and assembling detailed lists of Jewish institutions looted in Axis-occupied territories and tracking down caches of material that remained hidden in underground bunkers and secret rooms. Many of these recovered works, including Jewish ceremonial objects and tens of thousands of books, were sent to the United States, where they were stored in depots in Brooklyn and at the Jewish Museum, New York.

The transference of knowledge—and the fragility of language on paper and in memory—is a hook for Eichhorn, a means to surface her subject matter through written accounts and testimonies. Both Valland and Arendt were copious note-takers who applied their research skills to a form of activist sleuthing that directly affected the restitution effort. In the present project, commissioned by the Jewish Museum, Eichhorn adopts Arendt's field reports, modest documents originally used to keep track of objects, as her inherited script. A performer reads from the tattered pages of one, taken from the museum's archives (see page 230), in which Arendt describes the challenges of sorting through and managing large groups of stranded objects. As in Eichhorn's other works, there is no overt drama or acting. The medium is understated and quietly enunciated by a human voice—articulating a memo of tasks, findings, and observations that are, in their seeming banality, expressions of a relentless dedication to dig into history to excavate its startling remnants, and to effect change in the present.[2]

1 *Rose Valland Institute* website, www.rosevallandinstitut.org/about.html.

2 Information compiled from the artist's proposal, October 4, 2019, and interviews conducted on September 10 and December 17, 2019.

Right:
Books from Jewish Cultural Reconstruction in the Jewish Theological Seminary, Yeshiva University, Columbia University, the YIVO Institute for Jewish Research, and the New York Public Library, 2020
Photograph of books donated by Jewish Cultural Reconstruction to Yeshiva University Library, New York

Following pages:
Hannah Arendt's Jewish Cultural Reconstruction field reports, 2020
Hannah Arendt, Jewish Cultural Reconstruction Field Report no. 16, February 18, 1950, Archives of the Jewish Museum, New York, archival text, reading, bibliography

JEWISH CULTURAL RECONSTRUCTION, INC.
1841 Broadway, New York 23, N.Y.

CONFIDENTIAL

Field Report No. 16
Hannah Arendt

February 18, 1950

I

Generally speaking, conditions in Berlin are most unfavorable
for us because all larger libraries as well as the main stocks
of the Jewish Community are located in the eastern sector. The
following cultural treasures are exceptions to this rule:

1. The collection of paintings of the Jewish Museum which is now
being claimed by the new offices of JRSO in Berlin according to
a specified JCR list. This collection seems to be complete and
will eventually come into our custody.

2. More than 300 pounds of silverware (ceremonial objects) are
now housed in the JDC warehouse of the Jewish Community building
at Joachimsthalerstrasse 13. These are the remnants of an almost
complete Gestapo collection in the Muenchener Strasse consisting
of synagogue silver from all over Germany. There were originally
more than 500 pounds of silver. There is no doubt that the Berlin
community has no right to these ceremonial objects, but, un-
fortunately, it is also beyond doubt that one will have consider-
able difficulty in persuading this community that it should give
up its greatest financial asset. Information on these objects
was given to me by some Jews who had worked in the Muenchener
Strasse, and the story was confirmed by Rabbi Schwarzschild who
told me about the present whereabouts of this huge collection.

3. A small quantity of books and archival material in the Haupt-
Archiv of Berlin, formerly belonging to the Reichssippenamt.
This material contains stray books from the Fraenkelsche Stiftung
and the Viennese Community Library as well as some documents be-
longing to Yivo, Vilna. This material is now being claimed by
JRSO and is awaiting transfer to JCR.

4. It is possible that some material is still in the Volksbuech-
ereien in the western sectors of Berlin. The Berlin Municipality
through the Volksbildungsamt (Mr. S. Link) and the Amt fuer
Literatur (Dr. Moser) will initiate a systematic search.

II

The following collections are now in the eastern sector:

1. On the cemetery in Wissensee there are about 1,000 Torah-
scrolls, kept in a small room in rather poor condition. It was
already difficult to be permitted into the room, and quite im-
possible to really examine anything. We made a rough count; the
scrolls seem to be in pretty good condition, but handles are
mostly broken and there are hardly any covers.

2. In the community building there are still an estimated
8-10.000 books as well as many archives, documents, etc. From
this "library" a small staircase leads up to a room directly
under the roof where I found mountains of paper which, upon clos-
er inspection, turned out to be: parts of the Gesamtarchiv -
I don't know how great a part, impossible to estimate - , unbound
periodicals, books, loose documents, folders of the Reichsver-
einigung up to 1943, books bearing the stamp of the Gesamtarchiv,
possibly manuscripts, correspondence, etc. The so-called libra-
rian, a certain Mr. Fink whose "catalogue" of the library defies
description, did his best to prevent me from climbing the stairs
and "soiling" my hands. I asked Rabbi Schwarzschild to give the
good man specific instructions to forget his "catalogue" and
start sorting the material and putting it on shelves in the
library.

3. I worked in the library for many hours, but the conditions
are such that it is almost impossible to say exactly what is
there and what is not. However, I ascertained at least 70 bound
volumes of Ketuwoth from Amsterdam, covering a period of 250
years or more as well as a great many unbound documents. Among
the latter, I saw documents from Mantua, Germany, Bialystok, the
correspondence of Caro, Posen 1810, apparently from the archives
of the Lehranstalt, pinkassim of the 18th century from Breslau
good/ and Posen. About 1,500/non-Jewish books, such as the complete
set of Die Zukunft of Maximilian Harden, 5 volumes Aristoteles
(Akademie edition), some nice modern bibliographical items.

There are not more than about 1,000 German Judaica, but a great
many Hebrew and German-Jewish periodicals as well as non-Jewish
periodicals (Magazin fuer die neue Historie und Geographie of
1769 etc.)

The following periodicals: Der Jude, 1916-1922, scattered, the
Monatsschrift, Israelitisches Familienblatt, CV Zeitung, Der
Morgen, Neue juedische Monatshefte, Jhb. f. Juedische Geschichte
u. Litteratur, Jued. Zeitschrift (A. Geiger), Jued. Zeitschrift
f. Wissenschaft und Leben I-IX, Allgemeine Zeitung d. Judentums,
etc. etc.

A small collection of music literature.

A collection of about 700 volumes of legal literature.

Some good theological literature. About 200 Zionistica, and a
few hundred Judaica in English, Russian and French.

There are thousands of prayer books and chumashim and some 800
Hebraica, mostly Talmud and Mishnayoth as far as I could determine.

About 500 Hebrew periodicals.

III

1. Our main source is still Prof. Grumach and the people with
whom he has or had contact. It appears that the German synagogue
silver which we always thought had been smelted was on the

contrary carefully preserved for the purpose of establishing an
anti-Jewish museum. The people who worked under the Gestapo in
the Muenchener Strasse, told me that they had seen silver from
all over Germany and many items from abroad, for instance a Torah-
scroll from Sloniki which was 500 years old.

2. Library of the Hochschule: Part of it has been destroyed
through bombing in the Eisenacher Strasse, part of it was shipped
to Theresienstadt, a few volumes are in the Oranienburgerstrasse,
and part seems to have been sold in Jerusalem by the firm Bamberg-
er and Wahrmann who apparently bought these volumes in Holland!

3. In 1945/46 hundreds of thousands of books were spread all over
Berlin. Even parts of the Jewish central collection in the Eisen-
acherstrasse were still there. The German libraries (especially
the State library in this instance) took whatever they wanted.
Some months later, the Bergungsgesellschaft stepped in and dis-
tributed books to the Staatsbibliothek, the Stadtbibliothek and the
Ratsbibliothek as well as to a number of Volksbuechereien.

4. In 1947 the Oranienburgerstrasse still housed the following
material which had been put there by the Nazis: (a) One room
with archival material from the Reichssippenamt (which generally
received Jewish archives everywhere in Germany) and (b) one room
stacked with books to the roof. According to information from
various sources, partly from Germans and partly from Jews who had
worked there, the current president of the Community handed all
this material over to the municipal authorities of the east-
sector and retained only the Jewish material.

5. For reasons generally unknown, the Mormones were the first to
get permission from the Russians to have a look at caches. They
seem to have taken a certain number of archives and especially
the films of the Gesamtarchiv and other Jewish archives which had
been prepared by the Nazis and which partly are now in Duisburg-
Hamborn in Westfalen. The photographer in Westfalen is also a
Mormone and currently offers photostats or films to Jewish com-
munities in the western zone for money. Munich and Stuttgart
have bought such material, whereas for instance Karlsruhe had no
money. Parts of these films are now in the hands of Mr. Lang-
heinrich, a photographer in the Staatsbibliothek. One probably
could get them for a small amount of money. Mr. Langheinrich said
he wanted to hand these films over to his colleague in Duisburg.

6. Gesamtarchiv: I wish Mr. Bein is right and that there is some
hope to get this back. From what I heard in Berlin, I am not
very hopeful. The Gesamtarchiv, originally in the cache in
Schoenebeck, was transported years ago -- to Halle?, to Merse-
burg?, to Potsdam?? Mr. Korfess of the Zentralarchiv in Potsdam
knows probably where it is.

IV

What can we do?

1. I did not even attempt to talk to the community people but
talked and tried to arrange a little understanding with Rabbi

Schwarzschild who will be back in the States around June 1.
Schwarzschild has a certain but limited influence in the com-
munity. He might try to work out an agreement with us along the
following lines: a) We get the Torah-scrolls via western sector
with the understanding that not more than 15% of the scrolls are
returned in repaired condition to the community for distribution
in Germany, and that some high rabbinical authorities in Israel
and the United States write a letter felicitating them on their
steadfastness. (b) We get the more valuable parts of the libra-
ry to be determined by Schwarzschild and one representative of
JCR and all the archival material, as well as manuscripts etc.
In return we give them what they need, and since we won't have
it in Wiesbaden -- textbooks and Einheitsgebetsbuch -- we give
them money as a contribution toward publication of text- and
prayer-books. The silver in the Joachimsthaler Strasse should
be claimed by JRSO, in my opinion. I don't know if they will
succeed. But there is a chance since it is housed in a JDC
warehouse and it is doubtless not silver which ever belonged to
the Berlin community. As far as I can see and from what Schwarz-
schild and others told me, there is no hope for getting it from
the community through an agreement.

2. Considerable quantities of Judaica and Hebraica are now being
offered through dealers from the eastern zones because of an
acute lack of money everywhere in eastern Germany. Schwarzschild
told me that he buys everything he can afford to buy and showed
me a few nice items, such as a set of Der Jude of 1771 (9 volumes
the first missing), a Kessuva from Padua of 1680 and an illustrat-
ed Pessah Haggadah (Wolf) 1740. He would like to have a fund of
1,000 Marks and buy for us certain special items.

3. This is a pretty sad report, but we should try along these
lines. There is hardly an alternative left.

SELECTED JEWISH CULTURAL RECONSTRUCTION DOCUMENTS FROM THE ARCHIVES OF THE JEWISH MUSEUM

The Jewish Cultural Reconstruction organization worked closely with the Jewish Museum in New York between 1949 and 1952. Administrative documents from the JCR's work are preserved in the archives of the museum. Those written by or to Hannah Arendt, the executive secretary, are listed here.

Agreement between Jewish Cultural Reconstruction, Inc., and Recipient Museums and Congregations. JCR, undated.

"Annual Financial Statement." JCR, December 1, 1950–November 30, 1951.

"Appendix I: Financial Statement." JCR, July 1, 1949–November 30, 1950.

"Appendix II: Wiesbaden—Worldwide Distribution." JCR, 1950.

"Appendix III: Distribution of Torah Scrolls via JDC, Paris." JCR, 1950.

"Appendix IV: In-Shipments, Wiesbaden." JCR, 1950.

"Appendix V: Incomplete List of Discoveries and Pending Claims." JCR, 1950.

"Appendix VI: Distribution of Books from New York Depot." JCR, July 1, 1949–November 30, 1950.

"Appendix VII: Distribution of Ceremonial Objects from New York Depot." JCR, 1950.

"Appendix VIII: New York Distribution of Books for 1951." JCR, 1950.

Arendt, Hannah. Jewish Cultural Reconstruction Field Reports, no. 12, December 1949; no. 15, February 10, 1950; no. 16, February 18, 1950; no. 18, February 15–March 10, 1950.

——————. Letters to Guido Schoenberger, Jewish Museum, New York. JCR, September 7, 1949; September 12, 1949; November 9, 1949; August 28, 1950; September 5, 1950; October 2, 1950; November 8, 1950; November 13, 1950; March 13, 1951; April 13, 1951; October 16, 1951; October 23, 1951; February 1, 1952.

——————. Letter to Guido Schoenberger and Stephen S. Kayser, Jewish Museum, New York. JCR, June 10, 1951.

——————. Letter to Joshua Starr. JCR, July 20, 1950.

——————. Letter to Members of the Advisory Committee. JCR, June 26, 1950.

——————. Letter to Saul Kagan, Jewish Restitution Successor Organization (JRSO), Frankfurt am Main. JCR, April 13, 1951.

——————. Letter to Stephen S. Kayser, Jewish Museum, New York. JCR, August 10, 1949; August 22, 1949; September 7, 1949; October 17, 1949.

——————. Letter to Stephen S. Kayser and Guido Schoenberger, Jewish Museum, New York. JCR, July 20, 1952.

——————. Memorandum to Members of the Advisory Committee. JCR, undated; October 30, 1950; July 20, 1951.

——————. Memorandum to Members of the Board of Directors and the Advisory Committee. JCR, August 29, 1950; December 21, 1950; January 17, 1951; April 13, 1951; May 31, 1951; February 8, 1952; July 1952.

——————. Memorandum to Stephen S. Kayser, Jewish Museum, New York. JCR, August 10, 1949; August 15, 1949; August 22, 1949.

——————. "Minutes of Advisory Committee Meeting." JCR, September 19, 1949.

——————. "Minutes of the Annual Meeting of the Corporation." JCR, December 21, 1950.

——————. "Minutes of Special Meeting of the Advisory Committee." JCR, March 27, 1950.

——————. "Minutes of Special Meeting of the Board of Directors." JCR, October 9, 1950; December 21, 1950.

——————. "Notice of Meeting." JCR, September 20, 1950; May 7, 1951.

——————. "Re: Ceremonial Objects in the Heimat Museum, Schnaittach, Bavaria." Memorandum to Members of the Board of Directors and the Advisory Committee. JCR, September 24, 1951.

——————. "Re: Distribution of Ceremonial Objects, New York Depot." Memorandum to Members of the Board of Directors and the Advisory Committee. JCR, August 18, 1950.

——————. "Re: Mail Vote on the Baltic Collection and the Frankfort Ceremonial Objects." Memorandum to Members of the Board of Directors and the Advisory Committee. JCR, July 11, 1951.

"Ceremonial Objects, Marked JCR." JCR, undated.

Dallob, Samuel. Letter to Hannah Arendt, JCR. Jewish Restitution Successor Organization (JRSO), Frankfurt am Main, October 22, 1951.

"Itemized List of Collections of Coins and Medals: From the Estate of Dr. Otto Goldschmidt of Gotha (deceased); Owned by Dr. F. B. Lorch of Johannesburg, South Africa, and His Sister, Mrs. Ruth Fleischer, of London." JCR, undated.

Kagan, Saul. Letter to Hannah Arendt, JCR. Jewish Restitution Successor Organization (JRSO), Frankfurt am Main, June 22, 1951; July 9, 1951; August 31, 1951.

"List of Objects to Jewish Museum, New York." JCR, undated.

"Meeting of Advisory Committee: Agenda." JCR, September 19, 1949.

"Meeting of Board of Directors and Advisory Committee: Agenda." JCR, December 10, 1951.

Memorandum to Members of the Board of Directors and Advisory Committee. JCR, April 24, 1950.

"Minutes of Special Meeting of the Board of Directors and Advisory Committee." JCR, December 19, 1951.

Schoenberger, Guido. Letter to Hannah Arendt, JCR. Jewish Museum, New York, September 9, 1949; October 23, 1950.

"Sheet No. 1: World Distribution of Books." JCR, July 1, 1949–January 31, 1952.

"Sheet No. 2: Distribution of Books in the U.S." JCR, July 1, 1949–January 31, 1952.

"Sheet No. 3: World Distribution of Ceremonial Objects and Torah Scrolls." JCR, July 1, 1949–January 31, 1952.

"Sheet No. 4: Financial Report." JCR, October 1947–March 1952.

"Total Books Distributed to May 1, 1950." JCR, undated.

Maria Eichhorn, *Hannah Arendt's Jewish Cultural Reconstruction field reports*, 2020, reading of Hannah Arendt's Jewish Cultural Reconstruction Field Report no. 16, rehearsal with Nora Rodriguez, December 12, 2019, Jewish Museum, New York

Hadar Gad

Born in Ein Harod, Israel, in 1960
Lives and works in Pardes Hanna-Karkur, Israel

The silent, enveloping paintings and drawings of Hadar Gad open themselves slowly, revealing a practice shaped by intensive and often solitary labor undertaken in her studio in the Israeli countryside, in a village ever-so-changing, confined between the sea and disappearing orchards. This is where the work begins: the thinking, reading, sketching, and mental preparation that constitute the prehistory of every piece. Recently the artist has been using archival photographs as a point of departure—specifically those documenting the inflows and outflows of books, artworks, and Judaica, first by the Nazis as they found and seized them, and then, conversely, at various Allied collecting points, which served as repositories for pillaged works after the war. The photographic source material is cool and crisp and clinical (see pages 152, 156, 55, 3, 151, 10), the opposite of what Gad is after—as she describes it, a quest to find "cultural, spiritual, and moral meaning" in the wake of the war.

Defined color choices shape continuity among the images. In the latest works, brown, amber, and gray saturate intricately crafted paintings possessed by a tonal halo that suggests the fading of color itself. Aged paper, old photographs, and archival folders are called to mind, products used to organize history. The paintings follow Gad's practice of working through complex historical details and taking inventory of her surroundings. In earlier works she systematically recorded the contents of her kitchen cabinets, delineating each item as one would care for a beloved piece of jewelry or family memento. Indeed, hers is a process of reckoning with *what one lives with*—whether or not that coexistence is defined by objects or memories. As they relate to the Holocaust, these "memory symbols" are a powerful part of her generational identity. In addition to the recovery sites pictured in this recent series, she has painted images of cemeteries, hospital grounds, and bookshelves—places where the past is stored.

The destruction of culture that attended the Holocaust is a major thread running through Gad's work. Her paintings attest to its vastness and complexity. The coordinated efforts of the Nazis were not, she writes, aimed solely at destroying physical objects of great cultural significance, but sought to erase something much bigger, "the spirit and knowledge that are within them ... symbols of the Jewish spirit and mind." Her work contends with this void—how does one visualize the loss of knowledge?—by filling it with new presences and feelings, "as if aspiring to cleanse the fabric going back to a new beginning—and still, with history and time embedded in it."[1]

Gad's work maintains a calibrated balance: finding a space—literally, on the canvas—to articulate this profound loss while at the same time recuperating the power of artistic expression as a generative and healing process in the present moment. In her compositions, minute detail lives with highly abstract forms, and color washes over and reshapes the precision of her lines; it is the filter through which her subjects are seen. The larger compositions are richly textured, painted and scraped back and painted again. In this pairing of precision and subtraction, Gad asks us to engage her works in several ways—as the depiction of a specific history that must be acknowledged, and as one that is also receding with the loss of the people who lived it. To be clear, the work is also a testament to the artist's agency and skill. Her ability to give form to crammed and confused environments through extraordinary manual dexterity is a signature feature of her art. It demands to be looked at.

1 Interviews with the artist conducted on November 8 and December 19, 2019, and January 7, 2020.

Right:
But the Books, 2020
Oil on linen, 78¾ × 59 in.
(200 × 150 cm)

Pages 234-35:
The Last Painting, 2020
Oil on canvas, 39⅜ × 78¾ in.
(100 × 200 cm)

Page 236:
Nineteen marks per ton, 2020
Oil on canvas, 78¾ × 59 in.
(200 × 150 cm)

Pages 237-38:
Untitled, from the *Capsules of Memory* series, 2019
Pencil on paper, 13¾ × 10¼ in.
(35 × 26 cm)

Page 239:
Polish Landscape, 2020
Oil on linen, 78¾ × 59 in.
(200 × 150 cm)

All works collection of the artist

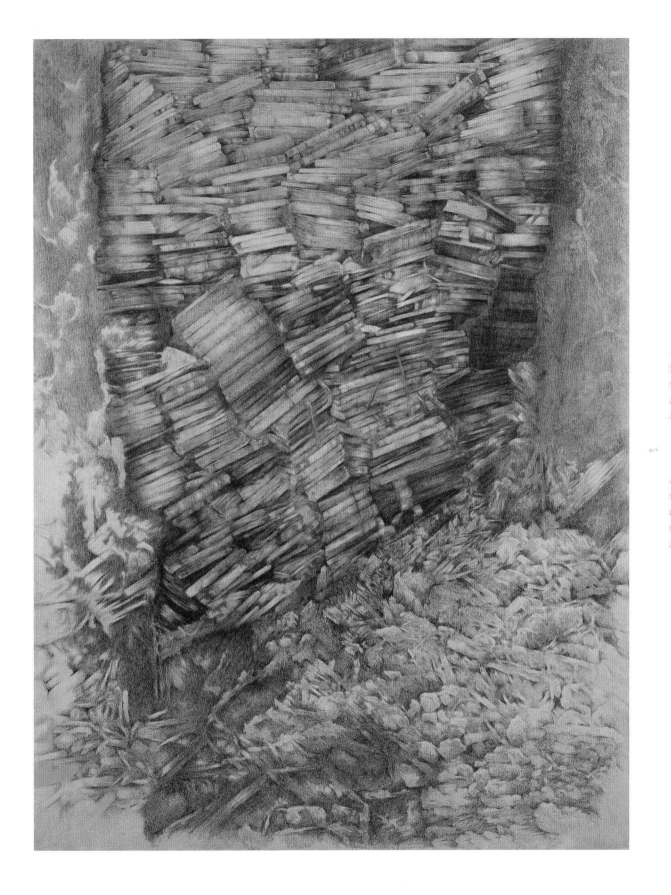

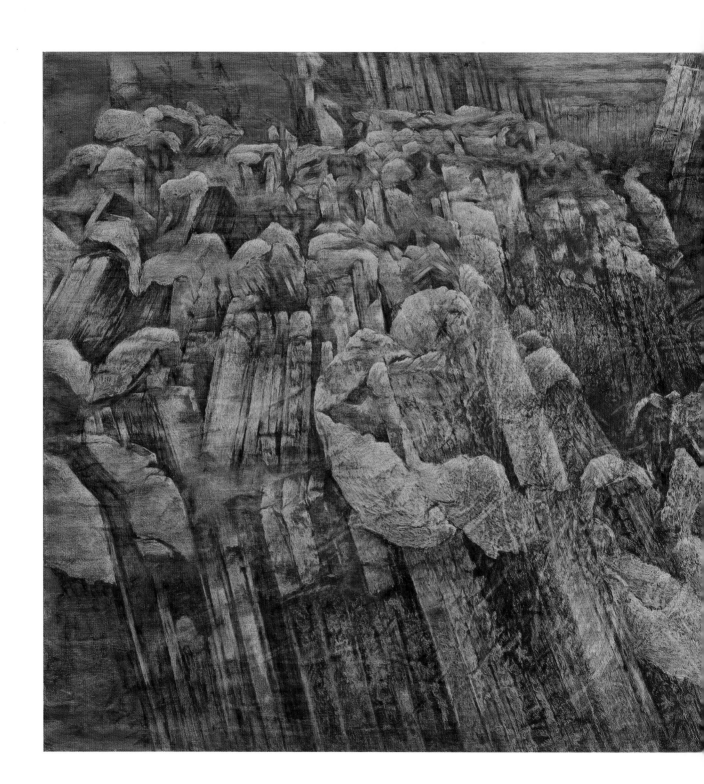

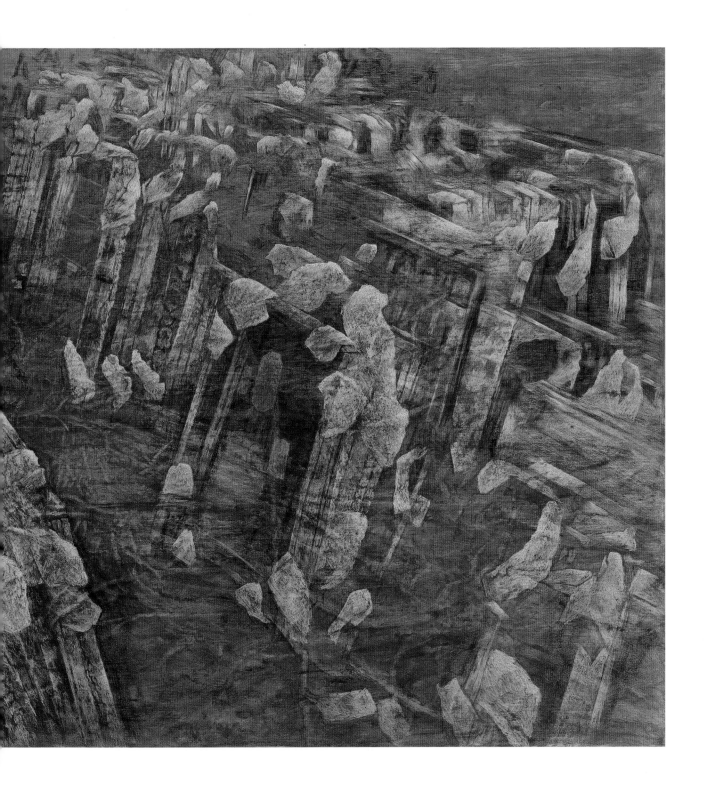

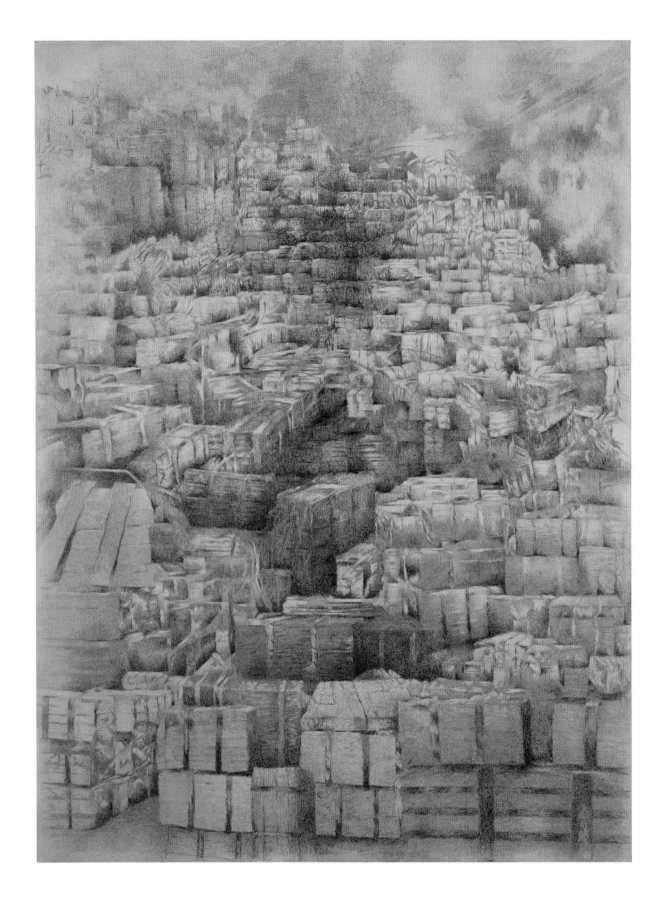

Dor Guez

Born in Jerusalem in 1982
Lives and works in Jaffa

Dor Guez's artistic practice is at once forensic and personal. It culminates in installations of found objects as well as deeply textured "scanograms," a term he uses to describe a unique digital imaging process. Born into a blended family of Palestinians and Tunisian Jews, Guez explores chapters of his own layered history to expose the hidden connections, subversive undercurrents, and present-day contexts of his family's unique story, and that of the region he comes from. Oftentimes the point of departure is a seemingly modest treasure from the family archive—a vintage wedding photograph, a dressmaker's pattern, or a notebook written in an ancient Judeo-Arabic dialect. Yet for Guez such relics are the stuff of expansive possibility.

Guez's work plays on the tension between what one inherits—a language, a name, a place of origin—and what one reinvents over time. Stories are told and retold, and traces of the past are rediscovered, shedding light on little-known facts and familial chapters. One recent work, *Letters from the Greater Maghreb,* reflects a pivotal moment in Guez's family history, when his grandparents—who both worked in theater—escaped from concentration camps in Nazi-occupied Tunisia and later, in 1951, immigrated to Israel. The journey was arduous and key personal documents were damaged by water during the trip. One of these was a manuscript written by his grandfather in Judeo-Tunisian Arabic, using what looks like a mix of Hebrew and Arabic characters. Taking the fragile pages of the surviving document and creating enlarged scans of the single sheets and sections, Guez intensifies themes of blurring and loss in the resultant prints, at once bringing the viewer closer to and farther away from the meaning of the original words.

This visualization of disappearance evokes several cultural shifts simultaneously, particularly relating to language; Tunisian Jews adopted

Hebrew as their language when they moved to Israel, and Judeo-Tunisian Arabic has begun to disappear. Duplication and fragmentation thus reify the immigrant's experience of doubling and absence. Speaking of the visual devices at play in his work, Guez writes, "The words are engulfed in abstract spots and these become a metaphor for the harmonious conjunction between two Semitic languages, between one mother tongue and another, and between homeland and a new country."

Operating on multiple levels at once, Guez finds and resituates objects to reveal not only what from the past was lost but what has been largely forgotten or even consciously suppressed; the Nazi occupation of Tunisia, for example, is rarely addressed or publicly acknowledged. Yet his work allows these connections to emerge so poignantly because he cleaves so closely to the people whose lives they affected. In some instances his work quite literally fills negative space, as evidenced in his colorization and scanning techniques. He also uses light boxes to exaggerate overlooked relics, heightening their graphic presence. Adapting the clean, sterile casework of museum display, he puts personal objects on view, drawing attention not only to their intricacy and fragility but also to their powerful hybridity as displaced cultural artifacts *and* postwar readymades. It is in this unclassifiable realm—between the personal and the social, the found and fabricated, the seen and obscured—that Guez's work gathers its force.[1]

1 Background information was obtained from the artist's statement, December 19, 2019, and virtual interviews conducted on January 2, June 15, and July 10, 2020.

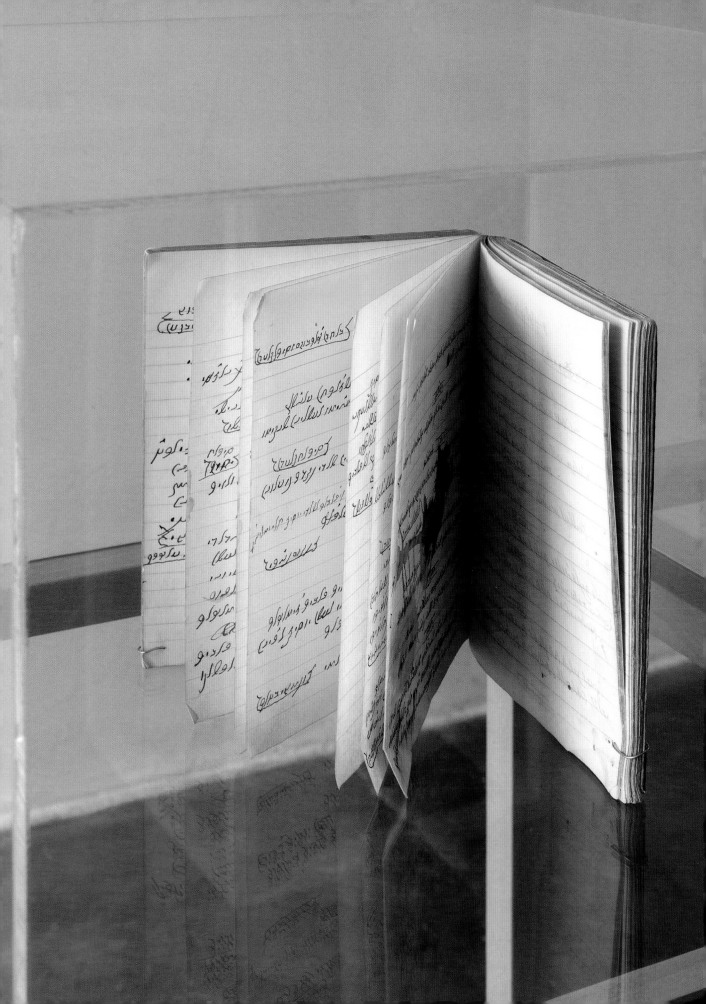

Lisa Oppenheim

Born in New York in 1975
Lives and works in New York

Certain through-lines visible in Lisa Oppenheim's work suggest the many ways the history of photography can be a lineage of impossibly wide potential for an artist whose practice is inseparable from her research. Using various means, including but not strictly limited to photography, Oppenheim draws upon the resources of libraries, collections, and online repositories that become a point of departure for work that is layered and at times starkly abstract. Reaching back into documentary archives, for example, Oppenheim examines the overlooked outtakes of great photographers that were, for whatever reason, excised from the historical record, resurrecting them in her imagery. These missing links and obscure finds have technical corollaries in her work as well. Her images often focus on fragments and play with exposures to suggest the nuances of what is seen and unseen, revealed and hidden, by the mechanics of the camera and chemistry of processing. In her multifaceted work, she can invoke photography's most complex functions: the capacity to remain completely mute while seeming to describe the world in infinite detail.

Two recent experiments made for these pages attest to the confounding difficulty of finding anything concrete in a photograph, while at the same time suggesting its limitless possibilities. A set of cloud pictures extracted from Google Maps may be a nod to Alfred Stieglitz's famous sky photographs, the *Equivalents* (1925–34), or an oblique reference to the potential, in the internet age, of storing everything in a virtual cloud, accessible through clicks and downloads. In fact, as the artist concedes, these pages depict the sky over a building in Paris that once housed a still-life painting by Jean-Baptiste Monnoyer (1636–99), which was probably destroyed by the Einsatzstab Reichsleiter Rosenberg (ERR), the Nazi looting agency. Thus the story of one picture leads to another, as Oppenheim follows the interwoven threads emanating from a black-and-white photograph she found online that documented the stolen painting before it disappeared. Only through tags and labels used to identify the picture— secondary details that become primary when the *thing itself* is gone—can anything be reconstructed about the fate of the original canvas. The painting, it turns out, was owned by the prominent Jewish family of Pierre Michel-Levy before being confiscated. "The last mention of this painting I could find," writes the artist, "was in November 1943 when the ERR's own records indicate that it was transported from Paris to Nikolsburg, now Mikulov, in the formerly German-speaking part of the Czech Republic."[1]

Last mentions are often the domain of photography—volumes have been written on the medium's relationship with death, especially in the nineteenth century—and Oppenheim respects the weight of historical gravitas in much of her work. But she is just as drawn to how images that are disembodied from the past can activate the imagination and become something altogether new, released of their origin stories, contexts, and captions. Indeed, history becomes a process of constant reinvention in which cataloguers and archivists, on whose work Oppenheim often depends, inflect the record with their own edited shorthand, which can in turn confuse or expand the ways chapters of knowledge or memory are formed. Nothing is stable as it moves through time and is passed through human hands, notwithstanding photography's perceived ability to "fix" and "capture" visual evidence—words that suggest a state of certainty, if not finality. "The photograph becomes a record of a series of decisions that allow for its circulation through a variety of technical formats, categorizations, and names," the artist counters. Sorting through these fragments and gaps, Oppenheim argues, also creates "a space for speculation, imagination, and a space for art."[1]

1 Information compiled from the artist's statement and conversations conducted on November 8 and December 17, 2019, and February 7, 2020.

Handwritten annotations:
1
15-242
/126
99
3
4
5
6
8
9
see 53
15/181
11
45
12
635
15/2
13
14
15-298
Russian
General
14
sent to Russia
15
16
with stamp 54
14 15-146
15/165
17
stamps 1 74 orig. with 57
18
46 books sent to Russia No II
37 books 15-131
15/9.
19

Selected Bibliography

Olivia Casa

Aalders, Gerard. "By Diplomatic Pouch: Art Smuggling by the Nazis." *Spoils of War*, no. 3 (December 1996): 29–32.

———. *Nazi Looting: The Plunder of Dutch Jewry during the Second World War*. Oxford: Berg, 2004.

Abramovicz, Dina. *Guardians of a Tragic Heritage: Reminiscences and Observations of an Eyewitness*. New York: National Foundation for Jewish Culture / Council of Archives and Research Libraries in Jewish Studies, 1999.

Adam, Peter. *Art of the Third Reich*. New York: Thames and Hudson, 1992.

Adams, E. E. "Looted Art Treasures Go Back to France." *Quartermaster Review*, September–October 1946.

Adams, Robert M. *The Lost Museum: Glimpses of Vanished Originals*. New York: Viking, 1980.

Adler, Andrew. "Expanding the Scope of Museums' Ethical Guidelines with Respect to Nazi-Looted Art: Incorporating Restitution Claims Based on Private Sales Made as a Direct Result of Persecution." *International Journal of Cultural Property* 14, no. 1 (February 2007): 57–84.

Akinsha, Konstantin. *Stolen Treasure: The Hunt for the World's Lost Masterpieces*. London: Weidenfeld and Nicolson, 1995.

Akinsha, Konstantin, and Grigorii Kozlov. *Beautiful Loot: The Soviet Plunder of Europe's Art Treasures*. New York: Random House, 1995.

Aksionov, Vitaly. *Führer's Favorite Museum: Stolen Treasures*. Saint Petersburg, Russia: Neva, 2003.

Aldous, Tony. "Lost without Trace." *History Today*, August 1992.

Alford, Kenneth D. *Allied Looting in World War II: Thefts of Art, Manuscripts, Stamps, and Jewelry in Europe*. Jefferson, NC: McFarland, 2011.

———. *Hermann Göring and the Nazi Art Collection: The Looting of Europe's Art Treasures and Their Dispersal after World War II*. Jefferson, NC: McFarland, 2012.

———. *Nazi Plunder: Great Treasure Stories of World War II*. Cambridge, MA: Da Capo; London: Eurospan, 2003.

———. *The Spoils of World War II: The American Military's Role in the Stealing of Europe's Treasures*. New York: Birch Lane, 1994.

Allais, Lucia. *Designs of Destruction: The Making of Monuments in the Twentieth Century*. Chicago: University of Chicago Press, 2018.

Amit, Gish. " 'The Largest Jewish Library in the World': The Books of Holocaust Victims and Their Redistribution Following World War II." *Dapim: Studies on the Holocaust* 27, no. 2 (2013): 107–28.

———. "Ownerless Objects?: The Story of the Books Palestinians Left Behind." *Jerusalem Quarterly* 33 (2008). https://www.palestine-studies.org/jq/fulltext/77868.

Arendt, Hannah. *Between Past and Future: Eight Exercises in Political Thought*. New York: Penguin, 1968.

———. "Jewish Culture in This Time and Place: Creating a Cultural Atmosphere." *Commentary* 4, no. 5 (November 1947): 424–26.

———. *Jewish Writings*. Ed. by Jerome Kohn and Ron H. Feldman. New York: Schocken, 2007.

———. *Origins of Totalitarianism*. New York: Harcourt, Brace, 1951.

Arendt, Hannah, and Gershom Scholem. *The Correspondence of Hannah Arendt and Gershom Scholem*. Ed. by Marie Luise Knott, trans. by Anthony David. Chicago: The University of Chicago Press, 2017.

"Art Museums and the Identification and Restitution of Works Stolen by the Nazis." Association of Art Museum Directors website, May 2007. https://aamd.org/sites/default/files/document/Nazi-looted%20art_clean_06_2007.pdf.

Atlan, Eva, Raphael Gross, and Julia Voss, eds. *1938: Kunst, Künstler, Politik*. Trans. by Herwig Engelmann. Exh. cat. Jewish Museum, Frankfurt. Göttingen: Wallstein, 2013.

Baensch, Tanya, Kristina Kratz-Kessemeier, and Dorothee Wimmer. *Museen im Nationalsozialismus: Akteure, Orte, Politik*. Cologne: Böhlau, 2016.

Baresel-Brand, Andrea, Meike Hopp, and Agnieszka Magdalena Luińska, eds. *Gurlitt: Status Report*. Exh. cat. Kunstmuseum, Bern, and Bundeskunsthalle, Bonn. Munich: Hirmer, 2017.

Baron, Lawrence. "The Holocaust and American Public Memory." *Holocaust and Genocide Studies* 17, no. 1 (Spring 2003): 62–88.

Baron, Salo W. *The Contemporary Relevance of History: A Study in Approaches and Methods*. New York: Columbia University Press, 1986.

———. "Cultural Pluralism of American Jewry." In *Steeled by Adversity: Essays and Addresses on American Jewish Life*, ed. Jeannette Meisel Baron, 495–505. 1st ed. Philadelphia: Jewish Publication Society of America, 1971.

———. *A Social and Religious History of the Jews*. New York: Columbia University Press, 1937.

———. "The Spiritual Reconstruction of European Jewry." *Commentary* 1, no. 1 (November 1945): 4–12, online at https://www.commentarymagazine.com/articles/commentary-bk/the-spiritual-reconstruction-of-european-jewry.

Barron, Stephanie. *"Degenerate Art": The Fate of the Avant-Garde in Nazi Germany*. Exh. cat. Los Angeles County Museum of Art, Los Angeles. New York: Abrams, 1991.

Bathrick, David, Brad Prager, and Michael D. Richardson, eds. *Visualizing the Holocaust: Documents, Aesthetics, Memory*. Rochester, NY: Camden House, 2008.

Bator, Paul M. "An Essay on the International Trade in Art." *Stanford Law Review* 34, no. 2 (January 1982): 275–384.

Bazyler, Michael J. *Holocaust Justice: The Battle for Restitution in America's Courts*. New York: New York University Press, 2005.

Bazyler, Michael J., and Roger P. Alford, eds. *Holocaust Restitution: Perspectives on the Litigation and Its Legacy*. New York: New York University Press, 2006.

Beker, Avi, ed. *The Plunder of Jewish Property during the Holocaust: Confronting European History*. New York: Palgrave Macmillan, 2014.

Beniston, Judith, and Robert Vilain, eds. " 'Hitler's First Victim?': Memory and Representation in Post-War Austria." Special issue, *Austrian Studies* 11 (2003).

Benjamin, Walter. *Illuminations*. Ed. by Hannah Arendt. Trans. by Harry Zohn. New York: Shocken Books, 1968.

———. *Reflections: Essays, Aphorisms, Autobiographical Writing*. Ed. by Peter Demetz, trans. by Edmund Jephcott. New York: Schocken, 1978.

Bernsau, Tanja. *Die Besatzer als Kuratoren?: Der Central Collecting Point Wiesbaden als Drehscheibe für einen Wiederaufbau der Museumslandschaft nach 1945*. Berlin: Lit, 2013.

Bertz, Inka, and Michael Dorrmann, eds. *Raub und Restitution: Kulturgut aus Jüdischem Besitz von 1933 bis Heute*. Exh. cat. Jewish Museum, Berlin, and Jewish Museum, Frankfurt. Göttingen, Germany: Wallstein, 2008.

Blau, Joseph L., and Salo W. Baron, eds. *The Jews of the United States, 1790–1840: A Documentary History*. New York: Columbia University Press, 1963.

Blecksmith, Anne. "The Johannes Felbermeyer Collection at the Getty Research Institute." *VRA (Visual Resources Association) Bulletin* 39, no. 1 (December 2012), article 3. https://online.vraweb.org/cgi/viewcontent.cgi?article=1032&context=vrab.

Blum, Yehuda Z. "On the Restitution of Jewish Cultural Property Looted in World War II." *Proceedings of the Annual Meeting: American Society of International Law* 94 (April 5–8, 2000): 88–94.

Bodemann, Y. Michel, ed. *Jews, Germans, Memory: Reconstructions of Jewish Life in Germany*. Ann Arbor: University of Michigan Press, 1996.

Boguslavskij, M. M. "Contemporary Legal Problems of Return of Cultural Property to Its Country of Origin in Russia and the Confederation of Independent States." *International Journal of Cultural Property* 3, no. 2 (1994): 243–56.

Left: Bookplates from Jewish book collections (see page 87).

Bohn, Elga. "Der Central Collecting Point München: Erste Kunstsammelstelle nach 1945." *Kolner-Museums Bulletin*, 1987.

Borák, Mecislav. *"The West" versus "The East" or the United Europe?: The Different Conceptions of Provenance Research, Documentation, and Identification of Looted Cultural Assets and the Possibilities of International Cooperation in Europe and Worldwide; Proceedings of an International Academic Conference Held in Podebrady on 8–9 October, 2013*. Prague: Documentation Center for Property Transfers of Cultural Assets of WWII Victims, 2014.

Borin, Jacqueline. "Embers of the Soul: The Destruction of Jewish Books and Libraries in Poland during World War II." *Libraries and Culture* 28, no. 4 (Fall 1993): 445–60.

Born, Lester K. "The Archives and Libraries of Postwar Germany." *American Historical Review* 56, no. 1 (October 1950): 34–57.

Bouchoux, Corinne. *Rose Valland: Resistance at the Museum*. Dallas: Laurel, 2013.

Bradsher, Greg. "Monuments Men and Nazi Treasures." *Prologue: Quarterly of the National Archives and Records Administration* 45, no. 2 (Fall 2013): 12–21.

———. "Nazi Gold: The Merkers Mine Treasure." *Prologue: Quarterly of the National Archives and Records Administration* 31, no. 1 (Spring 1999): 7–12.

Bradsher, Greg, and Sylvia Naylor. "The Kümmel Report." United States National Archives and Records Administration blog post, July 14, 2015. https://text-message.blogs.archives.gov/2015/07/14/the-kummel-report.

Breitenbach, Edgar. "Historical Survey of the Intelligence Department, MFAA Section, in OMGB, 1946–1949." *College Art Journal* 9 (Winter 1949–50): 192–98.

Brenner, Hildegard. *Die Kunstpolitik des Nationalsozialismus*. Hamburg: Rowohlt Taschenbuch, 1963.

Brenner, Michael. *Prophets of the Past: Interpreters of Jewish History*. Princeton: Princeton University Press, 2010.

Brey, Ilaria Dagnini. *The Venus Fixers: The Remarkable Story of the Allied Monuments Officers Who Saved Italy's Art during World War II*. New York: Picador, 2009.

Brinkley, Howard. *M.F.A.A.: The History of the Monuments, Fine Arts, and Archives Program (Also Known as Monuments Men)*. Lexington, KY: BookCaps Study Guides, 2013.

Broyde, Michael J., and Michael Hecht. "The Return of Lost Property According to Jewish Common Law: A Comparison." *Journal of Law and Religion* 12, no. 1 (1995): 225–53.

Brückler, Theodor. *Kunstraub, Kunstbergung und Restitution in Österreich von 1938 bis Heute*. Vienna: Böhlau, 1999.

Buck, Rebecca A., and Jean Allman Gilmore. *The New Museum Registration Methods*. Washington, DC: American Association of Museums, 2001.

Buomberger, Thomas. *Raubkunst, Kunstraub: Die Schweiz und der Handel mit Gestohlenen Kulturgütern zur Zeit des Zweiten Weltkriegs*. Zurich: Orell Füssli, 1998.

Burr, Nelson R. *Safeguarding Our Cultural Heritage: A Bibliography on the Protection of Museums, Works of Art, Monuments, Archives, and Libraries in Times of War*. Washington, DC: Library of Congress, 1952.

Busterud, John A. *Below the Salt: How the Fighting 90th Division Struck Gold and Art Treasure in a Salt Mine*. Philadelphia: Xlibris, 2001.

Cachin, Françoise, et al. *Pillages et Restitutions: Le Destin des Oeuvres d'Art Sorties de France pendant la Seconde Guerre Mondiale*. Paris: Biro, 1997.

Cassou, Jean. *Le Pillage par les Allemands des Oeuvres d'Art et des Bibliothèques Appartenant à des Juifs en France: Recueil de Documents*. Paris: Centre, 1947.

Chamberlin, Russell. *Loot!: The Heritage of Plunder*. New York: Facts on File, 1983.

Charney, Noah. *The Museum of Lost Art*. New York: Phaidon, 2018.

Chesnoff, Richard Z. *Pack of Thieves: How Hitler and Europe Plundered the Jews and Committed the Greatest Theft in History*. London: Weidenfeld and Nicolson, 1999.

Clarke, Paul, Simon Jones, Nick Kaye, and Johanna Linsley, eds. *Artists in the Archive: Creative and Curatorial Engagements with Documents of Art and Performance*. New York: Routledge, 2018.

Cohen, Julie-Marthe, with Felicitas Heimann-Jelinek, eds. *Neglected Witnesses: The Fate of Jewish Ceremonial Objects during the Second World War and After*. Builth Wells, Wales: Institute of Art and Law; Amsterdam: Jewish Historical Museum, 2011.

Cohen, Julie-Marthe, Felicitas Heimann-Jelinek, and Ruth Jolanda Weinberger. *Handbook on Judaica Provenance Research: Ceremonial Objects*. New York: Conference on Jewish Material Claims against Germany, 2018.

Cohen, Morris R. "Jewish Studies of Peace and Post-War Problems." *Contemporary Jewish Record* 4, no. 2 (April 1941).

———. "Philosophies of Jewish History." *Jewish Social Studies* 1, no. 1 (January 1939): 39–72.

———. "Publisher's Foreword." *Jewish Social Studies* 1, no. 1 (January 1939): 3–4.

Cohen, Naomi W. *Not Free to Desist: The American Jewish Committee, 1906–1966*. Philadelphia: Jewish Publication Society of America, 1972.

Collins, Donald E., and Herbert P. Rothfeder. "The Einsatzstab Reichsleiter Rosenberg and the Looting of Jewish and Masonic Libraries during World War II." *Journal of Library History (1974–1987)* 18, no. 1 (Winter 1983): 21–36.

Confino, Alon. *A World without Jews: The Nazi Imagination from Persecution to Genocide*. New Haven: Yale University Press, 2014.

Consolidated Interrogation Reports. Washington, DC: Office of Strategic Services (OSS), Art Looting Investigation Unit, 1945.

Coremans, Paul B. *La Protection Scientifique des Oeuvres d'Art en Temps de Guerre: l'Expérience Européenne pendant les Années 1939 à 1945*. Brussels: Laboratoire Central des Musées de Belgique, 1946.

Crary, Jonathan. "Spectacle, Attention, Counter-Memory." *October* 50 (Autumn 1989): 96–107.

"Cultural Plunder by the Einsatzstab Reichsleiter Rosenberg." Washington, DC: United States Holocaust Memorial Museum (USHMM); New York, Conference on Jewish Material Claims against Germany (Claims Conference). https://www.errproject.org.

Davidson, Israel, ed. *Essays and Studies in Memory of Linda R. Miller*. New York: Jewish Theological Seminary of America, 1938.

Davies, Martin, and Ian Rawlins. *War-Time Storage in Wales of Pictures from the National Gallery, London*. London: National Gallery, 1946.

Dean, Martin. *Robbing the Jews: The Confiscation of Jewish Property in the Holocaust, 1933–1945*. Cambridge, UK: Cambridge University Press, 2008.

Dean, Martin, Constantin Goschler, and Philipp Ther, eds. *Robbery and Restitution: The Conflict over Jewish Property in Europe*. New York: Berghahn, 2008.

Decker, Andrew, and Konstantin Akinsha. "A Worldwide Treasure Hunt." *Art News* 90, no. 6 (Summer 1991): 130–38.

Dehnel, Regine. *NS-Raubgut in Museen, Bibliotheken und Archiven: Viertes Hannoversches Symposium*. Frankfurt am Main: Klostermann, 2012.

Dekker, Ariëtte. *A Controversial Past: Museum Boijmans Van Beuningen and the Second World War*. Exh. cat. Museum Boijmans Van Beuningen, Rotterdam, 2018.

Delage, Christian. *Caught on Camera: Film in the Courtroom from the Nuremberg Trials to the Trials of the Khmer Rouge*. Ed. and trans. by Ralpha Schoolcraft and Mary Byrd Kelly. Critical Authors and Issues. Philadelphia: University of Pennsylvania Press, 2014.

Dembsky, Kerstin, ed. *"Sieben Kisten mit Jüdischem Material": Von Raub und Wiederentdeckung 1938 bis Heute*. Exh. cat. Jüdisches Museum, Munich. Berlin: Hentrich and Hentrich, 2018.

Deme, Katalin. "From Restored Past to Unsettled Present: New Challenges for Jewish Museums in East Central Europe." *East European Jewish Affairs* 45, nos. 2–3 (2015): 252–60.

de Stefani, Lorenzo, ed. *Guerra, Monumenti, Ricostruzione: Architetture e Centri Storici Italiani nel Secondo Conflitto Mondiale*. Venice: Marsilio, 2011.

Deshmukh, Marion. "Recovering Culture: The Berlin National Gallery and the U.S. Occupation, 1945–1949." *Central European History* 27, no. 4 (1994): 411–39.

Didi-Huberman, Georges. *The Surviving Image: Phantoms of Time and Time of Phantoms; Aby Warburg's History of Art*. Trans. by Harvey L. Mendelsohn. University Park: Pennsylvania State University Press, 2017. First pub. in French, 2002.

Diner, Dan, and Gotthard Wunberg, eds. *Restitution and Memory: Material Restoration in Modern Europe*. New York: Berghahn, 2007.

Dorléac, Laurence Bertrand. *Art of the Defeat: France, 1940–1944*. Los Angeles: Getty Publications, 2009.

Dreyfus, Jean-Marc. *Le Catalogue Goering*. Paris: Flammarion, 2015.

———. *L'Impossible Réparation: Déportés, Biens Spoliés, Or Nazi, Comptes Bloqués, Criminels de Guerre*. Paris: Flammarion, 2015.

Ebert, Hans. *Kriegsverluste der Dresdener Gemäldegalerie: Vernichtete und Vermisste Werke*. Dresden: Staatliche Kunstsammlungen, 1963.

Eckert, Astrid M. *The Struggle for the Files: The Western Allies and the Return of German Archives*. Trans. by Dona Geyer. New York: Cambridge University Press, 2012.

Edsel, Robert M. *Rescuing Da Vinci: Hitler and the Nazis Stole Europe's Great Art; America and Her Allies Recovered It*. Dallas: Laurel, 2006.

———. *Saving Italy: The Race to Rescue a Nation's Treasures from the Nazis*. New York: Norton, 2014.

Edsel, Robert M., and Bret Witter. *The Monuments Men: Allied Heroes, Nazi Thieves, and the Greatest Treasure Hunt in History*. New York: Center Street, 2009.

Eichwede, Wolfgang, and Ulrike Hartung. *Betrifft, Sicherstellung: NS-Kunstraub in der Sowjetunion*. Bremen, Germany: Temmen, 1998.

Eizenstat, Stuart E. *Imperfect Justice: Looted Assets, Slave Labor, and the Unfinished Business of World War II*. New York: Public Affairs, 2003.

Esterow, Milton. *The Art Stealers*. New York: Macmillan, 1966.

Estreicher, Karol. *Cultural Losses of Poland: Index of Polish Cultural Losses during the German Occupation, 1939–1944*. London: n.p., 1944.

Farmer, Walter I. *The Safekeepers: A Memoir of the Arts at the End of World War II*. Berlin: De Gruyter, 2000.

Fasola, Cesare. *The Florence Galleries and the War: History and Records, with a List of Missing Works of Art*. Florence: Monsalvato, 1945.

Feldman, Shoshana. *The Juridical Unconscious: Trials and Traumas in the Twentieth Century*. Cambridge, MA: Harvard University Press, 2002.

Feliciano, Hector. *The Lost Museum: The Nazi Conspiracy to Steal the World's Greatest Works of Art*. New York: Basic Books, 1997.

Filbrook, Mary. *Reckonings: Legacies of Nazi Persecution and the Quest for Justice*. Oxford: Oxford University Press, 2019.

Fishman, David E. *The Book Smugglers: Partisans, Poets, and the Race to Save Jewish Treasures from the Nazis*. Lebanon, NH: University Press of New England, 2017.

Flanner, Janet. "The Annals of Crime: The Beautiful Spoils; I—A. H., Linz." *New Yorker*, February 22, 1947: 31–48.

———. "The Annals of Crime: The Beautiful Spoils; II—Collector with Luftwaffe." *New Yorker*, March 1, 1947: 33–38.

———. "The Annals of Crime: The Beautiful Spoils; III—Monuments Men." *New Yorker*, March 8, 1947: 38–55.

Florisoone, Michel. "La Commission Française de Récupération Artistique." *Mouseion*, nos. 1–2 (1946): 67–73.

Francini, Esther Tisa, Georg Kreis, and Anja Heuss. *Fluchtgut-Raubgut: Der Transfer von Kulturgütern in und über die Schweiz, 1933–1945, und die Frage der Restitution*. Zurich: Chronos, 2001.

Friedman, Philip. *Roads to Extinction: Essays on the Holocaust*. New York: Conference on Jewish Social Studies, Jewish Publication Society of America, 1980.

———. "The Fate of the Jewish Book during the Nazi Era." *Jewish Book Annual* 15 (1957–58): 112–22.

Friemuth, Cay. *Die Geraubte Kunst: Der Dramatische Wettlauf um die Rettung der Kulturschatze nach dem Zweiten Welt*. Brunswick, Germany: Westermann, 1989.

Frietag, Gabriele. "Archival Material on National Socialist Art Plundering during the Second World War." *Spoils of War*, no. 1 (December 1995): 34–36.

Fuhrmeister, Christian. *Kunsthistoriker im Krieg: Deutscher Militärischer Kunstschutz in Italien, 1943–1945*. Cologne: Böhlau, 2012.

Fuhrmeister, Christian, et al. *"Führerauftrag Monumentalmalerei": Eine Fotokampagne, 1943–1945*. Cologne: Böhlau, 2006.

Gallas, Elisabeth. "Kulturelles Erbe und Rechliche Anerkennung: Die Jewish Cultural Reconstruction, Inc., nach dem Zweiten Weltkrieg." *Jahrbuch für Antisemitismusforschung* (2013): 35–56.

———. *A Mortuary of Books: The Rescue of Jewish Culture after the Holocaust*. Trans. by Alex Skinner. Goldstein-Goren Series in American Jewish History. New York: New York University Press, 2019.

Gambrell, Jamey. "Displaced Art: Art Seized from Nazi Germany by the Soviet Union after World War II." *Art in America* 83, no. 9 (September 1995): 88–95, 120.

Ganslmayr, H. "Study on the Principles, Conditions and Means for the Restitution or Return of Cultural Property in View of Reconstituting Dispersed Heritages." *Museum* 31, no. 1 (1976): 62–67.

Gaudenzi, Bianca, and Astrid Swenson. "Looted Art and Restitution in the Twentieth Century: Towards a Global Perspective." *Journal of Contemporary History* 52, no. 3 (July 2017): 491–518.

Gaudenzi, Bianca, Astrid Swenson, and Mary-Ann Middelkoop, eds. "The Restitution of Looted Art in the Twentieth Century: Transnational and Global Perspectives." Special section, *Journal of Contemporary History* 52, no. 3 (July 2017): 491–687.

Gensburger, Sarah. *Images d'un Pillage: Album de la Spoliation des Juifs à Paris, 1940–1944*. Paris: Textuel, 2010.

———. *Witnessing the Robbing of the Jews: A Photographic Album, Paris, 1940–1944*. Trans. by Jonathan Hensher and Elisabeth Fourmont. Bloomington: Indiana University Press, 2015.

Gerstenblith, Patty. "International Art and Cultural Heritage." *International Lawyer* 44, no. 1 (Spring 2010): 487–501.

Gilbert, Sophie. "The Persistent Crime of Nazi-Looted Art." *Atlantic*, March 11, 2018. www.theatlantic.com /entertainment/archive/2018/03 /cornelius-gurlitt-nazi-looted-art/554936.

Glickman, Mark. *Stolen Words: The Nazi Plunder of Jewish Books*. Philadelphia: Jewish Publication Society, 2016.

Goggin, Mary-Margaret. " 'Decent' vs. 'Degenerate' Art: The National Socialist Case." *Art Journal* 50, no. 4 (Winter 1991): 84–92.

Goldberg, Hannah. "The Jewish Museum: An Interview with Its Curator, Stephen S. Kayser." *The Reconstructionist* 16, no. 8 (June 2, 1950): 10–16.

Goodwin, Paige S. "Mapping the Limits of Repatriable Cultural Heritage: A Case Study of Stolen Flemish Art in French Museums." *University of Pennsylvania Law Review* 157, no. 2 (December 2008): 673–705.

Grabowski, Jörn, and Petra Winter, eds. *Zwischen Politik und Kunst: Die Staatlichen Museen zu Berlin in der Zeit des Nationalsozialismus*. Cologne: Böhlau, 2013.

Greenfield, Jeannette. *The Return of Cultural Treasures*. New York: Cambridge University Press, 1996.

Grenzer, Andreas. "The Russian Archives and Their Files: Researching the Soviet Losses of Property." *Spoils of War*, no. 1 (December 1995): 33–34.

Grimsted, Patricia Kennedy. *Archives in Russia: A Directory and Bibliographic Guide to Holdings in Moscow and St. Petersburg*. Abingdon, UK: Routledge, 2015.

———. "Displaced Archives and Restitution Problems on the Eastern Front in the Aftermath of the Second World War." *Contemporary European History* 6, no. 1 (March 1997): 27–74.

———. *The Odyssey of the Turgenev Library from Paris, 1940–2002: Books as Victims and Trophies of War*. Amsterdam: International Institute of Social History, 2003.

———. "The Postwar Fate of Einsatzstab Reichsleiter Rosenberg Archival and Library Plunder, and the Dispersal of ERR Records." *Holocaust and Genocide Studies* 20, no. 2 (Fall 2006): 278–308.

———. *Reconstructing the Record of Nazi Cultural Plunder: A Survey of the Dispersed Archives of the Einsatzstab Reichsleiter Rosenberg (ERR)*. Amsterdam: International Institute of Social History, 2011. Expanded and rev. ed., https://www .errproject.org/guide.php, 2019.

———. "Roads to Ratibor: Library and Archival Plunder by the Einsatzstab Reichsleiter Rosenberg." *Holocaust and Genocide Studies* 19, no. 3 (2005): 390–458.

———. *Trophies of War and Empire: The Archival Legacy of Ukraine, World War II, and the International Politics of Restitution*. Cambridge, MA: Harvard University Press, 2001.

Grimsted, Patricia Kennedy, F. J. Hoogewoud, and Eric Ketelaar, eds. *Returned from Russia: Nazi Archival Plunder in Western Europe and Recent Restitution Issues*. London: Institute of Art and Law, 2007.

Grynberg, Anne, and Johanna Linsler. *L'Irréparable: Itinéraires d'Artistes et d'Amateurs d'Art Juifs, Réfugiés du "Troisième Reich" en France*. Magdeburg, Germany: Koordinierungsstelle, 2013.

Haase, Günther. *Kunstraub und Kunstschutz: Eine Dokumentation*. Norderstedt, Germany: Books on Demand, 1991.

———. *Die Kunstsammlung Adolf Hitler: Eine Dokumentation*. Berlin: Edition Q, 2002.

———. *Die Kunstsammlung des Reichsmarschalls Hermann Göring: Eine Dokumentation*. Berlin: Edition Q, 2000.

Hall, Ardelia R. "The Recovery of Cultural Objects Dispersed during World War II." *Department of State Bulletin*, August 27, 1951.

———. "The U.S. Program for Return of Historic Objects to Countries of Origin, 1944–1954." *Department of State Bulletin*, October 4, 1954.

Hamlin, Gladys E. "European Art Collections and the War." *College Art Journal* 5, no. 3 (March 1946): 219–28.

———. "European Art Collections and the War: Part II." *College Art Journal* 4, no. 4 (May 1945): 209–12.

Hammer, Katharina. *Splendor in the Dark: The Recovery of Art Treasures in Salzkammergut at the End of WWII*. Vienna: Osterreichischer Bundesverlag, 1986.

Hammond, Mason. "The War and Art Treasures in Germany." *College Art Journal* 5, no. 3 (March 1946): 205–18.

Hamon-Jugnet, Marie. *Collection Schloss: Oeuvres Spoliées pendant la Deuxième Guerre Mondiale non Restituées, 1943–1998*. Nantes: Ministère des Affaires Etrangères, Direction des Archives et de Documentation, 1998.

Hancock, Walker. "Experiences of a Monuments Officer in Germany." *College Art Journal* 5, no. 4 (May 1946): 271–311.

Hansen-Glucklich, Jennifer. *Holocaust Memory Reframed: Museums and the Challenges of Representation*. New Brunswick, NJ: Rutgers University Press, 2014.

Harclerode, Peter, and Brendan Pittaway. *The Lost Masters: The Looting of Europe's Treasure Houses*. London: Victor Gollancz, 1999.

Hartt, Frederick. *Florentine Art under Fire: The True Story of a Monuments Man*. Princeton: Princeton University Press, 1949.

Hartung, Ulrike. "De 'Sonderkommando Künsberg': Looting of Cultural Treasures in the USSR." *Spoils of War*, no. 2 (July 1996): 14–16.

Hauschke-Wicklaus, Gabriele, Angelika Amborn-Morgenstern, and Erika Jacobs. *Fast Vergessen: Das Amerikanische Bücherdepot in Offenbach am Main von 1945 bis 1949*. Offenbach am Main, Germany: Geschichtwerkstatt Offenbach, 2011.

Hay, Bruce L. *Nazi-Looted Art and the Law: The American Cases*. Cham, Switzerland: Springer, 2017.

Heil, Johannes, and Annete Weber, eds. *Ersessene Kunst: Der Fall Gurlitt*. Berlin: Metropol, 2015.

Henraux, Albert. *Les Chefs-d'Oeuvre des Collections Privées Françaises, Retrouvés en Allemagne par la Commission de Récupération Artistique et les Services Alliés*. Exh. cat. Commission de Récupération Artistique, Paris, 1946.

Herman, Dana. "*Hashavat Avedah*: A History of Jewish Cultural Reconstruction, Inc." PhD diss., McGill University, Montreal, 2008.

Hershkovitch, Corinne, and Didier Rykner. *La Restitution des Oeuvres d'Art: Solutions et Impasses*. Paris: Hazan, 2011.

Hickley, Catherine. *The Munich Art Hoard: Hitler's Dealer and His Secret Legacy*. London: Thames and Hudson, 2018.

Hinz, Berthold. *Art in the Third Reich*. New York: Pantheon, 1979.

Hitler, Adolf. *Reden zur Kunst- und Kulturpolitik, 1933–1939*. Ed. by Robert Eikmeyer. Introduction by Boris Groys. Publikationsreihe Kunst, Propaganda, Dokumente 1, no. 4. Frankfurt am Main: Revolver, 2004.

Hoffman, Barbara. *Art and Cultural Heritage: Law, Policy, and Practice*. New York: Cambridge University Press, 2009.

———. "The Spoils of War." *Archaeology* 46, no. 6 (November–December 1993): 37–40.

Hoffmann, Meike, and Nicola Kuhn. *Hitlers Kunsthändler: Hildebrand Gurlitt, 1895–1956; Die Biographie*. Munich: Beck, 2016.

"Holocaust Records Project." United States National Archives and Records Administration website. https://www .archives.gov/preservation/products /definitions/project-hrp.html.

Holzer-Kawałko, Anna. "Jewish Intellectuals between Robbery and Restitution: Ernst Gumach in Berlin, 1941–1946." *Leo Baeck Institute Year Book* 63, no. 1 (November 2018): 273–95.

Hoogewoud, F. J. "The Nazi Looting of Books and Its American 'Antithesis': Selected Pictures from the Offenbach Archival Depot's Photographic History and Its Supplement." *Studia Rosenthaliana* 26, nos. 1–2 (1992): 158–92.

Hopp, Meike. *Kunsthandel im Nationalsozialismus: Adolf Weinmüller in München und Wien*. Veröffentlichungen des Zentralinstituts für Kunstgeschichte in München 30. Cologne: Böhlau, 2012.

Houpt, Simon. *Museum of the Missing: A History of Art Theft*. New York: Sterling, 2006.

Howe, Thomas Carr, Jr. *Salt Mines and Castles: The Discovery and Restitution of Looted European Art*. New York: Bobbs-Merrill, 1946.

Huyssen, Andreas, Anson Rabinbach, and Avinoam Shalem, eds. "Nazi-Looted Art and Its Legacies." Special issue, *New German Critique* 44, no. 1 (130) (February 2017). With essays by Konstantin Akinsha, Meike Hoffmann, Lawrence M. Kaye, Olaf Peters, Jonathan Petropoulos, and Julia Voss.

Jaeger, Charles de. *The Linz File: Hitler's Plunder of Europe's Art*. Exeter, UK: Webb and Bower, 1981.

Jewish Post-War Problems: A Study Course. Vol. 7, *Relief, Reconstruction and Migration*. New York: Research Institute on Peace and Post-War Problems of the American Jewish Committee, 1943.

Jungblut, Marie-Paule. *Looted!: Current Questions Regarding the Cultural Looting by the National Socialists in Europe*. Trans. by Frances Cooper and Claire Weyland. Exh. cat. Musée d'Histoire de la Ville, Luxembourg, 2008.

Keenan, Thomas, and Eyal Weizman. *Mengele's Skull: The Advent of a Forensic Aesthetics*. Berlin: Sternberg, 2012.

Klenner, Jost Philipp. "Mussolini und der Löwe: Aby Warburg und die Anfänge einer Politischen Ikonographie." *Zeitschrift für Ideengeschichte*, no. 1 (2007): 83–98.

Kline, Thomas R., and Willie A. Korte. "Archival Material on National Socialist Art Plundering during the Second World War." *Spoils of War*, no. 1 (December 1995): 40–41.

Kochavi, Shir. "Salvage to Restitution: 'Heirless' Jewish Cultural Property Post-World War II." PhD diss., University of Leeds, UK, 2017.

Koldehoff, Stefan. *Die Bilder Sind unter Uns: Das Geschäft mit der NS-Raubkunst*. Frankfurt am Main: Eichborn, 2009.

Kowalski, Wojciech. *Art Treasures and War: A Study on the Restitution of Looted Cultural Property, Pursuant to Public International Law*. Leicester, UK: Institute of Art and Law, 1998.

———. "Introduction to International Law of Restitution of Works of Art Looted during Armed Conflicts: Part I." *Spoils of War*, no. 2 (July 1996): 6–8.

———. "Introduction to International Law of Restitution of Works of Art Looted during Armed Conflicts: Part II." *Spoils of War*, no. 3 (December 1996): 10–11.

———. "Introduction to International Law of Restitution of Works of Art Looted during Armed Conflicts: Part III." *Spoils of War*, no. 4 (August 1997): 39–41.

———. "Introduction to International Law of Restitution of Works of Art Looted during Armed Conflicts: Part IV." *Spoils of War*, no. 5 (June 1998): 39–41.

———. *Liquidation of the Effects of World War II in the Area of Culture*. Warsaw: Institute of Culture, 1994.

Kramar, Konrad. *Mission Michelangelo: Wie die Bergleute von Altaussee Hitlers Raubkunst vor der Vernichtung Retteten*. Saint Pölten, Austria: Residenz, 2013.

Kubin, Ernst. *Sonderauftrag Linz: Die Kunstsammlung Adolf Hitlers*. Vienna: Orac, 1989.

Kunzelman, Charles J. "Some Trials, Tribulations, and Successes of the Monuments, Fine Arts and Archives Teams in the European Theatre during WWII." *Military Affairs* 51, no. 2 (April 1988): 56–60.

Kurtz, Michael J. *America and the Return of Nazi Contraband: The Recovery of Europe's Cultural Treasures*. Cambridge, UK: Cambridge University Press, 2006.

———. "American Cultural Restitution Policy in Germany during the Occupation, 1945–1949." PhD diss., Georgetown University, Washington, DC, 1982.

———. "Resolving a Dilemma: The Inheritance of Jewish Property." *Cardozo Law Review* 20, no. 2 (1998–99): 625–55.

Kurz, Jakob. *Kunstraub in Europa, 1938–1945*. Hamburg: Facta Oblita, 1989.

La Farge, Henry, ed. *Lost Treasures of Europe*. New York: Pantheon, 1946.

Lambourne, Nicola. *War Damage in Western Europe: The Destruction of Historic Monuments during the Second World War*. Edinburgh: Edinburgh University Press, 2001.

Lauterbach, Iris. *The Central Collecting Point in Munich: A New Beginning for the*

Restitution and Protection of Art. Trans. by Fiona Elliott. Los Angeles: Getty Research Institute, 2018. German ed., Deutscher Kunstverlag, Berlin, 2015.

Lester, Robert. *Art Looting and Nazi Germany: Records of the Fine Arts and Monuments Adviser, Ardelia Hall, 1945–1961.* Bethesda, MD: University Publications of America, 2002.

Levin, Itamar. *The Fate of Stolen Jewish Properties: The Cases of Austria and the Netherlands.* Jerusalem: Institute of the World Jewish Congress, 1997.

———. *The Last Chapter of the Holocaust?: The Struggle over the Restitution of Jewish Property in Europe.* Jerusalem: Jewish Agency for Israel and the World Jewish Restitution Organization, 1998.

Liberles, Robert. *Salo Wittmayer Baron: Architect of Jewish History.* New York: New York University Press, 1995.

Lipman, Rena. "Jewish Cultural Reconstruction Reconsidered: Should the Jewish Religious Objects Distributed around the World after WWII Be Returned to Europe?" *Jewish Cultural Reconstruction Reconsidered* 8, no. 4 (2006): 89–92.

Listl, Mathias, ed. *(Re)discovery: The Kunsthalle from 1933 to 1945 and the Aftermath.* Exh. cat. Kunsthalle Mannheim, Germany, 2018.

Löhr, Hanns Christian. *Kunst als Waffe: Der Einsatzstab Reichsleiter Rosenberg; Ideologie und Kunstraub im "Dritten Reich."* Berlin: Mann, 2018.

Looted, but from Whom? Exh. cat. Hollandsche Schouwburg, Amsterdam, 2006.

Lustig, Jason. "Who Are to Be the Successors of European Jewry?: The Restitution of German Jewish Communal and Cultural Property." *Journal of Contemporary History* 52, no. 3 (July 2017): 519–45.

Malaro, Marie C. *A Legal Primer on Managing Museum Collections.* Washington, DC: Smithsonian Institution, 1998.

Mallinger, Stephen. *Historical Study of the Fate of Jewish Libraries during the Holocaust.* Cincinnati: Special Collections, Klau Library, 1975.

Manchin, Anna. "Staging Traumatic Memory: Competing Narratives of State; Violence in Post-Communist Hungarian Museums." *East European Jewish Affairs* 45, nos. 2–3 (2015): 236–51.

Mann, Vivian, et al. *Danzig 1939: Treasures of a Destroyed Community.* Exh. cat. Jewish Museum, New York. Detroit: Wayne State University Press, 1980.

Marrus, Michael R. *Some Measure of Justice: The Holocaust Era Restitution Campaign of the 1990s.* Madison: University of Wisconsin Press, 2009.

Mazauric, Lucie. *Le Louvre en Voyage, 1939–1945.* Paris: Plon, 1978.

Methuen, Paul Ayshford. *Normandy Diary: Being a Record of Survivals and Losses of Historical Monuments in North-Western France, Together with Those in the Island of Walcheren and in That Part of Belgium Traversed by 21st Army Group in 1944–45.* London: Hale, 1952.

Meyer, Karl E. *The Plundered Past: The Story of the Illegal International Traffic in Works of Art.* New York: Atheneum, 1973.

———. "Who Owns the Spoils of War?" *Archaeology* 48, no. 4 (July–August 1995): 46–52.

Meyers, David N. *The Stakes of History: On the Use and Abuse of Jewish History for Life.* New Haven: Yale University Press, 2018.

Michaud, Eric. *The Cult of Art in Nazi Germany.* Stanford, CA: Stanford University Press, 2004.

Mihan, George. *Looted Treasure: Germany's Raid on Art.* London: Alliance, 1944.

Milosch, Jane C., Lynn H. Nicholas, and Megan M. Fontanella. "Provenance Research in American Institutions." Special issue, *Collections: A Journal for Museum and Archives Professionals* 10, no. 3 (Summer 2014).

Missing Art Works of Belgium, Part I: Public Domain. Brussels: Office Belge de l'Economie et de l'Agriculture, 1994.

Morey, Charles R. "The War and Mediaeval Art." *College Art Journal* 4, no. 2 (January 1945): 75–80.

———. "What We Are Actually Doing to Save Europe's Art." *Art News,* May 1944.

Morozzi, Luisa, and Rita Paris, eds. *Treasures Untraced: An Inventory of the Italian Art Treasures Lost during the Second World War.* Rome: Istituto Poligrafico e Zecca dello Stato, 1995.

Morris, Collin R. "The Law and Stolen Art, Artifacts, and Antiquities." *Howard Law Review* 36, no. 1 (1993): 201–26.

Mravik, László. *The "Sacco di Budapest" and Depredation of Hungary, 1938–1949: Works of Art Missing from Hungary as a Result of the Second World War; Looted, Smuggled, Captured, Lost, and Destroyed Art Works, Books and Archival Documents; Preliminary and Provisional Catalogue.* Budapest: Hungarian National Gallery for Joint Restitution Committee, 1998.

Müller, Melissa, and Monika Tatzkow. *Lost Lives, Lost Art: Jewish Collectors, Nazi Art Theft, and the Quest for Justice.* Trans. by Jennifer Taylor and Tammi Reichel. London: Frontline, 2010.

Munz, Ernest. "Restitution in Postwar Europe." *Contemporary Jewish Record* 6, no. 4 (August 1943): 371–80.

Naimark, Norman M. *The Russians in Germany: A History of the Soviet Zone of Occupation, 1945–49.* Cambridge, MA: Belknap Press of Harvard University Press, 2001.

Nicholas, Lynn H. *The Rape of Europa: The Fate of Europe's Treasures in the Third Reich and the Second World War.* New York: Knopf, 1994.

Noblecourt, André. *Protection of Cultural Property in the Event of Armed Conflict.* Paris: UNESCO, 1958.

O'Donnell, Nicholas M. *A Tragic Fate: Law and Ethics in the Battle over Nazi-Looted Art.* Chicago: American Bar Association, 2017.

O'Donnell, Thérèse. "The Restitution of Holocaust Looted Art and Transitional Justice: The Perfect Storm or the Raft of the Medusa?" *European Journal of International Law* 22, no. 1 (2011): 49–80.

O'Keefe, Patrick J., and Lyndel V. Prott. *Cultural Heritage Conventions and Other Instruments: A Compendium with Commentaries.* Builth Wells, UK: Institute of Art and Law, 2011.

Olin, Margaret Rose. *The Nation without Art: Examining Modern Discourses on Jewish Art (Texts and Contexts).* Lincoln: University of Nebraska Press, 2001.

Opper, Dieter, and Doris Lemmermeier. *Cultural Treasures Moved Because of the War: A Cultural Legacy of the Second World War; Documentation and Research on Losses; Documentation of the International Meeting in Bremen.* Bremen, Germany: Koordinierungsstelle der Länder für die Rückführung von Kulturgütern, 1995.

Origins Unknown: Report on the Pilot Study into the Provenance of Art Recovered from Germany and Currently under the Custodianship of the State of the Netherlands. The Hague: SDU Servicecentrum, 1998.

Osborne, Dora. *What Remains: The Post-Holocaust Archive in German Memory Culture.* Rochester, NY: Camden House, 2020.

Paintings Looted from Holland: Returned through the Efforts of the United States Armed Forces; A Collection to Be Exhibited in . . . Ann Arbor, Michigan, Baltimore, Maryland, Buffalo, New York [Etc.]. Exh. cat. National Gallery of Art, Washington, DC, 1946.

Palmer, Norman. *Museums and the Holocaust: Law, Principles and Practice.* London: Institute of Art and Law, 2000.

Pars, H. H. *Pictures in Peril.* London: Faber and Faber, 1957.

Perry, Victor. *Stolen Art.* Hewlett, NY: Gefen, 2000.

Peters, Olaf, ed. *Degenerate Art: The Attack on Modern Art in Nazi Germany, 1937.* Exh. cat. Neue Galerie, New York. Munich: Prestel, 2014.

Petropoulos, Jonathan. *Art as Politics in the Third Reich.* Chapel Hill: University of North Carolina Press, 1996.

———. "Art Historians and Nazi Plunder." *New England Review* 21, no. 1 (Winter 2000): 5–30.

———. *The Faustian Bargain: The Art World in Nazi Germany.* New York: Oxford University Press, 2000.

———. "For Germany and Themselves: The Motivation behind the Nazi Leaders Plundering and Collection of Art: Part II." *Spoils of War,* no. 5 (June 1998): 28–35.

———. "Not a Case of 'Art for Art's Sake': The Collecting Practices of the Nazi Elite." *German Politics and Society,* no. 32 (Summer 1994): 107–24.

Pikety, Caroline, Christophe Dubois, and Fabrice Launay. *Guide des Recherches dans les Archives des Spoliations et des Restitutions.* Paris: Documentation Française, 2000.

Pillage en Europe. Paris: International Council of Museums (ICOM), 2001.

Plaut, James S. "Hitler's Capital." *Atlantic Monthly* 178, no. 4 (October 1946): 73–78.

———. "Loot for the Master Race." *Atlantic Monthly,* 178, no. 3 (September 1946): 57–63.

Plunder and Restitution: The US and Holocaust Victims' Assets: Findings and Recommendations of the Presidential Advisory Commission on Holocaust Assets in the United States and Staff Report. Washington, DC: United States Government Printing Office, 2000.

Polack, Emmanuelle. *Le Marché de l'Art sous l'Occupation: 1940-1944*. Paris: Tallandier, 2019.

Pool, James. *Hitler and His Secret Partners: Contributions, Loot and Rewards, 1933-1945*. New York: Pocket Books, 1997.

Posey, Robert K. "Protection of Cultural Materials during Combat." *College Art Journal* 5, no. 2 (January 1946): 127–31.

Poste, Leslie Iriyn. "The Development of U.S. Protection of Libraries and Archives in Europe during World War II." PhD diss., University of Chicago, 1958.

Poulain, Martine. "De Mémoire de Livres: Des Livres Spoliés durant la Seconde Guerre Mondiale Déposés dans les Bibliothèques: Une Histoire à Connaître et à Honorer." *Bulletin des Bibliothèques de France*, January 2015.

Preiss, Kathy. "Cultural Policy in a Time of War: The American Response to Endangered Books in World War II." *Library Trends* 55, no. 3 (2007): 370–87.

Prott, Lyndel V., and Jan Hladik. "The Role of UNESCO 'Intergovernmental Committee for Promoting the Return of Cultural Property' in the Resolution of Disputes Concerning Cultural Property Removed in Consequence of the Second World War." *Spoils of War*, no. 4 (August 1977): 59–61.

Puloy, Monika Ginzkey. "High Art and National Socialism: Part I, The Linz Museum as Ideological Arena." *Journal of the History of Collections* 8, no. 2 (1996): 201–15.

Rauschenberger, Katharina. "The Restitution of Jewish Cultural Objects and the Activities of Jewish Cultural Reconstruction, Inc." *Leo Baeck Institute Year Book* 53, no. 1 (2008): 193–211.

Reininghaus, Alexandrea, ed. *Recollecting: Looted Art and Restitution*. Exh. cat. Austrian Museum of Applied Arts, Vienna. Vienna: Passagen, 2008.

Reisenfeld, Robin. "Collecting and Collective Memory: German Expressionist Art and Modern Jewish Identity." In *Jewish Identity in Modern Art History*, ed. by Catherine M. Soussloff, 114–34. Berkeley: University of California Press, 1999.

Remy, Maurice Philip. *Der Fall Gurlitt: Die Wahre Geschichte über Deutschlands Grössten Kunstskandal*. Munich: Europa, 2017.

Renold, Marc-André. *Claims for the Restitution of Looted Art: Some Preliminary Reflections*. Zurich: Schulthess Médias Juridiques, 2004.

Répertoire des Biens Spoliés en France durant la Guerre 1939-1945. Berlin: Imprimerie Nationale, 1947.

Report of the American Commission for the Protection and Salvage of Artistic and Historic Monuments '46. Washington, DC: United States Government Printing Office, 1946.

Rickman, Gregg J. *Conquest and Redemption: A History of Jewish Assets from the Holocaust*. London: Taylor and Francis, 2017.

Riding, Alan. "Art Looted by Nazis Goes on Show in Paris, Seeking Its Owners." *New York Times*, October 25, 1994.

Rigby, Douglas, and Elizabeth Rigby. "Embattled Collectors: How Treasures of Art and Culture Flee from War." *Harper's Magazine*, January 1941.

Ritchie, Andrew C. "The Restitution of Art Loot." *Gallery Notes* 11 (July 1946): 3–10.

———. "Return of Art Loot from and to Austria." *College Art Journal* 5, no. 4 (May 1946): 353–57.

Robinson, Jacob. *Guide to Jewish History under Nazi Impact*. New York: YIVO Institute for Jewish Research, 1960.

Ronald, Susan. *Hitler's Art Thief: Hildebrand Gurlitt, the Nazis, and the Looting of Europe's Treasures*. New York: St. Martin's, 2016.

Rorimer, James J. *Survival: The Salvage and Protection of Art in War*. New York: Abelard, 1950.

Rose, Jonathan. *The Holocaust and the Book: Destruction and Preservation*. Amherst: University of Massachusetts Press, 2001.

Roth, Cecil. "The Restoration of Jewish Libraries, Archives, and Museums." *Contemporary Jewish Record* 7, no. 3 (June 1944): 253–57.

Roth, John K., Elizabeth Maxwell, Margot Levy, and Wendy Whitworth, eds. *Remembering for the Future: The Holocaust in an Age of Genocide*. London: Palgrave Macmillan, 2001.

Rothfeld, Anne. "Project ORION: An Administrative History of the Art Looting Investigative Unit (ALIU); An Overlooked Page in Intelligence Gathering." MA thesis, University of Maryland, Baltimore County, 2002.

Rousseau, Theodore. *The Goering Collection*. Washington, DC: Office of Strategic Service, 1945.

Roxan, David, and Ken Wanstall. *The Rape of Art: The Story of Hitler's Plunder of the Great Masterpieces of Europe*. New York: Coward-McCann, 1964.

Rudolph, Sabine. *Restitution von Kunstwerken aus Jüdischem Besitz: Dingliche Herausgabeansprüche nach Deutschem Recht*. Berlin: De Gruyter, 2007.

Rydell, Anders. *The Book Thieves: The Nazi Looting of Europe's Libraries and the Race to Return a Literary Inheritance*. Trans. by Henning Koch. New York: Viking, 2017.

Saisies, Spoliations et Restitutions: Archives et Bibliothèques au XXe Siècle. Rennes, France: Presses Universitaires de Rennes, 2012.

Scarlini, Luca. *Siviero contro Hitler: La Battaglia per l'Arte*. Milan: Skira, 2014.

Schachl-Raber, Ursula, Helga Embacher, Andreas Schmoller, and Irmgard Lahner, eds. *Buchraub in Salzburg: Bibliotheks- und-NS Provenienzforschung an der Universitätsbibliothek Salzburg*. Salzburg: Müry Salzmann, 2012.

Schleusener, Jan. *Raub von Kulturgut: Der Zugriff des NS-Staats auf Jüdischen Kunstbesitz in München und Seine Nachgeschichte*. Berlin: Deutscher Kunstverlag, 2016.

Schnabel, Gunnar, and Monika Tatzkow. *Nazi Looted Art: Handbuch Kunstrestitution Weltweit*. Berlin: Proprietas, 2007.

Scholem, Gershom. *Walter Benjamin: The Story of a Friendship*. Trans. by Harry Zohn. New York: New York Review of Books, 2001.

Schölnberger, Pia, and Sabine Loitfellner. *Bergung von Kulturgut im National-sozialismus: Mythen, Hintergründe, Auswirkungen*. Vienna: Böhlau, 2016.

Schubert, Jessica. "Prisoners of War: Nazi-Era Looted Art and the Need for Reform in the United States." *Touro Law Review* 30, no. 3 (October 2014): 675–95.

Schuster, Peter-Klaus, ed. *National-sozialismus und "Entartete Kunst": Die "Kunststadt" München, 1937*. Exh. cat. Munich: Prestel, 1987

Schwarz, Birgit. *Auf Befehl des Führers: Hitler und der NS-Kunstraub*. Stuttgart: Theiss, 2014.

———. *Hitler's Museum: Die Fotoalben Gemäldegalerie Linz; Dokumente zum "Führermuseum."* Vienna: Böhlau, 2004.

———. *Hitlers Sonderauftrag Ostmark: Kunstraub und Museumspolitik im Nationalsozialismus*. Vienna: Böhlau, 2018.

Sedlmayr, Hans. *Verlust der Mitte: Die Bildende Kunst des 19. und 20. Jahrhunderts als Symbol der Zeit*. Salzburg: Müller, 1948. English ed., *Art in Crisis: The Lost Centre*, Hollis and Carter, London, 1957.

Shandler, Jeffrey. *Holocaust Memory in the Digital Age: Survivors' Stories and New Media Practices*. Stanford, CA: Stanford University Press, 2017.

Sidorsky, David, ed. *Essays on Human Rights: Contemporary Issues and Jewish Perspectives*. Philadelphia: Jewish Publication Society of America, 1979.

Silverman, Lisa. "Repossessing the Past?: Property, Memory and Austrian Jewish Narrative Histories." *Austrian Studies* 11 (2003): 138–53.

Simon, Matilda. *Battle of the Louvre: The Struggle to Save French Art in World War II*. New York: Hawthorn, 1971.

Simpson, Elizabeth, ed. *The Spoils of War: World War II and Its Aftermath: The Loss, Reappearance, and Recovery of Cultural Property*. New York: Abrams, 1997.

Sinkoff, Nancy. "From the Archives: Lucy S. Dawidowicz and the Restitution of Jewish Cultural Property." *American Jewish History* 100, no. 1 (January 2016): 117–47.

Smith, Arthur L., Jr. "A View of U.S. Policy toward Jewish Restitution." *Holocaust and Genocide Studies* 5, no. 3 (1990): 247–59.

Smyth, Craig Hugh. *Repatriation of Art from the Collecting Point in Munich after World War II: Background and Beginnings, with Reference Especially to the Netherlands*. The Hague: SDU, 1989.

Soussloff, Catherine M., ed. *Jewish Identity in Modern Art History*. Berkeley: University of California Press, 1999.

"Spoliation of Jewish Cultural Property." International Council of Museums (ICOM) website. http://archives.icom.museum /spoliation.html#guidelines.

Sroka, Marek. "The Destruction of Jewish Libraries and Archives in Cracow during World War II." *Libraries and Culture* 38, no. 2 (Spring 2003): 147–65.

———. " 'Nations Will Not Survive Without Their Cultural Heritage': Karol Estreicher, Polish Cultural Restitution Plans and the Recovery of Polish Cultural Property from the American Zone of Occupation." *Polish Review* 57, no. 3 (2012): 3–28.

"Standards Regarding the Unlawful Appropriation of Objects during the Nazi Era." American Alliance of Museums website, [1999]. http://ww2.aam-us.org/resources/ethics-standards-and-best-practices/collections-stewardship/objects-during-the-nazi-era.

Starr, Joshua. "Jewish Cultural Property under Nazi Control." *Jewish Social Studies* 12, no. 1 (January 1950): 27–48.

Steinberg, Shlomit, ed. *Orphaned Art: Looted Art from the Holocaust in the Israel Museum.* Exh. cat. Israel Museum, Jerusalem, 2008.

Steinweis, Alan E. *Art, Ideology, and Economics in Nazi Germany.* Chapel Hill: University of North Carolina Press, 1993.

———. "German Cultural Imperialism in Czechoslovakia and Poland, 1938–1945." *International History Review* 13, no. 2 (August 1991): 466–80.

———. *Studying the Jew: Scholarly Antisemitism in Nazi Germany.* Cambridge, MA: Harvard University Press, 2009.

Stier, Oren Baruch. *Committed to Memory: Cultural Mediations of the Holocaust.* Amherst: University of Massachusetts Press, 2003.

Sutton, Peter C., ed. *Reclaimed: Paintings from the Collection of Jacques Goudstikker.* Exh. cat. Bruce Museum, Greenwich, CT; Jewish Museum, New York, 2008.

Takei, Ayaka. " 'The Gemeinde Problem': The Jewish Restitution Successor Organization and the Postwar Jewish Communities in Germany, 1947–1954." *Holocaust and Genocide Studies* 16, no. 2 (Fall 2002): 266–88.

"Tentative List of Jewish Cultural Treasures in Axis-Occupied Countries." *Jewish Social Studies*, suppl. 8, no. 1 (1946): 1–103.

Tilmans, Karin, Frank van Vree, and Jay Winter. *Performing the Past: Memory, History, and Identity in Modern Europe.* Amsterdam: Amsterdam University Press, 2010.

Tollebeek, Jo, and Eline van Assche, eds. *Ravaged: Art and Culture in Times of Conflict.* Exh. cat. Museum Leuven, Belgium. New Haven: Yale University Press, 2014.

Tooze, Adam. *The Wages of Destruction: The Making and Breaking of the Nazi Economy.* New York: Penguin, 2008.

Treue, Wilhelm. *Art Plunder: The Fate of Works of Art in War, Revolution, and Peace.* New York: John Day, 1961.

Tully, Judd. "The War Loot Questions: No Easy Answer." *Art News* 94, no. 6 (Summer 1995): 144.

Tymkiw, Michael. *Nazi Exhibition Design and Modernism.* Minneapolis: University of Minnesota Press, 2018.

Tythacott, Louise, and Kostas Arvanitis, eds.

Museums and Restitution, New Practices, New Approaches. London: Routledge, 2017.

Valland, Rose. *Le Front de l'Art: Défense des Collections Françaises, 1939–1945.* Paris: Librarie Plon, 1961. Rev. ed., Réunion des Musées Nationaux, Paris, 2014.

Van Beurden, Jos. *The Return of Cultural and Historical Treasures: The Case of the Netherlands.* Amsterdam: KIT Tropenmuseum, 2012.

Varsavskij, Sergej, and Boris Rest. *The Ordeal of the Hermitage: The Siege of Leningrad, 1941–1944.* Leningrad: Aurora Art Publishers; New York: Abrams, 1985.

Venema, Adriaan. *Kunsthandel in Nederland, 1940–1945.* Amsterdam: Uitgeverij De Arbeiderspers, 1986.

Vitalizing Memory: International Perspectives on Provenance Research. Washington, DC: American Association of Museums, 2005.

Vlug, Jean. *Report on Objects Removed to Germany from Holland, Belgium, and France during the German Occupation of the Countries.* Amsterdam: Report of Stichting Nederlands Kunstbesit, 1945.

Vogel, Barbara, ed. *Restitution von NS-Raubkunst: Der Historisch Begründete "Anspruch auf eine Rechtslage"; Beiträge einer Veranstaltung der Historischen Kommission beim Parteivorstand der SPD.* Essen, Germany: Klartext, 2016.

Von zur Mühlen, Ilse. *Die Kunstsammlung Hermann Görings: Ein Provenienzbericht der Bayerischen Staatsgemälde-sammlungen.* Munich: Bayerische Staatsgemäldesammlungen, 2004.

Voss, Julia. "Kulturgut aus Jüdischem Besitz: Restitution Ist Keine Stilfrage." *Frankfurter Allgemeine Zeitung*, April 22, 2009. https://www.faz.net/aktuell/feuilleton/kunst/kulturgut-aus-juedischem-besitz-restitution-ist-keine-stilfrage-1790678.html.

Vries, Willem de. *Sonderstab Musik: Music Confiscations by the Einsatzstab Reichsleiter Rosenberg under the Nazi Occupation of Western Europe.* Amsterdam: Amsterdam University Press, 1996.

Waite, Robert G. "Returning Jewish Cultural Property: The Handling of Books Looted by the Nazis in the American Zone of Occupation, 1945 to 1952." *Libraries and Culture* 37, no. 3 (Summer 2002): 213–28.

Walker, John. "Europe's Looted Art." *National Geographic* 89, no. 1 (January 1946): 39–52.

Wallace, Ian. *The First Documenta, 1955 / Die Erste Documenta, 1955.* 100 Notes, 100 Thoughts 2. Ostfildern, Germany: Hatje Cantz, 2011.

Warburg, Aby. *Der Bilderatlas Mnemosyne.* Ed. by Martin Warnke. Gesammelte Schriften 2, pt. 1. Berlin: Akademie, 2008.

———. *Bilderreihen und Ausstellungen.* Ed. by Uwe Fleckner and Isabella Woldt. Gesammelte Schriften 2, pt. 2. Berlin: Akademie, 2012.

———. *The Renewal of Pagan Antiquity: Contributions to the Cultural History of the European Renaissance.* Trans. by David Britt. Los Angeles: Getty Research Institute for the History of Art and the Humanities, 1999. First pub. 1932.

———. *Tagebuch der Kulturwissenschaft-lichen Bibliothek Warburg.* Ed. by Karen Michels and Charlotte Schoell-Glass. Gesammelte Schriften 7, pt. 7. Berlin: Akademie, 2001.

"Washington Conference Principles on Nazi-Confiscated Art." United States Department of State website, December 3, 1998. https://www.state.gov/washington-conference-principles-on-nazi-confiscated-art.

Weber, John Paul. *The German War Artists.* Columbia, SC: Cerberus, 1979.

Wechsler, Helen J., Teri Coate-Saal, and John Lukavic. *Museum Policy and Procedures for Nazi-Era Issues.* Washington, DC: American Association of Museums, 2001.

Weil, Stephen E. *Making Museums Matter.* Washington, DC: Smithsonian Institution, 2002.

Weinryb, Bernard D. "Jewish History Nazified." *Contemporary Jewish Record* 4, no. 2 (April 1941): 148–67.

Weissman, Gary. *Fantasies of Witnessing: Postwar Efforts to Experience the Holocaust.* Ithaca, NY: Cornell University Press, 2004.

Woolley, Leonard. *Record of the Work Done by the Military Authorities for the Protection of the Treasures of Art and History in War Areas.* London: His Majesty's Stationery Office, 1947.

Works of Art in Austria (British Zone of Occupation): Losses and Survivals in the War. London: His Majesty's Stationery Office, 1946.

Works of Art in Germany (British Zone of Occupation): Losses and Survivals in the War. London: His Majesty's Stationery Office, 1946.

Works of Art in Italy: Losses and Survivals in the War. London: His Majesty's Stationery Office, 1946.

Yeide, Nancy H. *Beyond the Dreams of Avarice: The Hermann Goering Collection.* Dallas: Laurel, 2009.

Yeide, Nancy H., Konstantin Akinsha, and Amy L. Walsh, eds. *The AAM Guide to Provenance Research.* Washington, DC: American Association of Museums, 2001.

Youngblood Reyhan, Patricia. "A Chaotic Palette: Conflict of Laws in Litigation between Original Owners and Good-Faith Purchasers of Stolen Art." *Duke Law Journal* 50, no. 4 (February 2001): 955–1043.

Zabludoff, Sidney. "At Issue: Restitution of Holocaust-Era Assets; Promises and Reality." *Jewish Political Studies Review* 19, nos. 1–2 (Spring 2007): 3–14.

Zaldumbide, Rodrigo Pallares. "Return and Restitution of Cultural Property: Cases for Restitution." *Museum* 34, no. 2 (January–December 1982): 71–137.

Zelizer, Barbie. *Remembering to Forget: Holocaust Memory through the Camera's Eye.* Chicago: University of Chicago Press, 1998.

Zuschlag, Christoph. *"Entartete Kunst": Ausstellungsstrategien im Nazi-Deutschland.* Worms, Germany: Wernersche Verlagsgesellschaft, 1995.

Index

Illustrations and information in associated captions are indicated by page numbers in italics. Titles of artworks appear under the names of the artists. Exhibitions with specific titles are grouped under the main heading "exhibitions."

A

Abetz, Otto, 52, 57

Abs, Hermann J., 138

abstraction, 58, *118–19*, 208

Adler, Jankel, 128, 135

Adorno, Theodor, 103

afterlives, 50–51, 70, 73–75, 125, 138. *See also Nachleben*

Allais, Lucia, 115–16, 123n24

Allies: art exhibitions at collecting points, 117–20, 132–33, *133*; "Book Distribution from OAD Reversing the Flow Started by the Einsatzstab Reichsleiter Rosenberg" (map), 62–63, *63*, 109; collecting points to sort looted materials, 64, 85–86, 107, 116, 117, 133, 144–68; denazification of Munich buildings, 116; off-limit sites to bombings by, 115; photographic albums produced at art collecting points, *68*, 68–70, 144; recovery of paintings from stash sites, 115, *115*; thefts and destruction of artwork by, 70, 77n37, 176; travel pass issued to Rose Valland by, *117*; U.S. tour of recovered artworks (1948), 65, 73, 120, 198. *See also* Marburg Collecting Point; Munich Central Collecting Point; Offenbach Archival Depot; Wiesbaden Central Collecting Point

Altaussee salt mine (Austria), *109*, 114, 172, 180, 196, 200

Altripp, Alo, *161*, *165–66*, 169

American Jewish Committee: *Relief, Reconstruction and Migration*, 83

American Joint Distribution Committee, 105n23

Amsterdam: Bibliotheca Rosenthalania, 86; Esnoga synagogue, 182; General Commission of Recuperation, 176

architecture of dispossession, 108–14, 121

Arendt, Hannah, *78*, 79–80, 82–83, 88, 90–94, 97, 99–101, 103; administrative documents by, 224, *225–30*; "Books Looking for Their Owners" list compiled by, 100, *101*; letter to Jewish Museum (1949), *92*; *The Origins of Totalitarianism*, 79

Armistice Convention (World War I), 113

Arp, Jean: *Composition,* or *Head and Leaf*, 46

Aufbau: "Books Looking for Their Owners," 100, *101*

B

Barlach, Ernst, 76n25, 127, 129

Baron, Salo, 80–85, 90, 97–98, 100, *102*, 103; "Emphases in Jewish History," 81; "The Spiritual Reconstruction of European Jewry," 85

Bataille, Georges, 103

Bauchant, André: *Dahlias in a Pink Vase*, *29*

Bauer, Simon, 77n42

Beaudin, André: *Pink Stairs, Two Figures,* or *Group of Female Nudes by the Stairs*, 47

Becker, Fridericus, Sr., *95*

Beckmann, Max, 76n25, 135

Bencowitz, Isaac, 67–68, *146*, 169

Benjamin, Walter, 49, 102, 121; "On the Concept of History," 102–3; "Unpacking My Library," 100

Berchtesgaden tunnels, 133, 176, 178

Bergson, Henri, 121

Berlin: book burning (1933), 53; Gesamtarchiv der Deutschen Juden (Central Archives of the German Jews), 94; as hub for Nazi art trafficking, 62; Ministry of Propaganda, 127; Nationalgalerie, 58, 138, 198; Prussian State Library's music collection, 66; Prussian State Museums, 160; Rose Valland Institute, 224; Schloss Schönhausen, 59, *60. See also* exhibitions

Berlinger, Arthur (Asher): Jewish calendar for the year 5704, 220, *220–21*

Bernheim brothers, 57

Bilodeau, Francis Waterhouse, *164*, 169

Blaue Reiter group, 125, 127, 133–34, 206

Bleeker, Maaike, 69

Bles, Herri met de: *Landscape with Burning City*, 176, *177*

Blumfeld, Anna, 130

B'nai Brith Hillel Foundation, 93

Boehmer, Bernhard, 59

Boldini, Giovanni: *Pheasant*, 46

Bonnard, Pierre: *Coffee Grinder*, *38*; *Still Life with Guelder Roses*, 200, *201*; *Woman Eating Breakfast*, 47

books: Eichhorn's portfolio and, 224, *225–30*; number recovered, 76n4, 109; pillaging and destruction of, 53–54, 82, 127, *152*; post war sorting and restitution, 66–67, 94, 145, *146–53*, 169; preserving for inclusion in anti-Semitic museums and institutes, 54–55, *55. See also* Offenbach Archival Depot

Botticelli, 198

Braden, Peter Paul, 125

Bradley, Omar N., *108*

Braque, Georges: *Bowl of Fruit and Partition*, *27*; *Glass and Compote*, 46; *Man with a Guitar*, *43*; *The Mauve Tablecloth*, *31*

Braun, Mme Robert, 46

Breker, Arno, 56, *56*

Brooklyn Museum, 93

Brooklyn warehouse storing JCR books and Judaica, 92, 224

Die Brücke group, 127, 128, 134, 212

Bruegel the Elder, Pieter: *Parable of the Blind Leading the Blind*, 133, *133*

Buchholz, Karl, 59, 208

C

Canadian Jewish Congress, 93

Cassirer, Lilly, 72

Cassirer, Paul, 129, 138

Central Collecting Points. *See* Allies; Marburg Collecting Point; Munich Central Collecting Point; Offenbach Archival Depot; Wiesbaden Central Collecting Point

Cercle des Nations, 43

Cézanne, Paul: *Bather and Rocks*, *34*; *Bathers at Rest*, 46

Chagall, Marc, 128, 135; *Man with a Goat*, 45

Chan, Paul, 50

Clairin, Pierre-Eugène: *Female Nude*, 46

Claude Lorrain: *Coast View with the Abduction of Europa*, 180

Cohen, Morris Raphael, 80–81, 98; "Philosophies of Jewish History," 81

Cologne, 210

Commission de Récupération Artistique, 117

Commission on European Jewish Cultural Reconstruction, 79, 82, 83, 87, 224

Committee on Restoration of Continental Jewish Museums, Libraries, and Archives, 93

Conceptualism, 224

Conference on Jewish Relations, 79–83, 98

Confino, Alon, 76n6

Constructivism, 206

Contemporary Jewish Record, 81–82

Corinth, Lovis, 129

Corot, Camille: *Evening in the Valley*, 46

Courbet, Gustave: *Dead Doe*, *16*, 50, 194, *195*; *Deer Forced Down in the Snow*, 194

Cranach, Lucas, 169

Crary, Jonathan, 121

Cubism, 206, 210, 214, 216

cultural genocide, 80–81, 112, 115

cultural pluralism, 99

cultural reconstruction, 85, 97–99, 107, 109

Czako, Eva-Maria, *166*, 169

D

Dada, 58, 214, 216

Dalí, Salvador: *The Angelus of Millet*, 47; *Derstender Planet* (record showing marked for destruction), *69*; *Herodias*, 47; *Mountainous Southern Landscape with Cloudy Sky*, 47; *Standing Figure, Leaning on an Elbow*, 47; *Study of Horses and Women*, 47; *Swans Reflecting Elephants*, *40*

Danzig's Great Synagogue and Jewish community, 71, 77n40, 94–95, *96–97*, 105nn23–24, *184*

David-Weill, David, 200

de Benzion, Levy, 30, 41, 46–47

de Brye, Hubert, 65, *167*, 169

De Chirico, Giorgio: *The Day of Celebration*, *42*

Degas, Edgar: *Dancer*, 47

"degenerate" artworks, 32, 37, 58, *60*, 113, 128–29, 131, 206, 214, 216; destruction or sale of, 58–60, *69*, 76n25, 132, 135, 180, 206, 208, 210, 212; postwar painting exhibitions as response to Nazi vilification, 120, 133–35, *134. See also* exhibitions; Jeu de Paume *for Room of the Martyrs*

Delacroix, Eugène: *Interior of a Mosque*, 46

Delage, Christian, 110, 122n9

Delaunay, Robert, 134

Delegación de Asociaciones Israelitas Argentinas, 93

Derain, André, 206; *Portrait of Mme Osusky*, *25*; *Seated Female Nude*, *26*; *Still Life, or Still Life with Pot*, 46

Der Stürmer, 88, *89*, 92

de Vlaminck, Maurice, 206; *Forest*, 46; *Still Life with a Bowl of Fruit*, 46

de Vos, Marten: *Adam and Eve in Paradise*, *158*, 169

de Waal, Edmund: *The Hare with Amber Eyes*, 138

de Witte, Emanuel: *Interior of the Portuguese Synagogue in Amsterdam*, 182, *183*

Didi-Huberman, Georges, 76n1

Dietrich, Otto, 130

displaced persons camps, 66, 145

Dix, Otto, 58, 76n25

Documenta 1 (Kassel 1955), *118–19*, *120–21*, 133–35, *134*, 140–41n30; *Documenta 3* (Kassel 1964), 135; *Documenta 14* (Kassel 2017), 224

E

Edelmann, Charles-Auguste: *Painter's Table*, 47

Eichhorn, Maria, portfolio of, 224–31, *225–30*

Eichmann, Adolf, 100

Einsatzstab Reichsleiter Rosenberg (ERR), 20, 32, 37–38, 43, 52, 76n5, 82, 113, 122n23, 123n27, 131, 132, 180, 188, 200, 218, 248; albums and exhibitions compiled for Hitler and Goering by, 112, 114, 117, 122n23; documents and images salvaged from, 67, *69*, 70, 112–15, 122n12, 169; Möbel-Aktion operation (1942), *16*, 194; "Task Force for the Occupied Territories" (map), 62, *62*. *See also* Institute for the Study of the Jewish Question; Jeu de Paume

Einstein, Albert, 80

Eisenhower, Dwight D., *108*, 123n24

Elias, Mayer, 174

Emergency Rescue Committee, 135

Ephrussi, Charles, 138

Erhart, Gregor, 169; *Mary Magdalen*, *68*, *142*, 178, *179*

Ernst, Max, 128; *Seashells*, 47

ERR. *See* Einsatzstab Reichsleiter Rosenberg

Essen: Museum Folkwang, 58

exhibitions (by title): *Art du Front* (Jeu de Paume 1941), *108*; Blaue Reiter exhibition (Munich 1911), 206; *The Blaue Reiter: Munich and the Art of the Twentieth Century* (Munich 1949), 133–34; *Les Chefs-d'Oeuvre des Collections Privées Françaises* (Paris 1946), 120, 200; *Degenerate Art* (Dresden 1933), 212; *Emil Nolde: A German Legend; The Artist during the Nazi Regime* (Berlin 2019), 138–39; *Entartete Kunst* (*Degenerate Art*) (Munich 1937), 58, 74, 127–29, *128*, 206, 208; *Entartete Kunst* (*Degenerate Art*) touring exhibition (1938–41), 129–30; *Exhibition of Twentieth Century German Art* (London 1938), 206; *German Watercolors, Drawings and Prints, 1905–1955* (U.S. touring exhibition 1956), 135–38; *Grosse Deutsche Kunstausstellung* (Great German Art Exhibition, Munich 1937–44), 129, 131, 134, 140n13; *Le Juif et la France* (*France and the Jew*) (Paris 1941–42), 218; *Manet Project '74* (Cologne 1974), 138; *Paintings from the Berlin Museums* (1948), 73, 198; *Paintings Looted from Holland* (1946), 73, 120, *120*; *Politics of Restitution* (Munich 2003), 224; *Project '74* (Cologne 1974), 138; *Twentieth Century Banned German Art* (U.S. touring exhibition 1939), 206. *See also Documenta*

Expressionism. *See* German Expressionism

F

Fantin-Latour, Henri: *Roses in a Glass Vase*, *48*

Farmer, Walter I., 64, *165*, 169

Fauvism, 58, 206

Favory, André: *Bust of a Woman, or The Wife of the Artist*, 46

Feibusch, Hans, 128

Feininger, Lyonel, 206

Felbermeyer, Johannes, 154, 169

Feliciano, Hector, 76n5

Ferdinand-Dreyfus, Jean, 49

Fioravanti, José, *64*

Fischer, Theodor, 60, 132

Flavian, Salomon, 46

Flechtheim, Alfred, 130, *130*

Fleischhacker, Leopold: alms container, 204, *205*

Flinsch, Annemarie, *161*, 169

Floris, Frans (unknown artist after): *Adam and Eve*, 66, *67*

Forain, Jean-Louis: *Visit to the Dancers, or Dancers and Subscriber*, *41*

Ford, John, 110

Freud, Sigmund, 127

Freundlich, Otto, 58, 127, *128*, 135; *Large Head*, 128, *128*, 129–30, *130*; *The Unity of Life and Death*, 59

Friesz, Achille-Emile Othon: *Spring, or Almond Tree in Bloom*, *23*

Fry, Varian, 135

Führerbau, 116, 117, 154

Führermuseum planned for Linz, Austria, 52, 54, 56, 69, 112, 130, 131, 138, 180, 182, 212

Führervorbehalt policy, 130

Fulda, Bernhard, 138

G

Gad, Hadar, portfolio of, 232, *233–39*

Gallas, Elisabeth, 54

Gallatin, Albert Eugene, 208

Gauguin, Paul, 60

genealogy cards on German Jews, 79, 92

German Expressionism, 58, 72, 127, 134, 140n6, 206, 210, 212

German Lost Art Foundation, 72

German Officers' Association, 129

German Students' League, 127

Gesamtarchiv der Deutschen Juden (Central Archives of the German Jews), 94

Gestapo, 127, 210

Gieldzinski, Lesser, 97, 184

Goebbels, Joseph, 52, 53, 57, 58, 127

Goering, Hermann, 32, 37–38, 43, 52, 66, 82, *108*, 112, 154, 169, 172, 176, 178, 180, 188, 218; Carinhall residence, 131, 133, 176; Jeu de Paume private art exhibitions for, 130–32, *131*

Gottschalk, Alice, 210

Goudstikker, Jacques, 176, 180

Greenblatt, Stephen, 77n47

Groys, Boris, 50–51

Guez, Dor, portfolio of, 240, *241–47*

Guggenheim, Peggy, 57

Guigou, Paul: *View of Chailly, or Chailly Plain, Stormy Sky*, 46

Guillemet, Jeanne and Jules, 198

Gunzberg, Aryeh Leib ben Asher: *The Roar of the Lion: Questions and Answers*, 88, *89*, 92

Gurlitt, Cornelius, 132, 138

Gurlitt, Hildebrand, 59, 74, 132, 135–38, 141n34

H

Haacke, Hans: *Manet Project '74*, *136–37*, 138

Haberstock, Karl, 180

Haftmann, Werner, 134–35

Hamburg: Kulturwissenschaftliche Bibliothek Warburg, *124*, 125

Hanfstaengl, Eberhard, 58

Hannover, Germany, 216; Provincial Museum (Provinzialmuseum Hannover), 206

Hartt, Frederick, 63

Haubrich, Josef, 210

Hebrew Union College, 79

Heckel, Erich, 127, 135

Heidelberg: Heidelberg University, 54; Prinzhorn Collection, 130

Heimatmuseum, 55

Hengstenberg, Lore, *162–63*, *166*, 169

Henraux, Albert, 120

Herculaneum, 172

Hermanos, Levy, 46

Herzog, David: *Kriegspredigten* (*War Sermons*), 87–88, *89*

Hesse, Raymond, 47

Hirsch, Max, 190

Hirschfeld, Miss, *146*

Hirszenberg, Samuel: *The Black Banner*, 202–3, *202–3*

Hitler, Adolf, 52–53, 55–56, *56*, 127–29, 130, 154, 178. *See also* Führermuseum

Hobirk, Renate, 160, *162–64*, 169

Hochschule Collection, *100*

Hofer, Karl, 76n25

Hofer, Walter Andreas, 131

Hohe Schule, 54, 65

Holzinger, Ernst, *161*, 169

Hungarian royal coronation regalia, *166*, 169

I

IG Farben, 109, 145

Institute for the Study of the Jewish Question, 54, 82, 95, 169, 218

International Council of Museums, 77n43

International Foundation for Art Research, 72

J

Jackson, Robert, 122n5

Jaffé, Hans, *167*, 169

James, Edward, 40, 47

Jawlensky, Alexej von, 134, 206

JCR. *See* Jewish Cultural Reconstruction

Jerusalem: Bezalel National Museum, 95–96; Yad Vashem, 145, 220

Jeu de Paume (Paris), 20, 57, 64, *64*, 69, 112, 122n23, 188, 194, 200, 214, 218; lost and untraced works, list of, 21, 46–47; private exhibitions for Goering at, 130–32, *131*; Room of the Martyrs, *20–21*, 46–47, 57, 132. *See also* Valland, Rose

Jewish artists, art dealers, and galleries: missing from German postwar exhibitions, 134–35; Nazi bans on, 58, 60–61, 129–30

Jewish Cultural Reconstruction (JCR), 79, 80, 84, 87–93, *88*, 95, 97–102, 145, *225–30*; aluminum tags attached to ceremonial objects, 93, *94*, 105n21; ballot cards to determine distribution of objects, 99–100, *100*; bookplates, 87, 87–88, *89*, 92, *256*; obstruction by Germans, 94; paper tags, *90–91*. *See also* Arendt, Hannah; books; Judaica

Jewish Museum (New York): ceremonial objects accessioned by, 95; Danzig's Great Synagogue collection, 71, 77n40, 95, 96; letter from Hannah Arendt (1949), *92*; Rothschild collection objects in, *84*, *93*; as temporary storage for objects, *90–91*, 92–93, *93*, *95*, 224; in Warburg mansion, 76n1, 95

Jewish National Fund, 204, *205*

Jewish National Welfare Board, 98

Jewish Question, 79. *See also* Institute for the Study of the Jewish Question
Jewish Restitution Successor Organization (JRSO), 87, 95, 190, 192
Jewish Social Studies, 80–81, 83
Joint Distribution Committee, 71, 77n40
Jongkind, Johan Barthold: *Ice Skaters on the Canal*, *30*
Joost, Christine, *166*, 169
JRSO. *See* Jewish Restitution Successor Organization
Judaica: album compiled at Offenbach warehouse, 67; ceremonial objects in temporary storage, *90–91*, 92, *93*; global distribution of objects by JCR, 93; Hanukkah lamp, *94*, 97, 192, *192–93*; Torah crown, 184, *185*; Torah pointer, *95*; Torah scrolls, burial of (1952), 100, *102*; Torah scrolls, collected at Offenbach warehouse, *151*. *See also* Danzig's Great Synagogue

K
Kandinsky, Wassily, 58, 127, 134, 135, 206
Kann, Alphonse, 26–27, 29–30, 33–35, 37–39, 42–44, 46–47
Katz, Nathan and Benjamin, 182
Keenan, Thomas, 122n5
Kiley, Dan, 110–12, *111*
Kirchner, Ernst Ludwig, 76n25, 127, *130*, 135; *Peasants' Meal*, 128; *Street Scene in Front of a Hair Salon*, 212, *213*
Kirstein, Lincoln, 63–64
Kisling, Moïse: *Portrait of Renée Kisling*, 210, *211*
Klee, Paul, 58, 76n25, 128, 134, 206; *Angelus Novus*, 102–3, *104*; *Swamp Legend*, 140n7
Klimt, Gustav: *Jurisprudence*, 196; *Philosophy*, 196; *Szerena Pulitzer Lederer*, 196, *197*
Kloster Buxheim, 122n22, 132
Koblenz, Germany: Bundesarchiv, 69
Koenigs, Franz, 176
Kohlmaier, Josef, *165*, 169
Kokoschka, Oskar, 76n25
Kollwitz, Käthe, 60, 76n25, 129
Königssee cave (Germany), 169
Kristallnacht (November 9, 1938), *53*, 81–82, 88, 130, 178, 190, 192
Kühnel-Kunze, Irene, 65, *164*, 169
Kulturbund Deutscher Juden (Cultural Federation of German Jews), 127
Kümmel Report (1941), 56, 76n13
Kutsch, Ferdinand, *161*, 169

L
Lämmle, Siegfried, 178
Laurencin, Marie: *Trophy*, *23*; *Two Female Heads*, *22*; *Young Breton Woman*, *22*
Lauterbach, Iris, 123n26
Law for the Restoration of a Professional Civil Service (1933), 127
Lederer family, 196
Léger, Fernand, 218; *Girl with a Bouquet*, *39*; *Odalisques*, *35*; *Woman in Red and Green*, *32*
Lehmbruck, Wilhelm, 127, 129; *Head of a Girl (Contemplation)*, *60*; *Torso*, *60*
Leonardo da Vinci: *Mona Lisa*, 56, *74*
Le Sidaner, Henri: *Table in the Garden,* or *Mid-Afternoon Snack, Gerberoy*, 47
Library of Congress Mission, 65
Liebermann, Max, 60, 76n25, 129, 138
Lindenbaum, Alfred, 47

Lindsay, Kenneth C., *162*, *165*, 169
Lissitzky, El: *Proun 2 (Construction)*, 208, *209*
Lissitzky-Küppers, Sophie, 140n7
List, Herbert, 133
Lohse, Bruno, 131–32, 214
Lohse-Wächtler, Elfriede, 135
London: Warburg Institute, 125. *See also* exhibitions
Lorrain, Claude: *Battle on a Bridge*, 180, *181*; *Coast View with the Abduction of Europa*, 180
lost and untraced works, list of, 21, 46–47, 69
Louis-Dreyfus, Jean, 214
Löwenstein, Fédor, 47; *Composition*, *29*; *The Modern City*, 47
Lucerne: auction (June 1939), 59–60, 132; Galerie Fischer, 60
Ludwig Bock & Sohn, 125

M
Macke, August, 127, 129, 134, 206
MacLeish, Archibald, 63
Macmillan Commission, 115
Manet, Edouard: *Bunch of Asparagus*, *137*, 138; *In the Conservatory*, 198, *198–99*
Marburg Collecting Point, 64, 117, 133
Marc, Franz, 125, 127, 129, 134; *The Large Blue Horses*, 206, *207*; *Mare with Foals*, 125, *126*, 129, 140n2; *The Tower of Blue Horses*, 129
Margalith, Aaron, *88*
Marx, Karl, 127
Masonic paraphernalia, 54, 68
Masson, André: *Wounded Animal*, 46
Matisse, Henri, 60; *Composition*, *37*; *Daisies*, 218, *218*; *Girl in Yellow and Blue with Guitar*, 218, *219*; *The Rose Marble Table*, *38*; *Seated Woman*, 132, 138, 140n22; *Still Life with Sleeping Woman*, *70*; *Two Sisters*, 46
Mayer-Dreyfuss family, 174
Meidner, Ludwig, 128, *130*, 135
Merkel, Angela, 139, *139*
Merkers salt mine (Germany), 108, 198
MFAA. *See* Monuments, Fine Arts, and Archives
Michelangelo, 64
Michel-Levy, Pierre, 248
Miedl, Alois, 176
Mies van der Rohe, Ludwig, 76n25, 206
Mintz, Benjamin, 202–3
modernism, 56–58, *118–19*, 120–21, 135, 206, 210
Mondrian, Piet, 206
Monet, Claude: *Sailboat at Sea, Offshore near a Cliff,* or *Sailboats at Sea*, 47
Monneray, Henri, 122n21
Monnoyer, Jean-Baptiste, 248
Monuments, Fine Arts, and Archives (MFAA, also known as Monuments Men), 63, 65, 77nn27–28, 115–20, 122n3, 123n29, 169
Mueller, Ferdinand, 59
Mueller, Otto: *Gypsy Woman*, 128
Munich: Archäologische Institut, 128; Führerbau, *116*, 116–17; Verwaltungsbau, 116–17, 120, 133, 154; Zentralinstitut für Kunstgeschichte (Central Institute for Art History), 123n26, 154. *See also* exhibitions
Munich Central Collecting Point, 64, *68*, 86, 95, 108, 114, 116–17, 120, *120*, 123n26, 132–33, *133*, 144, 154, *155–59*, 169, 172, 178, 180, 190, 194, 200
Münter, Gabriele, 134, 206
Murillo, Bartolomé Esteban: *Santa Rufina*, 133, *133*

Musées Nationaux Récupération, 21, 194
Mussolini, Benito, 126

N
Nachleben (afterlife), 49, 76n1, 125–26
Naples: Museo Archeologico Nazionale, 133, 172; Museo Nazionale di Capodimonte, 133
Napoleon, 56, 76n14
National Jewish Welfare Board, 93
Nazi bureaucracy, 111–12
Nazi looting, 51–52, *73*, 82; agenda to act as stewards of cultural treasures, 112–13, 178; auctions, 59–60, 129, 132; ban on Jewish artists, art dealers, exhibitions, and galleries, 58, 60–61, 129–30; bombings, protection of artwork from, 114–15; census data giving location of Jewish residents, 112; exhibitions of plundered artworks, 107–8, 126, 129–32, *131*, 134, 140n13; fear of artwork converted into espionage and military threat, 113–14; French museum officials' demand for inventory and tracking of removed artworks, 113; genocide and, 112, 114; looting mindset, 52–57, 74–75, 76n13, 82; in pattern of Nazi war criminality, 110, 121; recovered artworks, 171–221; reversing the flow, 62–69, 108–9, 116, 120; secret caches, 94, *152*, 224; value of Nazi plunder, 122n12, 132. *See also* "degenerate" artworks; Einsatzstab Reichsleiter Rosenberg (ERR); Jeu de Paume *as repository of looted art*
Nefertiti bust, *165*, 169
New York City: Jewish Theological Seminary, 94, 96, 105n24; Museum of Living Art, 208; New York Public Library, *88*; New York University's Library of Judaica and Hebraica, 93. *See also* Jewish Museum; Yeshiva University
Nicholas, Lynn H., 76n14
Nischwitz, Otto, 67
Nolde, Emil, 58, 127, 128–30, *130*, 134–35, 138–39, 140n15, 141n37; *Breakers*, 139, *139*; *Nudes with Eunuch (Harem Guard)*, 128; "Unpainted Pictures," 135
Nolde Foundation, 139
Nuremberg Race Laws, 60, 80, 129
Nuremberg war-crime trials, 68, 69, *106*, 107; documents as preferred form of evidence in, 122n5; film *Nazi Concentration Camps* shown at, 122n9; Hall of Justice, design of, 110, *111*; lists of cultural artifacts as evidence in, 115, 122n10; photo albums as evidence in, 112, 114; screening of artworks, 110–12, 121
Nussbaum, Felix, 135

O
O'Donnell, Nicholas, 77n45
O'Donnell, Thérèse, 112
Offenbach Archival Depot, 55, 62, 64, 66–69, 86, *87*, 88, *89*, 90–92, 95, 108–9, 117, 122nn2–3, 144–45, *146–53*, 169
Office for Ideological Research and Evaluation of Worldviews, 82
Office of Strategic Services (OSS) Presentations Branch report, 110, 113
old masters, 60, 120, 132
Olivier, Friedrich: *Shriveled Leaves*, 186, *187*
Oppenheim, Lisa, portfolio of, 248, *249–55*
Oppenheim, Moritz: *Portrait of Adolph Carl von Rothschild*, 95–97, *98*
Ossietzky, Carl von, 127
Osusky, Stefan, 25, 46

P

Pacaut, Félix, 71
Panofsky, Erwin, 127
Paris: abandoned apartments and houses, 113, 122n21, 194; Musée du Louvre, 56, 74, 131, 178, 194, 218; Nazi looting and plans for, 56–57, 60, 76n5, 113–14, 122n16, 122n21, 131; postwar painting exhibitions in, 120; Salon of the Société des Artistes (1906), 202. *See also* exhibitions; Jeu de Paume
Parnin, Madeleine, 71
Patton, George S., Jr., *108*
Pechstein, Max, 76n25
Petropoulos, Jonathan, 77n37
Picabia, Francis: *Judith*, 214, *215*
Picasso, Pablo, 206, 210, 218; *Acrobat and Young Harlequin*, 60–61; *Apple*, 28; *Girl Before a Mirror*, 118–19; *Group of Characters*, 26; *Head of a Woman*, 60; *Nude Woman by the Seaside*, 46; *Seated Nude Drying Her Foot*, 24; *The Soler Family*, 60; *Still Life with Blue Guitar*, 30; *Still Life with Compote, Mandolin, Wall, and Bottle*, 46; *Violin* (*Jolie Eva*), *33*
Piette, Ludovic, 188
Pinson, Professor, 66
Pissarro, Camille, 72, 76n42; *Portrait of Minette*, 188, *189*; *Road through Fields*, 47
Pomrenze, Seymour J., 66–67, 169
Posey, Robert, 63
Posse, Hans, 182, 212
postwar painting exhibitions, 65, 73, 120, 132–35, *134*, 160, 198
Prinzhorn, Hans, 130

R

Raffaëlli, Jean-François: *Church Square*, or *Leaving Mass*, 46
Raginsky, M. Y., 112
Ratibor (Racibórz), *55*
Reich Institute for the History of New Germany, 82
Reichskammer der Bildenden Künste (Reich Chamber of Fine Arts), 129, 135, 178
Reichsministerium für Volksaulärung und Propaganda (Reich Ministry of Public Enlightenment and Propaganda), 76n17, 208
Remarque, Erich Maria, 127
Rembrandt van Rijn, 169, 198
Renoir, Auguste: *Dancer (En Pointe, Turned to the Left),* or *Rosita Mauri in "La Farandole,"* 47; *Head of a Man*, 47; *Head of a Woman*, 47; *Rose*, 47; *Thicket, Brush, or Landscape*, 47; *Young Nude Girl*, 47
restitution of artwork, 51–52, 70–75; American belief in importance of, 123n29, 198; archiving of pieces, 68–69; falsification of documents by Nazis, 72; first restitutions to Italian museums, 133; Lucerne auction records and, 59; Nazi records used in, 70; number of artworks recovered, 76n4; photographs of, *68*, 68–69; recovered artworks, 171–221; standards and guidelines for, 72; West German resistance to, 138. *See also* Munich Central Collecting Point; Wiesbaden Central Collecting Point
restitution of books. *See* books; Offenbach Archival Depot
restitution of Jewish religious and cultural items. *See* Judaica
Reynolds, Joshua, 107
Riezler, Käthe, 138

Roberts Commission, 63, 115–16
Rochlitz, Gustav, 32, 37–38, 218
Rodin, Auguste: *Burghers of Calais, 114*, 115–16; *Walking Man, 168*, 169
Roeder, Emy, 128
Rominger, Johannes, 192, *192*
Rorimer, James, 63
Rosenberg, Alexandre, 138
Rosenberg, Alfred, 52, 54, 82, 112–13, 122n21, 131, 218
Rosenberg, Paul, 22–24, 28, 31–32, 46–47, 57, 74, 132, 138, 188, 218
Rothschild, Adolph Carl von, 95–97, *98*
Rothschild, Hanne Mathilde Freifrau von, 84, *93*
Rothschild, Wilhelm Carl von, 84
Rothschild collection, 23, 25, 26, 45, 46–47, 56–57, 66, 71, 95, 133
Russia. *See* Soviet Union/Russia
Rust, Bernhard, 129

S

Sachs, Paul, 63
salt mines as storage facilities, *108–9*, 108–10, 116, 160. *See also* Altaussee; Merkers
Savreux, Maurice: *Umbrella and Apples*, 46
Schloss Herrenchiemsee (Bavaria), 122n22, 133
Schloss Immendorf (Austria), 196
Schloss Kogl (Austria), 122n22
Schloss Neuschwanstein (Bavaria), 114, *115*, *117*, 122n22, 132
Schloss Nikolsburg (Mikulov Castle, Czechoslovakia), 122n22, 188, 194, 200, 248
Schloss Schönhausen (Berlin), 59, *60*
Schloss Seisenegg (Austria), 122n22, 214
Schmidl, Marianne, 186
Schmidt-Rottluff, Karl, 76n25, 127; *Evening*, 128
Schnorr von Carolsfeld, Julius: *A Branch with Shriveled Leaves*, 186, *186*
Schoenberger, Guido, 95
Scholem, Gershom, 86, *86*, 103, 145; *Major Trends in Jewish Mysticism*, 86; *Sefer ha-Bahir* (*Book of Illumination*), 86
Schönhausen castle (Berlin), 59, *60*
Schoppa, Wulfhild, *162*, 169
Schüler, Johann Valentin: sabbath and festival lamp, *84*
Schutzstaffel (SS) films, 110–12
Schwitters, Kurt: *The Autumn Crocus*, 216; *Opened by Customs*, 216, *217*
Seated Hermes, *68*, 133, 172, *172–73*
Sedlmayr, Hans, 135
Segall, Lasar, 128
Soika, Aya, 138
South African Jewish Board of Deputies, 93
Soviet Union/Russia: German Jews fighting against in World War I, 88; postwar organization of Europe and, 117; removal of artworks from Germany, 72
Speer, Albert, 56, *56*
Spies, Walter: *View across the Sawahs to Gunung Agung*, 27
Stahl, Heinrich and Bruno, 188
Standen, Edith A., *65*, 133, *167–68*, 169
Starr, Joshua, 105n20
Stieglitz, Alfred: *Equivalents*, 240
Storey, Robert, 107, 112, 122n12
Stout, George, 63
Streicher, Julius, and Streicher Collection, 88, *88*
strongbox (eighteenth-century German), 174, *174–75*

Swarzenski, Georg, 127
Synagogue Council of America, 100, *102*

T

Tanguy, Yves: *Composition,* or *The Surveyor*, 46
Theresienstadt (Czechoslovakia), 220
Titian, 198; *Danaë*, 133, *133*
Toch, Wilhelm, 220
Torres-García, Joaquín, 47
Troller, Norbert: *Hannover, Terezín*, 50, *50*
Troost, Paul, 116
Tucholsky, Kurt, 127
Tunisia, Nazi occupation of, 240

U

Unterstein cave (Germany), *66*
Utrillo, Maurice: *Church in the Country-side*, *43*

V

Valentin, Curt, 208
Valland, Rose, 64, *64–65*, 114–15, 122n16, 131, 133, *167–68*, 169, 224; travel pass of, *117*
Vallotton, Félix: *Reclining Female Nude*, *44*
van Dyck, Anthony, 107; *Family Portrait*, *68*
van Eyck, Jan, 64
van Gogh, Vincent, 60
van Groeningen, F.: *Woman Sitting on a Trunk*, 190, *190–91*
Vaucher Committee, 115
Velázquez, Diego, 107
Venice Biennale, 134
Verwaltungsbau, 116, 117, 120, 133, 154
Vermeer, Johannes, 64, 198
von Behr, Kurt, 131

W

Wallace, Ian, 118, 120–21
Warburg, Aby, 49, 76n1, *124*, 125, 134
Washington Principles on Nazi-Confiscated Art (1998), 72, 176
Watson, Peter, 27, 46–47
Watteau, Jean-Antoine, 107
Weidemann, Hans, 127, 140n6
Weinmüller, Adolf, 178
Weizman, Eyal, 122n5
Werefkin, Marianne von, 134, 206
Westheim, Paul, 72
Wiesbaden Central Collecting Point, 64–65, 86, 92, 95, 117, 133, 144, 160, *161–68*, 169, 190
Wildenstein, Georges, 180, 188
Winter, Fritz: *Composition in Front of Blue and Yellow*, 118–19
Wolff-Metternich, Franz, 57
Wollheim, Gert, 135
women: in postwar German exhibitions, missing from artists in, 135; in restitution work, 64–65, 160
Würzburg, Germany: Mainfränkische Museum, 192

Y

Yeshiva University (New York), 93; Streicher Collection, 88, *89*
YIVO Institute for Jewish Research (Vilnius), 86, *153*, 169
Youth Aliyah, 83

X

Ziegler, Adolf, 58
Zyklon B, 109, 145

Image Credits and Copyrights

The copyright holders, photographers, and sources of visual material other than the owners indicated in the captions are listed below. Every reasonable effort has been made to supply complete and correct credits; if there are errors or omissions, please contact Yale University Press or the Jewish Museum so that corrections can be addressed in any subsequent edition. Material in copyright is reprinted by permission of copyright holders or under fair use. Images may be listed in more than one location. Page numbers are **bold**.

COPYRIGHTS

© Artists Rights Society (ARS), New York / ADAGP, Paris: **25, 27 top, 29 bottom, 31, 32, 35, 39, 42, 43, 45, 211, 215**. © Associated Press: **10**. © Salvador Dalí, Gala-Salvador Dalí Foundation / Artists Rights Society (ARS), New York: **40–41**. Compilation © Maria Eichhorn: **225–231**. © Documenta Archiv, Dauerleihgabe der Stadt Kassel, Germany: **118–19**. © Fondation Foujita / Artists Rights Society (ARS), New York / ADAGP, Paris: **22, 23 bottom**. © Hadar Gad: **233–39**. © Dor Guez: **241–47**. © Hans Haacke / Artists Rights Society (ARS), New York, VG Bild-Kunst, Bonn: **136–37**. © JM Jüdische Medien AG, Zürich: **101**. © Herbert List / Magnum Photos: **172**. © Succession H. Matisse / Artists Rights Society (ARS), New York: **37, 38 top, 70, 218, 219, back cover**. © Lisa Oppenheim: **249–55**. © Estate of Pablo Picasso / Artists Rights Society (ARS), New York: **24, 26, 28, 30, 33, 61**. © Fred Stein Archive: **102**. © United States Holocaust Memorial Museum: **73, 106**. © Warburg Institute, London: **124**.

IMAGE PROVIDERS

Acquavella Galleries: **31**. ADER Auction House, Paris: **23 top**. AKG-Images: **126, 215**. Album / Alamy Stock Photo: **14**. Archives du Ministère de l'Europe et des Affaires Etrangère–La Courneuve: **20, 21, and details on 22 left, 24 left, 26 left, 28 left, 30 left, 32 left, 34 left, 36 left, 39 right, 41 right, 43 right, 45 right, 131**. Archives of American Art, Smithsonian Institution, Washington, DC: Andrew Carnduff Ritchie Papers, 1907–1983: **120**. Archives of American Art, Smithsonian Institution, Washington, DC: James J. Rorimer Papers, 1921–1982, bulk 1943–1950: **170–71**. Artcurial: **29 bottom**. Art Institute of Chicago / Art Resource, New York: **218, 219, back cover**. Art Resource, New York: **197**. BPK Bildagentur / Art Resource, New York: **108 right**. BPK Bildagentur / Galerie Neue Meister, Staatliche Kunstsammlungen, Dresden / Art Resource, New York: **213**. BPK Bildagentur / Museum Berggruen, Nationalgalerie, Staatliche Museen, Berlin / Art Resource, New York: **24, 30**. BPK Bildagentur / Nationalgalerie, Staatliche Museen, Berlin / Art Resource, New York: **199**. BPK Bildagentur / Staatsgalerie, Stuttgart / Art Resource, New York: **33**.

BPK Bildagentur / Zentralarchiv, Staatliche Museen, Berlin / Art Resource, New York: **161–68**. Bridgeman Images: **25, 40–41, 61**. Bundesarchiv, Koblenz, Germany: B 323 Bild-1056-038 verso: **69**; B 323 Bild-1060-032: **70**. CNAC / MNAM / Dist. RMN–Grand Palais / Art Resource, New York: **29 top, 43, 195**. Christie's Images / Bridgeman Images: **27 top, 27 bottom, 28**. Coeur d'Alene Art Auction: **23 bottom**. Documenta Archiv, Kassel, Germany, MS, d02, DCA-005-18.001-d01.042: **118–19; 134**. DPA Picture Alliance / Alamy Stock Photo: **78**. Fine Art Images / Heritage Images / Getty Images, Hulton Archive: **60**. Gabinetto Fotografico delle Gallerie degli Uffizi, Florence: **67**. Getty Research Institute, Los Angeles, 89.P.4: **114; 155; 156; 157; 158; 159; 268; 279–80**. Israel Museum, Jerusalem: **98, 104, 183, 190, 191**. Jewish Museum Archives, New York: **90–91, 92, 93 left, 226, 227, 228, 229, endpapers**. Leo Baeck Institute, New York: **101**. LIFE Picture Collection via Getty Images: **66**. Lukas Web; Art in Flanders VZW: **109**. Musée du Louvre, Dist. RMN–Grand Palais / Art Resource, New York: **179**. Musée National d'Art Moderne, Centre Pompidou, Paris / Bridgeman Images: **32**. Museum of Fine Arts, Boston: **48, 177, back jacket**. Museum of Modern Art / Licensed by SCALA / Art Resource, New York: **37, 59**. National Archives, 260-MCCP-1-20: **3**; 43-0024M: **56**; 111-SC-206905: **116**; 111-SC-203453-5: **198**. National Gallery of Art, Washington, DC, Gallery Archives, Edith A. Standen Papers, 28MFAA-H10_14685_29: **65**. Nelson-Atkins Museum of Art, Media Services: **201**. New York Public Library, Dorot Jewish Division: **89 top left, top right**. New York Public Library, Lionale Pincus and Princess Firyal Map Division: **87 left and right**. New York Public Library, Manuscripts and Archives Division: **100 top and bottom**. Rheinisches Bildarchiv Cologne: **136–37, 211**. RMN–Grand Palais / Art Resource, New York: **16**. Shawshots / Alamy Stock Photo: **74**. SIK-ISEA, Zürich: **38 bottom**. Sotheby's, Inc., New York: **22**. Sotheby's, Zürich: **44**. Stringer / Getty Images, Hulton Archive: **142–43**. Succession H. Matisse: **38 top**. Tate, London: **217**. United States Holocaust Memorial Museum, courtesy of Gerald (Gerd) Schwab: **106**; courtesy of the National Archives and Records Administration, College Park, MD: **4; 53**; courtesy of James Snyder: **73**. Warburg Institute, London: **124**. White House Photo / Alamy Stock Photo: **139**. Yad Vashem Photo Archive, Jerusalem, FA1 73/74: **55**; FA1 73/3: **62**; FA2 73/44: **63**; FA2 73/8: **86**; FA2 73/1: **146**; FA2 73/18: **147**; FA2 73/22: **148**; FA2 73/31: **149**; FA2 73/36: **150**; FA2 73/33: **151 left/bottom**; FA2 73/42: **151 right/top**; FA1 73/18: **152**; FA1 73/47: **153**. Yeshiva University Archives: **88**. Yeshiva University, Mendel Gottesman Library: **89 bottom left, bottom right, 225**. Zentralinstitut für Kunstgeschichte, Photothek, Munich: **68**; 390876: **133**.

PHOTOGRAPHERS

Horace Abrahams: **142–43**. S. Ahlers: **128**. Giorgio Albano: **173**. Avshalom Avital: **98**. Günther Becker: **118–19, 134**. Maël Dugerdil, Geneva, Switzerland: **26**. Elke Estel / Hans-Peter Klut: **213**. Johannes Felbermeyer: **68, 114, 155–59**. Lieutenants Kern & Sieber: **109**. Jean-Pierre Kuhn: **38 bottom**. Herbert List: **172**. Jamison Miller: **201**. Thierry Ollivier: **179**. Allen Phillips: **189**. Jean-Claude Planchet: **43**. Elie Posner: **104**. Bertrand Prévost: **29 top**. Tony Querrec: **195**. Luisa Ricciarini: **40–41**. Elad Sarig: **241, 247**. Lt. Colonel George Raymond Snyder: **73**. Patrice Schmidt: **16**. Fred Stein: **78, 102**. William Vandivert: **66**. Katherine Wetzel: **181**. Jens Ziehe: **24, 30**.

ACCESSION NUMBERS

Alte Nationalgalerie, Staatliche Museen: inv. A I 550 (**199**).
Art Institute of Chicago: 1983.206 (**218**); 2007.290 (**219**).
Centre Pompidou: AM1973-51, R28P (**29 top**).
Chrysler Museum of Art: 71.505 (**34**).
Deutsches Historisches Museum: inv. R 92/749 (**128**).
Galerie Neue Meister: inv. no. 2016/01 (**213**).
Gallerie degli Uffizi: inv. 1890 no. 9961 (**67**).
Israel Museum: B52.11.1795 (JRSO 3165/56) (**98**); B87.0994 (**104**); B53.05.4450 (**183**); formerly Israel Museum:, B52.11.1891 (JRSO 36082) (**190–91**).
Jewish Museum: JM 37-52 (**84**); JM 50-52a-c (**93 right**); X1952-13 (**94**); F 5947 (**95**); D 307 (**96**); D 205 (**97**); 1993-37a-c (**175**); D 58 (**185**); F 487 (**192**); JM 63-67a (**202–3**); 1994-66 (**205**); X1986-329 (**220, 221**).
Leo Baeck Institute: 82.318 (**50**).
Metropolitan Museum of Art: 1980.412 (**197**).
Musée d'Orsay: MNR652 (**195**).
Musée du Louvre: RF1338 (**179**).
Musée National d'Art Moderne, Paris: inv. AM 1981-540 (**43**).
Museo Archeologico Nazionale, Naples: inv. 5625 (**173**).
Museum Berggruen: inv. 782 C (**24**); NG MB 47/2000 (**30**).
Museum für Franken: inv. 63105.026 (**193**).
Museum Ludwig: ML 76/2782 (**211**).
Museum of Fine Arts, Boston: 1987.291 (**48**); 46.1 143 (**177**).
Museum of Modern Art: 109.1990 (**59**); 355.1997 (**37**); 554.1956 (**38 top**).
National Gallery of Art, Washington, DC: 2007.111.137 (**187**).
Nelson-Atkins Museum of Art: 2004.12 (**201**).
Petit Palais: inv. 17829 (**26**).
Philadelphia Museum of Art: 1952-61-72 (**209**).
Staatsgalerie, Stuttgart: inv. 2561 (**33**).
Tate: T00214 (**217**).
Virginia Museum of Fine Arts: 60.37 (**181**).
Wadsworth Atheneum: 1958.144 (**189**).
Walker Art Center: 1942.1 (**206**).

Designed by IN-FO.CO
(Adam Michaels, Siiri Tännler,
Dani Grossman)
Set in Walbaum, Founders Grotesk,
and Coordinates

Printed in China

Jewish Museum
Director of Publications: Eve Sinaiko

Yale University Press
Editor, Art and Architecture: Amy Canonico
Production Manager: Sarah Henry
Assistant Managing Editor: Heidi Downey

Jewish Museum
1109 Fifth Avenue
New York, New York 10128
thejewishmuseum.org

Yale University Press
P.O. Box 209040
New Haven, Connecticut 06520–9040
yalebooks.com/art

Library of Congress Control Number:
2020936906

ISBN: 978-0-300-25070-1

A catalogue record for this book is available from the British Library.
The paper in this book meets the requirements of ANSI/NISO Z 39.48-1992 (Permanence of Paper).
10 9 8 7 6 5 4 3 2 1

IMAGE DETAILS
All artworks and most photographs also appear in full within the book, as noted.

Front cover: The *Venus de Milo* is prepared for transport from the Musée du Louvre, Paris, to Valençay, 1939, to safeguard it from an imminent German invasion, see page 14.

Back cover: Henri Matisse, *Girl in Yellow and Blue with Guitar*, 1939 (see page 218).

Endpapers: Materials recovered by Jewish Cultural Reconstruction in storage at the Jewish Museum, c. 1949.

Pages 1, 2 left: Paintings found in the salt mine at Altaussee, Austria, at the end of World War II, photographed July 1945 (see page 109).

Page 2 right: Pierre Bonnard, *Still Life with Guelder Roses*, 1892, reworked 1929, (see page 201).

Page 3: A basement room at the Munich Central Collecting Point, formerly the Verwaltungsbau, a Nazi administrative building wth leftover Nazi propaganda material. Photograph taken by Allied staff at the Munich Central Collecting Point.

Page 4: The charred remains of books from libraries in Berlin and Marburg that had been stored by the Nazis in a salt mine near Heimboldshausen, Germany; photographed by the Allies on April 30, 1946.

Page 5 left: Kurt Schwitters, *Opened by Customs*, 1937 or 1938 (see page 217).

Pages 5 right, 6, 7 left: From the Munich album (see pages 159, 169).

Page 7 left: Ernst Ludwig Kirchner, *Street Scene in Front of a Beauty Parlor*, 1926 (see page 213).

Pages 7 right, 8 left: From the Wiesbaden album (see pages 164, 169).

Page 8 middle: Paul Cézanne, *Bather and Rocks*, c. 1860–66 (see page 34).

Pages 8 right, 9: United States generals Omar N. Bradley, George S. Patton Jr., and Dwight D. Eisenhower inspect stolen artwork in the Merkers salt mine, occupied Germany, July 12, 1945 (see page 108 right).

Page 10: The Great Synagogue of Danzig, built in 1887, being dismantled by the Nazis, May 1939.

Page 12: Friedrich Olivier, *Shriveled Leaves* (large detail), 1817 (see page 187).

Pages 142–43: A United States soldier stands next to looted art in a former German military barracks at Königssee, May 1945 (see pages 169, 178).

Pages 170–71: Edith A. Standen and Rose Valland supervise staff of the Wiesbaden Central Collecting Point loading or unloading recovered paintings, c. 1946.

Page 256: Bookplates collected by Jewish Cultural Reconstruction (see page 87 right).

Page 271 left: From the Wiesbaden album (see pages 164, 169).

Page 271 right: Unknown artist after Frans Floris, *Adam and Eve*, late sixteenth or early seventeenth century (see page 67).

Page 272 left: From the Wiesbaden album (see pages 164, 169).

Page 272 right: El Lissitzky, *Proun 2 (Construction)*, 1920 (see page 209).

Pages 273, 274 left: From the Munich album (see pages 156, 169).

Page 274 middle: Henri Fantin-Latour, *Roses in a Glass Vase*, 1890 (see page 48).

Pages 274 right, 275, 276: From the Wiesbaden album (see pages 166, 169).

Page 277 left: Camille Pissarro, *Portrait of Minette*, 1872 (see page 189).

Page 277 right, 278 left: From the Wiesbaden album (see pages 164, 169).

Page 278 right: Moritz Oppenheim, *Portrait of Adolph Carl von Rothschild*, c. 1850 (see page 98).

Pages 279, 280: Crated artworks being loaded out of the Munich Central Collecting Point for return to their owners. The photograph is by Johannes Felbermeyer, c. 1947.

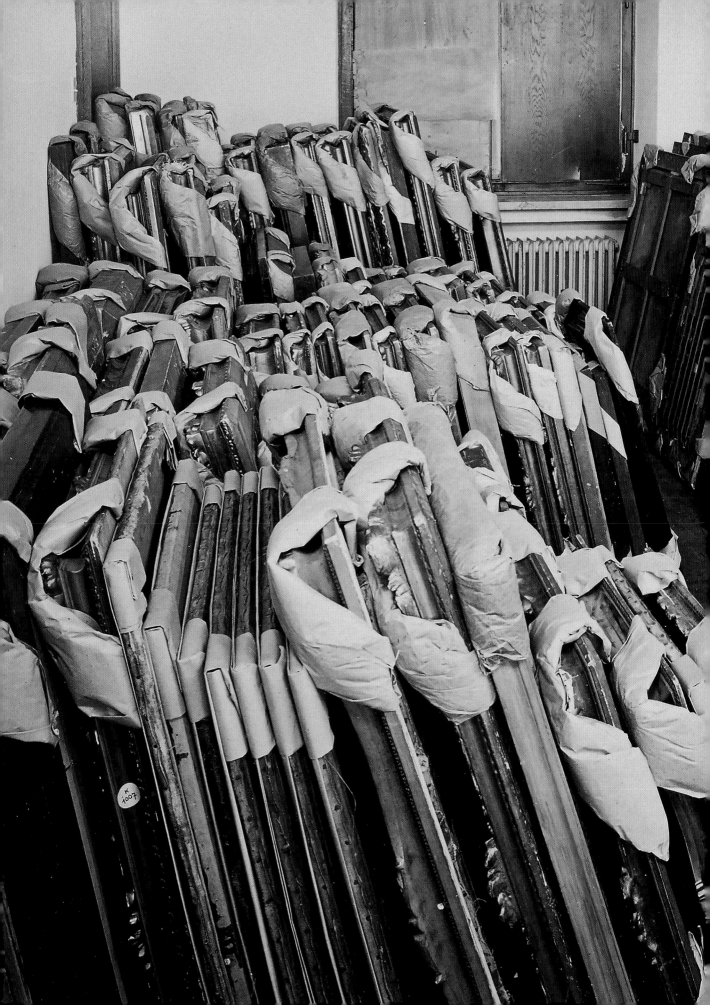

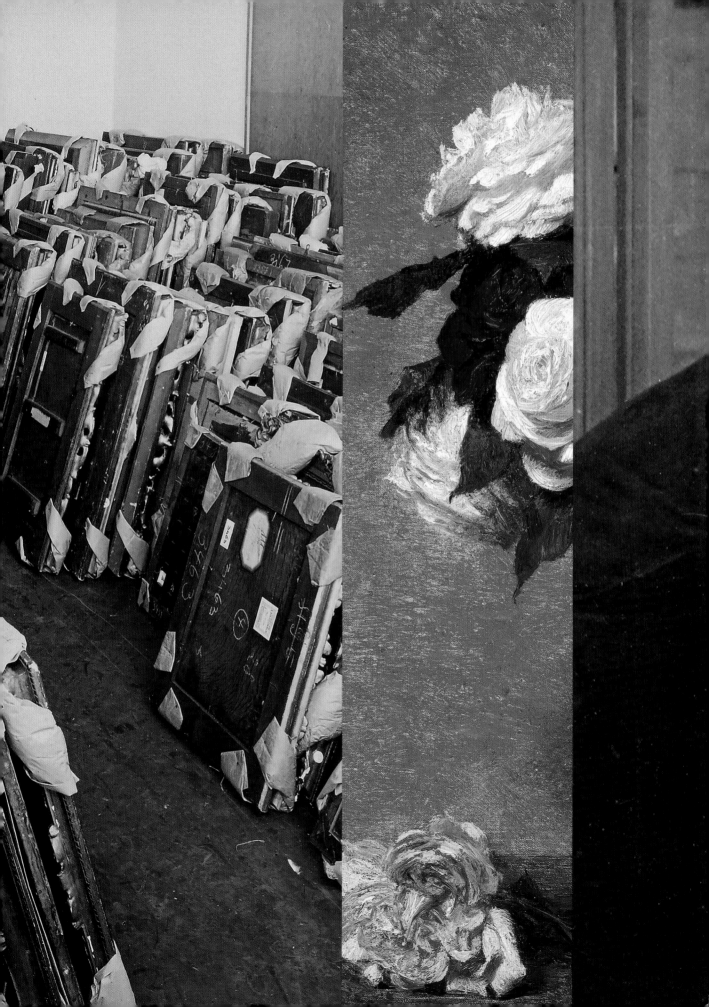

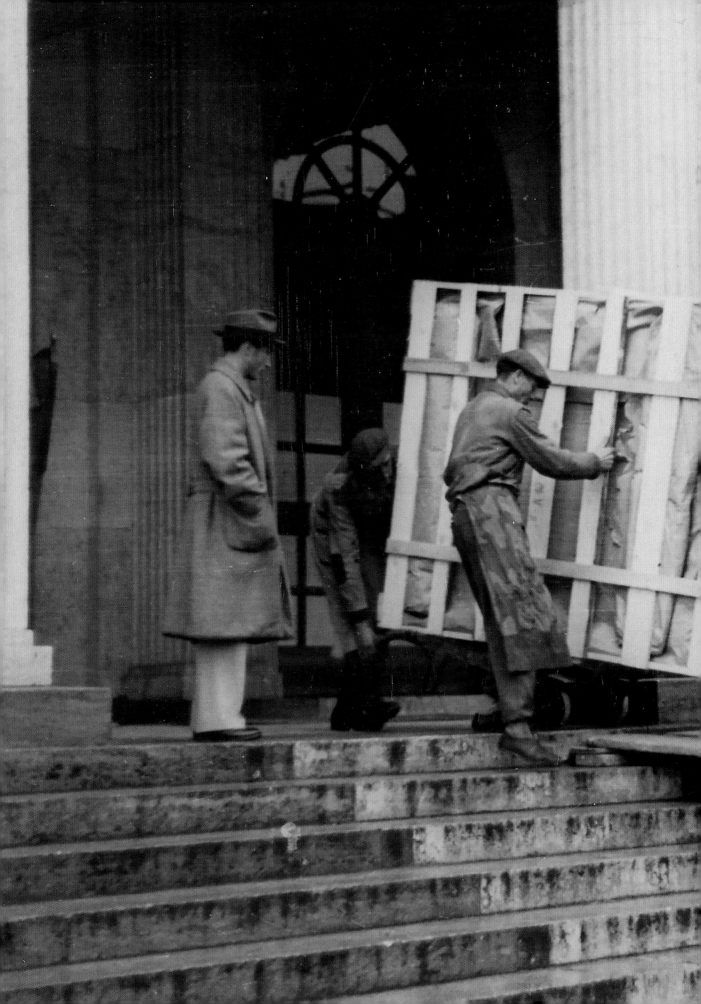

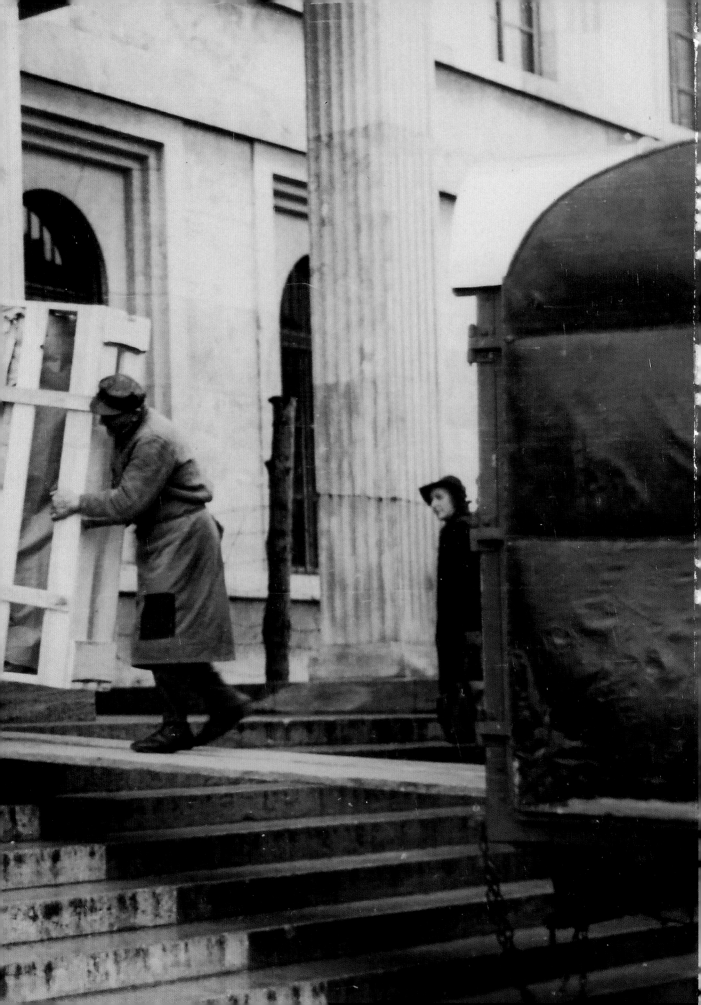

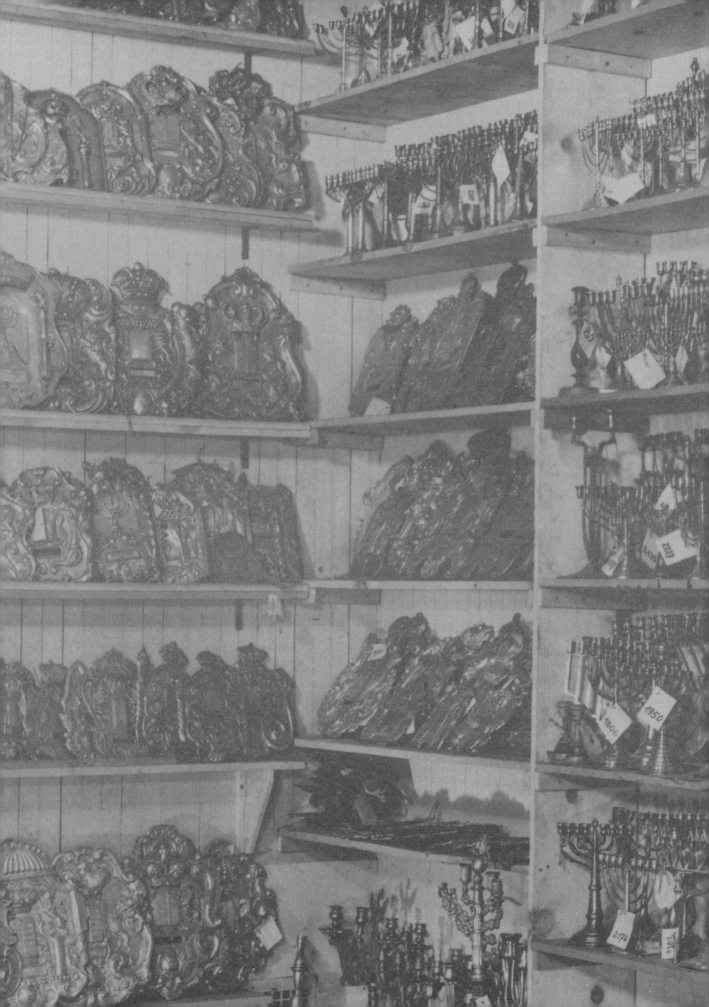